New Practices – New Pedagogies

New Practices – New Pedagogies

A Reader

Malcolm Miles

Routledge
Taylor & Francis Group

LONDON AND NEW YORK

First published 2005
by Routledge
2 Park Square, Milton Park, Abingdon, Oxon, OX14 4RN

Simultaneously published in the USA and Canada
by Routledge
270 Madison Ave, New York, NY 10016

Routledge is an imprint of the Taylor & Francis Group

© 2005 Malcolm Miles

Reprinted 2006

Printed and bound in Great Britain by
Antony Rowe Ltd, Chippenham, Wiltshire.

The European League of Institutes of the Arts – ELIA – is an
independent organisation of approximately 350 major arts
education and training institutions representing the subject
disciplines of Architecture, Dance, Design, Media Arts, Fine Art,
Music and Theatre from over 45 countries. ELIA represents
deans, directors, administrators, artists, teachers and students in
the arts in Europe. ELIA is very grateful for support from, among
others, The European Community for the support in the budget
line 'Support to organisations who promote European culture'
and the Dutch Ministry of Education, Culture and Science

British Library Cataloguing in Publication Data
A catalogue record for this book is available from the British
Library

Library of Congress Cataloging in Publication Data
Miles, Malcolm.
 New practices, new pedagogies: a reader/edited by Malcolm
Miles. – 1st ed.
 p. cm. – (Innovations in art and design)
 1. Art – Study and teaching (Higher) 2. Educational innova-
tions. 3. Artists and community. I. Title.
 II. Series.
 N345.M55 2004
 700'.71'1 – dc22 2004023490

ISBN 0–415–36618–6
ISBN 978–0–415–36618–2

European
League of
Institutes
of the Arts

the arts
council
chomhairle
ealaíon

Supported by the European Commission,
Socrates Thematic Network 'Innovation in
higher arts education in Europe'

CONTENTS

FOREWORD

New Practices/New Pedagogies is a collection of essays inspired by *Cómhar*, the 7th Biennial conference of the European League of Institutes of the Arts (ELIA) in Dublin, Ireland at the end of October 2002. The conference title *Cómhar* is a Gaelic word signifying cooperation and companionship and from the 24th – 26th of October, 2002 over 600 arts educators and practitioners gathered in Dublin to discuss, debate and participate in a series of symposia, talks and workshops on key issues affecting higher arts education.

Keynote speakers included Saskia Sassen, Luc Tuymans, Fintan O'Toole and Noel Sheridan; but the main body of the conference focused on an extensive series of structured symposia with invited presentations. The symposia were organised by working groups made up of members of Irish creative arts colleges and board members of ELIA. In the spirit of the conference title, arts educators from Ireland worked with their colleagues in Lisbon, Berlin, Bucharest, Warsaw, Barcelona, Helsinki, Bratislava, London and Amsterdam to devise a series of symposia examining issues such as changes in the role of the profession of the artist, practice-based research, ethics and critical aesthetics, e-learning and distance learning in arts pedagogy, student mobility and diversity in arts education, and the debate on cultural expression, power and privilege in the context of an expanded Europe. In addition, a special practice-based interdisciplinary symposium involving live exercises with music, drama and fine art students looked at how key terms and ideas of arts practice can be introduced through teaching.

This highly structured framework for the conference proved to be successful. The practice-based interdisciplinary symposium inspired a whole conference called *The Teachers' Academy* which was held in Barcelona in 2003, while issues raised in the *Monstrous Thinking: on practice based research* symposium have led to the development of a European Commission funded project called *re:search*, which is being led by ELIA and 10 partner institutions across the EU. The aim of the project is to achieve a better understanding of cultural differences in research in higher arts education through a comparative analysis of how research traditions, structures and approaches to research practice and supervision are integrated in EU countries.

The success of *Cómhar* was due to the hard work of many individuals and institutions and I would like to acknowledge the contribution of the representatives of art, design, media and performing arts institutions throughout Ireland who gave freely of their time, energy and creativity in numerous meetings helping to develop a stimulating conference and cultural programme for their European colleagues. The Irish Department of Education and Science, the Arts Council of Ireland, the Irish Museum of Modern Art, Dublin City Council, the Dublin

Chamber of Commerce and Bord Failte / Irish Tourist Board all provided invaluable help. Finally, a special word of thanks goes to The Dublin Institute of Technology, University of Ulster, National College of Art and Design and The Council of Directors of the Institutes of Technology of Ireland whose generous financial and administrative support made the conference possible.

Kieran Corcoran, Dublin Institute of Technology,
Chair of the Local Steering Committee for *Cómhar*.

June 2004

PREFACE:
THE EUROPEAN LEAGUE OF INSTITUTES OF THE ARTS

The European League of Institutes of the Arts (ELIA), founded in 1990, is an independent membership organisation representing over 350 higher arts education institutions from over 45 countries. ELIA represents all disciplines in the arts, including architecture, dance, design, fine art, media, music and theatre. Through this network ELIA facilitates and promotes dialogues, mobility and activities between artists, teachers, senior managers and administrators responsible for more than 250,000 students graduating and entering the professional world annually.

As the principal European higher education network of arts institutions, one of our major objectives is to support and promote new developments in arts practice that challenge old orders and rigid historical boundaries. ELIA fosters new approaches to pedagogies that critique traditional practices and promote more socially and culturally engaged programmes, encouraging international and interdisciplinary collaborations.

ELIA's activities include: international advocacy - representing and promoting higher arts education; organising international symposia and conferences; research and development projects relating to European and world-wide issues within higher arts education, and the production of publications and on line services.

In co-operation with the Dublin Institute of Technology, the Council of Directors of the Irish Institutes of Technology, the University of Ulster and the National College of Art and Design in Dublin, ELIA organised its 8th biennial conference *Cómhar* in Dublin, Ireland in October 2002. Over 600 representatives of higher arts education (deans/directors, teachers, artists and students) participated in the conference. Many chapters in this publication are outcomes of this conference.

On behalf of ELIA I would like to warmly thank President Mary McAleese as the Patron, and all the fourteen higher education institutions of the visual, performing and media arts from throughout the island of Ireland, for their contributions to the conference. We are also grateful for the financial support of the Department of Education and Science, Dublin; the Irish Tourist Board/Bord Failte; the Dublin Chamber of Commerce; the Dublin City Council; the Irish Museum of Modern Art (IMMA), Dublin; the Royal Hospital, Kilmainham, Dublin; the Department of Arts, Sport and Tourism; Aer Lingus; the European Commission DG Education and Culture; LUAS; Temple Bar Properties; ESB; the French Embassy in Dublin; Digital Hub; Enterprise Island and the Irish Arts Council.

I express our gratitude to all the authors for their enlightening and probing contributions and to the editor, Dr Malcolm Miles, Reader in Cultural Theory at the University of Plymouth, for devising a coherent structure to this complex and challenging publication. Our thanks also go to the Arts Council of Ireland for their ongoing support.

John Butler, ELIA President

June 2004

CONTRIBUTORS:

Saskia Sassen is Ralph Lewis Professor of Sociology at the University of Chicago and Centennial Visiting Professor at the London School of Economics.

Clémentine Deliss is an independent writer and editor, and researcher with Edinburgh College of Art, UK

Geoff Cox and *Joasia Krysa* teach in the School of Computing, University of Plymouth, UK, and are Editors of iDAT Broswer

Tim Collins and *Reiko Goto* are Research Fellows in the Studio for Creative Inquiry in the Fine Arts School at Carnegie Mellon University, USA

Matthew Cornford and *David Cross* constitute the London-based artists' group Cornford & Cross

Judith Rugg is Reader in Fine Art Theory at the Kent Institute of Art & Design, UK

Ann Rosenthal is an environmental artist and educator working with social and natural histories and community landscapes, based in Pittsburgh, USA

Peter Renshaw is an arts education consultant and was Principal of the Yehudi Menuhin School before becoming Head of Research at the Guildhall School of Music & Drama, UK

Amanda Wood is Associate Dean in the Faculty of Art, Media and Design at the University of the West of England, UK

Iain Biggs is Reader in Visual Arts Practice in the Faculty of Art, Media and Design at the University of the West of England, UK

Peter Dallow lectures at the University of Western Sydney, Australia, and is researching art practice, visual imagery and media, and fiction writing at the School of Communication, Design and Media, University of Western Sydney, Australia

Katy MacLeod is Senior Lecturer in Fine Art at the University of Plymouth, UK

Lin Holdridge is a Research Assistant in the Faculty of Arts, University of Plymouth, UK

Lucien Massaert is Head of the Department of Drawing at the Royal Academy of Fine Arts, Brussels, Belgium, and founder of the journal *La Part de l'Oeil*

Mika Hannula is Rector of the Academy of Fine Arts, Helsinki, Finland

Tony Aldrich is Senior Lecturer in Architecture at the University of Plymouth, UK

Beverly Naidus teaches interdisciplinary arts and sciences at the University of Washington, Tacoma, USA

Jane Trowell is an artist and art historian, and core member of the London-based group PLATFORM

Noel Hefele is a graduate student and teaching assistant in the Studio for Creative Inquiry, School of Fine Arts, Carnegie Mellon University, USA

Malcolm Miles is Reader in Cultural Theory in the Faculty of Arts, University of Plymouth, UK

GENERAL INTRODUCTION

My aim in this General Introduction is, very briefly, to set out the structure of
this book and say a little about its derivation from a series of papers from the
ELIA conference in Dublin in 2002 and consequent events, and from wider dis-
cussions – many of which have been enabled by ELIA – over the two years prior
to its publication. I do not attempt to summarise the book's individual chapters,
only to note their points of departure, the texts themselves being short enough to
be read whole and I hope clear enough to need no translation. In my conclusion I
draw out what I see as some common strands adding a few thoughts of my own.

The book is structured in four sections plus a conclusion.

The first section outlines some of the contexts in which art practices (or cultural
production and mediation) and higher arts education take place today. These
include the world of globalisation and trans-national cultural flows, discussed in
an opening paper by Saskia Sassen; the emergence of radical thinking and new
trans-national networks of participation outside the sites and hegemonies of the
affluent society, exemplified by Clémentine Deliss; the development of digital
networks of communication which either reproduce old technologically based
tyrannies or liberate us from them, outlined by Geoff Cox and Joasia Krysa; and
the rising importance of the environmental agenda, described by Timothy Collins
and Reiko Goto.

To these contexts can be added, apart from the increased prominence of climate
change in public imagination likely to follow the blockbuster movie *The Day After
Tomorrow*, recognition that art's publics are not generalised but highly specific and
diverse. As Catherine David said in a closing keynote to the ELIA Dublin confer-
ence in 2002:

> The challenge is to be able to circulate images, ideas, and projects to
> more and more heterogeneous audiences, and not the mass audience that
> our politicians ... present as a single one (unpublished conference paper,
> 2002) .

This is an important point, and goes against much of the grain of European cul-
tural policy which still assumes the unified subject (self) of a liberal humanist
viewpoint which has been largely eclipsed, in academic writing, by post-modern
and post-colonial thinking - since the 1970s. As Catherine David went on to
argue, art's publics have many backgrounds and bring to their encounter with
contemporary art a diversity of knowledges. In a further gesture against the pre-
vailing grain, she continued:

What is also at stake in art schools, as it is elsewhere, is the speeding up
of culture and the instrumentalisation of culture for the sake of a market
economy and merchandising [of art] for the purposes of capital (ibid).

This does not automatically imply a politicisation of art making within the acade-
my, though that is one route alongside the distancing from immediate political
considerations – art's retention of a claim to autonomy – defended at the same
conference by Luc Tuymans (of the Rijksacademie, Amsterdam). What it does
suggest is a far wider awareness of art's publics, sites, and contexts than was
assumed in the, in retrospect simpler, days of the boom in art of the 1960s. That
was a period of expansion in higher arts education in Europe and north America,
and many of those currently teaching and managing arts education began their
training or careers then. Now times appear bleaker, and some of the absurdity of
the world situation is sedimented in ironic and at times aggressive art. But prac-
tices also emerge today which see a new potential for global communication and
a critical visual culture, and which engage with both new agendas and those of
the human condition.

The second section looks, then, selectively at new areas of art practice in Europe
and north America. Its chapters are not direct responses to those of the first sec-
tion, and the order does not exactly correspond; but there is a loose correlation of
the two sections. Matthew Cornford and David Cross describe projects they have
conceived and exhibited, but not carried out in public sites. Their aim is to push
the boundaries of assumptions, and provoke public debate rather than comply
with cultural or civic norms - one example of work inserting itself in new inter-
stices. Judith Rugg then writes of Sophie Calle's engagement with the Freud
Museum as a site of patriarchal attitudes which is (as museum) a public space
and (as Freud's house and consulting room) private. Ann Rosenthal gives two
cases of projects for art as social interaction and research, one using digital
means, beginning with a recollection of her participation in the United Nations
Fourth World Conference on Women (Beijing, 1995). And Reiko Goto and Tim
Collins extend their previous text on the environmental agenda by looking at the
varieties of contemporary ecological-art practices. These are by no means the
only kinds of new practice. The work of Jochen Gerz, for instance, featured in the
first issue of the *European Journal of Higher Arts Education* (on-line, April, 2004),
has an overt political aspect, countering fascism.

Section three, the largest, approaches pedagogies which demonstrate how, in
actuality not fantasy, new approaches informed by new contexts and practices are
applied. This section has more breadth, seeing art education (that is, fine art) as
needing to be more integrated into culturally and socially based programmes in
higher education. This includes a stronger link between programmes in the visual
and performing arts; and a greater willingness to engage in social criticism. It also
reflects the extension of art education into doctoral research, now well established

enough throughout the Anglophone world to construct its own critical terrain. This section begins with a call for conversations from Peter Renshaw, whose background is mainly in music education. He sees isolationism in arts education as engendering a crisis which will be resolved only in cross-artform and socially engaged critique. Amanda Wood and Iain Biggs reconsider the wider cultural context of post-graduate art education, and the relation between practice and the student's subjectivity. Among the challenges they identify is the need to understand that graduate students tend to bring with them more life experience and more mature critiques than the academy perceives itself as mediating. Among four papers from doctoral provision in art education, grouped together here, Peter Dallow argues that research through practice entails a re-examination of the material and immaterial facets of creativity, in effect an enquiry into creativity itself. Katy MacLeod and Lin Holdridge relay the findings of UK-wide research into the candidate's experience of doctoral programmes in art, and cite several cases of the kinds of work currently produced. Lucien Massaert cites Derrida paraphrasing Goya, to construct an intricate web of inter-relations between rationality and its shadow, to problematise some of the assumptions made when art as research too closely mimics scientific models. At the core of his text is a problem of representation, and the reproduction of old modes of representation in new technologies. Mika Hannula then outlines similarities between methods in art and those in hermeneutics (within the humanities). Looking to Vatimo and Gadamer, he perceives art research as a dialogic event. The final four papers arise from specific courses taught either now or very recently. Tony Aldrich introduces the idea of humane architecture and a course in which the student's self-perception is central. Given the extent of overtures between art and architecture practice in the past three decades it is surprising that education in the two areas remains startlingly separated (as if architects were merely designers). Aldrich emphasises the breadth of insight necessary for architectural education to address qualitative issues. Beverly Naidus writes (from a north American perspective) about her discontent with an art education system seemingly designed to repress imagination (including, or particularly, that of a better world), and describes courses which test alternatives such as an art of activism. From the UK, Jane Trowell writes about a new course at Birkbeck College, London University. This integrates higher education, in this case for adult learners, with radical art practice which questions structures of power and wealth, as in the global oil industry. Finally, again from north America, Noel Hefele gives a detailed account of an innovative course at Carnegie Mellon University on environmental vision in context of the grey infrastructure of a post-industrial city. One of the students writes "these are exciting and new ideas to me", which I hope might be a response to this book as well.

The book began, as indicated above, as a collection of conference papers from the ELIA conference in Dublin in 2002. Saskia Sassen was as an opening keynote speaker there, and papers by Katy MacLeod and Lin Holdridge, Peter Dallow,

and Lucien Massaert were part of a parallel strand within the conference. The full set of those papers appears in issue 1 of the on-line journal, with other keynotes. Clémentine Deliss reviewed the Dublin conference for the on-line journal, and here contributes a new paper giving an extended form of her contributions to previous debates within ELIA. Peter Renshaw's paper was delivered as the keynote at the ELIA Teachers' Academy in Barcelona in 2003. To these I have added invited contributions, some papers heard at other conferences or seminars organised in conjunction with ELIA, some written specially. These fill gaps and give a more rounded impression of the current situation. They also bring in several writers based in north America, where ecological and activist art is more widespread than in the UK.

The book has a number of limitations: it is in English while ELIA is a European organisation, a majority of its member institutions working in languages other than English. Resources were not available for translations and this restricts the range of inclusions. It is also a selection based on my own judgements as Editor, and inevitably on my own contacts as far as the invited chapters are concerned. There are gaps: more on digital art would have been useful; maybe a stronger presence of feminism and post-colonialism (though these are not absent), and on the area of artist as curator; and I would have liked in my politicised way to see something on opposition to the occupation of Iraq and the fallacies of a war against terror, but perhaps this is still too raw and partisan a terrain. Since I do not wish to do the reviewer's job for her/him I will end here.

Or almost: because there are sincere thanks to express to all the writers who have produced and revised their texts within the agreed schedule, a remarkable collective achievement for a book with eighteen chapters; to Kieran Corcoran for his Foreword; to John Butler for his Preface and invitation to edit the volume; and to Francesca Pagnacco as Managing Editor of the book and on-line journal without whose unfailing support and intelligence I would have no chance to carry out my tasks in these enterprises. Recognition is due, too, to the Irish Arts Council for its generous funding for the production and dissemination of the book, and the University of Plymouth for funding the book's design and providing my time as Editor.

Malcolm Miles

June 2004

1 Globalisation: issues for culture

Saskia Sassen

I want to address three issues about globalisation. As you know I am not an artist, I am not involved with any art institution and I am possibly quite ignorant about the arts, so I am writing from a perspective of economic globalisation and what it means in a broader socio-cultural context. I want to address three issues within that, then, each of a different kind. One is the question of representation, or of narration and rhetoricisation, today - at a time of transition when, in my view, prose (which is what I do) does not always help because the necessary disruptions, discontinuities and de-stabilisations of older meanings are such that a fully reasoned account is no longer possible. We need poetry and we need poesis-making to do this, and in that sense I think of art and cultural work as important to narrate the contemporary situation, including that aspect of it which links with globalisation. Secondly, and briefly, the kinds of organisation-infrastructure that globalisation produces and how it affects the world of art, not necessarily just artists, or producers, but also the whole question of international art exhibits and events - the biennials, the art fairs, and so forth. And then finally, because I have recently been to Argentina, and Argentina as you know is in a deep crisis linked to neo-liberal economic globalisation; one of the things that has happened in this context is a resurgence of artistic practice, cultural work and participation either as consumers or in a more collective form by people (who thus become more than a public for the work, become in fact its co-producers). Buenos Aires, which is where I grew up, is a place that has long had a rich artistic life, but what is happening today is that out of the desert and the devastation that engagement with neo-liberal economic globalisation has left in this country, suddenly the arts are becoming a domain where people can practice. This is what we call a natural experiment situation. I think that out of this devastation the arts give hope. The arts are what make people feel that they are still making something. The notion I want to impart here is that it has been and continues to be the arts which give people hope and a mode of participation and I think the microcosm of the Argentine case signals a broader history.

On the question of the organisational infrastructure: as we now know, especially after September 11 the organisational infrastructure for economic globalisation has created bridges. These are resources that can be used by other kinds of actors as well. It seems to me as a distant observer that in the case of the world of the arts, biennials have sprung up in many places. I have discovered the existence of cities because they have started a biennial and I think, though I'm sure there are many negative issues here, there is something positive in the connectivity that comes about when a small city (or not so small city), a city that is out of the global loop, feels that it can become engaged with the broader community of artists, curators and art commentators, and itself become part of that process of commentary, because there is both an emergent consciousness of globality, and an infrastructure that involves not just transport facilities but the whole world of specialised services through which a lot of these cross border flows can get enacted. In terms of this infrastructure of both the transportation issue and, I think very importantly, the specialised services issue, there has been an enormous amount of innovation when it comes to legal and accounting issues. For me it is interesting how existing infrastructures, in a figurative way, can serve a multiplicity of other projects; I have a distinct impression that there is a lot of this happening in the world, and an element that I like in it is the notion of a proliferation of networks that connect very different kinds of places around shared interests, shared ways of engaging with the broader world, in this case various forms of art and culture.

Now finally, and what I most want to talk about, some of these issues about representation and narration that come out of the arts can be used to capture some of the dynamics and issues that I, as a social scientist, am concerned with but am not necessarily ideally equipped to narrate because I am largely confined to prose, and prose has its little prisons. There has to be a logic that is very tight, there has to be a rationality in prose in the social sciences that is a confinement that does not allow you to capture the full range of issues.

I want to share four themes with you that come out of my observations and work on globalisation. One of them is the question of new types of subjects, and I think of subjects as actors: one synthesising category here might be new types of political subjectivities. Secondly, what are the strategic spaces that make legible some of these developments? They may also produce them but they certainly make them legible and here I think of large cities. Thirdly, the kinds of new, post-modern geographies we see where a given dynamic installs itself in a geography that cuts across older divisions, such as the North/South division. And then finally, something that I call non-cosmopolitan forms of emergent globality or global consciousness.

Everything that is global now is thought to be cosmopolitan, and in the kind of research I do I find that there is a lot of incipient globality that is not necessarily

cosmopolitan, and in that sense I use the term non-cosmopolitan. One of the key issues that globalisation produces is a de-stabilising of existing formalised hierarchies of power, of legitimacy and the national state. By de-stabilising these existing hierarchies of power, openings are created for new types of actors to enter in domains once exclusive to national states or to other kinds of very formalised actors. These openings that allow other kinds of actors to enter into the picture are of a variety of sorts, but the main point is that subjects (actors) may not be fully formalised. This moves into questions of citizenship and identity and you may know that there is an enormous debate, enormous amount of literature and scholarship that has been produced in the last ten years on questions of citizenship and identity. I think of the history, especially in the West but also in other parts of the world, of the last hundred years that is marked by the will of national states to render national all the key building blocks of our societies: territory, law, security and identity in the form of formal citizenship. It seems to me that with globalisation, with this de-stabilising of existing hierarchies of formal power, other kinds of identities can be produced with greater ease and mutability; it's not that this is new or has never happened before, but it is that there is a greater set of options and there are now diverse circulating imaginaries, which mean that lots of people who may not have thought about re-thinking their identities or expanding the range of identities they might resonate with, can now do so - because of this emergent imaginary that opens up the question of identity beyond questions of the national state. This is like thinking via a new semantics which opens up a new syntax as well. I think internal minorities, any kind of repressed people, have often escaped the boundaries imposed by the notion of a national identity. The main point here is that there are many different ways in which people understand their identity, even in the case of the United States after such an event as September 11. Now I am thinking of subjects (actors) – especially in large cities which I think of as strategic spaces where these processes become legible – and when I say cities I mean a certain kind of environment. I think there are a lot of urban areas today that have nothing to do with city-ness. I mean here places which accommodate quite a bit of anarchy, that are messy, that are disorganised, where you can have multiple logics running through the place. As we know the state has the obligation to eliminate chaos but we citizens have the right to chaos and I think of cities as a place where this is made legible and evident.

In these places we see a prolific extension of subjectivities and of ways of thinking who you are which is astounding. It has in the era of globalisation taken on internationalised meanings so that many people describe their prime identity as a human rights activist, a feminist, an international feminist, an activist, a green activist, an anarchist. A crucial issue for me is the extent to which many of these identities are informal identities; unauthorised immigrants living in these cities participate in a variety of politics that take place in cities – street level politics, demonstrations against police brutality, demonstrations for the rights of the homeless, whatever it may be. These are non-formalised subjects but they are engaging in what is akin in a way to citizenship practices. Another example is,

and again this is a microcosm, the anti-globalisation activism where the activists go from one city to another using the formal status of tourists, but while doing political work. So they are informal subjects in terms of the substantive activity or rationality that is organising their efforts. We lack a language in the social sciences to capture this; so I speak about informal identities or not yet formalised identities. Some of these will become formalised and there are discussions about re-thinking the citizenship question in terms of modes and regimes that are not encompassed by the national state. The strategic spaces where a lot of this becomes legible is the space of the city. In there also hangs this third point on new geographies through which dynamics get constituted.

I think of the geographies of the global corporate capital, the geographies of the global capital market, the geographies of human rights activists. I think if I were dealing in the world of art I would have a whole other set of geographies in mind, the geographies of international biennials, the geographies of the global market for art which involves several sites. Because of globalisation the systemic connectivity that gets established among the different components of each of these geographies then allows one to speak about these cross-border geographies. These geographies of the global are very partial, not universal, not planetary, and I would think that in the world of the arts are multiple, rather specialised and partial geographies still in development. Another issue that might be of interest to people dealing with the world of the arts is the fact that what we call the global economy is actually constituted through a multiplicity of specialised global circuits. So that if I were doing research on museums, galleries and art markets in terms of globalisation I would start by mapping what are the multiple specialised global economic circuits that connect with the world of art. There is a research agenda here that has to do with mapping issues that concern substantively the world of culture, and more specifically the world of the arts, onto this broad category that we call the global economy.

2 Future Academy: collective research into art practices and pedagogies of a future global world

Clémentine Deliss

One of the most visible signs of the changes taking place in European art colleges today can be located in the constitution of the student body. With the implementation of EU policies such as Socrates and Erasmus increasing numbers of art students in Europe travel to different institutions to complete their studies, sometimes covering three or four different countries in the process. In the UK, the reputation of art colleges and their recruitment exercises have significantly increased the quota of Japanese and American students alongside their European colleagues such that one department alone may house a large number of nationalities not to mention a multitude of spoken languages and aesthetic paradigms. Such cultural diversity within one institution raises issues that go beyond the borders of an individual location. These address the changing forms of intercultural dialogue in correlation with earlier institutional, national and colonial histories. Art colleges are witnesses to shifts within art practice as well as transformations with regard to the identities of the collaborative working groups that populate them. As a cultural institution in flux, the art college offers a powerful breeding ground for critical reflections and research into the future of a global aesthetic dialogue.

In Spring 2002, with the support of Colin Cina, Head of Chelsea College of Art & Design (The London Institute), the research initiative *Future Academy* was set into motion to discuss and forecast conditions that might affect and define the changing parameters of the art and design college in a global world.[1] Three key areas were proposed: the shifting epistemological framework or knowledge base of art and design, the architectonics of the college including the effects of increased mobility on the physical and virtual sites of such institutions, and finally structural considerations that might support deeper transfers of knowledge across disciplines and continents. For this, an outline for a potential International Roaming Professorship was prepared and implemented on a somewhat ad hoc basis in advance of an appropriate trans-national and financial framework.[2] The first phase of *Future Academy* culminated after two years of research in April 2004

with *Synchronisations*, an international think-tank hosted and produced by Srishti School of Art, Design & Technology in Bangalore.[3] This paper seeks to expose some of the results gleaned from *Future Academy* and to suggest that an enquiry into new contexts for practices and pedagogies can benefit from a reflexive engagement with non-European and non-American locations and their histories.

Future Academy could best be characterised as a multi-sectoral investigation in that it aims to highlight the overlap of contingent problems facing the art college of the future. As such it has to contend with the gently nervous instability of a research proposal that questions economic factors, communications strategies, and forms of management and ownership as an integral part of its own constitution. At the same time, it embarks on a content-led forecasting process that as far as possible seeks to remain modular, testing the very limits of research and aesthetic production. In terms of recent interventionist and transversal practices, it can be viewed as a borderline artwork, an initiative that aims to redefine curatorial practice, or can fall within the rubric of cultural policy making.

During the research and development period of 2002, a decision was taken to go beyond European partnerships and establish links with key players and associated institutions in India and West Africa. An early recce to India included visits to Bangalore, Mumbai, Baroda, Ahmedabad and Delhi, during which seminars were held in art, design, and architectural colleges and the basic *Future Academy* proposal was presented to students.[4] Faculty and independent scholars were consulted too, but it was the students who were key in confirming the compatibility between the concept of the project and its application outside of the UK and Europe. Likewise in Senegal, special gatherings were organised both in the context of the Ecole Nationale des Arts and the non-governmental organisation Média Centre de Dakar (FORUT), as well as with established practitioners of architecture, new media, fashion, music, and the visual arts.[5] In both countries, the legacies of European art education resonated, but this perhaps more so in India where direct links had been forged with UK models of art schools since the 19th century. In Dakar, where the poet and president Léopold Sédar Senghor had established an art school of Independence in the 1960s, a need for change could be felt today that made *Future Academy* relevant to the wishes of the younger generation of arts practitioners.

At first, the cartography of *Future Academy* appeared incongruent spanning art and design colleges in the UK, one West African country and a sub-continent with a powerful sense of heritage. The link between Senegal and India became clearer when a joint commission to support agricultural developments, transport, and trade was set in place by the two countries. In dialogue with official structures in Senegal and India, *Future Academy* managed to encourage a further collaboration through the arts, education, and the creative and cultural industries. In this way the joint commission would reiterate the earlier wishes of Senghor and

other intellectuals from Senegal and India to forge ties based on historical, aesthetic and linguistic similarities between the two countries.[6] Nevertheless, the mapping of a transcontinental relationship based on new forms of culture has proved excessively difficult to fundraise for. Earlier colonial routes between France and Senegal, and the UK and India, and upon which the majority of funding is based do not foresee a transversal connection that foregrounds a south-south dialogue for which Europe takes on a third party position. In addition the private sector's potential involvement in the cultural industries is pitted against a multitude of urgencies in health and primary education for which tax benefits are more likely than in areas that demand unprecedented investment with no immediate returns. If *Future Academy* can build critically on the triad empire, education and trade, reformulated in today's world as globalisation, learning, and the creative industries, geopolitical issues of equity and ownership are not only central but also fundamental to the ethics of the project.

By April 2003, *Future Academy* had become an international research collective for which the Indian participation was hammered out at a small think tank held in Mumbai at the Kamla Raheja Vidyanidhi Institute for Architecture & Environmental Studies.[7] Over two days students and faculty from arts institutions in Bangalore, Mumbai and Delhi conferred with independent artists, critics, and social scientists on the content and structure that would take the project further and give it a specific identity in India. If *Future Academy* were to bear the responsibility of a joint institution it would need to work towards equal funding and participation. Colin Cina suggested one might construct a series of Parallel Actions that would be activated in each participating location. We hoped that *Future Academy* would lead to an interconnected chain of mobile workstations, addressing internationalism yet foregrounding local problematics and needs. Students from Srishti School of Art, Design & Technology in Bangalore were concerned that international interaction should be realised through meetings in time and space and not reduced to web dialogues. They saw themselves both as the highlighters and the editors of the material and the meanings that would emerge through the research initiated by *Future Academy*.

In a statement that sums up the objectives of *Future Academy*, Geetha Narayanan, the Director-Founder of Sristhi suggests that "if the past was built on empire and export, the future lies in networking across nations, economies, and structures. Therefore the big idea is to create a space under the overall umbrella of *Future Academy* where students, faculty, and practitioners can create new ideas and develop a notion of an academy that engages with society at every level – from creative to productive. This trans-regional network will work through a series of Parallel Actions conducted in studios across India, Senegal, and the UK in a manner that reinforces communication and helps to establish greater linkages between education and industry."[8]

In Senegal regular visits and communications throughout 2003 led to a working cell of graduates and students of the Ecole Nationale des Arts and the Média Centre de Dakar, who in January 2004, decided to form a legal entity: the Association Future Academy Sénégal. Far less reliant on a host institution than in the UK and India, and precariously short of finance, the Association nevertheless managed to carry out significant research in Dakar. Whilst still in its beginnings, it is worth elaborating on certain aspects of this research as it testifies to the manner in which *Future Academy* finds relevance and definition in different locations.

From the start of their investigation and with the theoretical input of Modibo Diawara of the Média Centre de Dakar, the students adopted the concept of the Penc, a traditional model of social communications that stresses a formal meeting point for the transmission of decisions, a nodal intersection of different perspectives and groupings that reinforces communality and the ordering of power.[9] In this manner the Penc concept acts as a reflexive elaboration on past, present and prospective conventions of dialogue with regard to pedagogies of the arts.[10] It also helps to identify the physical location of learning and communication. For if the village oak (or baobab tree in the case of Senegal) signifies the place of gathering, then by extension it can be compared to the art school building. In the case of the Penc the physical parameters required for successful democratisation processes are located in a specific socio-geographical space. Such an emblematic place with its sense of negotiated governance would require a conversion and reformulation if, in the future, it were to be harboured within a virtual and non-localised site. Digital dialogue in other words questions the socialisation procedures that certain art practices incorporate. Similarly, the relationship between the body as a carrier of communication and an instrument within art practice is a theme that needs to be recognised in the context of new technologies and their translation within different global environments. During the *Synchronisations* think-tank in Bangalore, the issue of the physical site was critically recast by some of the Indian architectural graduates who warned of the relationship between buildings and bureaucracies, colonial heritage and institutional histories. One could deduce that the architectonics of a future academy would be contested differently depending on the models of communication and notions of presence proposed in different cultural contexts.

Central to the propositions advanced in Dakar has been the model of the student as a both a bearer and a client of knowledge. This spans communications (as we have see with the Penc system), and economic structures. Here the working group in Dakar decided to adopt the Tontine or rotating savings association to support immediate financial requirements (e.g. visas for getting to India), and to assess the economic survival on the longer term of a working collective that does not adhere to global debt-based economic models. Further, the Tontine system might "enable participants to get involved in strategic sectors of the project and reinforce relations of trust and interdependence within the group".[11] The Neapolitan Lorenzo Tontine, who set up the first scheme in 1653 in France, developed the Tontine model of economics which operates with local variations

from country to country.[12] Tontines in Dakar are implemented by a large number of citizens to encourage community support and provide funds for events. Members are dependent on one another's provision such that if a person fails to contribute, his or her partner in the Tontine will be made liable. The Tontine can be clandestine whereby members remain anonymous within the community, or can be connected to much larger groupings and institutions (e.g. religious brotherhoods). In India, the equivalent of the Tontine is the Kitty Party, a widely adopted scheme for mainly middle class associations that nonetheless operates with a sense of communal solidarity.

When information on the Tontine was presented to the *Future Academy* working group in Edinburgh, it proved stimulating enough to be adopted and tested out for three months leading up to the Bangalore think tank. The sums invested proved to be larger in Scotland than in Senegal, and Edinburgh College of Art participated in the initiative by enabling these independent funds to be housed in an appropriate way within the finance department rather than in a bank. The Tontine scheme still needs to be built on and consolidated but it has without doubt engineered an important reflection upon economics that might prove invaluable to independent aesthetic research in the future. It helps to question the basis of economic structures within art colleges and the increasing dependency of the student for whom state grants as opposed to loans are a thing of the past.

The Senegalese working group extended these economic deliberations to include future parameters for the exchange of knowledge. As they wrote in a paper for *Synchronisations*: "commercial relationships in the context of *Future Academy* define the salesperson as the professor and the client as the student. The salesperson or professor wishes to prescribe knowledge and is openly available towards the interests and curiosity of the student. The latter also provides an important personal experience through his or her specific knowledge. It is here that one can refer to knowledge as a currency which is not only material but is a means of communication built upon a system of reciprocity that encourages exchange and even bargaining. This takes place through forms of negotiation whereby the exchange results in a mutually enriching process. The currency dictates the forms of negotiation and exchange. If students as clients affect sales within a future academy then a future academy would constitute a point of transit in the acquisition of knowledge which can include competence and new ideas as well as products."[13] This approach offers a quite different take on merchandising and its relationship to art education as we know it today. Foreign students directly affect the funding of an art school in the UK, but as yet they are not able to negotiate their presence in terms of epistemological value. The model proposed by the Senegalese *Future Academy* association empowers the student in a form of partnership that recognises the implicit cultural codes he or she carries with them. If this concept were pursued, art and design colleges in Europe and the USA would have to account within their institution for a minimum knowledge base that emanated from the 'home' of the foreign student whether this be this a discipline or a geo-aesthetic location.

A final issue raised in Dakar and then extended in Bangalore relates to the question of memory. Concerned with the increase in begging in the capital and its connections to religious education, the *Future Academy* association in Senegal looked closely at *Daara* or coranic schools to which many small children are sent between the ages of four and nine. In analysing these they not only made connections between advertising and pauperism, but they uncovered a key precept in the pedagogical framework of the *Daara*: memorisation. The Coran is learnt off by heart in Arabic, a language which functions more like Latin in the religious context of Senegal yet is by no means moribund. The exercise of memorisation is a skill aligned to rhetorical codes and orality. It could be regarded as a form of inscription with parallels to drawings of the mind or a mental atlas.[14] An art school of the future might include classes in memorisation that by extension would reflect analogously with the skills afforded by life drawing. Moreover, this pedagogical foundation contrasts with the general use of memory today for which a form of pin-codification or telephone number literacy combined with an increasing adherence to the English language is the dominant function.[15] During *Synchronisations*, participants on one of the field trips to the Tamil-French enclave of Pondicherry tested out "self-directed learning" by developing mnemonic devices with which to come to terms with their environment. They searched for a fictional zoo that they had read about in a novel, saw doors, junctions and street corners as "triggers and nodes of orientation" and identified a number of logic systems and games.[16] The proposition they put forward for *Future Academy* was essentially methodological: to elaborate new ways with which to constitute references and create short circuit connections between phenomena and histories. Ayisha Abraham, artist, filmmaker and faculty member of Srishti also investigated the construction of referentiality but through the neurological metaphor of the phantom limb. How would we contend with the inevitable recurrence and automatism of a template of that which had existed, of cultural memories, scripts, anecdotes, and identities? Could one recast the definitional parameters of a reference in order to suspend the ideological discourse of various art historical canons, including those established through colonial and post-colonial frameworks? Here mnemonic devices would operate as archiving systems that would be polysemic, heterogeneous in form, and thereby multiply points of entry and question the concept of the library of the future.

During *Synchronisations* domestic industries that reflect latent productions of aesthetics understood as relationships became the subject of several analyses that might help to explore reality at ground level. Shoes were investigated that linked craftspeople to industry (in this case, the Acupressure Flip Flops of BATA), potential trade routes between India and Senegal were considered based on style and fashion, and agro-ecosystems at the Coorg research station offered radical models for diversity and equilibrium. All these studies led to experiments by the participants of *Synchronisations* with different forms of representation and documentation. The outcome was in great part the production of performative knowledge, knowledge that was interdependent on several contextual backgrounds, and that tested out interfaces between these through multi-media formats. There was

an attempt to establish a "thought architecture" within *Future Academy* rather than a terrain or physical campus.[17] Instead of the physicality of a future academy, a "transiting working unit" would be devised according to parallel research into future forms of energy. "We are looking at a collapsible moving infrastructure and a framework in which a future academy might be launched within the next ten years. Only then would we be ready to harness some of the technologies that are currently being researched. For this we need to look at different tools, and regard these as an integral dimension to defining the future academy's operational activities in advance. We want to invest in the research of every dimension of our work and its parameters of activity, whether this be the concept of a working environment and what that is, business models and exchange systems, or tools and what they could provide."[18]

Several of the research topics described above that include communications, economic structures, and spatial considerations for a future art and design academy were fused together during the *Synchronisations* think tank.[19] The forty-five participants, students and arts graduates from over ten countries, whose professional nomenclature remains in flux, were engaged in a form finding process for new identities and activities within art, filmmaking, design, and architecture.[20] The students from Edinburgh College of Art were the most culturally diverse originating from Japan, China, South Africa, North America, Sweden, Holland, Germany, Austria, Northern and Southern Ireland, Scotland, and England. Their research prior to *Synchronisations* focused on different perceptions of what the future could bring. They interviewed professionals as well as amateurs and spoke to economists, doctors, cultural theorists and even members of their own family. Behavioural codes, concepts of the individual artist and the inestimable difficulties of real-time intercultural exchange were all highlighted both in advance of the meeting in Bangalore and then accentuated at different moments throughout the two weeks. Language was regarded as a location rather than means of communication such that multi-lingual situations, which included the input of translators into French and Japanese, seemed to exemplify the difficulties of establishing and then maintaining a common ground for any length of time Yet the potential dissonance that might have emerged through the heterogeneity of the Edinburgh students appeared levelled out when placed against the Indian or Senegalese working groups. It was not so much that the contrast between the groups was based on general college affiliations in the manner of a football team, but that the fairly new potential for transcultural dialogue to exist within art colleges today operated within a passive rather than aggressive or confrontational register of discourse. The sensitivity imparted by an art educational institution, including a type of homing device carried by its students, responds to the location of the campus rather than the separate and incommensurable nationalities it houses. How this campus and the student body are defined was in great part the subject of *Synchronisations*.[21]

Future Academy as *research in motion* has begun in a modest yet experimental way to animate reflections amongst a diverse group of young artists, designers and architects who "think in beat" across continents.[22] Where the challenge lies now is in developing not just the structures that enable this synchronicity to develop, but in identifying the various forms of knowledge that can constitute cultural and aesthetic currencies of the future. Here it becomes vital to emphasise issues of plurality, mobility and circulation between the different environments that influence art practices today and will affect and mould new pedagogical frameworks in the future.

Notes

1 Funding and logistical support was provided by Chelsea College of Art & Design, The London Institute, but also through the financial participation in the R&D of *Future Academy* by Edinburgh College of Art, Glasgow School of Art, and to a lesser degree the Vienna Academy of Fine Art.

2 By pooling funds from CCAD, The London Institute, ECA, and GSA a salary was made available for further research and curatorial development.

3 *Synchronisations* took place over two weeks from April 21st-May 5th 2004. The majority of activities were held at the Visthar ashram, although initial trips into Bangalore were to acquaint the participants with the city. These trips included special meetings at the Chitra Kala Parishad Academy of Art, the National Centre for Biological Studies, the Janaagraha Community Organisation plus visits to City Market, Russel Market, Malleshwaram Market, Koshy's bar, and pubs where one could watch the India vs. Pakistan cricket matches. Following this introduction, each of the *Future Academy* working groups (from Mumbai, Bangalore, Dakar, Edinburgh, and London) made an initial presentation. These were followed by in depth seminars. In the evenings films were screened. Four study trips were organised to the following locations: Hampi and Vidyanagar, the archaeological ruins and the award winning new steel township; Coorg research station into ecological and biological developments; Pondicherry and Auroville; and the town of Hassan. These field trips enabled the participants to test out their recommendations, and analyse different communities of crafts people, artists, scientists, researchers, producers, and clients, and their respective systems of communication. Whereas certain locations such as Hampi or Pondicherry were historically weighted, others such as the transit town of Hassan on the way to Mangalore signified a more global form of unplanned urban environment for which the arts, design, crafts, and local trade and industries could be viewed as potential resources.

4 I am grateful to the Arts and Humanities Research Board for providing me with a Small Grant for this research abroad.

5 Thanks to architect Abib Diène, a *Future Academy* meeting was held at his house in January 2003 together with Issa Samb, El Hadji Sy, Abdou Ba, Claire Kane, Sahite Sarr Samb, Marie-Angélique Savané, Youssou N'Dour, Mamadou Traoré Diop, Antoine Ngom and others.

6 Linguists have claimed that there are affinities between Dravidian languages and Wolof. Immaterial aesthetics, performance, and even common culinary characteristics can be recognised in India and Senegal.

7 This think was enabled by The British Council India and was housed by KRVIA.

8 Published in the *Future Academy* proposal, October 2003.

9 Further input on the concept of the Penc (pronounced Pench) was provided in the form of seminars by Brahima Diop (historian at the University Cheikh Anta Diop, Dakar) and Issa Samb (philosopher, artist, and founder member of the Laboratoire Agit'Art, Dakar).

10 In the early 1970s the Penc was a model used by the Neurological and Psychiatric units of the Fann University Hospital in Dakar directed by Dr. Collomb. As a method, it enabled patients to socialise their conditions and whilst not group therapy as such, created a valuable continuum between traditional healing methods and French or European psychiatry. For more information on Fann and experimental cross-cultural psychiatric methods in Dakar, see 'Psyche Glossen' by Hubert Fichte, 1990, S. Fischer Verlag, Frankfurt/Main.

11 Mar N'Diaye, President of the *Association Future Academy Senegal* speaking at *Synchronisations*, Bangalore April 2004.

12 It functioned with a system of annuities with dividends in which the benefits were passed onto the surviving subscribers until only one remained. It was banned in the USA and the UK in the mid 19th century when too many subscribers were murdered to enable access to their funds!

13 Mariama Diallo and Auro Nalla N'Diaye

14 See Hubert Fichte, "ein Atlas der Seele, das gemalte Contenu Mental eines jungen Afrikaners zwischen Negritude und Neokolonialismus", ibid, page 514.

15 Is it perhaps far fetched to suggest that if Islamic groups manage to set up elaborate networks across the world that defy counter intelligence, then it because memorisation and oral transmission are part of the strategy of reconnaissance and dissimulation?

16 Quotations taken from the final paper delivered by the 'Pondicherry Group' at *Synchronisations*. I am grateful to Mar N'Diaye, Pierre Leguillon, and Noe Mendelle for their input here.

17 The concept of "thought architecture" was proposed by the MFA students of Chelsea College of Art & Design.

18 Arvind Prabhakar, Research Associate, Srishti School of Art, Design & Technology.

19 Alongside faculty and students from Srishti School of Art, Design & Technology, Bangalore; Kamla Raheja Vidyanidhi Institute for Architecture & Environmental Studies (KRVIA), Mumbai; Edinburgh College of Art, Chelsea College of Art & Design (The London Institute); Ecole Nationale des Arts, Senegal; and the Media Centre de Dakar, participants in *Synchronisations* included artists and social scientists Shekhar Krishnan, Pierre Leguillon, Torstein Nybo, Christos Papoulias, and Cedric Vincent.

20 Indeed, there emerged a certain resistance to existing definitions of professional activities within the arts. This indicates more than the lack of clear perspective that a student may be confronted with. It suggests that a paradigm shift may be connected to denominations, languages, and transformations in the locations and roles adopted by aesthetic practitioners in the future.

21 Project Director and Research Scholar: Geetha Narayanan; Curator for *Synchronisations* and *Future Academy*: Clémentine Deliss; *Synchronisations* Project Coordinator: A V Varghese; Research Assistants: Jasmine Partheja, Arvind Prabhakar. Guest Artists and Social Scientists: Shekhar Krishnan, social scientist, Mumbai; Pierre Leguillon, artist, curator, Paris; Torstein Nybo, photographer, director of Media 19, Oslo, London; Christos Papoulias, architect, Athens; Cédric Vincent, artist and anthropologist, Paris. Graduates and students from: Srishti School of Art, Design & Technology, Bangalore; KRVIA, Kamla Raheja Vidyanidhi Institute for Architecture & Environmental Studies, Mumbai; Média Centre de Dakar, Senegal; Ecole Nationale des Arts, Dakar, Senegal; Chelsea College of Art & Design, London; Edinburgh College of Art, Edinburgh. Financial support from Ford Foundation India; The British Council India; The Jindal Arts Foundation; Srishti School of Art, Design & Technology; Edinburgh College of Art; Chelsea College of Art & Design; Kamla Raheja Vidyanidhi Institute for Architecture & Environmental Studies; Industries Chimiques du Sénégal; AFAA, Association Francaise d'Action Artistique; Norwegian Ministry of Foreign Affairs; Grover Vineyards.

22 From a statement by the students of Srishti School of Art, Design & Technology.

3 System Error: economies of cultural production in the network society

Geoff Cox and Joasia Krysa

'The rise of the network society... cannot be understood without the interaction between these two relatively autonomous trends: development of new information technologies, and the old society's attempt to retool itself by using the power of technology to serve the technology of power' (Castells, 1996: 52).

In much recent criticism, particularly addressing 'new' technologies, there is far too crude a distinction between industrial and post-industrial economies. In contrast, Manuel Castells, in *The Rise of the Network Society* (1996) sees the current technological mode as discontinuous from the industrial mode but its overall logic continuous in serving power. The distinction (or alleged paradigm shift) that Castells points to, is the change in the ways technological processes are organised – from a mode of development focussed on economic growth and surplus-value (industrialism) to one based on the pursuit of knowledge and increased levels of complexity of information (informationalism). In this way, new technologies have enhanced the effectiveness of global capitalism, enabling it to become more flexible, adaptable, faster, efficient and pervasive. Culture, too, has become integrated in the process of the creation of capital, with cultural regeneration as the clearest example of capital's renewal. To Maurizio Lazzarato, although culture has become subordinated to economics, objections have mistakenly tended to concentrate on the autonomy of culture enforced by intellectuals and artists, as well as some governments (1999: 159). He sees this as a problem, and instead argues that these new modes of the production of knowledge and culture are not the same as the production of wealth, and therefore new strategies are required. Art and art education clearly follow economic imperatives for the most part but do they also offer the possibility of influencing it?

This essay tries to reveal some of the mechanisms and contradictions in relation to cultural production using networked technologies, and the limitations and hierarchies offered under the so-called knowledge economy. It attempts to do this in the context of new formations of knowledge that reflect the current relation-

ship between culture, technology and the economy (often described under the fashionable term of the 'creative industries' – especially in cultural regeneration programmes that emphasise the role of culture in terms of capital's renewal). Castells asks if 'the new technological paradigm [is] a response by the capitalist system to overcome its internal contradictions?' (1996: 51) A system error has occurred, but a more detailed understanding of the internal dynamics is required.

Network preferences

A closer look at the operating system reveals some contradictory tendencies. In *The Macintosh Computer: Archetypal Capitalist Machine?* (1990), William Bowles argues that these tendencies of the capitalist system are not only enhanced by development of new technologies but also expressed to some extent through the technological tools themselves. For Bowles, the Macintosh computer in particular represents a further development of the rationalised process of development as a 'general tool' for 'generalised education' in that it is designed to be easy to operate – to be 'user-friendly'. Despite appearances however, the underlying processes are decidedly complex and there is a vast amount of expertise invested in the operating system. To all intensive purposes, the operating system 'masks' the 'real' operation of the computer by interposing itself between the user and the Central Processing Unit' and thus the Macintosh computer presents itself as a 'black box' denying access to its depths (to use terms from cybernetics). This reflects conditions of work and production, and arguably can be extended to describe wider mechanisms of knowledge production and transfer (through research and education) in the network society.

These inherent contradictions somewhat describe the current conditions for creative work and production in network societies. From an overtly Marxist perspective, Bowles examines the peculiarities of the operating system to understand how technology is employed to extort more surplus value from labour. (It is worth adding here, that Apple Macintosh computers are still the machines of choice for most art schools in the UK at least – regarded as more sympathetic to visual culture.) The historical parallel of the introduction of new technologies can be traced to the beginnings of the industrial period not least, in the introduction of machine tools that transfer skills from the human to the machine itself, reflecting a trend to alienate the worker/user from the very processes they are involved in. For Bowles, this is entirely expected:

> 'What we are seeing then is an exact duplication of the first industrial revolution where craft skills were stolen and locked into the industrial machine, then perfected to the point whereby general principles could be extracted and applied to ever more sophisticated machines, each in turn, requiring less and less skill (and labour) to operate!' (1990)

His argument is that the computer has enhanced this logic and this is to be entirely expected in the generation of surplus value.

What Macintosh tried to do was to make a 'universal' graphic user interface, to set a standardised way of operating a computer that enabled the relatively 'unskilled' user to gain access to computers 'without resort to educating everyone to the level of the university' (Bowles, 1990). In general, the user interacts with the operating system via a command structure, using a toolbox that parallels the kinds of standards developed in machine tools. It may be easy to use but it is made impossible to use it at a greater level of operation. It is a closed system that somewhat 'mystifies' the processes involved and the available choices open to the user. For Bowles, this encourages an 'unquestioning acceptance of the supremacy of technology' (1990). The irony is that much 'educative' and 'creative' work using computers in art and design subjects is delivered on these machines ignorant of the actual working operations. Even in its current form (of OSX) there is little understanding that the operating system is now UNIX-based and that it is possible to work at a deeper level of operation through the command line interface (terminal) – but only if you have the knowledge and skills to do so.

The importance of the argument is that it is only through this systematic deception that a dominant class can sustain itself: 'If the technical/professional elite are to maintain the system, they must make it as simple as possible to operate' (Bowles, 1990). This is assimilated by society in such a way that it is normalised, and becomes part of the general knowledge of that society.

For a number of complex reasons, art students are generally unable to engage with technology at a deep level of understanding or operation. It seems that art schools neither have the resources nor the willingness to see that a deep understanding of technology is necessary to engage with the cultural realm or network society. On the contrary, in those fields that actively engage in the necessary interaction of culture and technology, much recent creative and critical work emphasises that hardware and software are not merely functional but can have expressive qualities too. In this connection, Florian Cramer draws upon Roland Barthes (in S/Z) in making the distinction between 'readerly' and writerly' texts and applying this to operating systems. Rather than the readerly properties of a GUI (Graphical User Interface) operating system that encourages consumption, the command-line operating system of UNIX is seen as writerly in terms of openness and encouraging the reader to become a producer of text. This is important for Cramer as it breaks down the false distinction between the writing and the tool with which the writing is produced, and in terms of the computer between code and data. It is almost as if GUI software disguises itself as hardware (Cramer, 2003: 101) using crude and patronising analogies like desktops and trash cans. On the other hand, the UNIX command line holds multiple possibilities for transformation and manipulation – combining instruction code and conventional written language – that can take poetic forms. Cramer cites the 1998 essay by Thomas Scoville *The Elements of Style: UNIX as literature* in this connection (2003: 102) to insist on the writerly and literary aspects of programming. There has simply been too much emphasis on the visual and graphical aspects of

creative computing in art schools in this regard with dire consequences in terms of a wider understanding of the apparatus and cultural expression.

Good pedagogy here would require going against the grain of recent cultural policy-making and traditional art and design education, perhaps upgrading mere visual literacy for more critical work and hardcore programming to situate practice more overtly in terms of the network society. This logic suggests clear lines of continuity from the industrial period, such as Walter Benjamin's recommendation, in *The Author as Producer* (of 1934), that the 'cultural producer' intervene in the production process, in order to transform the apparatus (1983). This is necessary according to Benjamin's dialectical logic, as it is only through an engagement with the conditions of production that the relations of production can be addressed, and it only through this that social change can arise. In this way, the artist is transformed 'from a supplier of the production apparatus, into an engineer who sees his/her task in adapting that apparatus' (Benjamin, 1983: 102). We are suggesting that this general line of thinking retains relevance for cultural production at this point in time – even when activities of production, consumption and circulation operate through complex global networks served by information technologies. In this sense, we attempt to draw together hard and soft-wares as well as technical and artistic activity - the traditional mechanical or electrical (hardware) engineer and the software engineer or software artist. If the logic of capital is continuous, the argument holds. Can we begin to think of art education itself in terms of software? If so, do we advocate the use of proprietary software or open source principles? Rather than be determined by economics or technology, art should clearly strive to be productive.

Knowledge economy or knowledge society

If we proceed on the basis that art is produced necessarily in a networked and social context, then this needs further investigation. Castells defines this contemporary condition as the 'network society', a social order characterised as the 'space of flows' in contrast to the historically created institutions and organisations of the space of places of industrial society. The logic of the network defines a new industrial space, in which technological and organisational factors combine to make production flexible, able to produce goods across different locations but unified through telecommunications linkages. This is the post-industrial factory, if you like, not defined by a fixed site but by flows between multiple sites. The separate units are defined by the processes and labour required for the component parts of the overall operation. Automation has crucially contributed to this in requiring a highly skilled technological labour force on the one hand and relatively unskilled assembly work on the other – deciders and participants or mere executants perhaps (to use Castells's terms). The geographies often literally reflect the crude terminology of the developed and developing world, in an international spatial division of labour (Castells, 1996: 387) based on cheap labour costs, tax waivers, lack of environmental constraints, under the ruling ideology of globalisation. These new enterprises are multinational, and the networks are international in scope – summarised in terms of economic globalism.

This describes a general tendency, but the forms vary according to cultural speci-fities. Anita Gurumurthy, in *Unpacking the Knowledge Economy - Whither Knowl-edge Society?* (2004) explores some of these issues in the context of India as a ris-ing economy based upon knowledge accumulation and access to technology. She wishes to challenge the newfound optimism in the sobering context of 'the sub-servience of knowledge society to knowledge economy'. The irony of increased access to internet technologies in a culture where a third of the population remain illiterate emphasises the point of a policy of social stratification that is contributing to a hardening of existing class and gender distinctions. Further-more, Indian students are a target group for Western Universities keen to reap the benefits of the requirements of an English-speaking workforce with technological skills (the University of Plymouth, in the UK, where we work, is a case in point where students from India, China, Nigeria and Malaysia top the recruitment tar-gets of the International Office; whereas countries like Cyprus have dropped off the list now they have joined the EU; Education appears to be cynically deter-mined by economics). In particular, engineering courses are being set up, some-times validated by Western Universities and/or students seek grants to study in the West expecting that the investment will pay dividends. And yet, the information technological revolution is contingent on specific cultural, historical, and spatial conditions that determine its future evolution, and certainly do not guarantee any positive effects on society. It seems that a considerable time lag exists especially on those societies at a geographical or social distance from the site of innovation. On a local level, art schools might be seen as particularly slow to change in this respect, and can hardly be seen as sites of innovation. Economic success contin-ues to gravitate towards the United States underpinned by the interface between macro-research programmes and large markets developed by the State, as well as elements of decentralised innovation stimulated by a culture of technological cre-ativity (Castells, 1996: 60). The creative industries are simply meant to serve this scheme.

To Gurumurthy, there has been a systematic abdication of state responsibility by the Indian State to guarantee education for all 'exemplified not only by non-achievement of targets, but in the lack of will to improve quality of education, particularly of the marginalized' (2004). Clearly this critique does not fit the eco-nomic plan obsessed with information technology and the enthusiasm to become an active part in the global marketplace to the neglect of more pressing social concerns. In contrast to the claims of the knowledge economy, Gurumurthy points out that recent economic analyses prove how the optimism is misplaced – both in terms of its insignificant contribution to GDP or improved working con-ditions. The empty promises of more and more jobs (for geeks) in the high-tech industry have been proved in the West too, and there appears to be 'no systematic structural relationship between the diffusion of informational technologies and the evolution of employment levels in the economy as a whole' (Castells, 1996: 263). In the case of India, call centres are very much a condition of globalisation with few local benefits, that signals 'a new kind of work, and a new kind of worker,

whose invisibility (in the network) is mirrored by a rhetorical excess of national wealth generation, new global work culture, and cheap labour, that, in the end, renders the conditions that produce this work and the experience of the worker, equally invisible' (Gurumurthy, 2004).

Outsourcing labour is a cheap solution to the benefit of trans-national capital merely disguised under the rhetoric of the knowledge economy. Labour, including creative labour, is transformed by the need for the required knowledge to operate information technology, offering new relational patterns in the performing of tasks (Lazzarato calls this 'immaterial labour'). Castells makes the distinctions between the *networkers*, who set up connections on their initiative, and the net-worked, who are online but without any control over decisions; and another category of the *switched-off* who are tied to tasks and operate through non-interactive, one-way instructions. As mentioned, he presents these characterisations in terms of decision-making: the deciders (who make the decisions in the last resort), the participants (who are involved in decision-making), and the executants (who merely implement decisions) (Castells, 1996: 244). With informational production, constant networked interaction is required between workers, management and machines. Systems must be networked and integrated in order to process information efficiently in much the same way, through an integrated network of computers that link to each other and to mainframes – both arranged in decentralised and centralised working relations.

The relationship between capital and labour has undoubtedly changed making it more flexible and adaptable like the networked technologies that support these changes. Microsoft, the symbolic target of most negative attention in this field, provides opportunities for 'contingency workers' (or 'flextimers' as they are sometimes called), not employment as such but temporary work for 'temp slaves' as part of a 'disposable labour force'. Naomi Klein claims Microsoft 'wrote the operating manual' for this approach, 'engineering the perfect employee-less corporation' (2001: 249). Labour is still crucial, but disaggregated in the network society – for 'on the surface, societies were/are becoming dualised, with a substantial top and a substantial bottom growing at both ends of the occupational structure, so shrinking the middle, at a pace and in a proportion that depend on each country's position in the international division of labour and on its political climate' (Castells 1996: 279). In Gurumurthy's terms, the knowledge economy is therefore a smokescreen for a lack of will to use technology to build a knowledge society. This decision-making process is deliberate, and emanates from the very core of the logic of capital.

Network enterprise
These are familiar lines of domination wherein popular forms and interfaces are mistakenly understood as democratic. These ideas have been much explored in addressing the orthodox Marxist view of the political economy that would tend to see culture as determined. The interaction between culture and economy was

famously explored by Adorno and Horkheimer under the term 'the culture industry' to describe the production of mass culture (as opposed to high art) and resulting power relations between capitalist producers and mass consumers. Their account is a bleak one, but one that appears to hold continuing relevance despite being written in 1944:

> 'Interested parties explain the culture industry in technological terms. It is alleged that because millions participate in it, certain reproduction processes are necessary that inevitably require identical needs in innumerable places to be satisfied with identical goods. The technical contrast between the few production centres and the large number of widely dispersed consumption points is said to demand organization and planning by management. Furthermore, it is claimed that standards were based in the first place on consumer's needs, and for that reason were accepted with so little resistance. The result is the circle of manipulation and retroactive need in which the unity of the system grows ever stronger. No mention is made of the fact that the basis on which technology acquires power over society is the power of those whose economic hold over society is the greatest. A technological rationale is the rationale of domination itself'. (1997: 121)

Today, the pervasiveness of network technologies has contributed to the further erosion of the rigid boundaries between high art, mass culture and the economy, resulting in new kinds of cultural production charged with contradictions. On the one hand, the culture industry allows for resistant strategies using digital technologies, but on the other hand it also operates in the service of capital in ever more complex ways. Resistance reflects its organisational structures or chains of command in the emergence of decentralised trans-national cultural groups (such as techno-art collectives) that both reflect capital's organisational model and reject its politics. Global resistance is exactly that, as global as capital (and arguably needs to employ networked technology accordingly). Cultural activity is increasingly tied to these dynamics whether we like it or not.

Contradiction is part of the very working dynamism that allows capital to adapt to change so effectively. This flexibility might be characterised by the network organisational form, that Castells calls 'network enterprise' that 'makes material the culture of the informational/global economy; it transforms signals into commodities by processing knowledge.' (1996: 172) In this connection Lazzarato cites Gabriel Tarde who (in 1902) theorised the production of culture, and knowledge in particular, in such a way as to reject the traditional analysis of the political economy. Rather than concentrating on use-value, he posited the idea of 'truth-value' in that knowledge is the result of a process of production. However, unlike other products, knowledge is a mode of production that cannot simply be reduced to the market or through exchange without distorting its production and consumption value (Lazzarato, 1999: 160). Lazzarato's example is the production of books, and we might consider the production of this volume, the intellectual

rights and its exchange value - license agreements of the creative commons come to mind, as does the use of freely downloadable PDFs from the internet. A book's exchange value can be determined by the market as a product but not as knowledge that is more determined by moral issues of gift or theft (Lazzarato, 1999: 162). Capital tries to treat knowledge as it does any other goods, or else suffer the consequences of the threat to property rights and its preferred relations of production. In Lazzarato's terms, capital is obliged to turn 'immaterial products' into 'material products' to protect its logic ('immaterial economy' is Lazzarato's term for the informational economy). Relations of power extend beyond the market in other words.

In the UK, these contradictions were intensified in the 1990s by an increasing trend towards the new cultural economy, establishing links between cultural and corporate sectors with an emphasis on the 'creative industries'. Simon Ford and Anthony Davies refer to the 'surge to merge culture with the economy' (1998: 2) as a result of a wider political attempt to consolidate London and the UK's position at that time as the European financial services centre, with culture as an important element of the marketing mix. In this context, the recent governmental focus on 'creative industries' became a re-branding exercise: 'to boost the generation of wealth and employment in the creative industries and to increase creative activity and excellence in the UK' (1998: 3). Ford and Davies argue that, correspondingly, a new class of cultural workers emerged as did new terminologies to describe them as 'cultural brokers' or 'culture entrepreneurs'; representing a shift from traditional sponsorship projects towards 'co-production' with the formation of new institutions (for example, ABSA is a 'dating agency' for matching business managers with cultural officers). As a result, sections of the art world were transformed into thriving enterprise zones in which corporate and creative networks could interact, overlap and form alliances in 'culture clubs' dedicated to the networking of 'culturepreneurs' and the business community (Ford & Davies, 2000: 30). Much the same tendencies can be detected in both statutory and in turn higher education with the cynical merger of research and enterprise cultures in Universities and the increasingly vocationally focussed drive for mass education. For the most part, new graduates are being produced with suitably poor skills that situate them as consumers more than producers despite surface appearances to the contrary.

However, to simply call for the autonomy of culture misses the point for Lazzarato. If capital appropriates knowledge and culture for its purpose, then its opposition must attempt to use knowledge and culture to influence the economy. A further example of this is provided by pedagogy. Again, the production, communication and appropriation of knowledge can be seen to be different from that of wealth. Changes in government policy appear to desperately want to subordinate knowledge to the economy with the introduction of 'top-up' fees in the UK as the clearest and most recent example of this tendency. The wide and free distribution of knowledge over the internet somewhat reverses this trend (incidentally, the Lazzarato essay was first freely distributed over the nettime mail list in 1998, later

published in paper form). The significance of this in terms of intellectual production, for Lazzarato, 'is in the process of becoming a new "contradiction" within the information economy, for which the challenges represented today by the internet are but the premises of opposition to come'. (1999: 163) For Tarde, 'artistic labour is productive labour' (Lazzarato, 1999: 165) and holds the potential to influence labour in general. In this way, the economy might be influenced by culture and influence a change of operational logic.

In summary, what this essay attempts to demonstrate is the increasing complexity of production relations that in turn reflect a further problem of the current relationship between consumers and producers predicated on levels of knowledge. Indeed, who are the deciders, participants, or executants within cultural production? Art education in this context appears to be both a reflection of the generalising effect of capitalist production on the labour process which enables the de-skilled and unskilled to access technology tools and products as well as produces a deliberately undereducated work force to handle extremely complex tasks without actually having knowledge to understand them or influence them in any significant way. It is also a reflection of the specialisation necessary for modern science-based production methods predicated on the existence of a stratum of the work force who are highly trained and possess unique knowledge of the process involved (a technocratic caste). In UK arts schools, a very low level of technical knowledge of hardware and proprietary software is introduced for the most part. Knowledge of networks or server-based programming is barely taught at all. Thus, by analogy, the networked computer is both a means of ensuring the dominant relations of production and offers the potential to make knowledge accessible. The important aspect of this argument in terms of pedagogy is to make sure this happens by encouraging a deep understanding of the apparatus, in the spirit of Benjamin, by encouraging an engagement with the means of 'immaterial' production.

Knowledge is an immanent part of this culture-economy system; therefore current policies underpinning it might be examined in technological terms. If so, paraphrasing Adorno and Horkheimer, the technological rationale might be revealed to be a rationale of dominance dressed up in the rhetoric of the knowledge economy. We ask if the analogy of the choice of operating system or choice of computer interface describe the current conditions and challenges for art education in resisting standardisation and homogenised forms. There is a need to engage with the apparatus at a deep level of understanding. Can we begin to see that conventional interfaces and operating systems cut the majority of users off from a deep understanding of what is actually taking place, and stops them from becoming active cultural producers? Might this be the purpose of art to reveal these tendencies?

References

Theodor Adorno and Max Horkheimer (1997) '*The Culture Industry: Enlightenment as Mass Deception*' in Dialectic of Enlightenment (1944) London: Verso.

Walter Benjamin (1983), 'The Author as Producer' in *Understanding Brecht*, (1934) trans. Anna Bostock, London: Verso. A more recent translation is available in Michael W. Jennings, ed, (1999) *Walter Benjamin: Selected Writings, Volume 2, 1927-1934*, trans. Rodney Livingstone et al, Cambridge, Mass. & London: Belknap Press of Harvard University, pp. 768-782.

William Bowles (1990), 'The Macintosh Computer: Archetypal Capitalist Machine?' (1987) *Retrofuturism 13*, http://psrf.detritus.net/r/13/index.html

Manuel Castells, (1996), *The Rise of the Network Society*, (Volume 1 of *The Information Age: Economy, Society and Culture*), Oxford: Blackwell.

Geoff Cox & Joasia Krysa (2004), 'Art as Engineering: techno-art collectives and social change', *Art Inquiry*, Lodzkie Towazystwo Naukowe, Lodz, Poland.

Florian Cramer (2003), 'Exe.cut[up]able statements: the Insistence of Code', in Gerfried Stocker & Christine Schöpf, eds., *Code – The Language of Our Time*, Ars Electronica, Linz: Hatje Cantz.

Simon Ford & Anthony Davies (1998), 'Art Capital', in *Art Monthly*, February (2/98), no 213.

Simon Ford & Anthony Davies (2000), 'Culture Clubs', in *Mute*, no 18.

Anita Gurumurthy (2004) 'Unpacking the Knowledge Economy - Whither Knowledge Society?' *Nettime*, 5 February.

Naomi Klein (2001), *No Logo*, London: Flamingo.

Maurizio Lazzarato (1999) 'New Forms of Production and Circulation of Knowledge' in, Josephine Bosma, *et al*, eds., *Readme! Filtered by Nettime. ASCII Culture and the Revenge of Knowledge*. New York: Autonomedia.

4 An Ecological Context

Tim Collins with Reiko Goto

Introduction

Artists have always addressed nature-based themes. As artists working in an inter-disciplinary research setting we are interested in work that transcends singular authorship and integrates the arts with other areas of knowledge; and in knowl-edge that has the power to change perception and alter values. We seek to develop opportunities for discourse about place, its aesthetics and ideas about change. Returning to our primary discipline, we are particularly interested in art's rela-tionship to radical (socially transformative) ecological theories and the more adventurous ideas in public planning. We have been thinking about how art moves beyond the visual exposition of the nature/culture relationship to the role artists are beginning to take in the public discourse of this relationship. In this paper, we contextualize this emergent practice by examining the public realm as a setting that defines and focuses ecological and social questions, then review Arthur Danto's and Suzi Gablik's arguments for art's social and ecological engagement. In Chapter 8, we continue the discussion in terms of contemporary practices.

The Public Realm

We are interested in the systems and ecologies which create experiences that can be understood and framed in the post-industrial public realm. Post-industrial refers to the shift from carbon based industrial power and production towards a computer based economy of information, goods and services that began in the late 1970s. The post-industrial condition includes a pervasive legacy of human produced pollution that affects air, soil, water and ultimately the climate of the planet.

The question of the public realm is pursued from a broad interdisciplinary per-spective: artists, architects, historians, philosophers, political scientists, social sci-entists, urban planners all participate in explicating and theorizing this important area of social, environmental, spatial and political action. The public realm has

been variously charged through the years as a political entity with the responsibility (but not the power) to keep the state bureaucracy honest and the market economy in check. In other cases it is a performative zone outside the home where we practice civility. Only recently have ideas of intimacy, reproduction and domesticity entered the discourse. We argue for the inclusion of environmental concerns as well.

The Concept
Over the last two hundred years the public realm has taken on a variety of forms and constructs. The concept can be confusing because it is often formulated in opposition to or complicity with the state, private economic interests, or private/personal interests. Following Weintraub (1997) on the public/private distinction, we suggest four oppositional relationships which define the current concept of the public realm.

Public Realm Concept Models, (After Weintraub, 1997: 8-35)
I. The Market and The State model (a capitalist model), which sees the public/private distinction primarily in terms of the distinctions between the public sector of state administration and the private sector of the market economy. This idea places the state in a position to manipulate the rewards and punishments through political coercion and incentives that move the rational self-interests of the market economy toward greater social benefit.

II. The Active Citizenship model (a classical approach), which sees the public realm in terms of political community and citizenship distinct from both the market and the administrative state. Public life is a political process of active participation in collective decision making which provides a discursive-democratic set of checks and balances upon both the state administration as well as the market economy. This public realm is a field of discourse and action that emerges when humans act and deliberate in concert. (Arendt, 1958; Habermas, 1995, 1996)

III. The Spatial-Social model (an urban planning model) consists of interaction within a continuum of public, semi-public, municipal, market, corporate and private spaces all contributing to and framing an experience of sociability mediated by conventions that allow diversity and social distance to be maintained despite proximity. This is a realm of civility which has retreated from the idea of collective decision making. This idea of public realm is in opposition to the private realm of the family and the domestic sphere, but it is also in opposition to the state administration and the market economy which collaborate to provide the authority and administration of this public realm helping to maintain the opportunity for civility. (Aries, 1987-91; Jacobs, 1961: 29-112)

IV. The feminist model splits the social world into gendered domestic versus public lines. Where the public side includes the state, the economy and the realm of political discourse. This idea is based on a history of patriarchal bias in terms of

market-product based work, and the political viability of masculine forms of "public life". This is in direct contrast to a political history that denies women's voice, women's labor or the viability of issues that are placed behind the veil of privacy, intimacy or domesticity. (Fraser, 1994: 110) This is a transformative model, intended to critique the patriarchal traditions and the problems of dichotomous thinking about public/private realities.

The oppositional and conflicting aspects of these ideas can be clarified with a table (fig.1).

fig. 1: public realm concept models

Title	Public	Private	Authority
Market and State	**State** Administration	Market Economy	
Active Citizenship	Political Community and Citizenship	Market Economy and **State** Administration	
Spatial-social	Social Civility in a Spatial Contnuum	Family and the Domestic Sphere	**State** Administration Market Economy
Feminist	The **State**, Economy + Civic Discourse	Family and the Domestic Sphere	Social Critique

In this discussion, we are trying to understand what public means - not so much a site of comfort like the home, competition like the market, or poll-driven management by the state, but maybe a site of tolerance and unexpected experiences, and the potential for those that occupy urban spaces as well as those that claim expertise in urban spaces to find equitable means of creative engagement and the potential for transformative action.

> "...By definition a public space is a place accessible to anyone, where anyone can participate and witness, in entering the public one always risks encounter with those who are different, those who identify with different groups and have different opinions or different forms of life." (Young, 1990: 240)

Young is a political scientist who provides us with a sense of the complexities that face us once we move away from the theory and towards the reality of life in the public realm, observing the complex diversity which has replaced the reductive idea of a public by that of multiple publics. Through history, the public realm has never been singular or without contest. It is a dynamic reality with constant challenges to access, representation and authority. Stanley Aronowitz (1997) provides a concise overview of the authors through history who have addressed the question of the public realm. In *Is Democracy Possible?* John Dewey (1927) writes about the complexities of a democracy which has transcended the scale of personal relationship replacing it with a mediated continental nation state held together without political bonds. Walter Lippman (1955) has argued for an expert public

which services a phantom public of citizens. Each of these authors saw no easy path to an articulate public realm equipped to cope with complex issues. Jurgen Habermas (1996) faced with similar challenges in post-war Germany developed a theory of communicative action which provides a means to resolve structural barriers to understanding. His theory outlines an unconstrained dialogue amongst scientists, politicians and the public as the only one compatible with democratic self understanding. It is based upon human communication capacity and the potential of rational discourse. Authors like Seyla Benhabib (1992) and Nancy Fraser (1995) have gone into Habermas' theory of communicative action from a post-modern and feminist perspective of multiple and competing publics. Bent Flybvjerg (1998) integrates the ethical intention of Habermas' discourse theory with Foucault's analysis of power in a recent article that we think is quite useful as we consider current conditions of global power, unrestrained capitalism and environmental impacts of global proportions.

Given the recent history, Weintraub's framework is good as far as it goes. But he only begins to scratch the surface of the problems which are raised when feminist theory and new political philosophy begin to unpack the bias inherent to the public/private dichotomy. Mary Ryan (1994) tells a history of women constructing an alternative civil society with woman-only institutions, voluntary associations and philanthropic and moral-reform societies. Street protests and parades were the site of action for women excluded from participation in the legal, political and economic life of the public realm. Women, labor unions and civil rights activists are just some of the historic groups that have worked in opposition to singular and dualistic ideas of the public realm. Commenting upon the ongoing success of the feminist movement, she says, "The movement of women into the public is a quantum leap in our public life; it both expands membership in the public and articulates vital aspects of the general interest that have hitherto been buried in gender restrictions and disguised as (issues) of privacy". (Ryan, 1994: 286) Iris Young looks directly at political theories, and the tendency to reduce diverse political subjects to singularities and to value commonness or sameness over difference. She says, that "Social justice requires explicitly acknowledging and attending to those group differences in order to undermine oppression" (Young, 1990: 3). These emergent political philosophies uncover a public realm which is moving away from singular or dualistic conceptual constructs and towards ideas of complexity and diverse publics as a reality and a social ideal.

One could argue that the state, the market, civic discourse, multiple publics and diverse family constructs are all dependant upon a meta-public sphere called nature. Remove nature and human society will find nothing more than a vacuum, with no potential to support life, commerce, politics or intimate relationships. It could be argued that this statement is so obvious it's not worth saying. But then again, let's consider what the effect might be of not stating the obvious. First, nature, like women, and diverse publics have been and continue to be denigrated to a position of subservience, without equitable representation. (Merchant, 1980;

Plumwood, 1993). The issues are simply not on the table, or if they are, the power and voice of the representatives cannot compete with other interests. But let me take a moment to provide an overview of why nature should be included in the historically anthropocentric concept, spatial framework and discourse about the public realm.

Nature is the context and source for human experience and material production. Living systems, or "nature", cannot be replaced, nor can they be manufactured with the existing knowledge and tools of agricultural, industrial or post-industrial societies. Fertile soil, pure water, clean air and biological diversity are all disappearing. Environmental economics tell us these are capital goods, they are not income that can be spent with an expectation of replacement. (Prugh et al., 1995) It is a bit of a stretch, but one could say that nature has been repressed. It has been included in the public realm equation only in terms of its material relationship to capital. Yet, we would argue that nature is, and has been, a primary focus for the construction of ideas of shared spatial uses as well as shared resource. British common law is the basis for American common law and they both support hydrological systems as public rights. We have specific water rights: the right to access, to use, as well as rights to purity and consistent delivery. Clean air laws, and clean water laws have all been written in this century in response to the impacts of industrial economies. To date the rights of nature have been confined to the rights of specific species not to become extinct[1].

Following the eco-feminist argument we would state that historically nature and women have been pushed aside and constrained from the conceptualization of the public realm. Women have captured their place. Nature demands advocacy and voice. Like the architectonic context of the spatial social model, and following the critical and transformative intent of the feminist model, we think it is essential that we consider an ecological model of the public realm. Let me reconfigure the outline.

Public Realm Concept Models, (After Weintraub, 1997: 8-35)
I. The Market and The State model (a capitalist model)
II. The Active Citizenship model (a classical approach)
III. The Spatial-Social model (an urban planning model)
IV. The feminist model splits the social world into gendered domestic v public lines.
plus:
V. The ecological model is a co-evolutionary paradigm that recognizes that human culture coevolves in relationship to nature. The private sector, the public sector and the intimate sector of familial relationships have historically operated in a parasitical relationship to nature. The city is a node of pure consumption that must borrow carrying capacity and energy from elsewhere (ex-urban agricultural lands and forest lands) or from the past, in terms of fossil fuels. The development and sustainability of public, semi-public, municipal, market, corporate and private spaces are all in a parasitical relationship to nature.

Without ecological representation at the table of the public realm the enlightened self interest of capital, and complicity of the state influenced by global capital have the potential to decimate nature as we know it.

fig. 2: a fifth category

Title	Public	Private	Authority
Ecological	Social and Ecological Citizenship	State, Market, Family	Limiting Factor Natural Capital
	Nature: biosphere, bioregion, landscape, ecosystem, organism		

The Experience
Experiences of the public realm can be defined at two scales. In relationships between individuals in public space and as the more encompassing social-ecological-political concept of a shared commons. It is easy to think about being "in" a public space. Public space has both its spatial and discursive forms, it has a perceptible boundary. We choose to either participate or not participate in public space activities. In contrast we would define the commons as having no real boundary; it is part of the experience of place. The commons are a shared experience that is processed through a social-political lens. Public space is to the commons as skin is to breath in the body. The skin is a clear and perceptible public-place of our body, we are aware of its condition, its visibility and its cleanliness. Breath is the body-commons which we all share, it sustains life. The breath we breathe, however, gets less attention than our skin. We are seldom aware of its chemical condition, its cleanliness or even its ability to support life – until it's too late. The former is an obvious physical artifact that we are well aware of, the latter a ubiquitous necessity easily overlooked until compromised or removed.

The experience of public space is often framed by place, articulated by architecture, urban design or landscape and hydrology and defined by social-political action. Public space can be found in both terrestrial and aquatic conditions. It can be planned and constructed as in sidewalks, streets, roads and parks. It can be preserved, conserved as in forests, ponds, estuaries and natural ecosystems. It can be managed in terms of the ocean, the great lakes or the rivers, streams and creeks of the nation. Public space is an environmental continuum of material constructs and identifiable natural systems, which are assumed available to all. A range of social-political constructs, which are based upon long-term protection, but include opportunities for legal advocacy and public oversight, supports these public spaces. The idea of public space is constantly evolving and a number of authors suggest that it is actually in a period of significant decline or outright hostile take-over. They see a public realm caught between the self-interests of nations and capital, and the mediated spectacle of consumerist desire. They include Aronowitz (1993), Davis (1999), Schiller (1989) and Sennett (1994). Other authors like Brill (1989) and Carr et al. (1992,), as well as Marcus and

Francis (1998), suggest that the old forms of dense European cities are simply giving way to a diversity of new forms and that public space is simply evolving with new relationships to the state, capital, and diverse publics and politics.

Another public space is framed and defined by the voices of citizens engaged in discussion about shared aspects of life and the issues of the day. Two voices in dialogue create this space, which can be casual (personal) or targeted (civic). This discursive form of public space is considered by many to be the bedrock of an equitable democratic society, a site worthy of significant oversight and constant critical engagement. Arendt (1958), Dewey (1927), Habermas (1995), and Lippman (1955) have developed significant texts on the subject which point to decline or crisis. They seek to understand the reasons for decline as well as strategies for restoration. Arendt and Habermas have become key points of reference for a new generation of post-modernist writers interested in the move from singular notions of public, toward diverse publics with diverse relationships and access to power.

Throughout history, interested and powerful parties have captured both the spatial and discursive forms of public space for a range of invested interests. Spaces can be fenced , policed, monitored, or otherwise secured to stop, block or deny access. Access to discursive and spatial forms of public space has been controlled, managed or denied throughout history. Civic discussions can be captured and redefined to reflect powerful interests and minimize the voices of less powerful interests. (Benhabib 1992; Fraser 1994; Young 1990)

Public space is an intimate experience in comparison to the commons. We see the commons as diverse and ubiquitous resources, which are perceived as too dynamic, too diffuse or too well integrated into the fabric of human life to have the kind of value that needs to be defended. Where the experience of public space is intimate, the experience of the commons is expansively diffuse. Despite the collective ubiquitous and multiple benefits of the material commons (and the organisms and resources that inhabit the commons), they can and have become the target of desire for powerful interests.

There is no greater prize than wealth that is extracted from a ubiquitous once-public common good redefined as a desirable market resource. For this reason the meaning, form and function of the commons is constantly shifting. For example, a century ago, rivers were considered unalterable natural commons. In the last century industrial tools allowed us to re-define their function and manage them as resources for industrial production, minimizing their ecological values (Cioc 2002; Haglund 2002; White 1995). With the emergence of radio and television technology the airwaves were discovered and targeted as a public good, to be controlled by federal interests (Aronowitz, 1993; Schiller 1989). In the coming century, inner space is the commons of speculative desire with our worldwide genealogical heritage, the focus of new bio-industrial economies that seek to

market plants, organisms and natural systems that were previously considered part of our ubiquitous common heritage (Shiva 1997).

The post-industrial era provides significant challenges to our biological and ecological commons. First, the external world is affected by a legacy of industrial pollutants that remain in our atmosphere, soils and waters. We are just now beginning to realize that we have and are affecting nature and the global commons in ways never before thought possible. Secondly, the concept of resource extraction has now descended to the microbiological level, with market interests scrambling to capture value through mapping, manipulation and patenting of genes. The market interests in these processes are of course enormous, with desire and economic speculation outrunning moral and ethical constraints. In these examples we find a range of meaning, form and function, which radically redefines the concepts of humanity, nature, public space and the global commons in the coming century. This is an area of massive cultural flux, one where strategic energy in terms of interdisciplinary arts practices can result in opportunity for significant creative engagement, as well as economic and intellectual support with good potential for social-political impact.

> "The forms for actual change in our society are yet to be created, though created they must be, for affective forms for change will be tooled from the actual conditions and historical location of our cultural space and consciousness." (Kosuth, 1993: 171)

Art and Society - Art and Ecology

In the previous section, we have attempted to make an argument for nature and the public realm as sites that demand strategic, critical and creative attention. Yet isn't this simply another topic amongst a myriad of subjects that the artist might consider as the framework for a formal media study? After all, a proper education in the arts is about self expression through media, technology and technique, not subjects like society, ecology and the tension between the public and private realm. In the section below, we are simply recognizing a theoretical boundary between art that is concerned with itself and art and that engages the world. To draw a boundary and to name it creates the condition that allows us to breach that boundary.

Philosophical models

> "With modernism, the conditions of representation themselves become central, so that art in a way becomes its own subject." (Danto, 1997: 7)

Art has been its own subject for over a century. Our discipline has been deeply invested in the examination of its own media and method, the very concept of itself. We inhabit the world, but for the most part seldom seek to affect it in any direct way. Today the word art can be defined only in reference to artists' production framed by the authorizing reaction of institutional support, and an impact upon the viewer that demands intellectual and/or material consideration.

We should take a moment to discuss how we come to this condition. In the quote above by Danto he claims that modernism turned inward upon itself seeking to understand the material conditions of artistic representation much in the way that sciences sought to understand the material conditions of natural systems. In discussing this subject further, Danto comments upon the end of modernism and the beginning of what he calls the post-historical period, rather than the post-modern, which he feels is a label which misdirects the sense of contemporary possibilities and the lack of a definable style in the current period worth recognition at this point.

> "...nothing marks the difference, outwardly, between Andy Warhol's *Brillo Box* and the Brillo boxes in the supermarket. And conceptual art demonstrated that there need not even be a palpable visual object for something to be a work of visual art. That meant that you could no longer teach the meaning of art by example. It meant that as far as appearances were concerned, anything could be a work of art, and it meant that if you were going to find out what art was, you had to turn from sense experience to thought. You had in brief, to turn to philosophy."
>
> (Danto, 1997: 13)

From the perspective of philosophical logic, the denotation of the word art produces a larger set of things that art may be, than the set of things that art is not. The logic based connotation or dictionary definition of the world is harder to pin down as a result. It is very hard to describe today what may evolve into something new tomorrow. Our working definition above is relatively clear that the product of the artists work can be understood in terms of the integration of conceptual and material content. The material and conceptual form of the artist's production can also be defined in terms of its affect and effect. We would agree with Carol Becker writing about the Marxist philosopher Herbert Marcuse, who says that the strength of art lies in its otherness (its affect)[2] and its potential effect on society. "Fundamental to Marcuse's understanding of the possibility of human liberation was his belief in the imagination – its regenerative abilities to remain un-colonized by the prevailing ideology, to continue to generate new ideas, and to reconfigure the familiar." (1996: 37) This idea of otherness, suggests that art is not a part of everyday reality, instead it is part and parcel of the philosophical texts, the stories and creative materials that help us make sense of the world. We see this "making sense" as theoretical direction and creative opportunity, a sense of the potential for transformative engagement in the world, we would claim that the arts have a very specific role in the world. This is different from the "making sense" of science that is tied to the notion of an analytical method of proof and truth or quantitative description. Art does not develop in the way that the natural sciences develop, presenting progressively more adequate views of an essentially unchanging reality. This we think is an important point, and is part of the value of art, in that its foundation knowledge or "core truths" are not so rigorously held that new ideas require a paradigmatic change in the area of knowl-

edge before they can be considered valid by the community of practitioners. This is the heart of what is unique in art and why its effect upon society can be significant, if we choose to focus and engage.

The downside to this is that, without a history of progressive improvement, it is also very hard to define efficacy, value and impact within or outside the discipline. This is a significant question that we will return to later in chapter 8. Let's return to Becker's thoughts on art and its effect on society. While she patently believes in the potential for art and society she is also clear that "there is a lot of confusion about where it fits, what functions it serves and where its emphasis should be placed." (1996: 39) Furthermore she claims that there is little debate about art that is considered political, but exists outside the political arena. She also claims there are few theoretical models to examine as we attempt to address such issues. Where Danto opens the door to a new intellectual inquiry about what art is, Becker asks what is art's direct relationship to society and politics. Becker's claim is provocative for those of us that are interested in this kind of question.

> "We do now realize that anything can be art. That is, any material or element in any sense can be made to function within an art context. And that in our time quality is associated with the artist's thinking, not as a ghost within the object." (Kosuth 1993: 44)

In *Has Modernism Failed* Suzi Gablik (1984) asks the question, is art for arts sake or for society's sake? She outlines the struggle between those that believe art serves no purpose and indeed that anything that served a purpose could not be art. This tradition is examined in terms of the social relations of early modernist artists who felt that art about art was a protest against the materialist society of the early 20th Century. "The original meaning of the term avant-garde implied a double process of aesthetic innovation and social revolt; it took the form of an estranged elite of artists and intellectuals who chose to live on the fringe of society." (1984: 22) Arthur Danto in *After the End of Art* (1997) describes the same period as the "age of manifestos" referencing the work of Phyllis Freeman who has unearthed "500 examples, some of which - the surrealist manifesto, the futurist manifesto - are nearly as well known as the works of art themselves." (1997: 28) Danto describes a process of definition, where artists recover, disclose or reveal the truth about art, which had been lost or poorly acknowledged. These manifestos provided a philosophy that defined a period in history and its end state, which was the one true art of the time. What art was, until the period of modernism, can be defined as 'mimesis': the imitation or simulation of the world through two and three-dimensional media. He sees the period of modernism as a time when artists and intellectuals worked to clarify the philosophical truth of art, in the same way that a natural scientist clarifies the fundamental truth of natural organisms. In one instance he compares the astronomer considering a point of light as a star or not a star as similar to Duchamp viewing his urinal or Warhol viewing his boxes as art or not art. Danto describes the next transition, where art moves away from questions of truth.

"…a new level of philosophical consciousness has been reached. And it means two things. It means first that having brought itself to this level of consciousness, art no longer bears the responsibility for its own philosophical definition." (Danto, 1997: 36)

Where Danto sees the collapse of modernism[3] in Wahol's Brillo boxes, the loss of art as an identifiable typology, initiating a new period of variable forms of conceptualization and production, Gablik sees the dissipation of the revolutionary intent of the avant garde in a self referential formalism that is only aesthetic. Claiming this as a tragic end game she quotes Peter Fuller: "…the contemporary artist's freedom is, in any case illusory, since it is restricted solely to aesthetic questions. It is like the freedom of madmen and the insane; they can do what they like because whatever they do has no affect at all… they have every freedom except the one that matters: the freedom to act socially." (1984: 31) To act upon society, is at the heart of Gablik's thesis.

Gablik has a range of ideas, from questions about the ability to study art for moral results, to the restoration of spiritual content and tradition in the arts. At first glance the idea of tradition could seem somewhat reactionary and conservative for this vocal critic of the art world, but she is quite clear and typically to the point.

"What the early modernists failed to foresee, in their dedication to the new, was that such a conception of history could only be built on sand, since no belief ever had anything solid to support it. Maximizing the variable of change – stimulating it artificially and making it the most important thing on the stage – destroyed stability. Pressed to its ultimate conclusion, the steady violation of expected continuities – which has been the crucial element in modernist 'progress' – is radically at odds with systemic wisdom and equilibrium." (Gablik, 1984: 116)

In this statement she stakes out a ground, which is in curious tension with the statement in the previous section by Becker commenting upon Marcuse, stating that the strength of art is in its otherness. Gablik's conclusion identifies the conceptual point at which modernism was so deeply invested in otherness, and its pursuit of the form of that otherness, that it went beyond its capacity to sustain itself, developing a cultural position which could only result in its own demise, the end of modernism, or, in Danto's terms, the end of art. In these arguments of Gablik and Danto we have a clear sense that art is at a point of significant transition. It is open to the ideas that transcend its own meaning and methods of production. Becker, via Marcuse challenges us (the artists) to find that new way, through social-political fit, function and possibly impact. In Chapter 8 we suggest some cases of how artists have engaged with this context.

Notes

1 In western cultures the courts are the primary sites of action when the question of rights are considered. In eastern and mid-eastern countries, religion can provide the authority for rights of nature.

2 Becker, 1996: 44 discusses Marcuse's idea of "otherness" in terms of its "inability to become part of the reality principal or in any way to anticipate the needs of the perform-ance principle". We will go a bit deeper into this statement later in the text.

3 We should say that Danto is interested in the social function of art, it is a consistent subtext in his writing, it is simply not his primary agenda as it is with authors like Becker, Gablik, Lippard etc. As the art critic for *The Nation* a decidedly left-liberal publication he has been able to take unpopular stands and reveal the complexities of high culture and their impact on questions of art and public space. (See his article on Richard Serra's *Tilted Arc*.)

References

Arendt, H., (1958) The Human Condition, The University of Chicago Press, Chicago, ILL

Aries, P., Duby, G., et al., eds. (1987-91) A History of Private Life, 5 vols., Harvard University Press, Cambridge, MA

Aronowitz, S., (1993) Is a Democracy Possible? Decline of the Public in the American Debate, in The Phantom Public Sphere, Ed., Robbins, B., University of Minnesota Press, Minneapolis, MN P. 75-92

Beardsley, J., .(1977) Probing the Earth: Contemporary Land Projects, Hirschorn Museum, Smithsonian Institution, Washington D.C

Beardsley, J., (1984) Earthworks and Beyond, Abbeville Press, New York, N.Y.,

Becker, C., (1996) Zones of Contention: Essays on Art, Institutions, Gender and Anxiety, The University of New York Press, Albany

Benhabib, S., (1992) Situating the Self: Gender, Community and Postmodernism in Contemporary Ethics, Routledge, New York, N.Y.

Brill, M., (1989) Transformation, Nostalgia, and Illusion in Pubic Life and Public Place, in Public Places and Spaces, Ed. Altman, I., and Zube, E., Plenum Press, NY

Capra, F., (1997) The Turning Point, Simon and Schuster,New York

Capra, F., (1988) Conversations with Remarkable People, Simon and Schuster, New York and London

Carr, S., Francis, M., Rivlin, L.G., Stone, A., (1992) Public Space, University of Cambridge, Cambridge, U.K.

Cioc, M., (2002) The Rhine: An Eco-Biography, 1815-2000, Weyerhauser Environmental Books, University of Washington Press, Seattle WA

Danto, A.,C., (1997) After the End of Art: Contemporary Art and the Pale of History, the A.W. Mellon Lectures in the Fine Arts, 1995, Bollingen Series XXXV: 44, Princeton University Press, New Jersey.

Davis, M., (1999) The Ecology of Fear: Los Angeles and the Imagination of Disaster, Vintage

Books, A division of Random House, New York, NY

Dewey, J., (1927) The Public and Its Problems, Swallow Press, Ohio University Press, Athens, OH

Elliot, R., *Faking Nature*, (originally published in 1982) in Ed. Throop, W., Environmental Restoration: Ethics, Theory and Practice, Humanity Books, an imprint of Prometheus Books, Amherst, N.Y. (2000)

Flybvjerg, B., (1998) Empowering Civil Society: Habermas, Foucault and the Question of Conflict, in Cities for Citizens, John Wiley and Sons Ltd., Chichester, West Sussex, U.K.

Fraser, N., (1992) Rethinking the Public Sphere: A Contribution to the Critique of Actually Existing Democracy, in Habermas and the Public Sphere, Ed., Calhoun, C., MIT Press, Cambridge, MA

Fukuyama, F., (2002) Our Posthuman Future: Consequences of the Biotechnology Revolution, Farrar, Straus, and Giroux, New York, NY.

Gablik, S., (1984) Has Modernism Failed?, Thames and Hudson, New York, N.Y.

Habermas, J., (1995) The Structural Transformation of the Public Sphere: an Inquiry into a Category of Bourgeois Society. Trans., Burger, T., Lawrence, F., The original published in German (1962), MIT Press, Cambridge, MA.

Habermas, J., (1996) Moral Consciousness and Communicative Action, Trans., Lenhardt, C., Nicholsen, S.W., The original published in German (1983), MIT Press, Cambridge, MA

Haglund, K.T., (2002) Inventing the Charles River, MIT Press, Cambridge MA

Jacobs, J., (1961) The Death and Life of Great American Cities, Vintage Books, a Division of Random House, New York, N.Y.

Katz, E., (2000) The Big Lie: Human Restoration of Nature, in Environmental Restoration: Ethics, Theory and Practice, Ed. Throop, W., Humanity Books, an imprint of Prometheus Books, Amherst, N.Y. P. 83-94

Kastner, J., Wallis, B., Eds. (1998) Land and Environmental Art, Phaidon Press, London, U.K.

Kosuth, J., (1993) Art After Philosophy and After: Collected Writings, 1966-1990, MIT Press, Cambridge Mass.

Light, A., (2000) Restoration or Domination: A Reply to Katz, in Ed. Throop, W., Environmental Restoration: Ethics, Theory and Practice, Humanity Books, an imprint of Prometheus Books, Amherst, N.Y. P. 95-111

Lippard, L. R., (1983) Overlay: Contemporary Art and the Art of PreHistory, Pantheon Books, New York, N.Y.,

Lippman, W., (1955) Essays in The Public Philosophy, Atlantic Monthly Press, Little, Brown and Company, Boston MA

Marcuse, C.C., Francis, C., (1998) People Places: Design Guidelines for Urban Open Space, John Wiley and Sonse, Inc., New York, NY

Matilsky, B., (1992) Fragile Ecologies: Contemporary Artists Interpretations and Solutions, Rizzoli International Publications, New York, N.Y.,

Merchant, C., (1980) The Death of Nature: Women, Ecology and the Scientific Revolution, Harper Collins Publishers, New York, N.Y

Morris, R., (1979) Robert Morris Keynote Address, in Earthworks: Land Reclamation as Sculpture, Seattle Art Museum, Seattle WA., P. 11-16

Morris, R., (1993) Notes on Art as/and Land Reclamation, in Continuous Project Altered Daily: The Writings of Robert Morris. Massachusetts Institute of Technology, Boston Mass., P. 211-232

Oakes, B., (1995) Sculpting with the Environment, Van Nostrand Reinhold, New York, N.Y.,

Plumwod, V., (1993) Feminism and the Mastery of Nature, Routledge, New York, N.Y.

Prugh, T., with Costanza, R., Cumberland, J.H., et al. (1995) Natural Capital and Human Economic Survival, International Society for Ecological Economics Press, Solomons, MD.

Ryan, M., (1994) Gender and Public Access: Women's Politics in Nineteenth-Century America, in Habermas and the Public Sphere, Ed., Calhoun, C., MIT Press, Cambridge, MA

Sennet, R., (1974) The Fall of Public Man, Alfred A. Knopf, New York, New York.

Schiller, H.I., (1989) Culture Inc. The Corporate Takeover of Public Expression, Oxford University Press, New York, NY

Shiva, V., (1997) Biopiracy, the Plunder of Nature and Knowledge, South End Press, Boston, MA

Sonfist, A., (1983) Art in the Land : A Critical Anthology of Environmental Art, E.P. Dutton Inc., New York, N.Y.

Spaid, S., Lipton, A., (2002) Ecovention: Current Art to Transform Ecologies, Co-published by the Cincinnati Art Center, Ecoartspace and the Greenmuseum.org.

Strelow, H., (1999) Natural Reality: Artistic Positions Between Nature and Culture. Ludwig Forum for Internationale Kunst, Daco Verlag, Stuttgart.

Throop, W., Ed. (2000) Environmental Restoration: Ethics, Theory and Practice, Humanity Books, an imprint of Prometheus Books, Amherst, N.Y.

Weintraub, J., (1997) The Theory and Politics of the Public/Private Distinction, in Public and Private in Though and Practice, Eds., Weintraub, J., Kumar, K., The University of Chicago Press, Chicago Ill. 1-42

White, R., (1995) The Organic Machine: The Remaking of the Columbia River, Hill and Wang, a division of Farrar, Straus and Giroux, New York, NY.

Young, I., M., (1990) Justice and the Politics of Difference, Princeton University Press, Princeton, N.J.

5 Unrealised: projects 1997 – 2002

Matthew Cornford and David Cross

For us, a key function of contemporary art in an open society is to test concepts, assumptions and boundaries. One way we do this is through making site-specific work in public places; our projects are often satirical or polemic in nature, and involve a degree of risk and uncertainty. While they have resulted in very different sculptural or spatial forms, each project has made a critical engagement with its given context, which includes the physical site, the social situation and the historical moment. This engagement demands intensive interaction with the people and organisations that occupy places and influence events. As well as the visible artwork, we recognise that the outcomes include exchanged attitudes between ourselves, our associates, and the people who respond as our audience.

All our projects so far have been conceived and presented in response to invitations from arts organisations, or to published calls for proposals. In making a proposal we test our own preconceptions and impressions of a situation through lengthy, intensive and often adversarial debate, and discussion that equally tolerates over-determination and irrelevance. Gradually, this thinking is condensed into a single page of text, which together with an image forms the basis of each project proposal.

Our first solo exhibition in East London was held in October 2002 at Nylon, a private gallery directed by Mary Jane Aladren. In accepting the roles and responsibilities of 'gallery artists', we aimed to question two related assumptions: firstly that public funding for the arts is closely aligned with notions of cultural production and reception that are discursive, educational and democratic; and secondly that as a private gallery relies on the selling of art objects, the nature of its engagement with social and political issues tends to be conservative.

At the time of planning the exhibition, the number of projects we had realised with official support and public funds was equal to the number of our proposals

that had been officially rejected. As we knew of no practical reason for these rejections, we thought they might concern matters of aesthetic taste or political tendency. We imagined that by returning from such obscurity to critical attention in a commercial gallery, the projects might connect our discursive practice with the commodity system, and perhaps broker some cultural exchange between the public and private spheres. So we developed and presented our rejected proposal drawings, photographs, objects and texts, in the hope that the works might still be 'realised', at least in terms of producing a shift in understanding such as can follow the sharing of an idea.

At the end of the exhibition period we held a public colloquium in the gallery, to explore the issues raised by the individual proposals and by the exhibition overall. The colloquium was widely advertised, open to everyone and admission was free. Papers were presented by Lynda Morris, Director of the Norwich Gallery, and by artist and writer John Timberlake; the session was chaired by Edgar Schmitz, artist and lecturer in visual theory at Goldsmiths College, London. As a starting point to the debate, Cornford & Cross offered three questions: 'Can the public expect 'public service' in curating and commissioning, as in broadcasting?' 'Does ideological engagement compromise the artistic or aesthetic impulse?' and 'Is there a consensus on what constitutes appropriate subject matter for the arts?'

Avant Garde, 1997/2002
Based on a proposal for Brighton Seafront Public Art Project

Our proposal takes as a starting point the layers of representation, myth and collective memory of Brighton, England as a Bank Holiday destination for displays of public disorder by rival gangs of 'Mods' and 'Rockers'.

Our proposed installation, titled *Avant Garde*, would consist of a life-sized reproduction of an archive photograph showing 'vicious' fighting between Mods and Rockers, dressed in period costume and brandishing deck chairs in Brighton's first May-Day 'riots'. The photograph would be positioned exactly where it was originally taken in 1964 on the Aquarium Terrace, a seafront connected to the long history of military conflict along the coastline of Southern England.

The 1960s generation of British youths was the first not to undergo National Service after the Second World War, while also benefiting from the unprecedented economic prosperity of the postwar reconstruction period. The rebellious behaviour and conspicuous consumption of 'Mods' and 'Rockers' produced enough symbolic effect for the groups to be initially represented and dealt with as a significant threat to the established order.

Decades of cultural reference and quotation are now interposed between the present and the original time. By heightening the significance of a moment as

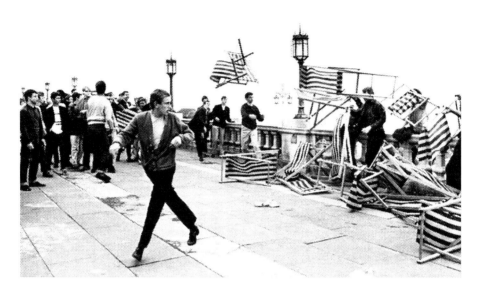

Avant Garde, 1997/2002 Bank Holiday 'riots', Brighton sea front, May 1964 Photographer unknown, courtesy of Brighton Local Studies Library

depicted in one photograph, *Avant Garde* would interrogate the use of photography to structure imaginative access to the past.

Avant Garde aimed to encourage consideration of how male violence becomes variously suppressed by the State, presented as spectacle in popular culture, or valorised and incorporated into official history. Yet the photograph is only an image of struggle between rival youth groups; it tells little of the complexities of class and gender in an important, albeit hedonistic struggle against the restrictions of society. As an official commission that aestheticises youthful rebellion, *Avant Garde* would offer an example of recuperation, the process by which the social order is maintained.

Avant Garde derives from a French military term, which was later used in revolutionary politics. Under Modernism it became a term of critical approval for experimental arts. As the term became widely used to describe anything fashionable or novel, it finally reached exhaustion and fell out of contemporary use.

Painting as a Pastime, 2001/2002
Proposal for Compton Verney House Trust

Our proposal was to offer a prize of £10,000, for a National painting competition, titled *Painting as a Pastime*: an artist-organised event open to absolutely everyone! All forms and genres of painting would have been welcome, with no limit on size, and admission would have been free. The event would have taken place over two glorious weeks of July, when the light and landscape can be at their most picturesque.

There would have been only two requirements: firstly, the painting must be completed within the landscaped grounds of Compton Verney Manor House, set in the beautiful Oxfordshire countryside. And secondly, all entrants agree to produce their work directly from life rather than from a photograph or other lens-based image.

The Grounds of Compton Verney were landscaped in the 18th century by the celebrated Lancelot 'Capability' Brown, whose idealisation of the English landscape produced a way of 'surveying the prospect' from a particular position. While *Painting as a Pastime* would invite reflection on the relationship between painting, photography and landscape, it positively favoured being artistically present in a place.

And while highlighting the ideal of art as a leisure activity, the competition would create a heightened atmosphere around it so that the aesthetic hobby becomes drawn into a materialistic, competitive situation. Through offering out the bulk of our production budget as prize money, we ask to exchange the role of artist for patron, and beneficiary for benefactor. By taking the offer up, members of the public would go beyond their role as the creators of individual artworks by becoming active performers in a collective artwork

'Painting as a Pastime' is the title of a book written by Winston S. Churchill in 1932, in which he extols the virtues of painting as a regenerative activity for 'the avoidance of worry and mental overstrain', if undertaken with enough focus and concentration of effort.

The competition would be judged by a panel of eminent figures (HRH Prince Charles? Lady Theresa Gleadowe? Sir Christopher Frayling? Sir Philip King, RA? Rt Hon. Chris Smith MP? Sir David Puttnam? David Bowie? Paul McCartney? Sister Wendy Beckett?) There would have been an award ceremony at which a single first prize of £10,000 would be presented with a commemorative trophy.

Painting as a Pastime might have been promoted on radio, for example BBC Radio 3, and Classic FM; also advertised in a range of publications including

Artist and Illustrator, Art Monthly, Country Life, and Frieze, as well as local newspapers, the Women's Institute, local art societies and Art schools both regional and national.

The Ambassadors
Proposal for the Liverpool Biennial 2001

The Ambassadors would consist of a set of flags of those nations with which H.M. Government does not currently maintain diplomatic relations. The flags would have flown from the flagstaffs on the Cunard Building by the river Mersey, in the area between the Tate Gallery and the Pierhead, which has a history not only as a site of arrival and departure, but also of public debate and demonstration.

The Foreign and Commonwealth Office informed us in July 2002 that 'There are indeed only two states which Her Majesty's Government recognises, but with which it does not have diplomatic relations. These are Iraq and Bhutan. Iraq severed diplomatic relations with the United Kingdom in February 1991. There are no relations with Bhutan for administrative reasons, rather than reasons of disapproval. We have trade and cultural offices in Taiwan, but do not recognise the state.'

If the proposal had been accepted for the Liverpool Biennial, we might have acquired the flags through correspondence and negotiation with representatives of the nations concerned. Through a process of diplomacy, we hoped to obtain in each case an official statement on the current situation.

We were equally interested in having the flags made in Liverpool by paying people on a piecework basis. Many such textile workers are women working from home, perhaps within immigrant communities. By 'outsourcing' production in this way we might have invoked the deregulated labour relations of the globalised economy, while making visible a symbolic connection between the domestic environment and the public sphere.

As part of Liverpool's international art biennial, *The Ambassadors* aimed to associate economics, politics and culture in a gesture of temporary but unconditional reconciliation.

In choosing the title *The Ambassadors*, we were thinking of the painting by Hans Holbein. 'The Ambassadors' (1533) portrays two courtiers of the Tudor period, surrounded by objects symbolising their status and function in the emerging international political and economic geography at the beginning of the rise of the nation state.

The End of Art Theory
Proposal for the Liverpool Biennial, 2001

We proposed to commission a 'Group 4' private security vehicle and uniformed crew, as used by HM Courts and Prison Service to transport defendants. During the Biennial, visitors would have been encouraged to enter the locked cells inside the vehicle, which would then have gone on a 'free' tour of the cultural institutions and public art works included in the Biennial.

The daily presence of the security vehicle at cultural venues might have gradually highlighted the association between authority and power. While inside, the viewing subject would have become an object of inquiry to passers-by. In any society's 'manufacture of consent' and control of dissent, a spectrum of approaches and institutions can be identified, ranging from co-option at the level of cultural production, to coercion at the level of law enforcement.

Our project, *The End of Art Theory*, aimed to engage participants directly in a social and spatial experience intended to appeal to the senses as much as the intellect. Entering the enclosed space would have been an act of voluntary self-denial, similar to that made by the ascetic aspiring to a higher state of consciousness or by the prisoner of conscience as a statement of protest. Uncertainties might have arisen, concerning the relationship between self-discipline and the rule of law. Equally, turbulent parallels exist between the notoriety of certain transgressive artists and the charisma bestowed on some criminals through media attention.

We would also have produced a series of portraits of the participants in our live project by photographing through the tinted windows of the security vehicle, while they are being transported through the city in confined isolation.

'The End of Art Theory' is the title of an essay* by Victor Burgin who 'refuses to think "art" in isolation from the political, or to conceive the "political" in purely socio-economic terms, without a theory of the unconscious.'

* *'The End of Art Theory', in The End of Art Theory: Criticism and Postmodernity, London, MacMillan 1987, pp. 140-204.*

Coming up for Air
Proposal for Making History, 2001

Coming up for Air was a proposal for a temporary public art project based on the production of an elegant and imposing landmark in the reservoir or pools of Chasewater Country Park, Staffordshire. The project aimed to promote debate on the relationships between art and history, especially the changing connections between economic activity and representations of landscape. As the work was conceived for Chasewater and it can only be realised through the democratic

Coming up for Air, 2001
Artist's impression by marine illustrator by Robert G. Lloyd Owned by Daniel Brooke, London

planning process, it would also raise issues of geography and politics, from a regional to a global level.

We proposed to build a large industrial chimney, cylindrical in form, perhaps made from smooth, pale concrete, and very plain as to detail. The scale of the chimney would be informed by current decision-making processes around public health, taking account of the type and quantity of emissions, the physical geography of the location, and the distribution and density of settlements in the fallout area.

The 'Black Country' landscape was defined in the late eighteenth century by coal mining, iron smelting and canal building. After centuries of deforestation and coal mining, the valley in Cannock Chase was dammed and flooded in 1797 to create the reservoir now known as Chasewater. This was a time of radical change from an agricultural to an industrial way of life, and within relations between the people who owned natural resources and the people who made them into commodities. From the outset, coal mining transformed the landscape and began Industrial society's dependence on fossil fuel, which continues to drive the consumerist ideology today.

Finally, after decades of research, the international scientific consensus is that fossil fuel use is seriously damaging the Earth's weather systems. Economists struggle to set the scale of risk by attributing monetary costs to environmental change, only to acknowledge that ultimately, such judgements are made on the basis of subjective values.

Coming up for Air contrasts with the Romantic tradition of the architectural 'folly' in the landscaped grounds of an English country house. Standing directly in the waters, the sculpture would be poised between suggestions of submersion and re-emergence. The object, its silhouette, shadow and reflection might bring together ideas of permanence with change, and perhaps operate as a metaphor for both loss and discovery.

Defined as a 'temporary' structure, *Coming up for Air* would bring to the surface how economic, social and aesthetic values relate to concepts of time. As a work moving between sociology and psychology, the project connects freedom and compulsion, dependency and denial. *Coming up for air* links ecology and conservation, civil engineering, historical geography, and town and country planning. In terms of art, its outcomes encompass sculpture, performance, and photography.

'Coming up for air' is the title of a novel by George Orwell, whose writing reached across class divisions — in this case to warn against the dangers of complacency, narrow materialism and short-term thinking. The novel centres on the narrator's journey through the modern landscape of England in 1939, to re-visit a pond, which for him had come to symbolise a lost paradise of youthful optimism and pristine nature.

The Treason of Images, 2001/2002
Proposal for Imperial War Museum, London
Commission on the aftermath of 11 September and War in Afghanistan

The Treason of Images would consist of a sculptural installation, the process of working towards its realisation, and visual documentation including plans, maps, photographs and video recordings.

We proposed to install a short section of oil pipeline in Afghanistan, somewhere along one of the intended routes linking the oil fields of Central Asia with the Arabian Sea.

The social process of this project would encompass the advocacy and negotiation we would undertake to gain approval and realise the physical part of the work. It would also include the talks and presentations we would give to a wide range of audiences. The help of Afghan people and international aid agencies, as well as the military and oil pipeline designers would be necessary for the project to bring together all the groups involved.

Our photographs of the project would emerge in precise relation to the appropriate news management procedures, as we were aiming this work at the news media as well as visitors to the Imperial War Museum.

As the project could only be realised through practice legitimised as art by official cultural support, and within territory protected by military force, it would exist as a function of influence and control.

Consumer culture has a problematic and contradictory relationship to other cultures, and to the natural environment. As finite resources become increasingly scarce, competition for them is likely to become more intense. The scale of this competition will be affected by levels of consumption, while its nature will be influenced by factors including corporate communications, diplomacy and military conflict.

Art historical precedent for the proposed work may be found in some of the American Land Art projects of the 1960's, including Nancy Holt's *Sun Tunnels* and Robert Smithson's *Site/Nonsite* displacements. Our proposed spatial and temporal project would have shared with these and other conceptual works a more permanent visibility through documentation, especially text and photography.

'The Treason of Images' (1929) is the title of René Magritte's seminal painting of a tobacco pipe and the words 'Ceci n'est pas une pipe'. The work spans surrealist and conceptual art, and highlights the contingent nature of the relationship between language and image, between perceptions of the world and representations of it.

6 Sophie Calle's *Appointment* at the Freud Museum: intervention or irony?

Judith Rugg

Introduction

The Freud Museum is Freud's house in north London where he lived and practiced in exile from September 1938 until his death in 1939 and contains his collection of classical artefacts and furniture within a number of rooms. His daughter, Anna, continued to live in the house after his death until her own death in 1982. Freud's widow Martha made no changes to his study during the rest of her lifetime (she died in 1951) and Anna continued to preserve her father's things, partly creating what was to become the Freud Museum. In 1980 she sold the house to a charity on condition that it become a museum after her death. It was opened to the public in 1986.

20, Maresfield Gardens is a large, detached, three-story house situated in a quiet street in the middle-class area of Hampstead, North London. The Freud Museum occupies the ground and first floors of the house. The visitor enters through the front garden, and through the front door: all seems as it was in Freud's time. Inside however, beyond the rush matting there is a small lobby with a security desk and guard and two CCTV monitors. One is immediately aware of being simultaneously inside a house, with an accompanying sense of privilege and voyeurism, and of being inside a museum.

There is a conflictual relationship between the Freud Museum as a home and its status as a museum: Freud's objects in his classical collection are the kind of thing that would normally be seen in a museum whilst his furniture is associated with the domestic interior of a home. The Museum is both a domestic setting and working environment; it is also a 'museumised' house which cannot be seen simultaneously as a home and a museum since the viewer's presence violates the intimacy and privacy of the space as a home yet completes it as a museum. Since 1994 the Museum has adopted a policy of curating artists' works which are sited there. This chapter will examine Sophie Calle's installation, *Appointment*, sited in

the Freud Museum from February to March 1999 and considers the significance for a woman artist to show work in the house of the father of psychoanalysis.

On entering the Freud Museum the visitor is directed to the conservatory, now a shop selling various books on psychoanalysis and other items such as mugs depicting Freud's image; 'Freud rug mouse- mats' and ballpoint pens showing a view of Freud's study and his couch which slides back and forth depending which way the pen is tilted. On the landing and outside the rooms on the first floor, are pieces of neoclassical Biedermeier furniture. A room on this floor is dedicated to Anna Freud and contains her loom, her analytic couch and modernist furniture designed by Felix Augenfeld and Mies van der Rohe. On the ground floor, is Freud's study-library-consulting room: the whole room is a 'display', preserved by Martha and Anna Freud, and is for that reason the most museum-like. It is the *pièce de résistence* of the museum and the room that holds the most interest and fascination in both voyeuristic and academic terms. At one end is Freud's desk on which lie a number of objects including a pair of spectacles and some of his favourite items from his archaeological collection in a row on the edge, simulating the 'just got up from his desk and left the room' type of *mis en scène* of house museums. Behind the couch is the green tub chair in which Freud used to sit and listen to his patients, out of sight. The room also contains his library consisting of over 1,600 titles and the majority of his archaeological collection, some of which is interspersed in the study and amongst the bookshelves.

The Museum as public space

As a 'house museum,' the Freud Museum functions as a form of public space granting physical access to the artefacts associated with Freud and psychoanalysis. The museum as a site of significance in western culture has, since the early 1990s, been increasingly used by artists as a site for intervention. As sites for art, museums exist outside and are separate from the 'white cube' and so-called value free gallery. Yet there are similarities between the gallery and the museum: if art galleries de-contextualise artworks and remove them from the spatial intercourses of the everyday, museums similarly isolate their collections from political and cultural meaning through their ideological underpinning and their discourses on value. However, as a force in the formation of national and cultural identities, museums occupy a public space and monopolise certain fields of vision. Inevitably, museums invite a form of institutionalised critique by commissioning artists to make and present work within them.

The Freud Museum is a complex place – a home, a museum, a conference centre, a social space and a shrine to a man who found new ways of problematising gender and rationality. Unlike a gallery, it is not an institution which assumes the neutralisation and isolation of its objects – its visitors are drawn to it precisely because of the place of Freudian psychoanalysis within western culture. The Freud Museum though, like other museums, institutionalises the context that it signifies. It functions as a museum in that it protects its objects' status within it

The Freud Museum, London

and consecrates its own system of values. Museums invariably are based on a system of classifying their objects and therefore create and define the public sphere in which this system operates. They generally sustain narratives of cultural hegemony and the Freud Museum, as all museums, exists within larger signifying processes outside of itself. It represents the community which it addresses and its audience is partly 'constructed' by its design and in the covert manipulation of the viewer through its space. Sophie Calle's installation temporarily disrupted its order by making an intervention within this dialectic.

The Freud Museum is a part of the construction of history (of Freud, of psychoanalysis and as a discipline) and helps to maintain the continued significance of (Freudian) psychoanalytic theory in western culture. It is not merely a container of objects but is endowed with meanings. The fact that it is the place where Freud (and Anna Freud) lived and worked and that there are vestiges of his presence in everyday life creates an enclosed space of privilege and meaning. The Museum exploits notions of the authentic in that it is the actual home of Freud and his collection. In it, both the objects it contains – Freud's couch, his chair, desk and even the spectacles as well as his collection of deities – maintain an eternal image of the past and have become totems of Freud and of psychoanalysis itself. Their original use value has become fetishised through the Museum which legitimates the Freudian hegemony with its 'aura of culture'. The Freud Museum utilises many conventions of museums in its presentation of Freud's objects within

the site of (Freud's) home. Information labels, subtle lighting, video surveillance and a gift shop all conform to contemporary museum display. In the style of other 'house museums' the objects and furniture have a 'semi-naturalness' but the only part of the house which is apparently intact since Freud's time is his consulting room / study / library. Like all museums, the Freud Museum maintains the 'perversion' of 'exhibitionism, voyeurism and fetishism' on behalf of itself, the viewer and its objects (Landers *The Desire of the Museum, Whitney Museum of American Art* (Whitney Museum of American Art, 1989) cited by Ferguson 'Exhibition Rhetorics: material speech and utter sense', Greenberg, et al. eds., 1996: 175-190, note 3:188). Its *raison d'être* is to valorise Freud and to preserve his environment as a place of reverence; he is the absent 'heroic genius author' and it 'soft-sells' the consumer-accessible whilst 'hard-selling' the authoritative discourse of psychoanalysis.

Appointment (February – March 1999)

Sophie Calle's installation consisted of thirty objects with texts placed in various positions in the Museum and juxtaposed with Freud's collection of furniture. Most were Calle's 'significant personal' objects, some were Freud's personal belongings 'displayed specially on this occasion' and some were objects on loan from shops or from one of the curators and included a blonde wig, a wedding dress, a bathrobe, a polaroid photograph, a painting, a telephone, a number of letters, a red shoe, a stuffed cat, a cut and slashed drawing, a piece of burned mattress and an embroidered sheet (*Appointment*, press release). The accompanying texts were detailed autobiographical narratives apparently referring to Calle's childhood memories and adult relationships. Historically art has been institutionalised as 'anti-domestic' – oriented towards the (art) museum/gallery and away from the home and separating everyday experience from that of aesthetic experience. The Freud Museum as a whole is a permanent exhibition which sanctions its own representations of Freud and psychoanalysis. Calle's installation did not sustain the cultural narratives of the Museum but made an intervention within them, displacing the ordering systems of museum conventions inhabiting it which help to endorse its authority, both formally in its use of labels, lighting, etc., and ideologically in its underlying 'narratives'. Her objects and texts, set amongst Freud's objects, displaced and exposed our own performative and passive complicity in museum convention in our 'reading' of museums' texts, whilst some of her objects irreverently sprawled over Freud's furniture, previously roped off and alarmed against 'jumpers' (people who try to sit or lie on Freud's couch). There is something ironic about these works in the 'home' of psychoanalysis which by definition investigates concealed motives and repressed urges. Sophie Calle's installation undermined the Freud Museum's attempts to evoke an atmosphere of place through its 'colour and smell of carpets, the mustiness of old books and the indefinable interplay of expectation and experience' (Davies at al. 1998:51) as it de-familiarises the ritual imposed by the Museum on the audience by collapsing the familiar with the surreal.

Domesticity

There are historical precedents for women artists using the home as a site for art. Feminist artists in the 1970s used domesticity as a subject to defy modernism's 'heroic' gestures (especially modernist abstraction) and as a way to bring attention to the gendering of space. *Womanhouse* (1972) for example, created by Judy Chicago and Miriam Schapiro and their students at the California Institute of the Arts' Feminist Art Programme, renovated a house in Los Angeles and made works critiquing the patriarchal suppression of women in the domestic sphere and within the family and sought to disrupt notions of the home as banal and familiar. In it students produced, among other things, fabricated fried eggs to represent breasts stuck on the ceiling in the kitchen and a bathroom containing the body of a woman trapped in a sand-filled bath. The siting of women artists' artworks within Freud's home inevitably evokes notions of the domestic. In the late nineteenth century, at the time of the emergence of psychoanalysis, there was a close association between women and the home and a metaphorical relationship between women's bodies and domestic furniture. The same words were used to describe the 'dressing' of women and houses: as in 'festooned' and 'draped.' Legs of tables were covered with skirts and bolsters were used both on sofas and on women's derrières; shawls and veils were used both on pianos and around female bodies and toilet stands had petticoats (Gordon, 1996: 291). From the nineteenth century and earlier, middle-class women, excluded from the public sphere, used their houses as a way to express themselves. Passivity continues to be associated with women and the domestic, and the home is a site for reinforcing notions of masculinity and femininity, heterosexuality and 'convention' where the conventional home represses deviation from the 'norm'.

Voyeurism, absence and identity were themes which ran through *Appointment*. The juxtaposition of texts and objects suggested the process of free-association but also how objects can 'fix' events in our past if we imbue them with the power to do so. The pieces of information from Calle's life that the viewer was presented with enabled them to piece together a kind of identity for her. Putting together scraps of information and constructing a 'story' is part of the process of psychoanalysis. Like Freud sitting out of sight in the tub chair behind the psychoanalytic couch in his consulting room, Calle herself is out of sight from the viewer who is witness to her confessional 'leavings'. The element of voyeurism inherent in much of Calle's work is inverted in the context of the Freud Museum: her stories, in reflecting the process of growing up 'is what Sophie Calle is asking us to look at, look at, look at' (Roberts, 2000: 42). But instead of the artist as voyeur of her subjects, it is the viewer who is enabled to look into the intimacies of the artist through her narratives and personal objects. Voyeurism expresses control over the object viewed and the denial of exclusion from it, and control through voyeurism is one of the central foci of Sophie Calle's work. Through voyeurism, the subject converts from a passive position to an active one and Freud saw voyeurism and exhibitionism as ultimately bound up with each other and ultimately linked through scopophilia to the desire to control. By exhibiting personal objects

Sophie Calle, *Appointment*, Freud Museum, London, February - March, 1999, by permission of the artist

accompanied by intimate texts, Calle placed the viewer not in the place of the artist or subject but in the active, masculine form of the voyeur thereby making the viewer conscious of their own intrusion into her life and of their own potential to become an object of another's gaze. In Freudian terms, in ego development the meaning of the penis becomes attached to the aims of seeing and being seen (voyeurism and exhibitionism) and is associated with the phallic phase: in Freudian terms occurring after the anal and oral stages where the boy or girl 'knows' only one genital organ and is the culmination of the Oedipus complex (La Planche and Pontalis, 1988: 309). The perceived distinction between female and male is in relation to the visible presence or absence of the penis. In *Appointment*, the manipulation of the visible and its consequences on meaning overlook mastery in favour of mystery and not the other way round where the 'visual regime' becomes the proof of knowledge (Pajaczkowska, 2000: 34) since without the texts, the objects' meanings are hidden.

The viewer of *Appointment* was left with a sense of the arbitrariness of life and of the human ability and need to make sense of random events, the part we play in them and their significance in our lives. Calle's objects were banal and 'fixed' the 'stories' and associations attached to them, transforming them into souvenirs of events of happiness, sorrow or unresolved conflict. Aspects of the confessional in the texts add to this a sense of intimacy with the viewer, a process echoing the patient's 'confessions' to the analyst.

Psychoanalysis deals with the repression and expression of the drives in the patient's wishes, desires and fantasies (Mitchell, 1975: 9). Although in *Appoint-*

ment the Freud Museum 'seems to have been invaded by Sophie Calle's unconscious as if by a patient who can't stop talking' (Romney, 1999) her narratives have closure, echoing our own attempts to make sense from the continuum of events in own lives. The process of identifying significant 'events' in our past and distinguishing between memory, imagination and desire is part of the process of psychoanalytic counselling, but whereas Freud believed that analysis can illuminate the dark regions of the psyche, Calle implies that 'the goal of self-discovery is… little more than a delusion.' (Rugoff, 1999). *Appointment* echoed both Bertha Pappenheim's (Anna O's) 'talking cure' and the expression of things in another language – the desires, longings and anxieties of the past – that the objects represent. Freud believed that in systemising the random expressions of the (normally repressed) unconscious, psychoanalysis could offer objective knowledge allowing the analyst to understand the patient's neurosis and cure them of their symptoms. The actual 'symptoms' of the artist are unknown to us - it is the process of psychoanalysis itself that the work appears to replicate in the context of the Freud Museum and Sophie Calle herself has stated that much of her art is 'therapy, filling the gaps left by insecurity and anxiety' (Burton, 1999: 10)

Fakes

Authenticity is a subtext of the Freud Museum and museums in general. Freud sought advice from Emmanuel Lowry, Professor of Archaeology at Rome on the authenticity of objects in his archaeological collection and also asked the historian Ernst Kris for authentication notes from the curators at the Vienna Kunsthistorisches Museum. This suggests that he placed importance on the authenticity of the objects he purchased. There are nevertheless some objects in his collection which are fakes. Museums endorse and perpetuate hegemonic hierarchies of culture and the Freud Museum with its collection of books, objects, and furniture is part of the 'normalising' of (Western) notions of civilisation. *Appointment*, in inserting personal objects with their associations of subjectivity and individual history into the Museum, repudiated ideas of cultural universality and disturbed the implicit and essentialised 'authenticity' of the Freud Museum. Similarly, the narratives in *Appointment* can be considered as fantasy – in Freudian terms, the fulfillment of a wish and its relationship to an event that never took place – in that they collapsed concepts of the fake with truth. In the story of her marriage, 'I crowned, with a fake marriage, the truest story of my life'; the fake policeman her mother had invented but which resulted in her stopping stealing; the false love that Greg conveyed to her but her doubts about it; the fake conversation that she prepared in advance but which never happened; her worries that her father is fake ('the letter was signed by a friend of my mother's. I assumed from this he was my real father'); the fake features her grandparents had planned for her through cosmetic surgery; the fake male genitals in the form of a dessert of two ice-creams and a banana (and itself a waxwork fake); her fake identity as a stripper when she wore a blonde wig; her fake love letter to herself; and her collection of fake, but once 'real', stuffed cats. Psychoanalytic therapy operates on the border between what is 'real' or 'fixed' and what is fabricated. The idea of the blurring of authenticity and fabrication runs throughout psychoanalytic therapy.

In the process of psychoanalysis, it doesn't matter if the 'stories' the patient tells about their lives are 'true' but their selection and interpretation of 'events'. Whether the stories are true or false, *Appointment* suggests that despite our own self-scrutiny we remain strangers to ourselves 'unaware of the degree to which we fictionalise our lives' (Rugoff, op cit.)

The double

The double reoccurs in Sophie Calle's work: in the process of shadowing in *Suite Vénitienne*; in her book *Doublegame*; in *Double Blind*; and in double-crossing where she asked her mother to hire a detective to follow her. *Appointment* is also a kind of double – many of the same objects and texts were used in her installation *La Visite Guidée* at the Boijmans Museum, Rotterdam in 1994. The double also reappears in *Appointment*: a pair of red, high-heeled shoes ('Amelia kept the right shoe, and I kept the left'); the double of Calle in the painting *The Love Letter* ('which portrayed a young girl who bore an uncanny likeness to me'); the apparent 'double' of her father and lover ('He was wearing the same bathrobe as my father'); the possibility of having two fathers ('The letter was written by a friend of my mother's. I assumed he was my real father'); having two lovers in succession with the same surname ('...two men with identical names loved me.'); and a visit to an unknown apartment where two sisters had died at the same age ('within six months of each other at the age of ninety'). The 'double' as what Freud called 'a preservation against extinction' and 'an insurance against the destruction of the ego' is an expression of the death drive and the urge to return to the inorganic state (S. Freud 'The uncanny' *Standard Edition*, 17: 217-252). The idea of the double Freud associated with a range of things including a person's conscience, a harbinger of death and the division between the ego and what is unconscious and repressed (Mitchell, 1975: 84). The idea of the doubling of an image was related by Freud to the fear of castration by the doubling of a 'genital symbol' in dreams which in turn is related to fetishism. Some of Calle's objects (deliberately?) represent those of the fetishist – high-heeled shoes, furry animals, wig and bathrobe, for example. Fetishism, with its root in the fear of the mother's genitals and 'proof' that castration can occur, finds solace in substituting the 'missing phallus' for an object which has some proximity to the mother's body, displacing the sight of the woman's imaginary castration. The fetish therefore has a 'doubling' – it is both an object of affection and hostility and represents both the absence and presence of the phallus. Because fetishism is linked to the castration complex, it has been asserted that it is unlikely that women and girls identify with fetish objects since the fetish is the way in which the subject disavows the possibility of castration (Pajaczkowska, 2000: 36-37) but in fixing the link between object and text, Calle implicitly addressed the anxiety produced by separation and the fear of loss of the object. Fetishism represents repression and displacement and signifies both desire and loss. Because Calle's objects themselves are reminiscent of those of the fetishist, in one aspect they suggest an ironic provocation of the missing, absent and unseen penis. She also collapses ideas inherent in the work (its subtext of loss and absence) with the suggestion of the

fetish as an object associated with loss (including its use in grieving rituals in primitive cultures).

Memory and absence

Ideas of absence and loss were inherent in *Appointment*. The death of Sophie Calle's cat; the loss of a lover; the death of her great aunt; the suicide of her plastic surgeon; her grandmother's death; the death of her mother's tenant and the implicit loss of her childhood; the loss and yearning for a church wedding; and the loss of love, desire, relationships and security all functioned as a foci for memories of death, fears, loss and desire. Additionally, *Appointment* manifested the extraordinary of the everyday in the banality of its objects. In periods of bereavement – from the death of someone we love or the break up of a relationship – objects and places are powerful signifiers. In the thirty texts in *Appointment*, seventeen of them refer to loss or absence. Absence is a theme which runs throughout Calle's work. In *The Hotel* she documented the belongings left in hotel rooms, of the absent guests. In *The Address Book* she asked the friends of an absent man (he was abroad at the time) to describe him in some way. In *Ghosts* she displayed texts describing absent and missing works of art which had been stolen or on loan. In *The Blind* she asked blind people to describe their idea of beauty which she then represented by texts. *Appointment* foregrounded the unseen in the relation between individuals and objects in the idea of absence and things hidden and then revealed. The objects themselves in *Appointment* were the 'leavings' of events and simulations of something that has been lost evoking absent events in the past.

The absent father

The theme of absence was continued in *Appointment* in Calle's references to her absent father. Her parents divorced when she was four and she was bought up mainly by her mother. As an installation in the Freud Museum, the idea of the absent father finds its corollary in the absent 'father' of psychoanalysis and the Museum being a place of Freud's 'absent presence' (Davies et al. 1998: 3). This is further paralleled by the fact that Calle's father was also a doctor who collected art and she admitted that 'doing art was a way of pleasing him' (Leith, 1999: 18). In revealing in the text that 'in my fantasies I am a man' and in her references to her father, an association inevitably occurs between the significance of Freud's theory of the little girl's penis envy and its relationship to the Oedipal complex. In Freudian theory, in seeking the maternal object the girl turns towards her father seeking pleasure from and towards him, subsequently establishing a 'chain of substitute equivalents for her father's love' (Pajaczkowska, 2000: 27). *Appointment* had connotations with the significance that Freud placed on the Oedipus complex in the structuring of personality and orientation of human desire and the formation of the unconscious. For girls it represents the change of love object from the mother to the father. Michèle Roberts observes that Calle was dependent on her father well into adulthood and suggests that she essentially suffers from arrested development as a consequence

of her father's absence when she was a child. Art is Sophie Calle's way to remain 'stuck as a little girl, playing' (Roberts, 2000: 43). The fact that Calle's father was absent was transferred by her to the idea of him being hidden. In the story about the letter to her mother from a man referring to 'our little Sophie', Calle assumed that this was her real father and waited for him to reveal himself as such to her. 'For 3 years I waited for this man to admit he was my real father which he never did'. This absence is transferred to men Calle has relationships with in adult life: 'the absence of my father, my loneliness as a child, choosing men I can't have...' (Leithe, 1999: 43). Her admission of her 'overwhelming desire to please her father' spells out her rejection of her mother in order to become 'daddy's little girl' is the stuff of psychoanalysis where the father is internalised as the superego (authoritarian) and represents the world beyond the mother's body, a reading that Calle manipulates in *Appointment* by placing the following text next to Freud's analytic couch:

> 'I was thirty, and my father thought I had bad breath. He made an appointment for me with a doctor whom I assumed was a general practitioner. Except that the man I found myself facing was a psychoanalyst. Given the hostility my father always manifested towards this profession, my surprise was total. My first words were: "There must be some mistake, my father is convinced I have bad breath and he sent me to a generalist". "Do you always do what your father tells you to do?" replied the man. I became his patient.'

According to Freud, the Oedipal stage, representing the separation from the mother and necessary for the child to achieve autonomy as a human being, is achieved by the entry into language and the law of the father. It represents the detachment from the mother and the moving into the world of culture and the law represented by the father which Freud developed in 'Some Psychical Consequences of the Anatomical Distinction Between the Sexes' (1925), 'Female Sexuality' (1931) and 'Femininity' (1933). In *Appointment*, Sophie Calle directly referred to aspects of penis-envy in her text. According to Freud, penis-envy represents the girl's 'failure to accept castration' and she subsequently feels 'lacking' in the eyes of the person she loves most (the mother), feeling that there is something wrong with her. In Freudian theory, penis-envy symbolises women's 'lingering disappointment' – in her inability to be what her mother wanted – someone different from herself and provides the impetus for the girl to separate from her mother and take her father as a love object. In *Appointment*, the possible effects of her absent father on Calle's adult relationships are alluded to in some of the texts. 'He was wearing the same bathrobe as my father. For an entire year, he obeyed my request and never let me see him naked from the front;' 'No matter how hard I try, I can never remember the colour of a man's eyes or the shape and size of his sex'; 'I closed my eyes the same way I closed them years later when I saw a naked man'. Calle denies the (real) presence of the penis in men other than her father and the viewer might deduce from these texts that she is 'stuck' in this phase of unconscious (Oedipal) development to take her father as a love object

and to get from him her own 'missing' penis which she transfers to her adult relationships with men. In Freud's view, in 'normal development' this stage then moves on to the girl's re-identification with the mother. Calle's deliberate evocation and reference to Oedipal readings can also be considered as ironic and draw attention to Freud's phallocentricism and his over-emphasis on the father's role in the construction of gender and his ideas on 'masculinity' and 'femininity'. Also, as has been noted, Freud's theory of penis envy symbolises the difficulties that women have in living in a patriarchal culture and the 'feminine' identities it endorses (Rosalind Minsky, 1996: 52).

Conclusion

Sophie Calle's installation existed in the space between Freud's house as a semi-recovered past (in its preservation) and the complexities of psychoanalysis in the present. The idea of the Freud Museum as a nostalgic object containing other nostalgic objects of the everyday is repeated in Calle's installation which evokes the nostalgia of the personal collection. But as has been noted, nostalgia is essentially a desire for the *heimlich* object which ultimately proves to be unstable (Iverson, 1998: 411). In *Appointment* meaning operates in the interface between this uncanny instability and the nostalgia (as fixed meaning) evoked by the objects. Freud's development of the idea of the *heimlich* to the *unheimlich* from cosy and intimate to hidden, repressed and concealed (but which subsequently comes to light) is reflected in Sophie Calle's confessional texts where the intimate and secret are revealed. In the work's references to Freud's notion of the *heimlich/unheimlich* – a transformation of something that once seemed homely into something not so – they provoked a kind of anxiety in the viewer in that these objects (with their texts), although banal and familiar, are not quite what we would expect to see in either a house or a museum. Within the 'shelter' of Freud's house, the uncanny is manifested in fragments. Lurking behind Sophie Calle's childhood memories, is the idea of the *unheimlich* where images of happiness coincide with secret and concealed anxieties at the point of their revealing. Her installation displaced the museum label's apparent 'objectivity' into autobiographical subjective texts, suggesting a sense of the 'suspended narrative' whilst fragments of the whole enticed the viewer to be aware of something missing and a sense of the incomplete. Notions of the real and the fake are manipulated – they 'undo' what is brought together and throw suspicion on what they assert to be 'true' and the texts have something of the inexplicable and extraordinary about them, evoking the intimate and strange. Calle attempts to annihilate Freud's 'uncanny presence' through her own 'absent presence' evoked by the work.

Collections are a form of loss in that they are made up of the 'leavings' of events and lack plays an essential part in collecting. Freud's collection is an excess in the sense that it is not containable within his cabinets. To collect is to possess and, it has been argued, is a form of representation and an expression of anxiety about loss. When the collection is complete, the subject is dead, but our own death transcends the collection and in this sense collections enact a form of holding-on, yet perpetually search for and maintain, a lack.

The conscious (the rational controlling self) is embodied by Freud's collection whilst *Appointment* created a kind of 'hysterical intervention' into the Freud Museum. Hysteria has been posited against the rational: Dora (Ida Bauer) was brought to Freud by her father when she was eighteen hoping that Freud would 'bring her to reason', and the fragmented narrative is the condition of the hysterical narrative (Borossa, 2001: 45). In 'Studies in Hysteria' Freud considered reminiscences to be a symptom of hysteria (and of trauma and its catharsis) and Sophie Calle's 'presence' as a 'patient who can't stop talking' critiques the 'choked off speech' of the hysteric. Bad breath – and also hysteria – may be a way to inhibit speaking. Calle's continual references to her father suggest further allusions to Freud's (famous) hysterical case studies whose symptoms were tied up with their relationships with their fathers.

The co-curator of *Appointment*, James Putnam, has stated that the potency of artists' temporary interventions in museums lasts only as long as they are in situ. Yet perhaps it is this very feature of Sophie Calle's installation in the Freud Museum that allows us to reflect further on her work and its potential to evoke considerations between the material 'container' and the conceptual relationships between gender and psychoanalysis.

References

Borossa, J. (2001) *Ideas in Psychoanalysis: Hysteria* London, Ikon Books

Burton, J. 'Sophie's World', *The Independent on Sunday*, 17 January, 1999:7-9

Davies, E., Davies J. K., Molnar M. O'Cleary S. and Ward I. (1998) *20, Maresfield Gardens: A Guide to the Freud Museum* London, Serpents Tail

Gen D. (2002), *Drapery: Classicism and Barbarism in Visual Culture* London, Tauris Press

Freud, S. (1953-66) 'The uncanny', vol. 17, *The Standard Edition of the Complete Psychological Works of Sigmund Freud*, trans. James Strachey (London, Hogarth Press, pp 217-252

Gordon, B. (1996) 'Women's Domestic Body: The Conceptual Conflation of Women and Interiors in the Industrial Age', *Winterbur Portfolio*, 31, 4 (Winter) pp 281-301

Greenberg, R., Ferguson B. and Nairne S. eds. (1996) *Thinking About Exhibitions* London, Routledge

Iverson, M. (1998) 'In the Blind Field: Hopper and the Uncanny', *Art History*, 21 pps 409-429

Burton J. 'Sophie's World' *The Independent on Sunday*, 17 January 1999:10

Laplanche, L and Pontatis J-B., trans. Donald Nicholson-Smith ([1974] 1984) *The Language of Psychoanalysis* Oxford, Blackwell Press

Leith, W. 'A Quick Calle', *Observer Life Magazine*, 17 March 1999: 17-20

Minsky, R. (1996) *Psychoanalysis and Gender* London, Routledge

Mitchell, J. (1975) *Psychoanalysis and Feminism* Harmandswoth, Penguin

Pajaczkowska, C. (2000) *Ideas in Psychoanalysis: Perversion* London, Ikon Books

Roberts, M. 'Doublevision', *Tate Magazine*, 22 (Summer 2000) pp 42-43

Romney, Jonathan, 'Double Exposure', *The Guardian*, 19 March 1999, page unknown

Rugoff, Ralf, 'The Culture of Strangers', *Evening Standard* 15 March 1999, page unknown

7 Imagination Can Save Us

Ann Rosenthal

Introduction

In 1995, I had the privilege of attending the NGO Forum of the United Nations Fourth World Conference on Women in Beijing. As one of 100 women artists in the Women's Caucus for Art delegation, I presented material to several panels and workshops, and networked with women from around the world. We feverishly exchanged slides and catalogues across the barriers of language; we listened to stories of pervasive violence and persistent hope; we danced, sang, mourned, and protested. Susan Griffin wrote of the conference in her 1996 essay, 'Can Imagination Save Us?':

> For months before the World Conference on Women met in Beijing, an informal debate circulated among women in the United States. Alongside the serious questions of China's violations of human rights, another question was posed. Why should we meet at all? What good will it do? ...For those who went to the conference in Beijing, though, something momentous occurred. In the creation of a different arena, defined in different ways by women from all over the world, another possible world began to exist, if even temporarily, and this has nurtured desire and imagination. (Griffin, 1996: 44)

For myself, another world did emerge. I could no longer spend 40 hours a week working for Corporate America; I felt compelled to apply my imagination full-time to realizing a socially just and ecologically sustainable world. I gave up a home in Seattle and a studio within walking distance of Puget Sound and headed to Pittsburgh to pursue my MFA. Eight years later, I am still chasing my dream, but I have found a growing community of "...artists who want art to have some worthy agenda outside of itself, and a socially redeeming purpose" (Gablik, 2004). For many of these artists, the agendas of feminism and ecology are intertwined. I give two cases below of how, in different ways, art operates from these beginnings.

Context

We are taught that imagination is heroic and solitary. Success is measured by how unique our imaginings are and how well we market them (take 'visionary' businessman Bill Gates, for example). In contrast, our social imagination hovers at the margins of society—where we pay our respects on designated holidays, yet exile our dreams for another year. Consider Martin Luther King, whose vision is celebrated each January 20th in the United States. Dr. King understood that imagination is a collective enterprise: in order to realize his dream, he had to make it the dream of a nation. It was the social desire King ignited for justice and possibility that gave people the courage to face brutality and their own mortality.

> As citizens of a liberal capitalist society, our desires constitute an amalgam of individualistic, competitive, and acquisitive yearnings. Consequently, we tend to see ourselves as individuals destined to compete for scarce resources, striving to fulfil a range of personal desires for sex, wealth, status or security. Desire is largely viewed as a matter of self-interest expressed within the realms of work, politics, and even love... Rarely do we view desire as a yearning to enhance a social whole greater than our selves, a desire to enrich the larger community. (Heller, 1999: 5)

Our cult of the individual, constructed by mass media and relentless advertising has reconstituted King's dream of equality into the 'right' to pursue money and power at any cost. Like children, we stubbornly refuse to recognize that our actions have social consequences. This 'freedom' to exploit human and non-human 'resources' in defiance of the social whole has become our most seductive export. To create a socially and ecologically sustainable future, we must first collectively imagine it, yet "...to imagine is not simply to see what does not yet exist or what one wants to exist. It is also a profound act of creativity to see what is. To see, for instance, that the freedom of public discourse is being circumscribed by corporate power requires an imaginative leap." (Griffin, 1996: 45) To see what is demands honoring the rich terrain of culture that is carved by conflicted histories, to look deeply into the legacy we have inherited and follow its trail. If we 'read' the landscape, where will it lead?

One path is represented by an emerging dialogue of ecological art (or ecoart), founded on the socially informed art movements of the last 30 years. This international and interdisciplinary field of study and practice is defined more by common values than by media or methods. The processes and forms of ecoart are as diverse as the ecosystems for which we advocate—webs of interrelationships that include "not only physical and biological pathways but also the cultural, political and historical aspects of communities or ecological systems." (Wallen, 2004). As Dutch artist Jeroen van Westen comments, "We all feed our art from completely different backgrounds, grow different 'plants'.... All our different plants together form a beneficial group. We are a kind of ecosystem in the world (of art)"

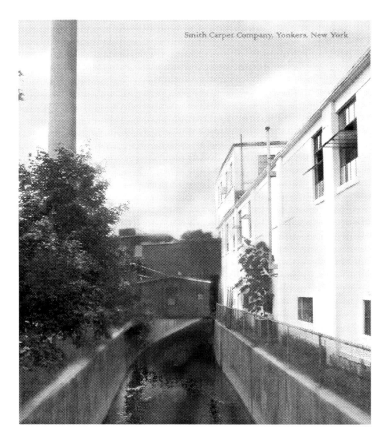

River Vernacular: "Smith Carpet Factory" postcard. Yonkers, NY, 2003.
Steffi Domike and Ann Rosenthal.

("ecoart manifesto"). Two case studies explore this emerging ecosystem of ecoart: the first excavates America's industrial past to reconsider the present; the other connects citizens to their local landscapes to imagine possible futures.

Case 1: Tracking the Past

I grew up believing that 'history' was comprised of objective facts. It took me many years to realize that tales of heroes and battles, which I resisted memorizing in high school, were only one version of history. In college, I learned that history encompasses ordinary people struggling to get through their days. However, it was not until I asked "How did things come to be this way?" that I began to grasp the meaning of history. We are all familiar with the tired cliché "Those who do not know history are doomed to repeat it," but what does *knowing* history actually entail? Is it reciting dates, places, and names as I was taught 40 years ago? What does 'knowing history' mean when much of the world's knowledge can

be accessed from a keyboard? Does this vast accumulation of data translate into an understanding of how things came to be this way?

In the summer of 2003, artist Steffi Domike and I were invited by visiting curator Amy Lipton to develop a project for the exhibition,"Imaging the River" at the Hudson River Museum in Yonkers, New York. Associate Director Jean-Paul Maitinski was particularly interested in our recreation of 'historic' postcards for our prior project, *Toxic Vernacular*, in which we interpreted the post-industrial landscapes of Western Pennsylvania. The museum had compiled its own postcard collection dating from the end of the 19th century, and we were encouraged to draw on this rich resource for our project. Our inquiry commenced amidst file cabinets, shelves, and archival boxes, home to photographs, maps, books, and the anticipated postcards—images of factories built into the riverbed; steam-powered ferry boats overshadowed by early automobiles and roadways; the looming, rose-colored cliffs of the Palisades across the Hudson; and scenes of a thriving downtown.

Taking a respite from our research for lunch, we ventured to downtown Yonkers and found ourselves at the end of a back alley—facing a gap between two buildings. We were standing on the edge of the Saw Mill River, witness to its surging, storm-filled waters. A sign read: "No Dumping: Flows to Hudson." Once the lifeblood of Yonkers, the Saw Mill was largely converted to bury the open sewage it carried and to make way for commerce. Considering Yonkers as a case study of boom-or-bust industrialization, we chose the Saw Mill as an emblem of America's evolving relationship to local waterways and their potential to revitalize community landscapes.

Returning to the museum with the Saw Mill as our focus, we identified postcards that would weave the social narratives and natural histories of Yonkers into a complex and visually compelling urban portrait. The postcard collection became an effective catalyst for our conversations with local historians and environmentalists, prompting engaging stories and insights. We augmented these interviews with research into the social and natural histories of the region. Our final postcard selections determined locations where we soaked cotton scrim (gauze) and photographed the same or similar sites as they appear today. Using digital tools, we created eight oversized postcards with the same nostalgic, colorized look as the originals. For the back of each card, we authored a brief interpretive text and a hand-written fictitious tourist narrative. A stamp for each card was derived from the original postcard that inspired it.

For the museum installation, we outlined the Saw Mill and Hudson Rivers, indicating site locations with our mounted stamps. The postcard fronts and backs followed the meandering line of the Hudson, viewed through veils of scrim that mapped the state of the Saw Mill River as it traveled from its source, through the city of Yonkers, and into the Hudson. The original postcards were framed at the

far side of the installation above a small writing desk that offered a stack of blank postcards of the Saw Mill River as seen from the back alley. Visitors were invited to write on a postcard their vision for restoring their communities and landscapes.

"Belief systems, which interpretation addresses, are at the heart of any real social, cultural, or political change. So interpretive work could be seen as a type of restoration: Instead of directly restoring the biological or physical environment, we are dealing with the human context, addressing the cultural, social and political systems that also must be healed or transformed for long-term ecological change to occur" ("Questions" 2). Our postcard texts excavate those histories that have been underrepresented – the collective efforts of women and the working class who stood behind the heroes we recognize. The blighted post-industrial landscape of Yonkers re-imagined as an urban oasis plays on the contradictions of history – the pride in building a modern economy while failing to address its subsequent costs to local communities. The ultimate irony of these seductive and nostalgic frames lies in the recognition that if the social desire and will to transform the land can be ignited, it may not be so difficult to restore this community and its natural heritage: "Moments when reality no longer appears seamless and the cost of belief has become outrageous offer the opportunity to create new spaces—first in the mind and thereafter in everyday life" (Helen Meyer Harrison and Newton Harrison qtd. in Spaid, 2002: 34).

Case 2: Reclaiming the future

> In these years after the Cold War, a time of the failure of old paradigms and systems of thought, perhaps hope lies less in the direction of grand theories than in the capacity to see, to look past old theories that may obscure understanding and even promise. To assume what the Buddhists call beginner's mind. (Griffin, 1996: 43)

The past and present offer up tangled webs of history, memory, and place; exchanges of labor, material, and capital—waiting for the imagination to unravel. In contrast, the future—approached with beginner's mind—is an open book of blank pages. Jackie Brookner and Susan Steinman have evolved community-based art practices "rooted in the process of dialog and inclusion" (Collaborative Proposal 2).

As inaugural artists for the Art and Community Landscapes Program (through the National Park Service Rivers and Trails program and in partnership with the National Endowment for the Arts and the New England Foundation for the Arts), the artists partnered with three communities "to inspire citizens to greater involvement in protecting and enhancing the(ir) rivers, trails, and greenways" (NPS Program Brochure). Caldwell, Idaho; Tillamook, Oregon; and Puyallup, Washington each sought to re-imagine and restore their waterways and trails as

assets for residents and businesses: "The City of Caldwell is pursuing an exciting new vision for its future. This vision includes daylighting, or uncovering, Indian Creek and revitalizing the historic downtown. Caldwell would like to create a place where you can live, work and play. A community-wide system of pathways and trails is integral to this broad vision." (Caldwell Master Plan, 2003: 1).

For each community, the artists conceptualized art works and events, site designs and demonstration projects, and then facilitated local production by community members. Two common components that the artists proposed were a visioning center and a festival. As a starting point, an Ecoart Visioning Center would offer a central space for local citizens to share ideas, influence project development, and participate in the artmaking process. Storefront window installations and interior displays would highlight trail projects and local ecology, while open house events would foster dialog, meetings, and forums. Local and regional student art would be a centerpiece. If a physical space could not be located, the community itself became the center—using schools, halls, libraries, homes, and public squares. As the Visioning Center built momentum at the outset, a festival at the end of the artists' residency would celebrate the diverse natural and social capital of the community while highlighting public artworks, demonstration projects, and planning documents. These project bookends comprised a shared approach going into each location—yet the social dynamics and ecologies of each community presented its own challenges and rewards: "Dialog changes the work—allowing the material, in this case the community, to talk back to you. If you listen, it will take you to where the rich potential is" (Personal Interview).

Working closely with National Park Service representatives, Jackie and Susan approached each community with a "beginners mind." The artists saw their primary role as empowering the citizens to own and craft their own vision by "listening for forgotten history and saving the best, airing the distasteful history, and pointing out how the context has changed—the future does not have to be the past" (Brookner and Steinman: 1). Their overarching strategy was to partner with key, vested residents who had long-term relationships with local civic organizations, schools, and community/church groups. These key partners made the work happen and sustained it long after the artists left. They assured that the work was community-specific, viable, sensitive, and wanted, "avoiding the superficial artifice of generic art conceptions" (Steinman, 2004).

In Caldwell, the two key residents were Janie Aguilar, Director of the Hispanic Cultural Center of Idaho, and Sylvia Hunt, a cherished music professor (Albertson College) and the Director of Caldwell Fine Arts – the sponsoring organization of music and performing arts in the schools and community. Although Caldwell had sought to engage the growing Hispanic community (comprising 28% of the population) in their plans, neither the City nor the NPS had been successful. Jackie and Susan made contact with Janie Aguilar by going to her office (instead of expecting her to come to them), where they were promptly invited to a potluck dinner party. Within minutes of entering the party, the artists had arranged a Girl

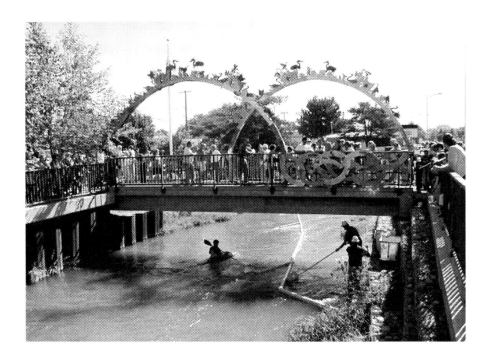

First Annual Indian Creek Festival to celebrate downtown and creek revitalization, October 2003. Crowds covered walkways & bridge to dedicate downtown Caldwell's first public art project. Bridge sculpture conceived by Steinman/Brookner, designed and built by local sculptor Juan Martinez and at risk high school students who went on to win national awards for their work. Managed by local collaborators: Sylvia Hunt, Caldwell Fine Arts; and Janie Aguilar, Hispanic Cultural Center of Idaho. *Photo by SL Steinman.*

Scouts' art workshop at the farm workers' housing project. A similar workshop with the Mayor's own select group of high school students yielded 12-inch square cloth banners—"literally tying the white and Hispanic community together through art" (Steinman, 2004). The banners were exhibited in the library and then hung creekside at subsequent creek events, including Earth Day and community clean-ups.

Experienced at garnering grants, Sylvia Hunt was looking for a vehicle to partner with the Hispanic community. Jackie and Susan introduced her to Janie and again, within 24 hours, they were writing an Idaho Arts Commission grant with the help of the artists. They were awarded $10,000 to produce Caldwell's first official public art work through the 'Building Bridges' program. Jackie and Susan originated the design concepts based on creek imagery, and they shepherded the project through city site plans, permissions, and the public art process. Local sculptor Juan Martinez worked with at-risk youth, while muralist Ignacio Ramos

worked with the Albertson College Student Art Club to realize the final sculptures and mural that depicted waterfowl, plants, and wildlife. The pieces were dedicated at the culminating Indian Creek Festival (now an annual event), and the trail master plan—drafted during a design charette—was showcased.

The numerous seeds the artists planted are growing into a forest: The Environmental Studies Program at Albertson College has adopted Indian Creek, and students continue to monitor and study it. Albertson's Environmental Studies and Creative Writing students are writing a book of stories highlighting the natural and cultural history of the creek. The 4H Club is developing a web site hosted by the College. The two Hispanic artists, who had never done public art before, are now producing projects that garner national awards, community pride in the creek and downtown, and a desire for more public art. "Our goal was to inform people about the projects, to create as broad interest and participation as possible, and to create common interest among people who wouldn't ordinarily come to the table to converse...This partly means changing the nature of the conversations. Listen—to their desires... listen to the site, its histories and potentia" (Brookner and Steinman, 2004).

As with Caldwell, the entry point into the community of Tillamook was through its children. The artists designed a unique science-plus-art lesson plan for elementary students to be team taught by Trail Committee members—retired teacher (co-leader of the nascent Trail Art Committee) April Petersen and Bay Conservation agency naturalist Phaedra Bennet. After a natural history lesson on Slough wildlife, students painted imaginative watercolor portfolios of native flora and fauna. The best images were selected for postcards, storefront displays, and illustrative banners, bringing attention to trail events and marking sites. In parallel, the artists were instrumental in producing a comprehensive design charette that developed designs for the Hoquarten Interpretive "Social Trail." Under the direction of a tight community arts network and a few key players paid through the Tillamook Estuaries Partnership, plans for the trail moved at a steady pace between the artists' monthly site visits. Early in the residency, Susan spotted an abandoned Victorian house near the town center, which will eventually become the Tillamook Ecoart Visioning Center—a permanent interpretive center at the trailhead leading to one of the last Sitka spruce swamps in the western U.S. "People COUNT. Artists give the validation to the community members who do the work, who make it happen."

The most visible outcome of the Puyallup residency was a delightful booklet written and illustrated by students who live near the creek. Titled "I am Clark's Creek," this creative "How to Care Guide" combines stories written from the perspective of the creek with creek-friendly tips on lawn, garden, and car care—informed by direct creekside observations during a field trip led by local ecology experts. The booklet was designed and produced by the artists in collaboration with District art and science teachers, NPS partners, and the local Watershed committee. The guides were distributed to residents and hundreds of visitors at

the nearby state fair. Student Stephanie Clark writes in the booklet:

> How to take care of me: Clark's Creek: To keep me clean is quite simple, really, just listen carefully. Just don't pollute. Don't put garbage in sewers, no oils ethier [sic] I was clean once long ago, then people came, and made pollution grow. We can make it that way again, just listen all you men. Come to me, to clean me up. Just take the ivy and pull it up. With all the garbage too. Now go, hurry before I die completely.

This charming and informative guide is an inspiration not only to Puyallup, but to Caldwell and Tillamook, which may adopt the format for their own ecoliteracy programs. What better way to teach a community than through its children? And the community seems to be listening—the school district wants a nature center on the creek, and various local groups and agencies are working toward increased environmental education and stewardship of the creek.

Jackie and Susan tease out the dreams of a community, empowering the individual and collective imagination to make those dreams real. They do so, not by denying the past, but by listening to the buried fears and lost promises of the present. Caldwell, Tillamook, and Puyallup share a social desire to integrate their social and natural landscapes. They long to make their place whole through a circulatory system that connects bustling business districts to energized cultural centers, educational institutions, and regional natural treasures. Within a process of dialog and inclusion, these community artists leave behind inspired creations as a testament to the collective imagination—and as a reminder of dreams yet to be fulfilled. The artists call their approach "The Tom Sawyer theory of art—you bring the enthusiasm to town with you. Just by virtue of being an outsider you spark curiosity; your attention says 'this is worthy of attention,' and you invite participation. The excitement is infectious."

Imagining Living Systems

As we embark on the 21st century, how can it be that our environmental and social systems are unraveling before our eyes? How have we created a world where the disparity between CEO and worker salaries in the U.S. is 500 to 1, and a fifth of the world's population lives on less than a dollar a day? Where wetlands have decreased by an estimated 50 percent in the last century, and almost a quarter of the world's coral reefs have been completely destroyed? Where "Of all food consumed by humans, breast milk is now the most contaminated?" (Steingraber, 1999)

My students' answer is greed. Yet, greed has been part of the human equation from the outset. Are we not at a moment in history where for the first time it is *possible* to meet basic human needs, so that greed is no longer a survival response to hunger? Are we lacking in wealth, knowledge, or technology to tackle the world's social and environmental problems? Perhaps I am being naive—the world is what it is. The best we can do is grab what we can for ourselves and our loved

ones. If others are not fit enough to survive, let them fall. My students say: That's the law of the jungle—the law of *nature*. Reality TV shows like *The Survivor* and *The Apprentice* confirm this—or do they?

Susan Griffin argues otherwise, as do the artists whose work is described in this essay. We represent a growing global movement of cultural workers who reject the *social* construction of "survival of the fittest" and offer alternative ways to imagine community landscapes. Jackie Brookner and Susan Steinman ignite our social desire to restore human and wild habitats, unearth buried waterways, and reclaim a vision of living systems for the children and youth who will decide the future. Steffi Domike and I interpret the rich terrain of people and place, to imagine how post industrial landscapes and communities can thrive again—"the future does not have to be the past" (Brookner and Steinman, 2004) .

The common ground these projects share—whether they employ interpretation and/or reclamation, is imagination—imagining the *intersections* of human and natural systems; imagining *relationships* between people and place, past and present, local and global; imagining the glorious *conversation* between nature and culture. Shall our desire be motivated by a rapacious hunger that will exhaust the world's human and natural resources, or shall we nourish our social desire with imagination to reconnect the living systems on which we depend and of which we are a part?

By reinforcing individualistic, acquisitive desire which undermines community, market-driven culture robs our youth of their imagination and hope. Ecoart contests this numbing paradigm by reclaiming social desire and catalyzing communities to collectively dream and create:

> Success in community building is rendered by achieving a critically effective state of internal and external connections which, in effect, allow the system to "self-actualize." A biologist might say the easiest way to heal an ecosystem suffering from ill health is to connect it to more of itself. In this respect this new design instinct represents a kind of healing for our communities, even, perhaps, a strategy of hope. (McDonough, 2002: 2)

In dreaming social and environmental justice, we must not erase the wounds we have inflicted on one another and the land. We must make visible how and why we have scarred the living social and ecological systems that are our home (ecos), lest we inflict such damage again. This demands reclaiming our social imaginations and restoring our social institutions. As ecoartists, we dream that our creations will repair the world. Yet we cannot do this alone, nor should we. Our world is a social sculpture that we have created together, and we must remake it collectively. Artists can only do their part—reconfigure the world in the imagination:

> Every important social movement reconfigures the world in the imagination. What was obscure comes forward, lies are revealed, memory shaken,

new delineations drawn over old maps: it is from this new way of seeing the present that hope for the future emerges. (Griffin, 1996: 45)

References

Brookner, J. and Steinman S. (2004) From Susan and Jackie. Email to the author. 7 March 2004 and personal interview 22 March 2004

Brookner, J and Steinman S. (2002). *Art and Community Landscapes Program: Collaborative Proposal.* New York and Berkeley

Caldwell Pathways and Trails System Master Plan. City of Caldwell: Caldwell, Idaho, 2003.

Gablik, S (2004) A New Front. Resurgence March/April 223 reprinted in http://greenmuseum.org>.

Griffin, S. (1996) "Can Imagination Save Us? Thinking about the Future with Beginners Mind," *Utne Reader*, (July/August) pp 43–46.

Heller, C. (1999) *The Ecology of Everyday Life: Rethinking the Desire for Nature.* New York Black Rose Books

LCA Town Planning & Architecture, LLC. (2004) "The Charter of New Urbanism: A Strategy of Change from William McDonough." Portland, Oregon. (24 Mar.). www.lcaarchitects.com/info/new-urbanism.html.

McDonough, W (2002). "Buildings Like Trees." *Resurgence* Jan./Feb. p 210 http://resurgence.gn.apc.org/issues/contents/210.htm

National Park Service (NPS) Rivers and Trails Program (2004) "Art and Community Landscapes." Program Brochure.

Spaid, S (2002). *Ecoventions: Current Art to Transform Ecologies.* Cincinnati: The Contemporary Arts Center

Steingraber, S. (1999) "Breast Milk Said 'Most Contaminated' of All Human Foods." *Rachel's Environment & Health Weekly* p 658 www.rense.com/health3/mostcont.htm

Steinman, S. (2004) "Corrections." Email to the author. (29 April)

van Westen, J. (2004) "RE: MY ecoart manifesto (diatribe?)--at 4AM." Online posting. 6 February. ecoartnetwork listserv.

Wallen, R. (2004) "Toward a Definition of Ecological Art." *Ruth Wallen: Ecological Artist.* University of California San Diego. (29 April) http://communication.ucsd.edu/rwallen/ecoframe.html

Wallen, R. (2004) "Questions on Interpretation." Email to the author. (30 Jan)

8 Eco-art Practices

Reiko Goto with Tim Collins

Introduction

Over the last seven years we have worked on projects in post-industrial public spaces, dealing with a landscape devastated by the steel industry and mining, trying to recover the rivers and forests of Allegheny County, Pennsylvania for both bio-diversity and public access. Our work most often focuses on plants and natural creatures. We believe that all life has value and deserves our respect and attention. Alongside our practical work, we have begun a series of conversations and more formal discussions about how artists contribute to change.

We begin this chapter by providing a historical overview of environmental and ecological arts, then introduce a mapping strategy that we have been working on together through which we see art practices as complex multi-dimensional networks. We have struggled with this idea for years, but after spending time looking at a vast insect collection at the Carnegie Museum of Natural History, we began to sense the effect of what natural scientists call systematics. That is: the process of identifying, naming and categorizing the relationships between wildly diverse (and wild) organisms is a fascinating if not tedious human endeavor. Wanting initially to know about moths that occur in Asia, we found that by using the taxonomic system we were able to understand the similarities and appreciate the differences of thousands of unique species. It occurred to us that the reason to map and classify common typologies can be found in the fact that by understanding the similarities, the most wondrous differences amongst these creatures emerge. If we are going to understand the methods and means that artists bring to processes of change, we need a flexible mapping system for this as well – or, at least, that is how it seems to us at present. The system outlined below is an initial attempt in this direction. During the process we have had discussions and disagreements about its application. No doubt they will go on.

The main focus of this chapter, however, is work presented at two recent group exhibitions of ecological art: *Natural Reality* at the Ludwig Forum in Aachen,

Germany in 1999, curated by art historian Heike Strelow, which looked at changing relationships between humans and the natural world; and *Ecovention* at the Contemporary Arts Center (CAC), Cincinnati, Ohio in the summer of 2002, co-curated by Amy Lipton and Sue Spaid, which focused on inventive strategies to transform local ecologies. Both exhibitions presented over thirty artworks that included documentation, re-creation, and new work created for the exhibition. We participated in these exhibitions and examine some of the works included in them below using the mapping structure noted above.

From Earth Art and Environmental Art to Eco-Systems Approaches

Sculpture has a different historical relationship to landscape from painting – it is only with the advent of the minimalist era of modernist sculpture in the 1960s that landscape began to play a sustained and primary role in it, while the European tradition of painting includes, from Poussin and Claude onwards, a specific framing of nature as the ground of human lyrical play or epic endeavor.

John Beardsley, Thomas Hobbs and Lucy Lippard are the primary authors on the subject of earth-art. Beardsley's *Probing the Earth: Contemporary Land Projects* (1977) and *Earthworks and Beyond* (1984) provide an overview on the originators of earth-art. Hobbs' *Robert Smithson: Sculpture* (1981) is the best reference on that artist's work, while Lucy Lippard, in *Overlay* (1983), willfully transcends the hierarchy of the artworld as well as the ranks of the earth-artists, providing a comprehensive overview of diverse archeological, historical and contemporary practices. Beardsely and Lippard describe a post-studio inquiry that integrates place, form and materials. The earth-artists engaged in landscape directly: earth was the material, the form oriented the viewer to the place of the work. Earth-art challenged the purpose of art as a collectable object. In some ways it was one of the first artworks to go public.

Herbert Bayer, Walter De Maria, Michael Heizer, Nancy Holt, Mary Miss, Isamuu Noguchi and Dennis Oppenheimer were just some of the original practitioners that began working as earth-artists, or environmental sculptors. They experimented with simple geometric forms that integrated place, space, time and materials. The work ranged from pristine natural environments to post-industrial environments. Theorists-practitioners Robert Smithson, Nancy Holt and Robert Morris expressed a more integrated relationship to nature as system. Smithson was acutely aware of nature's entropic and eutrophic cycles, embraced mining areas and quarries as the content and context for his work. Smithson's partner and colleague Nancy Holt was particularly interested in earth/sky relationships creating works that updated ancient techniques with a modern sculptural vocabulary. Morris addressed post-industrial landscapes, in both form and theory. Writing about his own work in Kent, Washington, his articles address the ethical responsibility of artists working in post-industrial landscapes. (Morris, 1979: 11-16; Morris, 1993: 211-232) Discussing the potential for aesthetic action to enable further

natural destruction on the part of industrial interests, he telegraphs issues that would emerge in restoration ecology, a decade later.

At the same time another group of artists emerged with a focused interest in systems theory and ecology. Hans Haacke, Helen Mayer Harrison and Newton Harrison, Alan Sonfist, and Agnes Denes were the original (and continuing) practitioners. They differed from the land-artists by their interest in dynamic living systems. Where the land-artists expressed themselves in the landscape, these ecological artists were interested in collaborating with nature and ecology to develop integrated concepts, images and metaphors. While earth art was amongst the first to go public, these ecological artists were the first to act in the greater interest of nature and the commons. Jack Burnham, for instance, wrote an important book - *Great Western Salt Works* (1974) that developed an initial approach to systems aesthetics.

Alan Sonfist's *Art in the Land* (1983) is a selection of texts which address the scope and range of artists working in relationship to environments then. Barbara Matilsky's *Fragile Ecologies* – a book accompanying a 1982 exhibition of that name - provides an overview of the historic precedents for this work, as well as some of the most important work of the first and second generation of ecological artists. Bylai Oakes (1995) *Sculpting with the Environment* is a valuable reference in that he asked each artist to write about their own work. Kastner's *Land and Environmental Art* (1998) is an international survey of both types of artists' projects, with a survey of writing on the subject by Brian Wallis. The text goes into the first, second and third generations of earth and ecological artists, providing an overview of works and accompanying articles. Heike Strelow's extensive catalogue for the *Natural Reality* show in Aachen (1999) expands the concept of ecological-art and its range of effort to include the human body as a site of natural inquiry. The catalogue provides arguments for the three areas of the exhibition, the unity of humans and nature, artists as natural and cultural scientists, and nature in a social context. The next exhibit to address ecolocial-art occurred at the Contemporary Arts Center in Cincinnati in 2002: *Ecovention: Current Art to Transform Ecologies*[1]. The accompanying catalog explores the artist's role in publicizing issues, re-valuing brownfields, acting upon biodiversity and dealing with urban infrastructure, reclamation and environmental justice. Recently, a new online Green Museum[2] has opened, loosely curated by Sam Bower. This site presents a range of eco-artists' works and texts as well as providing an area for dialogue about art and the environment.

A Mapping Strategy

In the simplest terms the map we use is a circular continuum, a taxonomic system, that mutually locates the different methods and means by which artists create change. No point in the circle is more or less valuable than another, they are simply different. We seek to understand commonalities and differences through this process, in the hopes of creating a dialogue that will lead to more effective practices and pedagogies. The components are as follows: Lyrical expression is a

productive internal response to existing social, political or environmental systems. It is a poetic response to an experience which can provide insight and new perception. It emerges from a desire to be involved (complicity) and express oneself with lyrical method and intention.

Critical engagement is primarily external from its social, political or environmental subject. It is a rational response to a particular concept or experience, that reframes perception and understanding. It tends to be an analytical monologue that seldom has any capacity or framework to receive or process response. It emerges from a moral or ethical idealism. Often rational and potentially didactic the critical practice is about the application of oppositional knowledge.

Transformative action requires critical (external) distance and a discursive (internal) relationship that is based in rational instrumental approaches to perception, understanding and value. It emerges from a moral and ethical position but embraces the creative potential of discourse and compromise.

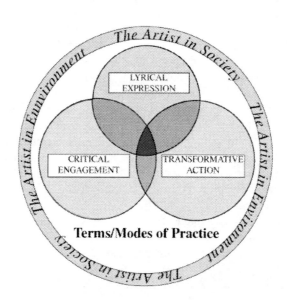

A graphic representation of modes of practice within a social-environmental setting. *(Image by Goto and Collins)*

Most artists have elements of two or three of these modes of practice embodied in their conceptual intent and in the range of their works. Following the goals of systematics this is merely a process of identifying, naming and relating common typologies. No single modality is more important or less important than any other. The diagram is actually a circular continuum, with the overlapping modalities of a Venn diagram, rather than a linear hierarchy.

TYPOLOGY	FOCUS	METHOD	PROCESS	RELATIONSHIP
Lyrical	Internal	Poetic	Expression	Complicity
Critical	External	Rational	Analysis	Oppositional
Transformative	Internal External	Compromise	Interaction	Transformative

Using some well known works as examples we demonstrate the use of this diagram. Each of these works effect change in important ways.

 If we were to consider Christo and Jean Claude's memorable *Running Fence*, the temporary project that ran across Sonoma County, California, and into the sea in 1976, it would fall into the space between lyrical expression and transformative action. The work is primarily poetic and expressive in its reception, the production of the work (the process) is fundamentally internal. Working with decision makers and land owners requires compromise, and interaction. For a brief moment the work was transformative, it changed the audience for, and the perception of, this particular landscape.

 Robert Smithson's *Site/Non-site* artworks from 1968 (which referred to the dump sites and industrial wastelands of his later work in a gallery setting), they would fall into the space between lyrical expression and critical engagement. The work has a sense of the poetic, yet at the same time it is primarily external and analytical. It can be viewed as either complicit or oppositional. The production of the work is a mix of external critical analysis and poetic expression.

 Maya Lin's *Viet Nam Veterans Memorial*, would fall in the area of transformative action. The work retained an external critical relationship to the war, memorializing military loss rather than accomplishment. The process was somewhat interactive as veterans groups sought a figural work to celebrate the warrior spirit in the same area, ultimately this work remains a clearly unique and transformative element amongst the ever increasing collection of war memorials that embrace more traditional element of power and warrior spirit in Washington D.C. today.

 Joseph Beuys' final project *7000 Oaks for Kassel*, occurs in the interstitial space at the center of the diagram, The work was initiated by the artist, yet it required interaction (planting of trees) to reach completion . The work will ultimately transform the City of Kassel by the sheer number of elements added to this

landscape. It is interesting to consider that if we were to examine the diverse body of work created by this artist, it would be distributed throughout the diagram.[3]

Returning to the *Ecovention* and *Natural Realities* exhibitions, we want to examine specific works that have been done by friends and colleagues. As we are primarily artists ourselves, we think it is important to be clear that this text is not intended to be a monologic work of art criticism. We have spent time with these artists, we have experienced the work and read their statements as well as having reflected upon our own experiences. The goal of this investigation is to introduce a method that might help us as practitioners find some common ground and a point of discourse about the similarities, differences, intentions and impacts of engaged social and ecological art.

The *Ecovention* exhibition, at the Contemporary Arts Center in Cincinnati, Ohio focused upon "getting it built". A pragmatic and instrumental relationship between artists, landscapes, ecologies and cultures. A key to the curators process is a "standard of inventiveness" based upon Plato's "Symposium". "...the subversive Diotima argues with Socrates about the significance of divine beauty, which entails imagination and brings forth not beautiful images, but new realities, which are presumably original or inventive." (Spaid 2002: 3) The curators created a framework of
 1. activism, issues and monitoring
 2. new values in brownfield (post industrial) landscapes
 3. biodiversity and species depletion
 4. urban infrastructure and environmental justice
 5. reclamation and restoration aesthetics.
The exhibition included forty artists, presenting work both within the museum as well as commissioned works outside the museum. We examine two of the commissioned works and one gallery presentation.

We want to start by comparing the artwork of Lynne Hull and Susan Leibovitz Steinman in the *Ecovention* exhibition. Both projects were constructed outdoors in Cincinnati. Hull created islands with tree branches and installed them on two different ponds located in two different places. Steinman created a temporary compost garden right next to the museum with found objects, plants and PVC pipes. Both Hull and Steinman's installations dealt with changing an existing space. Were their works transformative, critical or lyrical actions? What were the differences between them? Hull used mostly natural materials. "My sculpture and installations provide shelter, food, water or space for wildlife," Hull said, "An eco-atonement for its loss of habitat to human encroachment. (Spaid 2002: 140) Steinman used both natural and man-made materials. She said, "My commitment is to employ my art skills in the service of community health and empowerment." (Spaid 2002: 143)

 Susan L. Steinman used PVC pipes found objects such as old windows to make an expressive sculpture to celebrate a compost garden in the middle of a public-private city plaza. The materials provided a structure that supported plants, which attracted a mix of people, birds, and insects. Steinman's work altered a structured formal garden space that while including plants, subsumed their features in an architectonic structure. Her installation shifted experience towards a funky mix of materials that made explicit the human relationship between sunshine, soil and water, plants and birds, composition and decomposition, creating an atypical landscape for human consideration at the heart of the city. The work in our minds is a mix of lyrical and transformative intent and process. While primarily poetic and expressive, it retains a critical edge and demands compromise and interaction in its development.

 Lynne Hull wanted to attract wildlife, therefore her artwork had to blend into its living environment. Tim and I went to see her tree branch islands during the *Ecovention* exhibition. One was located in Swain Park, a small public park with lawn as its dominant feature. It was a hot day, and there was not much shade. We stood next to the pond to watch her artwork. The water looked still and troubled, with pollution marring the surface. We drove to the next piece. It was located in Rowe Wood Cincinnati Nature Center. There were many trees and the sounds of insects. We walked for a while on a wooden trail to get to the pond. When we reached the pond we sat on the trail to watch her tree branch island. We were totally relaxed but we did not see any wildlife at first. A few minutes later we saw some turtles. They were swimming and sticking their heads out of the water. Then we realized a very large snapping turtle was swimming toward us. We enjoyed imagining turtles climbing on Hull's tree branch island. If we were good observers and sensitive to the environment, perhaps we could notice more, like aquatic insects, small fish and birds. Hull integrated her artwork with the environment. Swain Park was a harsh environment for living things. Her branch island never quite integrated, instead it reflected the harshness. Rowe Wood Cincinnati Nature Center was a rich environment. Living things interacted with her tree branch island more visibly than they did in Swain Park. Hull's work is about an internal poetic relationship to nature, rather than culture. It relies on a thoughtful mix of expression and complicity with existing natural systems to achieve its product and its process. She is, in our minds, an exemplary lyrical practitioner who changes the way we think about the context and reason to make art.

 Kathryn Miller and Michael Horn presented an artwork called *Desert Lawn Action*. A plot of lawn is splayed out on a gurney attached to an intravenous drip and being rushed across the desert by medical personnel. The plot of lawn on a gurney was humorous but also incredibly poignant. Despite the desert environment in the south west United States, enormous effort and money is spent to artificially

create and sustain the green-laws of Arcadian development. Given the demands and conditions of the environment it is not out of the question to think of these natural plant communities as requiring life-support to sustain themselves under desert environmental conditions. This work is primarily critical, external from the social political decision-making processes that support such action, it is a rational oppositional analysis, with admittedly hilarious consequences. A powerful critical work that clearly illustrates the old axiom that a picture is worth a thousand words.

 Acid Mine Drainage & Art (AMD & Art) presented four frames of earth materials and man-made materials from their project site. Allan Comp, a historian, has directed the project since 1994 in Johnstown, Pennsylvania. The region is and was a site of considerable coal mining and steel production. The streams and rivers of the area are amongst the most heavily impacted by acid mine drainage in the country. Old coal mines collect water and leach out chemicals that change sweet water into a poisonous mix of acid and iron. The challenge of the *AMD & Art* project was not only to deal with enormous environmental problems but also to build an art project in a community that did not have any contemporary art practice. For ten years *AMD & Art* kept experimenting with cleaning the acidic water and introducing the project to large numbers of audiences outside of Johnstown. For the last three years the project has been working on a 35 acre site in Vintondale, PA, to transform it into a wetland treatment system and a park. Artist Stacy Levy, landscape designer Julie Bargman, and hydrogist Bob Deason worked on this biological water treatment system and landscaping plan. This work is transformative. It raises important questions about the nature-culture/industry relationship. The project has been a ten-year interaction and dialogue amongst artists and scientists, decision makers, community members and funders. The work has become an important example for Appalachia and for similar regions in north-east England. The artists, designer and project directors have worked closely with teams of young Americorps volunteers assuring that the expertise and commitment to change in the face of overwhelming problems becomes part of the culture of that region.

The *Natural Reality* exhibition at the Ludwig Museum in Aachen Germany in 1999 focused upon the future meaning of nature. The curator takes a critical position on the separation of nature and culture and argues for integration based on three artistic positions: 1. relationship between humans and nature; 2. critical analytical positions between nature and culture; and 3. artists as visionaries and creators of utopian ideals and realities. The exhibition was intended as a discursive platform. The curator integrated presentations and texts by scientists as well as artists and theorists in the project. The work was integrated into the culture of Aachen through onsite programs and funding from the policy-oriented Aachener Stiftung assured the connection between the products of museum culture and the decision makers of the region. The exhibition included workinside the museum as well as in the community. We examine works from both contexts.

 Romano Bertuzzi's work in the *Natural Reality* exhibition consisted of photographs of cheese making at his family farm and a regular performance where he produced cheese at the museum. Photographs included pictures of his mother making cheese and cleaning up the cattle pen. Bertuzzi's presentation is tuned for critical impact. He wants us to understand that cheese is not just a commercial product. Each day he uses 15 litres of fresh cow milk to begin the production of food. (Strelow 1999: 61) Within the space of the museum the food becomes artifact, a record of craftsmanship which in turn raises questions about consumption, collection and daily life. All of the artifacts, the wheels of cheese, are freely distributed for consumption at the end of the exhibition. This curious work is primarily critical. A rational and oppositional program strategically located in the museum [4]. Yet the work is also transformative. Bertuzzi's work relies on interaction to achieve his goals and make his point about quality, care and human attention.

In modern farming cow milk is often only used for humans, with calves being fed substitute nutrients. Farmers keep their milk cows for only for three to six years. Then they are slaughtered. In order to sustain human life, many other lives are sacrificed. This sacrifice has to be sacred. Bertuzzi's work did not make me feel guilty, but it made me more appreciative of that sacrifice. Cheese is a product of human wisdom across time and diverse cultures, products of places rather than the homogenous industrial product most of us consume today. There is wisdom in this idea that is relevant to the future.

 Georg Dietzler has been using oyster mushrooms to remove toxins from contaminated earth materials such as PCBs and heavy metals. Oyster mushrooms usually feed on oaks. The tannin in oak is similar in chemical structure to PCBs. Using plants to absorb pollution in soil is a new biotechnology called Phytoremediation. Dietzler created the mushroom piece for the *Natural Reality* exhibition as a temporary installation. The piece consisted of an oak and straw structure with stucco and oak table areas filled with earth infested with PCBs. The process takes years, so Dietzler and a scientist calculated the amount of toxin that was present in the soil and how long it would take for the mushrooms to decontaminate it. He made the structure so that the mushrooms would do the work. After the exhibition ended, Dietzler's work was kept until the structure collapsed. The soil was examined by a scientist and it was completely clean. Dietzler's work is clearly transformative. The work embraces the world yet retains a poignant critical position. The work transforms the culture of science and the culture of the museum. The former in terms of new bio-technologies to mitigate industrial byproducts. The latter in terms of an artifact, that carries within it the biological condition of its own demise. A potent reversal and commentary on modernist works that celebrate industrial self destruction. The work is also lyrical, the relationship between the structure, the significant threat of PCB pollutants and the tiny mushrooms is evocative in strange ways. The work both welcomes the audience in its simple construction yet denies entry due to the toxic materials it contains. Finally the work is time-based, but at a pace most of us would not perceive.

 Herman Prigann's *Terra Nova* project is a grandiose plan to integrate humanity and nature through the restoration of former industrial sites. The work has evolved during his travel and work in Eastern Europe. He presented definite plans for a brown coal site in Hiederlausitz, where the goal is to integrate the industrial waste through the efforts and knowledge of indigenous agricultural experts. Herman sees restoration as a mix of re-occupation and education that leads to new expertise and a restorative economy. Prigann uses the formal language of the earth artists, to frame and explain his concepts while describing a deep social/ecological systems methodology to realize that work. This work is primarily transformative. To achieve these projects Herman has to work both within and outside the systems of state regeneration; he has to embrace the real need to compromise and to interact with a mix of decisions makers, scientific experts, agricultural experts, laborers and citizens interested in the regenerative capacities of this work.

 Eve Andrée Laramée presented two movable gardens on large trucks. These gardens were driven around Aachen. One garden held topiaries and the other held growing herbs, vegetables and corn. Topiaries are a manicured and managed garden form, mostly evergreen trees trimmed into geometrical shapes or simple figures. Food gardens are also highly managed, hybridized forms of nature pushed to perform for human interests. Driving these trucks around Aachen suggests a captive yet mobile museum of nature-culture. Even though the vegetables could be harvested and eaten, this was not Laramée's intention. Her intention was similar to that of people who decorate their houses and gardens with natural materials without connection or reflection upon the natural environment. From the beginning Laramée claims this work in a humorous vein, a mobile pun that challenges the human relationship to nature and its stereotypical manifestations. This work is primarily critical, an external rational analysis, but it is not oppositional. The form of the work is poetic and ultimately complicit with dominant cultural interests. It is a mirror of society.

 Helen and Newton Harrison re-presented *Casting a Green Net: Can It Be That We Are Seeing a Dragon?* In 1996, in England, they explored the land between the estuaries of the Mersey River near Liverpool and the Humber near Hull, bordered on the north and on the south by old Roman roads that went over and between the contours of the Pennine Mountains. The shape of the 900 square miles of land looked like a dragon that had wings. In the museum, the Harrisons presented three large maps. One was about the current site condition while the other two were future predictions. One prediction looked like the dragon was dying because of over population and the neglect of a green network. Each scale of the dragon was marked in dark gray. The other prediction looked like a healthy dragon that was saved by a green network which was created between cities and communities. The scales of a healthy dragon were the green space that was surrounded by hedges, as multi-valent wildlife habitats. This work is primarily transformative, it

is both internal in terms of the decision makers and policy experts that participated in its formation, and external in terms of the artworld context of the presentation. The work embraces compromise in terms of the decisions that humans make to either enable or destroy nature, but the artists do not compromise on this conceptual vision. The work is about interaction in terms of development and ultimately in terms of realization and potential transformation. The work is particularly hard to verify for impact because of its scale and intent. This is rational and real utopianism, with transformative intent.

Conclusion

Much of this work presented in the *Ecovention* and *Natural Reality* exhbitions builds upon a new environmental practice called ecological restoration. Integrated with the preservation and conservation practices and methods of the last century restoration adds the potential to heal the ravages of the industrial economy. The importance of ecological restoration is that many different professionals, including artists, and communities, are involved, experimenting with ways to rethink the nature-culture relationship as well as ways we can heal and repair problems that we have created. The work creates new intellectual and physical relationships between humans and nature, which can result in new understanding and interrelationship with great meaning.

Some people think ecological restoration is like fixing a damaged painting. William Throop, in *Environmental Restoration*, argues that while the restorer of paintings works on the original and seeks exact fidelity to a pre-damage state, environmental restoration cannot claim that the original system remains after disturbance. Another way to see it is like getting a false tooth. Once a natural tooth is damaged, there is no way to make it as it was before but a false tooth certainly helps its owner eat, which in turn feeds body and mind. Restoration ecology plays a similar role in nature impacted by industrial avarice. This is the first step in a healing relationship to nature; like the peglegs of antiquity we are learning that life requires attention to health. There is no split between nature and culture, simply shadow and light relationships.

Notes

1 Available online at http://greenmuseum.org/c/ecovention
2 Available online at http://greenmuseum.org
3 Initiated at Documenta 7, in 1982. 7000 basalt columns were placed in a pile in front of the main exhibition hall. One basalt column would be paired with a newly planted tree. The diminishing pile indicated the process of planting trees and completion of the work. By 1987 the last tree was planted with an attendant basalt column. (See 7000 Oaks: Essay by Lynne Cooke with Statements by Joseph Beuys. www.diacenter.org/ltproj/7000/essay.html
4 This methodology follows Danto's statements about modernism, "With Modernism, the conditions of representation themselves become central" (Danto: 1997: 8)

References

Beardsley, J. (1977) *Probing the Earth: Contemporary Land Projects*, Hirschorn Museum, Smithsonian Institution, Washington D.C

Beardsley, J. (1984) *Earthworks and Beyond*, New York Abbeville Press

Burnham, J. (1974) *Great Western Salt Works: Essays on the Meaning of Post-Formalist Art*, George Braziller, Inc., New York, p. 15-24

Hobbs, R. (1981) *Robert Smithson: Sculpture*, London, Cornell University Press

Lippard, L. R. (1983) *Overlay: Contemporary Art and the Art of Pre-History*, New York, Pantheon Books

Matilsky, B. (1992) *Fragile Ecologies: Contemporary Artists Interpretations and Solutions*, New York, Rizzoli International Publications

Morris, R. (1979) Robert Morris Keynote Address, in Earthworks: Land Reclamation as Sculpture, Seattle, Seattle Art Museum p. 11-16

Morris, R., (1993) Notes on Art as/and Land Reclamation, in *Continuous Project Altered Daily: The Writings of Robert Morris*. Boston, Massachusetts Institute of Technology p. 211-232

Oakes, B., (1995) *Sculpting with the Environment*, New York, Van Nostrand Reinhold

Sonfist, A., (1983) *Art in the Land : A Critical Anthology of Environmental Art*, New York, E.P. Dutton Inc.

Spaid, S., Lipton, A., (2002) *Ecovention: Current Art to Transform Ecologies*, Co-published by the Cincinnati Art Center, Ecoartspace and the Greenmuseum.org.

Strelow, H., (1999) *Natural Reality: Artistic Positions Between Nature and Culture*. Stuttgart, Ludwig Forum for Internationale Kunst, Daco Verlag

Throop, W., Ed. (2000) *Environmental Restoration: Ethics, Theory and Practice*, Amherst, Humanity Books, an imprint of Prometheus Books

Wallis, B., Ed., (1998) Land and Environmental Art, London, Phaidon Press

9 Connecting Conversations: the changing voice of the artist

Peter Renshaw

Commitment to conversation

The motivation underlying this chapter stems from nearly forty years of being engaged in institutional change. In the 1960s, concern with raising the quality of the teaching profession led to my deep involvement in reforming the teacher education curriculum. Later, as Principal of the Yehudi Menuhin School, I focused on providing a supportive environment and balanced curriculum for the education of talented young musicians. Finally, for the last twenty years my primary aim has been to bring the training of professional musicians into the 21st Century. I have been driven by a strong personal belief in the power of the arts to make a difference and a conviction that their potential will never be fully realised unless they seriously engage with social change and the broader cultural context.

My quest has been rooted largely in conservatoires and it has broken new ground in its response to the demands of an evolving music industry, to major educational developments and to the diversity of our changing cultural landscape. Most recently, a growing awareness of the isolation of conservatoires has brought home clearly the need for all professional artists to be trained within a framework that acknowledges and understands the importance of cross-discipline, cross-arts, cross-cultural and cross-sector work.

Throughout this journey the challenge confronting conservatoires and all higher arts education institutions has become abundantly clear. Curriculum development and changes to pedagogy, by themselves, will never address the fundamental questions that bedevil professional training. Only a significant shift in the culture and mindset of each institution can hope to facilitate the necessary change. For this to be realised in practice, strong visionary leadership needs to create an environment in which honest, open critical dialogue is respected and actively encouraged. Each person's voice has a right to be heard. Without this commitment to a conversation that is premised on the making of connections, most

artists, teachers, students and managers will remain trapped in their silos, resistant to moving into uncharted territory. This can only be counter-productive for each institution and its partners, and for a profession that is becoming increasingly dysfunctional.

Connections, context and conversations

In light of this crisis, I would suggest that higher arts education institutions could well consider taking the three Cs – connections, context and conversations – as their mantra. No institution can remain cut off from the apparent contradictory demands of our constantly changing social, economic and technological world. The turbulent waves resulting from 9/11 and the forces of globalisation have helped to shape a revolution that is penetrating every aspect of our lives. At best, this revolution is blurring boundaries, challenging old assumptions, extending our horizons and providing new opportunities for innovation. But these new maps and pathways also constitute a threat to those individuals and institutions who are resistant to change. Global forces must not be allowed to erode our sense of who we are through our connections with the past and our engagement with living traditions. On the other hand, in a vibrant cultural democracy every effort has to be made to promote and understand those new images, sounds, movements and languages that lie at the heart of a contemporary living culture.

Any deepening of this understanding within our present world of diversity and inequality, can only be realised through engaging in a 'conversation' that respects differences, sees commonalities and crosses boundaries. Writing in a different context, but one which is equally relevant to artists and cultural institutions, Jonathan Sacks (2002) urges us to remember that :

> Bad things happen when the pace of change exceeds our ability to change, and events move faster than our understanding. It is then that we feel the loss of control over our lives. Anxiety creates fear, fear leads to anger, anger breeds violence, and violence – when combined with weapons of mass destruction – becomes a deadly reality. The greatest single antidote to violence is *conversation*, speaking our fears, listening to the fears of others, and in that sharing of vulnerabilities discovering a genesis of hope. I have tried to bring (my) voice to what must surely become a global conversation, for we all have a stake in the future, and our futures have become inexorably intertwined (p.2).

The notion of conversation can act as a powerful metaphor in any institution committed to change, especially when its future direction envisages a dynamic relationship with the local, national and global context. But, as was intimated above, any wider, external conversation will only have legitimacy if mirrored by an institutional conversation that embodies such qualities as trust, active listening, openness, humility, integrity and empathy.

In a cultural world of growing diversity, the ability to reach out, to respect and accept different points of view is critical to any personal or institutional conversation. All teachers, students and young people in education need to be valued and feel that their voices are heard within an ethos of shared responsibility and mutual interdependence. This presents a tremendous challenge to the leadership and culture of an institution. In many cases, critical dialogue fails to take place and a silo mentality prevents institutions from realigning their priorities. It now seems imperative that higher arts education institutions really engage with changing cultural values and with those deeper concerns confronting people in their everyday life. Connecting to context becomes a fundamental principle in any institutional conversation.

The voice of the artist and our search for meaning

Due to the destabilising factors arising from the global revolution, many individuals and institutions are searching for an overarching sense of purpose that will provide a more coherent, sustained narrative in their lives (see Sennett, 2000, pp.175-190). People are looking for an overall context that will enable them to understand the complexities of a world in which it is increasingly difficult to find a shared sense of community.

One of the greatest strengths of the arts is that they can enhance the quality and meaning of people's lives. They are a source of inspiration and celebrate the richness of the human spirit. Engaging in the arts can strengthen our sense of identity by helping each one of us to find our unique voice. Given a context to which people can relate, artistic processes can also be transformative. They can open new doors, extend personal boundaries, enable us to see past traditions in new ways and provide opportunities for us to redefine who we are in our current fractured world.

The question of identity and the place of the arts in helping us to find our unique voice is one of today's defining issues. It is imperative that the whole arts community begins to engage in a local and global dialogue about who we are and what we can achieve together. (For further discussion see Yasmin Alibhai-Brown, 2000.) This inevitably means reordering our priorities in relation to the changing cultural landscape and acknowledging the growing schizophrenic divide between traditional arts practice and popular culture. Contemporary culture is no longer limited to handing down a tradition. It constitutes a cultural melting pot in which everyone has the right to roam. Cultural choice is now unprecedented and all arts institutions have to reflect these changing values and meanings otherwise they run the risk of becoming pickled in time.

Conversation, then, becomes the bedrock of any cultural engagement in which the artist's voice resonates with the myriad of individual voices within the wider community. It is imperative that artists, creators, innovators, teachers and artistic leaders have the skills, confidence, imagination and vision to create live, shared

experiences which have something to say and make sense to audiences in different contexts.

This point of view is argued cogently by Jon Hawkes (2001) in his perceptive paper, *The Fourth Pillar of Sustainability*, written for the Victorian-based Cultural Development Network in Australia. For Hawkes, practical engagement in the arts is fundamental to the meaning and vibrancy of cultural life. In his paper, he captures the heart of artistic experience:

> The arts are the creative imagination at work (and play). Its techniques involve improvisation, intuition, spontaneity, lateral thought, imagination, co-operation, serendipity, trust, inclusion, openness, risk-taking, provocation, surprise, concentration, unorthodoxy, deconstruction, innovation, fortitude and an ability and willingness to delve beneath the surface, beyond the present, above the practical and around the fixed.... A society in which arts practice is not endemic risks its future. The support of professional artists is a laudable policy but far more important is offering all citizens, and their offspring, the opportunity to actively participate in arts practice – to make their own culture (p.24).

This perspective is reflected in Robert Putman's powerful analysis of the decline of American community and the need to rebuild social capital in the United States. Putman (2000), who is Professor of Public Policy at Harvard University, argues strongly for active participation in cultural activities rather than merely consuming them as spectators (see pp.114-115, 411), a point also clearly articulated by François Matarasso (1997) in his seminal work, *Use or Ornament*.

> The greatest social impacts of participation in the arts ... arise from their ability to help people think critically about and question their experiences and those of others, not in a discussion group but with all the excitement, danger, magic, colour, symbolism, feeling, metaphor and creativity that the arts offer. It is in the act of creativity that empowerment lies, and through sharing creativity that understanding and social inclusiveness are promoted (p.84).

Realigning priorities in higher arts education institutions

The dynamic and culturally responsive role of the artist in our seemingly interdependent, yet disconnected world, cannot help but invite higher arts education institutions to reappraise their priorities. This view has underpinned many of the international dialogues initiated by the European League of Institutes of the Arts (ELIA) in its conferences, symposia and publications. Fundamental changes have to grow out of the history and traditions of particular institutions, but changing expectations in the current social and cultural climate now challenge us to attach greater value to those artistic and educational developments that reflect the diversity of different contexts (for further discussion see Renshaw, 2001, pp.4-6; Renshaw, 2002, p.24). Examples might include:

- encouraging innovatory approaches to performance which open up access to quality artistic experiences and engage audiences from broad, diverse backgrounds;
- developing new work, new art forms and artistic languages which have resonance with different audiences;
- exploring the value and contribution of the vernacular within contemporary culture;
- using participatory processes to foster the development of creativity in different contexts;
- producing a common framework for evaluating and assessing quality across the whole range of artistic activities in accordance with diversity of need and purpose;
- providing opportunities that foster quality, accessibility, diversity and flexibility within a climate of inclusiveness;
- creating new performance environments and spaces which attract new audiences;
- extending artistic practice through exploring the interconnections between different disciplines, technologies and art forms;
- positioning research and continuing professional development as the artistic and educational motor that underpins the work of an institution;
- developing each training institution as a flexible resource for the professional arts community, the education community and the wider community.

Such developments exist in embryo in some higher arts education institutions, but priorities now need to shift significantly as artists and teachers begin to redefine their roles and responsibilities.

This need was recognised in a recent research report in the UK, *Creating a Land with Music*, on the work, education and training of professional musicians in the 21st century, which was commissioned by the Higher Education Funding Council for England and managed by Youth Music (2002). In its investigation of how far the needs of the music industry are being met by the training sector, the enquiry points out that:

> Musical practice is now embedded in, or being seen to have relevance and power in, much wider social contexts than what is restricted to traditional music venues and to recording studios. Being a musician today involves having the opportunity to take on a series of roles, different from and broader than the act of performing or composing (p.4, para.2.3).

The report demonstrates that most musicians now have a portfolio career that embraces the four central roles of composer, performer, leader and teacher (p.3 para.2.12). This raises the fundamental question as to what extent training institutions are preparing their musicians to function effectively within a portfolio culture. There is no doubt that for some musicians and other artists, the changing landscape is providing rich opportunities for them to use their creative energies in a

positive and fulfilling way. But many also feel lost, undervalued and dysfunctional.

Perhaps many higher arts education institutions would benefit from working in much closer partnership with those professional companies and ensembles that are radically redefining themselves. One powerful example can be found in the work of the London International Festival of Theatre (LIFT – of which I am a non-executive director), which has transformed its biennial festival into a five-year Enquiry examining the purpose and nature of theatre in today's world (see LIFT, 2003a, *The LIFT Enquiry 2001-2006*).

> The Enquiry asks a series of questions that open up ideas on theatre as a space for public dialogue. What is theatre? Where does theatre take place? Who is making it? Over the course of five years the answers to these questions will accumulate to provide a rich understanding of the role of theatre today. Involving artists and audiences, the LIFT Enquiry will be activated by the growing circles of conversations, evidence-gathering and research undertaken through three pathways: Performance, Learning and Evidence.

> …. The LIFT programme is designed as a kind of laboratory in which different aspects of contemporary performance can be explored in depth, challenging old perceptions and testing out new ideas. Each performance or season of work will ask a series of questions … Whose stories are ascribed value, and why? How do you marry tradition with modernity? What is tragedy today? How do you find sanity in war?

> …. In its journey to discover what is theatre? LIFT Learning asks: Who can be part of making theatre? What can be learnt in the process?

> …. Evidence at LIFT makes visible the Enquiry's discoveries and makes public some answers. How do ideas leave their mark? How do we capture, hold and share the experience of theatre?

> …. A LIFT evidencing team – artists, diarists, photographers, scientists, anthropologists, and other creative and academic recorders – bears witness to the phenomenon of theatre and traces the shifts of perception amongst artists and audiences. The Evidence they accumulate will be presented publicly as the story of the five-year Enquiry (pp.2-5).

It is clear that conversation lies at the heart of the LIFT Enquiry and as Peter Sellars, the opera and theatre director, points out – "the idea is that one person's voice does not obliterate another voice". Engagement in this kind of critical dialogue is the life-blood of a cultural democracy and it should constitute the basis of any reordering of priorities in higher arts education institutions. For such dialogues to have any resonance with the diversity of voices in the real world, these

"growing circles of conversation" should include cross-disciplinary, cross-cultural and cross-sector perspectives. They should also be rooted in partnerships that bring together performers, composers, writers, directors, visual artists, business people, teachers, school children and young people. Each person has a voice that needs to be heard and respected.

Connecting to context

There are countless examples of individuals in different parts of the world who have been activists and catalysts determined to change the seemingly closed mindset of many publicly funded cultural institutions. Significant artistic and educational developments have taken place, but many higher arts education institutions have proved peculiarly resistant to change – there is a grudging reluctance to move into the 21st Century. Those initiatives that are making a difference invariably have forged connections that resonate with different contexts. Again, conversation is critical to the success of any vibrant partnership.

One example of where this kind of conversation has transformed practice at higher arts education level lies in the strong partnership between LIFT, the Guildhall School of Music & Drama and the Royal College of Art in London. Their collaborative work is research-based and grounded in both the community and cutting-edge professional practice. It has enabled the Guildhall to strengthen its contribution in those key areas connected with access, social inclusion, cultural diversity and lifelong learning. At the heart of this work is the Guildhall *Connect* Project, launched in 2001 with generous funding from Youth Music. Its programme is building on and extending the Guildhall's experience in the London Boroughs of Newham, Tower Hamlets and Lewisham. These are all priority areas and form part of the network of Youth Music Action Zones, which are designed to strengthen local and regional collaborations that cut across all musical genres and educational sectors.

This major initiative, directed by Sean Gregory (Head of Professional Development at the Guildhall), is one of a number of projects through which the Guildhall is building up new partnerships and developing new models of effective practice in the field of creative and participatory music-making. The strategic alliances that have been formed reflect the diversity of practice within the Project. In London, for example, key partners include Newham Sixth Form College, Urban Development, Stratford Circus, Midi Music, Blackheath Conservatoire and Globetown Education Action Zone. Central to the trans-cultural work of the Project are the links that have evolved with the Education through Culture and Communication Organisation (ECCO) in The Gambia, Bagamoyo College for the Arts in Tanzania and Centro Multi Media in Mexico. All these distinct voices form part of a multi-faceted musical conversation that makes sense to a broad constituency in different parts of the world. A new artistic language is being created within a developing vernacular culture.

Peter Renshaw

The role of a flexible development agency like ECCO is crucial, not only in its host country, The Gambia, but also as an informed voice in the current debate in the West about the place of the vernacular within our contemporary living culture. ECCO (2003), coordinated by Guro Gardsjord Heilmann, already has a strong track record as a Non-Governmental Organisation promoting, protecting and sustaining local cultures through education and trans-cultural collaborations. It is an exemplary case of a cultural organisation putting the principle of 'connecting to context' into practice. ECCO is confronting the needs and realities of different cultures and is seeking to harmonise the culture of the past with that of the present. Its belief in community development is underpinned by a commitment to sustainability based on ecological and economic principles.

ECCO is about to set up the first Academy of West African Culture in Mediana, The Gambia, and its future success is partly dependent on strengthening the partnerships it has been nurturing in Europe over the past few years: for example, with Oslo College of Dance and Sund Folk High School in Norway; with Malmö College of Music, Örebro College of Music, Ingesund College of Music, Piteå College of Music and the Royal College of Music, Stockholm in Sweden; and with the Guildhall School of Music & Drama in London. Both teacher and student exchanges have had considerable impact on curriculum development and ways of learning in their respective institutions. ECCO is ensuring that the voice of The Gambia is being heard in Europe, and through its European office it is in the process of establishing models of trans-cultural collaborations within a network of like-minded initiatives.

The centrality of arts and culture in sustainable development is also argued cogently by Jon Hawkes (2001) in an Australian context. He maintains that cultural vitality, alongside social equity, environmental responsibility and economic viability, is critical to sustaining communities within a cultural democracy. Echoing the reflections of Putman and Matarasso instanced earlier, Hawkes states that:

> In the context of working towards a more inclusive and engaged democracy, it is active community participation and practice in the arts (rather than the consolidation of professional elites, 'audience development', economic development or cultural tourism) that should be the primary focus (Hawkes, 2001, p.30).

A similar commitment to a more inclusive approach to the arts and cultural development can be found in an ideas paper promoting a framework for a cultural policy by the Queensland Government (2001). At its heart the Government aims to shape a cultural policy:

> which will work for all of us so that our cultural life enlivens our personal sense of self; enriches our communities; builds community identity and pride; and helps us to celebrate our differences and diversity ... It will be

for all Queenslanders, crossing all Government departments and inclusive
of all Queenslanders – indigenous peoples; people from culturally diverse
backgrounds; rural and regional Queenslanders; people with disability;
young people and older people (p.2).

The Queensland Government is well aware that if it is to generate a relevant cultural policy that engages with the real world, it will have to encourage a cross-sector and cross-discipline approach to sustainable development:

The potential for government departments, arts organisations and local
groups to work together to deliver a vibrant cultural sector is enormous.
Not only does it make sense economically to work with other groups, but
it also lays the foundations for cross-fertilisation of artistic ideas (p.6).

Similarly, the Australia Council (2000), through its Multicultural Advisory Committee, recognises the need to establish different forms of creative partnerships if it is to succeed in promoting multicultural arts practice across the whole spectrum of arts activities. Its strategies include:

- exploring collaborative projects between artists, arts organisations, youth education and media;
- promoting partnership models between multicultural arts organisations and tertiary educational institutions on a national level;
- researching and publishing current definitions of multicultural arts practice;
- creating opportunities to engage key decision makers in the creation and development of multicultural artwork (p.16).

These few examples taken from Europe, West Africa and Australia illustrate the sense of urgency being felt by those cultural leaders who wish to see the arts playing a far more dynamic and meaningful role in their different communities. In each case every effort is being made to ensure that active participation in the arts is pivotal to a sustained cultural policy that operates across the widest constituency. It is almost self-evident that those higher arts education institutions responsible for the professional training of the next generation of artistic leaders should be at the cutting-edge of this aspect of creative practice. Yet in many instances there continues to be a stubborn resistance to addressing the challenges of cultural change. With a few notable exceptions, 'connecting to context' is just seen as an irrelevance to the core business of training and development.

Conversations between classical heritage and vernacular culture
If culture is really to be valued as the 'fourth pillar of sustainability' (Hawkes, 2001), the relationship between 'classical heritage' and 'vernacular culture' becomes absolutely fundamental to future developments in education and professional arts practice. The values we place on each of these cultural nodes help to determine the nature, content, delivery and funding of different arts activities.

The current vulnerable financial climate is creating a competitive situation in which Western 'classical traditions' enjoy an uneasy hegemony over the vernacular.

In those institutions that I know best, conservatoires, it is clear that at present they are delicately poised between conserving 'classical heritage' and acting as a catalyst within a living culture. At first sight these might be seen as uneasy bedfellows, but in my view, both perspectives are equally important and should command parity of recognition and resources. There is little doubt that a belief in the integrity and transformative power of 'classical' traditions will continue to be seen as central to the philosophy of a conservatoire, but changing cultural values now require them to shape a vision that is more inclusive and outward-looking.

No conservatoire, orchestra or opera company can ignore the fact that the 'classical' music industry is undergoing an immense transition. Professional players, teachers and students are having to redefine the nature of performance and its relationship to composers and audiences. Collaborative forms of music-making are increasingly seen as central to engaging with a vernacular culture. Growing interest in the cross-fertilisation of music, technology, other creative arts and cultural traditions is developing an artistic language that has resonance with a wider public.

In such a fluid context, connecting conversations becomes fundamental to the process of cultural change. Conservatoires, like any other higher arts education institution, have to find ways of re-engaging the public's imagination and commitment to 'classical heritage', but they also have to re-focus their creative energy, artistic and educational vision if they are to be a vital force in a living culture. Basically, they have to become less self-referential.

For many professional artists and teachers, the challenge of this reordering of priorities and shift in perspective is perceived as undermining the foundations of who they are. And yet the contemporary world is confronting us to recognise that our identity today rests on an understanding of the reciprocal relationship between two 'heritages'. In a riveting insight into the multi-faceted nature of identity, Amin Maalouf (2003) states that:

> Each one of us has two heritages, a 'vertical' one that comes from our ancestors, our religious community and our popular traditions, and a 'horizontal' one transmitted to us by our contemporaries and by the age we live in. It seems to me that the latter is the more influential of the two, and it becomes more so every day. Yet this fact is not reflected in our perception of ourselves, and the inheritance we invoke most frequently is the vertical one.

> This is an essential point with regard to current concepts of identity. On the one hand there is what we are in reality and what we are becoming as

a result of globalisation: that is to say, beings woven out of many-coloured threads, who share most of their beliefs with the vast community of their contemporaries. And on the other hand there is what we think we are and what we claim to be: that is to say, members of one community rather than another. I do not deny the importance of our religious, national or other affiliations. I do not question the often decisive influence of our vertical heritage. But it is necessary at this point in time to draw attention to the gulf that exists between what we are and what we think we are (p.102-103).

It seems to me that Maalouf's distinction between 'vertical' and 'horizontal' heritage mirrors the current conversation between 'classical heritage' and 'vernacular culture'. The integrity and values of the past matter. They must not be diluted by a uniformity and homogeneity due to the tyranny of commercialisation and political correctness. The guardians of 'classical traditions' are terrified of a dumbing down that might result in an impoverishment of everything they stand for. In the words of Maalouf (2003) the danger is that:

> the current free outpouring of musical expression (for example) will ultimately result in no more than sugary, mawkish 'wallpaper', and the extraordinary effervescence of ideas will produce only a simplistic conformism, an intellectual lowest common denominator (p.111).

But our reverence for the past must not blind our vision for the future. Within a cultural democracy it is imperative that opportunities are given for each individual creative voice to be heard. This principle lies at the heart of any society that believes in supporting a thriving vernacular culture. In no way does this commitment to widening participation in the arts necessarily lead to a bland vacuity and lowering of standards. Such a patronising attitude belies the fact that the quality of much that takes place within the traditions of 'classical heritage' is little more than mediocrity masquerading as 'excellence'. What matters is that every opportunity is given to promote quality experiences in both domains – that is within 'classical' traditions and in vernacular culture. The interrelationship between vertical and horizontal heritage becomes a springboard for a creative future within an open society. This ideal will not be realised in a world resistant to honest conversation and critical dialogue.

But unquestioning allegiance to closed tribal practices still acts as a major impediment to change in arts institutions today. Many artists remain trapped in a cultural bubble that is rooted within a vertical heritage. If their voices are to be heard in our contemporary world, they have to become more connected to their creative source and to the wider context of their audience. Only in this way will what they have to say make sense.

In music, for example, this is as true for soloists and orchestral players as it is for jazz, pop and world musicians. A recent EU-funded project on cultural diversity,

Sound Links (Rotterdam Academy of Music and Dance, 2003), highlighted the danger of different music genres becoming trapped within a silo mentality that effectively negates the open principles underpinning cultural diversity. One particular relevant statement stood out in the Report:

> Culturally diverse practices are often expected to break the rigidity of the 19th century model of teaching and learning in an institution. But especially in the case of tradition specific teaching, the opposite can happen. Instead of the institution developing its flexibility and curiosity that would benefit all musical traditions, the new musical tradition is fitted into the 'strait-jacket' of the institutional structure, or, alternatively, it isolates itself. In both cases, there is a risk of forming a new 'monoculture'.
>
> By the very nature and history of conservatoires, this has happened to many classical music departments. But this tendency can also be observed in pop and particularly jazz departments. In order to strengthen their position, musicians of a certain tradition take on a defensive role and concentrate exclusively on their own field. They close themselves off from the rest of the institution, rather than looking for connections and contacts. This may not be what an institution wanted to achieve by including cultural diversity in the first place, but treating a world music tradition the same as western classical music or as an emphatically distinct tradition, although valid in its own right, may lead to great opportunities for cross-fertilisation being lost (p. 72).

Again, this tribal insularity is unhealthy both for the institution and the development of the art form. Conversations that in the past remain fixed within a particular domain now have to become an integral part of a much wider interconnected web of conversations. Perhaps we are now moving towards a new paradigm that is shaped by an ecological understanding of those African and indigenous communities who have not lost touch with their cultural roots – communities who still value the organic connection between, for example, myth, story-telling, ritual, dance, theatre, voice and music. This shift in thinking and practice lies at the heart of the current move towards a vibrant vernacular culture.

A vocal champion of this view is Peter Sellars who feels that Western urban culture has lost its humanity and is totally disconnected from its roots. In a recent interview (see LIFT, *News*, 2003b) Sellars asserts that "To put the agriculture back in culture is a really important part of reclaiming this next century". We need to reconnect with people, with our environment, with shared space in our quest to rebuild a living culture that is sustainable and comprehensible.

Sellars sees clearly that active engagement in the arts is the bedrock of a vernacular culture. He states that:

> What's so great about this next generation of performance is that it is so

participatory and so engaged with eliminating those old definitions. And it is moving us all into a more interesting situation where every one of us is a citizen. For theatre, read democracy. Democracy is a participatory activity. It's not a spectator activity. The media has conspired to create a spectator state, and that's really unhealthy. So if we can create a stronger sense of participation and a greater diversity of voices, that's democratically engaging. Our goal must be to use those voices, that participation, to explore how we want to live and what kind of priorities we want to see in our community (p.3).

It is to be hoped that the creative energy, commitment and political will of artists like Peter Sellars will help to shift the intransigence of many higher arts education institutions and arts organisations. There is now a strong moral imperative for us all to engage in creating a dynamic living culture that speaks to people.

Magic, mystery and measurement – a conversation that matters

In the process of redefining contemporary culture and exploring the relationship between 'classical' traditions and the vernacular, fundamental questions have to be raised regarding the assessment of quality in both domains. This is especially the case in the multi-faceted area of vernacular culture where judgments have to take into account a whole range of different purposes and contexts.

Mapping the criteria for assessment has become a top priority as all cultural institutions, along with the rest of the public sector, are having to address the issue of accountability. This is confronting them with the challenge of how to define and manage their knowledge. Quality control systems, dominated by quantifiable performance indicators, are more often than not used to underpin higher education policies. This might be effective in terms of accountability and transparency, but this system can easily become controlling and debilitating. Within this culture of compliance it is only too easy for arts organisations to become disconnected from the heart of their artistic life.

Knowledge, understanding, skills and professional attitudes form the bedrock of learning in higher education, but the ways in which they are defined and acquired can too readily be undermined by the perceived expectations of Quality Assurance and performance management. An organic approach to curriculum and institutional development, which depends partly on the fostering of an institutional conversation, does not fit comfortably within a mechanistic system of controlling and managing knowledge.

It seems crucial that in the central areas of creating, performing, teaching, learning and assessing, higher arts education institutions understand and respect the fundamental distinction between explicit knowledge, in which targets can be measured in quantifiable, mechanistic terms, and tacit knowledge which is more intuitive, reflexive and learned in very particular situations. Explicit knowledge can be clearly articulated, codified, quantified, replicated and transferred from one con-

text to another. Tacit knowledge, on the other hand, is intangible, less observable, more complex and more difficult to detach from the person who created it or from the context in which it is located. The subtle nuances connected to tacit knowledge are more often caught and learned through a process of apprenticeship, through conversation, and are not readily transferable. Research in this domain is more likely to be qualitative in character, arising from reflective practice aimed at extending the boundaries of knowledge and experience.

In any arts institution there is an inevitable tension between tacit and explicit knowledge. For instance, the demands of Quality Assurance necessitate that knowledge and procedures are formulated and conveyed explicitly in the public domain. Yet much of the energy, immediacy, spontaneity and creativity central to artistic processes are rooted in a form of life in which knowledge and awareness are more implicit than explicit. Finding ways of managing the apparent paradox between Quality and quality, and between explicit and tacit knowledge, is critical to the future work of higher arts education institutions. Conversations involving artists and teachers are absolutely essential if the integrity of artistic engagement is not to be destroyed. A recent investigation into the skills and insights required of artists to work effectively in schools and communities provides an illuminating analysis of the kinds of implicit knowledge used by the animateur in practice (See Animarts, 2003, *The Art of the Animateur*, pp.38-44).

A telling example of the way in which the magic and mystery of creative experience can be damaged by crude measurement procedures was published recently in an article, *All around you is silence*, by Philip Pullman in The Guardian newspaper (5 June, 2003). Responding to a Government policy statement on the importance of creativity, imagination and innovative thinking in schools, Philip Pullman, one of Britain's leading writers for young people, urged us never to neglect those artistic experiences which are "private, secret, personal and which take time to reveal their effects. These forms of art are shadowed by mystery; their outcomes are unpredictable; they carry with them the continual possibility of failure".

Pullman went on to question how the Government could reconcile its renewed commitment to creativity with its perceived obsession with instrumental targets. He writes:

> How can you reconcile it with the task recently undertaken by 200,000
> 11-year-olds in their key stage 2 SATs (Standard Attainment Tests)? They
> were confronted with four crudely drawn pictures of a boy standing in a
> queue to buy a toy, and then had to write a story about them, taking
> exactly 45 minutes. It was a task of stupefying worthlessness and futility,
> something no one who was serious about the art of storytelling could
> regard with anything other than contempt. ... We need to ensure that chil-
> dren are not forced to waste their time on (such) barren rubbish.

Arts institutions and schools have to rise to this challenge and ensure that the

intrinsic value of creative experience is not trivialised by simplistic forms of assessment. In Britain the Government seems to be acknowledging that all is not well. At the conference alluded to by Philip Pullman, Tessa Jowell, Secretary of State for Culture, Media and Sport, emphasised that creativity is rather like a "benign untidy virus" that adds value and cannot be quantified. Perhaps this is an invitation to open up a conversation that retrieves the balance between the explicit and the implicit in artistic experience. Basically, creativity cannot exist without magic and mystery. These qualities are central to the inner life of being an artist and they must be allowed and encouraged to grow.

Leadership and connecting conversations

Throughout this chapter a strong case has been made for transforming arts organisations into dynamic cultural institutions with a contemporary voice. This has become a major challenge to leadership. In many instances only a fundamental change in the mindset of an institution can hope to bring about a radical reordering of priorities and a redefinition of effective practice in a 21st Century context. Such a shift in perspective and reappraisal of values will more readily be understood if all artists, teachers, students and managers feel part of a growing circle of conversation both within their institution and with their professional alliances in the wider world.

Central to this view is that leadership should be practiced at all levels within an organisation. At present, too many higher arts education institutions continue to hide behind hierarchical management structures that rest on outmoded assumptions and fail to respond to change and innovation. Often dominated by inflexible forms of line-management, in which departmental tribalism and parochial power politics prevail, little attempt is made to create a trusting environment in which shared leadership and authority are encouraged throughout an institution (see Leadbeater, 1999, pp.152-168).

Ironically, the very skills and qualities often associated with creative arts practice are denied the opportunity to flourish. For instance, such generic, transferable skills as leadership, project management, communication, creativity and the ability to work in collaborative teams can only be acquired in an environment committed to cross-tribal practices and connecting conversations. This is as relevant to staff as it is to students. In learning-based organisations like higher arts education institutions, leading might be compared with parenting. It is there to enrich, to nurture, to release human possibilities, to inspire people to believe that they matter and that they have something of value to say. This 'relational' form of leadership (see Clore Leadership Programme, 2002, p.3) should be given every opportunity to flourish, as it helps to provide a supporting climate for facilitating dialogue between senior management, teachers and students. Each person's voice has a right to be heard.

The case for a humanistic perspective on management was presented convincingly some years ago by Peter Senge (1990), in his widely acclaimed book, *The Fifth*

Discipline: the art and practice of the learning organisation. Subsequently he co-authored a field book outlining strategies and tools for building a learning organisation. In this, Senge (1994) and his colleagues emphasise that cultural change within an organisation will only occur when our deeply held beliefs and assumptions change through experience. As our individual and collective stories evolve, we begin to see and experience the world in different ways. We gradually grow in confidence as we find ourselves living in a professional community that respects "integrity, openness, commitment and collective intelligence – when contrasted to traditional organisational cultures based on fragmentation, compromise, defensiveness, and fear (p.21)".

Perhaps the ultimate challenge to leadership is how best to enable an institution to adapt effectively to change – how to confront change and uncertainty with a shared vision of the future. Basically, cultural change cannot be forced on people. Conditions have to be created which will enable new structures, new practices and new styles of management to evolve organically within newly aligned priorities.

At the heart of this process lies the critical role of 'conversation'. In higher arts education institutions, for example, a trusting environment has to be fostered that will positively enable an institutional conversation to take place. Focusing initially on certain key areas, like a Futures Strategy, a dialogue can be facilitated throughout the institution. In order to build up a measure of collective ownership, all staff, students, senior management and the governing body should be given every opportunity to engage in this conversation – sometimes at departmental level, but whenever possible, cross-departmentally. The whole process should also be informed by discussions with collaborative partners in the cultural industries, in the professional arts community, in education and in the wider community.

It is partly through this kind of sustained dialogue that cultural change evolves in an institution. Through respecting and listening to different points of view, people should gradually let go of cherished assumptions and begin to see themselves and their world in a different way. They might begin to tell a different story. For this process to work in practice, there has to be a sensitive awareness of the different levels of language used by groups when describing their experience and shaping their stories. Discussions also have to be grounded in where people perceive themselves coming from. The psychological climate in which these conversations take place is absolutely crucial to any likely shift in future action.

For example, most arts institutions are experiencing budgetary constraints, restructuring, reordering of priorities and changing patterns of work within an increasingly vulnerable industry. This very easily creates an atmosphere of stress and uncertainty, which means that any discussion of fundamental issues has to openly acknowledge feelings of fear, anger, apprehension and doubts. Staff and students must be given the opportunity to share their aspirations and any sense of

vulnerability arising from possible changes. This will not be achieved by limiting 'conversation' to formal committee meetings. Committees perform a very different function from those informal processes that provide opportunities for more inclusive dialogue in an institution.

The key to ensuring that honest conversation takes place throughout any institution lies in adopting a style of leadership which is genuinely open and facilitatory. As intimated at the beginning of this chapter, this involves a broad range of skills and attitudes, such as active listening, empathy, the ability to ask appropriate questions, the capacity to let go and most importantly, the ability to make connections. Such a collective approach inevitably invites an institution to reappraise its distribution of knowledge and power, shifting from mechanistic management structures to greater opportunities for shared leadership and shared responsibility. Effectively, it makes the processes and procedures in any institution more accountable and transparent, and it enables all staff and students to have a voice in shaping their own future. This can only be healthy for the life and work of an institution.

References

Alibhai-Brown J. (2000) *After Multiculturalism* London, The Foreign Policy Centre

Animarts (2003) *The Art of the Animateur* (www.animarts.org.uk)

Australia Council (2000) *Arts in a Multicultural Australia* Surry Hills, NSW

Clore Leadership Programme (2002) *Cultural Leadership: Task Force Final Report* (www.clore-duffield.org.uk)

ECCO (2003) *Academy of West African Culture*, The Gambia (www.ecco.gm)

Hawkes J. (2001) *The Fourth Pillar of Sustainability: Culture's essential role in public planning* Victria, Cultural Development Network, Australia)

Leadbeater C. (1999) *Living on Thin Air. The New Economy* London, Viking

LIFT (2003a) *The LIFT Enquiry, 2001-2006* (London International Festival of Theatre, 19-20 Great Sutton Street, London, EC1V 0DR)

LIFT (2003b) News, Autumn (www.liftfest.org)

Maalouf A. (2003) *In the Name of Identity. Violence and the Need to Belong* New York, Penguin Books

Matarasso F. (1997) *Use or Ornament? The Social Impact of Participation in the Arts* Stroud, Comedia

Pullman P. (2003) All around you is silence, in The Guardian, 5 June (London, *The Guardian)*

Putman R. (2000) *Bowling Alone: The Collapse and Revival of American Community* New York, Simon & Schuster

Queensland Government (2001) *Smart State – Creative Queensland.* An ideas paper for the development of a Queensland Government cultural policy Brisbane, Arts Queensland

Renshaw P. (2001) *An Enabling Framework for the Future of the Guildhall School of Music & Drama. A Continuing Journey* London, Guildhall School of Music & Drama

Renshaw P. (2002) Remaking the Conservatorium Agenda, in *Music Forum*, Vol.8, No.5 (Journal of the Music Council of Australia)

Rotterdam Academy of Music & Dance (2003) *Sound Links: cultural diversity, mobility and employability in music education* Rotterdam, Academy of Music & Dance

Sacks J. (2002) *The Dignity of Difference* London, Continuum

Senge P.M. (1990) *The Fifth Discipline: the art and practice of the learning organisation* New York, Currency/Doubleday

Senge P.M., Roberts C., Ross R., Smith B. & Kleiner A. (1994) *The Fifth Discipline Fieldbook: strategies and tools for building a learning organisation* London, Nicholas Brealey Publishing

Sennett R. (2000) Street and office: two sources of identity, in W. Hutton & A. Giddens (Eds) *On the Edge. Living with Global Capitalism* London, Jonathan Cape

Youth Music (2002) *Creating a Land with Music. The work, education and training of professional musicians in the 21st century* London, Youth Music: (www.youthmusic.org.uk)

10 Creative Practices and the 'Stigma of the Therapeutic': an issue for postgraduate pedagogy?

Iain Biggs and Amanda Wood

Introduction

In this chapter we begin by recapitulating an outline argument for a new pedagogic approach, published ten years ago, in order to contextualise a current example of innovative current postgraduate teaching in art, media and design[1]. We do so in the context of consideration of the 'stigma' of the 'therapeutic'[2] and, less directly, pedagogic understandings of the relationship between theory and practice. The chapter is divided into three parts. The first returns briefly to a paper given by Iain Biggs in 1993, arguing that issues involved in the teaching of fine art practice as 'a site for therapeutic action' were being neglected. The second uses ongoing pedagogic research at the University of the West of England (UWE), Bristol, to ask whether it is now necessary explicitly to identify and acknowledge a 'therapeutic' dimension in postgraduate teaching, given government policy on widening participation and life-long learning and, if so, how this should be understood in terms of a postgraduate pedagogy. The case study, concerned with students currently undertaking an MA Research by Project, is used to give concrete examples of the issues involved and their pedagogic implications. The third part identifies the benefits of an ongoing 'conversation' between students' aspirations and institutional pragmatics and suggests issues requiring further consideration.

Peripheral Vision?

Our reason for revisiting a paper published ten years ago is to identify a number of long-standing issues concerning postgraduate education. The original paper, entitled *Peripheral Vision*[3] challenged certain common assumptions about fine art education by questioning the ways in which its wider cultural context was understood. Among other things, it argued that fine art education needed to acknowledge its increasing focus on a particular understanding of 'professionalism' – seen as, in part, the result of the 'cultural Reaganomics' first promoted by the California Institute of the Arts[4] – and to recognise that over-investment in such professionalism trapped artists within an overarching and increasingly systematic discourse of

control. This situation was characterised as linked both to a professional narcissism at odds with good educational practice and to an insistence on the promotion of high theory at the expense of addressing the 'messier' ambiguities, paradoxes and particularities of the lived experience of an increasingly diverse range of students. The drive to what is, educationally speaking, a negative professionalism was characterised as the neglect of art as a site for therapeutic action.

The 'therapeutic' stance was understood as concerned to develop and sustain the interface between the student's practice and sense of self, while encouraging reconfiguration and change via forms of study that include play, insecurity, and respect for and openness to what is other. It was presented as an educational, social and ultimately political orientation focused by 'care' and was specifically linked, via Kenneth Frampton's understanding of Critical Regionalism, to both ecological perspectives and feminist pedagogies [5]. In short, the 'therapeutic' was understood as a corrective counter balancing the over-emphasis on 'professional' attitudes, knowledge and skills at the expense of encouraging the transformation of what is learned via a process of feeling and evaluation, into an informed and particular relationship between the learner, their developing personal values and a developing practice.

A need to re-establish a balance was presented in the context of the gradual reorientation of British universities through government intervention, a process aimed at promoting the totalising politics, culture and economic perspective opposed by Critical Regionalism. Those mechanisms have focused on consolidating universities' potential as sites for the production of new instrumental knowledge rather than as places of education, a process that could be said to have effectively reconfigured Higher Education as a service industry in line with the needs of the global free market economy. This process of reconfiguration, driven by state intervention in the form of audits and the control of research through financial incentives, has now been realised to a degree almost inconceivable ten years ago.

The paper also argued that art education needed to enter 'wider debates about the epistemological and pedagogic basis of the academy as a whole', to adopt 'therapeutic' rather than 'combative' educational strategies and to recognise and support the move towards a plurality of levels of practice contributing to a 'democracy of experience'. The experience of the last ten years means that these concerns have often been overtaken by more pragmatic demands. These include the need to deliver programmes of art and design education to an ever-growing number of students via a body of staff who must demonstrate to external audit: excellence in teaching; sophisticated administrative skills; maintenance of appropriate levels of professional practice and scholarship; and, increasingly, at least national prominence in academic research. Moreover, the insistence that universities involve themselves in widening participation and life-long learning now requires a genuine democratisation of education experience at postgraduate level that renders the perpetuation of pedagogies rooted in an autocratic 'professionalism' increasingly untenable.

In retrospect it is easy to see *Peripheral Vision* as over idealistic in seeking to persuade artist / educationalists to work against the grain of an increasingly dominant 'post-modern' culture that, for all its pandering to a media-oriented consumer democracy, is in fact profoundly repressive in its absolute subservience to the celebrity culture perpetuated by international capital. Arguably it may now be primarily in the delivery of our courses and the teaching strategies developed to support them that the possibility of any genuine cultural radicalism remains. We contend here that any such pedagogic radicalism is inseparable from what is referred to here as the 'therapeutic'.

Professor Sir Christopher Frayling recently quoted E.M. Forster in his address to graduating students from UWE: "How can I tell what I think till I see what I say". He went on to develop this idea, reaching a modified proposition in relation to the creative artist - more a case of: "How can I tell what I think till I see what I make and do". After further consideration of the type of education appropriate to the twenty-first century, this proposition was further modified as follows: "How can I tell what I am till I see what I make and do".

These three distinctive and explicit stages of 'revelation' can serve as a metaphor to describe the pedagogical model, the site for 'therapeutic' action, described in the case study that follows.

Case Study - Introduction

Research by creative practitioners through their own arts practice, then, is where the process of making, producing or creating cultural presentations, and the exploration and transformation which occurs in the process, is taken as an act of research itself, where knowledge is gained in the creative act, and can be directly attributable to the creative process.

The junction of the new and old is not a mere composition of forces, but is a recreation in which the present impulsion gets form and solidity while the old, the 'stored' material is literally revived, given new life and soul through having to meet a new situation.

(Dewey, *Art as Experience*, 1980)

The case study referred to below is based on the development of a specific programme for student-centred learning at postgraduate level developed at the Faculty of Art, Media and Design at UWE, Bristol in 2001. The programme entitled MA Research by Project is distinct from other postgraduate programmes in the graduate portfolio in that it advocates a demarcated period of structured critical self-reflection as the basis on which students are taught to research, develop and contextualise their own practice.

As noted above, since the first wholly inclusive Research Assessment Exercise in 1990, the pressure on institutions to develop nationally and internationally recognised research profiles and outputs has been immense. In the hurry to add

breadth and depth to research profiles tentatively constructed prior to 1990, many institutions see expansion of their postgraduate portfolios as adding weight to claims to academic excellence. Institutions are also aware that economic survival, in the form of a large overseas market for graduate study, may prove as critical an element in economic success as the RAE, thus driving forward the postgraduate agenda.

An analysis of UK Postgraduate Programme titles indicates that, in the initial flurry of activity to expand postgraduate provision post 1990, institutions depended largely on the enthusiasm and expertise of individuals whose specialist skills and interests/research could be translated into coherent programmes of study. This necessarily produced a range of often highly specialist awards that depended heavily on the sometimes idiosyncratic interests, practice and/or research of the 'person whose specific interests formed the basis for the programme' who then automatically became award leader. Such programmes, in seeking to ensure that the abstract notion of 'postgraduateness' was secure and distinct from 'undergraduateness', imported research methods (usually from the 'humanities') as the means by which students reviewed their practice. This situation was the perhaps inevitable outcome of the over-emphasis on a particular notion of 'professionalism' in the arts and humanities at the expense of clear pedagogic models supporting, for example, student-centred learning. Within the limited timescale allocated to the majority of current postgraduate programmes, it has become increasingly obvious to us that both the research methods offered to some graduate Art and Design students and the somewhat autocratic or auteurist approaches adopted in the design and delivery of some programmes have long been inappropriate to the needs, ambitions and abilities of the increasingly broad range of potential graduate students.

Graduate Study at the Faculty of Art, Media and Design (AMD) UWE
The development of the pedagogical approaches adopted for the MA Research by Project was based on a number of factors following the wholesale review of postgraduate provision in the Faculty between 2000-2002. The review led to the development of several new taught postgraduate awards and an overhaul of the overarching structure of the modular scheme still in the process of implementation. The review was based on the collective experience of colleagues working across a number of postgraduate awards in different institutions together with a modest survey undertaken over a period of six years exploring the reasons why students entered postgraduate programmes and their expectations of the experience. Together with other external factors, the development of the postgraduate scheme in its current convocation was based on consideration of the following three key issues:

i) the diverse needs and expectations of students entering postgraduate programmes in Art, Media and Design at UWE;

The survey demonstrated that the majority of students entering 'taught' post-graduate awards do so in order to enhance their career potential. This includes increasing numbers of students opting to take postgraduate awards which have little or no direct relationship to their undergraduate experience. The notion of 'reskilling' and consolidating existing skill bases is therefore of very real concern for many students, not least those entering from the international market. Many of these students select courses which appear to have a vocational orientation and come with an expectation that the programme will meet their vocational needs. Eurocentric research methodologies and their attendant critical theories are, perhaps unsurprisingly, particularly problematic for a group whose particular needs have had significant impact on our consideration of curriculum design, content and delivery in 'taught' programmes.

The Faculty at UWE, like similar Colleges of Art and Design elsewhere, also attracts large numbers of regional postgraduate students, often mature returnees who wish to develop/re-activate their creative practice. This group includes both staff working in other regional Further/Higher Education institutions seeking to develop skills to enhance their career prospects within their own institutions and regional practitioners who, having successfully maintained a practice of some kind since graduation, have reached a point where they have both the opportunity and the need to re-evaluate that practice. It is primarily this group of learners who are attracted to MA Research by Project and for whom the pedagogical model described in this case study is evolving.

The clear differentiation between the needs of different groups of AMD post-graduate students at UWE has lead to the development of a series of complementary 'taught' postgraduate awards where students from a diverse range of academic backgrounds develop their potential through the experience of a pre-determined skill base not necessarily experienced before. (There must, however, be evidence that the previous experience of the student can contribute to their potential to work at 'M' level in the discipline). This approach is evident in programmes such as Animation, Interactive Media and Screenwriting. *It is important to note that all the 'taught' awards demand a high level of self-directed study but most begin by mapping a conceptual and practical domain through which the student then develops a body of work.* This 'taught' postgraduate framework is complemented by MA Research by Project, where the student and their particular practice and individual concerns are taken as the starting point for a programme of study rather than a pre-determined curriculum.

ii) the skills and abilities of students entering postgraduate awards – the implications for widening participation and lifelong learning in the structuring and organisation of postgraduate programmes;

All too often the epistemological assurance required by institutions in terms of academic standards takes little or no account of the existing skills and abilities

of the students. It seems that the words used to describe the nature of a graduate student in course documents, especially around expected levels of achievement and profile, bear little relationship to the experience of the staff and students working in programme. An MA student is not necessarily *better* than a BA student and, in an increasingly competitive, expansive and expensive market, many of those whom we may wish to become postgraduate students simply cannot afford the luxury. So we have to work with those who can, many of them excellent students and some of whom, in the spirit of widening participation and lifelong learning, have a right to join the programme if they meet its minimum requirements. Consequently the wholesale review of undergraduate learning and teaching made during the last decade to accommodate new learners needs to be applied, in some measure, to postgraduate level study. It seems ironic that the student-centred approach to learning that now dominates undergraduate pedagogy is less well developed at postgraduate level, where a programme of postgraduate study may be heavily dependent on the skills, interests and ideas of a very small course team. It is often still the case that postgraduate pedagogy favours the 'auteurist' approach to teaching with the tutor as professional guru and the student as follower. Such approaches, whilst undoubtedly expedient in the development of courses in the past, now seem hopelessly out-of-date in a socio-political environment that seeks to promote participation and lifelong learning.

Although our postgraduate scheme contains at least two explicitly different postgraduate models – 'taught' and 'research' – all programmes are engaged in reviewing teaching and learning so as to give greater credence to the skills and abilities that students bring to the programme. In MA Research by Project, the model presents specific pedagogical challenges. Most of the students, whilst having a well-developed practice, have been out of education for some time, and in some cases for a great many years. Many have not written in a structured way since writing their undergraduate dissertation and are daunted by the demands of recording and presenting their findings on a regular basis, in an environment where they fear that their practice will become subject to forms of critical theorising 'from without'. Whilst all are used to the concept of an 'award' and the process of assessment and evaluation that goes with it, many are ill-prepared for the reality of engaging in such a public and at times seemingly mechanistic, even artificial process. Tutors are often faced not only with the well-established patterns of thinking of the students but with the vicarious experiences of their significant others who, unseen, can be heard loud and clear in the views, attitudes and behaviour of the students.

iii) the role of 'research' in the postgraduate curriculum
Whilst the academic community appears comfortable with the notion that doctoral research will contribute to the creation of 'new knowledge', no such clear distinctions have yet been articulated in relation to masters level study in Art and Design. Since 'postgraduateness' remains an abstract and fugitive

concept and as the range of students entering the sector continues to diversify it is becoming increasingly apparent that the term will have to embrace a number of different and equally robust models in which the meaning of 'research' may vary.

MA Research by Project – the admission process

As mentioned earlier, the majority of students in MA Research by Project are mature regional returnees. The majority are practitioners who, in putting themselves forward to enter the programme, also admit to an inability to move their practice forward as they would wish, feeling unable to develop strategies for doing so in isolation. The programme is structured so as to assist students to adopt a different attitude to thinking about and explaining their work, a prerequisite for the actual development of their practice. *They are accepted onto the programme on the basis of academic assessment of their willingness to engage in this educational process, not according to 'professional' value judgments about their existing practice.* It is important at this stage to realise that, while some students are fine art practitioners, the majority come from across the whole spectrum of design, fine and applied arts practices, including fashion/textile design, enamelling and ceramics, interactive media, sound design, etc.

The Curriculum

MA Research by project is developed around an experience of four credit-rated modules. Students may enrol full-time or part-time, with the majority being part-time and expecting to take three years to complete the programme. The four modules – units of learning – are as follows:

- Research Methods – Practice as Research 1 (30 credits)
- Research through Practice 1 (30 credits)
- Research through Practice 2 (60 credits)
- Practice as Research 2 (60 credits)

In order to promote dialogue both within the student group and with selected research topics, the programme of study presents a series of assignments that all students must undertake and then present to each other. This process both promotes the importance of working within an interdisciplinary peer group of students being subjected to the same experience and demands that students examine their own motives in order to define their practice, in relation both to a peer group of graduate practitioners and a range of practices from across the broad range of art, media and design disciplines. In the first instance these students are being asked to consider what knowledge they already have and how that relates to the work of other practitioners who may have or have had similar concerns, experiences and interests whether conceptual or material, rather than to contribute to the creation of new knowledge.

The students are then asked to make explicit that which to them is wholly personal and implicit and then to consider, through seminar discussion, how the recognition of a 'contextual framework' may have implications for the develop-

ment of their practice. The process of making explicit what they consider to be implicit reveals the work to the practitioner in new ways and so opens up alternative strategies for interpretation and progression. It is in this sense and at this point that one may further wish to consider the "stigma of the 'therapeutic' as being an issue for post-graduate pedagogy."

'How do I know what I think till I see what I say'
- Practice as Research 1 – Research Methods
- Research as Practice 1

The first module, supported by a series of workshops and presentations, requires that students address the following five issues, described in the curriculum as a series of tasks and designed to facilitate the development of a personally orientated contextual framework.

i) To explicitly consider and present artworks, artifacts, texts and events which they consider to be of particular importance to them.

ii) To consider the development of a critical/analytical vocabulary that will help to describe the selected works, including their own. In this sense the linguistic ability of the student to describe an experience is viewed as having the potential to develop, enhance and change their perceptions of what/how they approach their practice. This section asks: how close is the mastery of language related to mastery of experience?

iii) To develop a set of statements to describe their practice and then to translate those into a set of criteria. To then apply those criteria to a search for other practitioners from the full spectrum of creative practice-based disciplines whose ideas, motives, outcomes etc might be similar to their own. The students are asked to create a long list of 20 practitioners who meet with at least three of their criteria. To support this process, students are asked to curate a virtual exhibition, event from the work of the selected long list. The exhibition/event has to have a title and students are required to make a critique as if writing for a newspaper or magazine.

iv) Students are then required to make a shortlist of those five practitioners with whom they most clearly identify, not in terms of the appearance of the work but in relation to the creative motives, themes, interests and ideas explored in the work.

v) Students are then required to make a presentation of their own practice in relation to the ideas, artworks / artefacts / texts, practitioners researched in the preceding tasks.

Research here initially means a systematic review of and enquiry into the nature

of the student's own practice. The model assumes that the student has become 'stuck' (as indicated above), and will benefit from a period of structured/guided critical reflection and contextualisation rather than practice alone. The supposition is that to progress practice at this level requires altering the pattern of reflecting on that practice to allow different influences, exchanges and experiences to bear on the work. The process of making 'visible what is invisible' (in this case the artist/researcher's motives, interests, relationship to peer group etc.) presents the work in a new light which then allows the student to consider their work from a different viewpoint, not least because they have developed a different self-understanding.

This process has certain implications for the tutors in their interaction with the students. In this programme, it is the creative intention of the student that is the starting point and not the object, artwork, artefact or text. In this sense the students are being asked to consider both themselves and their work as the subject for research. In order to achieve this, it could be argued that one is automatically acknowledging a broadly 'therapeutic' dimension to postgraduate teaching in creative practice, where the exploration of context, artwork and motive is closely linked to the psyche of individual students rather than to the 'professional' development of the work alone.

Having embarked on a process of 'critical self-reflection' in which a contextual framework is developed through a series of set assignments and workshops described above, students are then invited to use that framework as a means of influencing the development of their practice in the second module – Research through Practice 1.

"How can I tell what I think till I see what I make and do?"
• Research through Practice 2

"Expression is the clarification of turbid emotion; our appetites know themselves when they are reflected in the mirror of art, and as they know themselves are transfigured. Emotion that is distinctively aesthetic then occurs."

(Dewey, *Art as Experience*, 1980: 77)

Having undertaken the first two modules, students continue the process of practical research through explicit development of their practice in relation to the contextual framework developed. The continued exploration of the practice together with the further development of the framework is recorded throughout the programme in the student's contextual journal. In module 3 – Research through Practice 2 – the students are explicitly researching their practice through engagement with that practice based on a new set of perspectives and ideas developed earlier. The tutors/facilitators are, in this context, both the students and the tutors. The onus lies very much with the tutors to create a non-confrontational environment in which students can gain sufficient confidence to discuss their

work and ideas. As the group progresses through the programme, students become heavily involved as facilitators to each other within a peer group dynamic – a powerful tool for learning and teaching with its own momentum. It is hard to identify the particular qualities or strategies developed to achieve this but the tutor/facilitator is certainly not acting as an 'auteur'/guru. "Understand what you can do" rather than "Understand what I can do" is the message sent to the student group. The programme is designed explicitly to aid students in making more of what they already have and then to develop that through the use of self-determined set of criteria and reference points. The approach demands that the focus is shifted from the student's practice in order to allow for development that will inevitably involve some failure, away from the pressure of over-interrogation and assessment.

The process of facilitating students' understanding of what they already know is a tantalisingly difficult exercise. Creating experiences that ensure students approach their practice from perspectives not previously considered depends heavily on the success of the structured learning environment. This environment is built around the tasks and the weekly seminars, discussions and presentations that support those tasks.

"How can I tell what I am till I see what I make and do"
• Practice as Research 2

"Considered introspection, in the form of practice-based research, into creative arts practice offers the opportunity to try to understand the way an artist engages in an original way with their physical, cultural and psychic raw materials"

Representing creativeness: practice-based approaches to research in creative arts
Peter Dallow – Art, Design and Communication in Higher Education, Vol. 2, isue. 1

At the point of final evaluation, the contextual framework and the practice developed dialogue with those reference points once again becomes the subject of the research. This moment of objectivity is likely to be transient since creative practice implies a lifelong struggle for 'further development' and 'progress' in the eyes of the practitioner. However, as a conclusion to this particular period of creative development, the summation of what has been achieved involves a second period of objective appraisal, the first having taken place during the first module (module 4 – Practice as Research 2).

It is through this process of finding the means to describe what one is thinking through an initial evaluation of practice (making 'explicit' what is 'implicit') and later through the application of that experience to a period of intensive 'making and doing' (studio/workshop practice) that one finally comes to know more clearly what their creative motivation is, who their peer group is and in what context the work may be further developed. This is later developed through further reflection on that practice once it has been subjected to the experience of the dialogue

with the contextual framework identified by, and then modified by, the student as they progress through the programme. It is these three distinctive stages of 'revelation' that form the site for 'therapeutic' action and 'revelation'.

Conclusion

In considering this particular model of postgraduate study as a site for 'therapeutic' action, a number of issues raised earlier deserve further reflection, not least the changing orientation of academic pedagogy and of the external agencies with which it must now interact.

In an educational system driven by audit and accountability, there are clear implications for the delivery of 'auditable' performance indicators and plenty of evidence to suggest that the impact of pedagogical strategies likely to enhance such performance are increasingly influential in the design and delivery of art, media and design curricula. Ironically, the 'student-centred' model of learning, long favoured by many institutions and arguably most in tune with the philosophical principles of lifelong learning, will probably ultimately be found to be at odds with current 'market-oriented' audit practices. As institutions become increasingly dependent on their ability to perform well against a very prescriptive set of indicators, both educators and students may decide that they can no longer afford the idiosyncrasies synonymous with the development of creative practice in Art and Design higher education. The indicators of success once taken as given by students and academics working within the disciplines may increasingly simply not fit the audit framework.

The second 'environmental' issue impacting on current pedagogic models is the pressure on the undergraduate (and increasingly on the 'taught' postgraduate) curriculum to focus on 'professionalism'. Add to this the impact of the almost obligatory part-time employment students require to minimize their debts and it is not hard to see that very little time is left for the development of meaningful creative practice. Today, most students are what would once have been called 'part-time' and increasing numbers are becoming, out of shear necessity, 'strategic learners'. Already aware of the implications of their situations, students themselves are limiting the potential learning experience offered to ensure that they 'pass' their degrees as effectively and efficiently as possible. There is evidence to suggest that in this learning environment, 'creative failure' and 'play', two of the pedagogical foundation stones in which creative practice has long invested, are considered too risky a strategy by many undergraduate students. When looked at from a long-term perspective this has some very real implications for 'lifelong' learning and 'widening participation' at postgraduate level.

Given pressures on their time, energy and finances, more and more students view being at University/Art School as a means to a short-term end. The broad educational experience that many of us had is now a luxury few students feel they can afford. However, the basic human desire to be creative and, with it, the need to keep developing a creative practice persists. Whilst many undergraduates are now

seeking to pass their degrees as 'strategically' as possible, this may yet come back to haunt them because they simply do not have the time to gain the level of knowledge and understanding needed to sustain and develop a substantial practice. Consequently we should expect a significant percentage of postgraduate students to return at a later stage to seek out some of the more personally sustaining learning experiences they were financially or psychology unable to take on when younger. We may therefore expect to find ourselves working in an environment where more and more postgraduate students have established themselves professionally, reached a level of independent financial security and are, therefore, able to consider taking on postgraduate study.

Certainly in the South West it would appear that increasing numbers of postgraduate students fit this profile. It is therefore inappropriate to consider that they are looking for programmes that simply privilege additional 'professionalisation' of practice over an educational experience rooted in personal development. Whilst we are used to designing postgraduate programmes for students who require further specialist skill development to compensate for a perceived shortfall in their undergraduate experience, we are less familiar with pedagogical models for graduates that particularly focus on personal creative development.

Already an increasing number of individuals are entering postgraduate education to develop practice with a personal agenda that does not necessarily reflect that of the QAA and other such regulatory bodies. As suggested earlier the language of student success and achievement in audit terms cannot include consideration of those personal agendas and concerns that bring certain postgraduate students back into higher education. It is also true that, given the preoccupation of the sector with the demands of international postgraduate students, this seemingly self sufficient group of mature returnees may not be receiving the consideration they deserve.

As increasing number of art and design students, working at both undergraduate and postgraduate levels, make choices driven by economic assumptions, one may assume an increasing number will return later, especially those who did not engage with the level of critical reflection and self-knowledge needed to sustain their creative practice. Certainly, the group described in the case study includes an increasing number of students who are seeking an experience of art and design in which the a paradigm that balances self-knowledge, critical reflection and creative action is of primary importance; a construct which has little space for considerations of 'professionalism' other than as equating with 'good' work and personal conduct in relation to the group. As mentioned earlier many of these students enter the programme with the primary intention of gaining greater knowledge and understanding of their potential as practitioners. If one acknowledges an autobiographic dimension to creative practice, then any attempt to develop work at a significantly later stage in one's career (later than average undergraduate aged between 21-25) must involve some consideration of motive,

sensibility and longer term 'life' plan – arguably a therapeutic dimension.

In this context it is interesting to note that at INSEAD, an international business school based in France, De Vries has developed a set of criteria for the selection of individuals for participation in a leadership development programme. The set of descriptors he has devised and identified are also those associated with 'the capacity for self-discovery and change.' When considering the criteria used to select students for entry to MA Research by Project, these characteristics, together with a willingness and desire to change and develop their creative practice, can equally be applied. They are:

- *Level of motivation. Are potential participants prepared to take a hard look at themselves? Are they willing to do serious work, or are they looking for a quick fix – a magic pill that will take care of all their problems?*

- *Capacity to be open and responsive. Are potential participants not only willing but also able to open up to others? Can they establish relationships without years of groundwork?*

- *Interpersonal connectedness. Are potential participants willing and able to engage in meaningful emotional interaction?*

- *Emotional management skills. Can potential participants tolerate the anxiety that comes with putting themselves in a vulnerable position?*

- *Degree of psychological mindedness. Are potential participants curious about their inner life? Would they like to learn more about themselves? Would they like to understand better why they behave the way they do?*

- *Capacity for introspection. Do potential participants have the ability to reflect on experience and learn from links to the past?*

- *Responses to observations of others. Are potential participants receptive to interpretation of their actions and attitudes of others, or do they become defensive? Do they generally understand what other people are trying to tell them?*

- *Flexibility. Do potential participants react constructively and appropriately to interventions? Or do they seek refuge in indirect defensive behaviour* [6].

The level of experience and self-knowledge being brought to the institution demand the development of new pedagogical approaches. The pedagogical model offered in MA Research by project combines student-centred learning with a period of directed 'critical reflection'. In this sense one could argue that there is nothing unfamiliar in the approaches being offered but that it is the way in which

the framework is structured that is of particular pertinence to the students for whom it has been developed. The 'therapeutic' dimension to this work demands that the course is explained and presented as an experience to which the students, through a process of negotiation, are prepared to submit themselves. It is not designed as a model that students can 'dip in and out of' and nor is it a model that students could work on without the support of a peer group and skilful facilitators/tutors.

The new pedagogies and practices that are likely to make demands of us in the future will force us to consider how concepts related to the development of critical, meaningful creative practice can be presented to mature students with well-established and well-understood approaches to their work. The MA Research by project is a pilot programme working on the development of such approaches. It is very likely that the programme will be subject to significant revision especially over the next two years. However, it has found and does acknowledge the need for new pedagogical approaches at the heart of which is the assumption that there is much that can be learnt with and from other people that cannot be learnt by oneself [7] and that the further development of established creative practice requires reinterpretation of past experience together with the capacity to identify fresh lines of enquiry.

Notes

1 Although we deal with postgraduate education here, it is important to note that three years ago we developed, in response to feedback from regional colleges and our own foundation course, an undergraduate BA (Hons) Drawing and Applied Arts programme. The regional Further Education sector claimed that, at this stage – 2000/01 – many of their students found, when looking for a course that explicitly privileged the development of a creative practice through material exploration, that there was literally nowhere for them to go. The inference at the time, and subsequently born out in a number of regional meetings and seminars, was that students not seeking highly vocational courses in which the form of work undertaken would, to some extent be driven by the market/industry, were not well catered for. This included consideration of our own fine art, seen as highly conceptual and working to a particular model determined by the demands of contemporary professional practice.

2 This stigmatisation of the therapeutic can be traced back to Clement Greenberg's 1965 article, 'Modernist Painting', where therapy is presented as the ultimate 'levelling down' of high art.

3 In Nicholas de Ville and Stephan Foster (eds) *The Artist and the Academy: Issues in Fine Art Education and the wider Cultural Context Southampton*, John Hansard Gallery 1994.

4 See Robert C Morgan *The End of the Art World* New York, Allworth Press 1998 pp203-205

5 See. Alexander Tzonis & Liane Lafaivre's 'Why Critical Realism Today' in Nicholas de Ville and Stephan Foster (eds) *The Artist and the Academy: Issues in Fine Art Education and the wider*

Cultural Context op. cit. Also Iain Biggs 'Educating "Local Cosmopolitans": the case for a critical regionalism in art education?' in Journal of Visual Art Practice 2001, vol. 1 no. 1

6 De Vries MFR. 'Can CEOs Change – Yes, But Only If They Want To'. INSEAD Working Paper 2002/36/ENT. 60pp

7 In this respect the perspective adopted here can be seen to be congruent with the ethical orientation set out by Paul Ricoeur in his *Oneself as Another* London and Chicago: University of Chicago Press 1992.

References

Biggs I. (2001) 'Educating "Local Cosmopolitans": the case for a critical regionalism in art education?' in *The Journal of Visual Art Practice*, vol. 1 no.

Dewey J. (1980) *Art as Experience* New York, Berkley

de Ville N. and Foster S. (eds) (1994) *The Artist and the Academy: Issues in Fine Art Education and the wider Cultural Context*, Southampton, John Hansard Gallery

De Vries MFR. 'Can CEOs Change – Yes, But Only If They Want To'. INSEAD Working Paper 2002/36/ENT

Morgan R. C. (1998) *The End of the Art World,* New York, Allworth Press

Ricoeur P. (1992) *Oneself as Another,* London and Chicago: University of Chicago Press

11 Outside 'The True'?: research and complexity in contemporary arts practice

Peter Dallow

It is the business of the future to be dangerous.
A. N. Whitehead

The Virtually New

Uniqueness and cultural authenticity in art withered in the Modern Era, according to Walter Benjamin, and subsequently the cultural conditions of *post*modernity in turn were supposed to have made the possibility of doing anything new in art *im*possible. None the less, it remains true that the contemporary creative arts still continue to coalesce around the formative notions of 'novelty', 'newness', and 'difference', even if the notion of *originality* appears to have become redundant as a defining element. Indeed, as will be asserted later, novelty itself serves as a broader cultural metaphor for contemporary existence. But how, though, might we go about investigating the way something new is done (creativeness), in the creative arts?

Art, in all its various manifestations, is an 'appearance incapable of appearing', as Lefebvre terms it (1991: 395). It appears to offer a doorway beyond mere perception. It certainly represents a plane of activity that cannot be strictly empirically understood, assessed or validated by traditional research methods. That is, its products, material and seemingly immaterial, cannot be reproduced or tested under controlled conditions. That work would itself stand to be considered art, in postmodern terms. Instead, like other social and cultural phenomena, art, taken quite broadly, might be best approached as a *formation*, which is to say, it is discursively constructed. All knowledge is now thought of as culturally constructed, and in particular to be socially situated. That is, a specific set of knowledges, such as are embodied or perhaps more pertinently dis-embodied in an art project, are understood to operate within specific social, cultural and historical circumstances. Notwithstanding research emphases upon its affective properties, and its

consumption, art is perhaps still best viewed as an active cultural *process* for intellectually and technically organising and deploying certain knowledge and skill into new conceptual and affective *forms* – the sensuous presentation of truth, as Nancy terms it (1997: 134).

The practices of some disciplines which sit under the broad category of 'the creative arts' (not a universally liked term by any means), such as much of design and media practice for instance, clearly (and uncomfortably) straddle the functional/symbolic divide. Architecture, for example, in a certain way is emblematic of this, being perennially caught between satisfying the functional and symbolic needs of the end user on the one hand, and also driven by the imperative of difference, of newness within architectural *form*, in fulfilling those needs. This appears true both in the broader cultural (aesthetic) sense, of its continuing development as a discipline/profession, and in terms of the individually expressive (creative) sense, for the individual practitioner, or indeed collaborators. No form of practice can be seen to be exempt from the tendencies represented by this duality. The fine and performing arts cannot be thought of as being devoid of any social or economic purpose. Of course grappling with these formal/functional, form and content distinctions were broadly emblematic of much of the work of Modernism, again especially in the most 'user focussed' forms of practice. In turn they were to come to be thought of as redundant with the advent of Postmodernism.

One way of investigating the possibility of still doing something new in the creative arts is to approach it by trying to locate something of the complexity of its *practice*, and practices. The examination by the contemporary arts practitioner/researcher of their 'being-as-performance', as Mikhail Bakhtin termed it, in their creative working, may help us understand something of what is involved in making the leap from established practice/s, to doing something new. Henri Lefebvre suggests that the creative practitioner 'is fated to live out the conflicts that arise as he/she desperately seeks to close the ever-widening gulf between knowledge and creativity' (1991: p.396). We might think of this as the increasingly wide gap which must be traversed by the individual practitioner between the space of the known, and that of the unknown. This 'gulf', Lefebvre argues, arises because art is based upon a paradox:

> Art in general and the artistic sensibility bank on maximum difference, at first merely virtual, sensed, anticipated, and then, finally produced. Art puts its faith in difference: this is what is known as 'inspiration', or as a 'project'; this is the motive of a new work – the thing that makes it *new*; only subsequently does the poet, musician or painter seek out means, procedures, techniques – in short, the wherewithal to realise the project by dint of repetition (1991: 395).

The task of investigating the flows backwards and forwards between reflection and activity, involves tracking the 'lines of flight', as Deleuze and Guattari term it,

as has been asserted elsewhere (Dallow 2003), tracking the movements from the repetition of the known/familiar, to the unknown/difference. This is a useful position to begin a consideration of how we might investigate the elusive conditions under which something new is produced (creativeness), however illusory the 'newness' of the outcomes may prove to be.

Building models of intelligibility in the creative arts, like that within the sanctioned scientific research methodologies, calls for 'identifying something invariant in the midst of difference' (Hausman 1984: 147). As Spinoza suggested, *method* is understanding what a 'true' idea is by distinguishing it from 'the rest' of perception (1992: 241). However, in approaching art there is an inherent contradiction, or at least contradistinction, in the perception of originality at work. Newness is predicated upon difference. But, tactically, contemporary work can only be achieved through repetition – 'a repetitiveness which foregrounds not sameness but difference', as ironically Broadhurst (1999: 1) termed it. In this sense, the seeming 'newness' of art is achieved by way of *form*, or a formal structure, however open or outside of established material forms it may initially appear. As Lefebvre suggests, novelty is 'a mere impression or conceit'. That is, in a sense, the novelty 'effect' issues from mistaking the seeming infinity or polysemy of the *conceptual* aspect of the project for the infinity of *meaning*. The very formal attributes of postmodern approaches to artistic practice bear this out, as Solomon-Godeau has indicated, in that the very devices employed by artists working in the postmodern era have been those of 'seriality and repetition, appropriation, intertextuality, simulation or pastiche' (1991: 115), much as they are in the so-called 'mass' media, and so often emulated. Artists were the first to acknowledge and act upon this cultural 'implosion', between the 'high' and the 'low', the 'fine' and the 'popular', the sublime and the everyday. Unfortunately, with this came the impression that it heralded the end of the possibility of anything new being done. That 'it had all been done before', already.

The Image of Thought

One way of approaching an investigation of the conditions under which something new might still be done, and indeed of considering whether creativeness might still be possible at all, is to view contemporary artistic practice as *performative*. Certainly, in a broader philosophical sense, the act or performance of *being* cannot be seen as separable from its product or effect. Mikhail Bakhtin described this as 'action-performing thinking', where *being* is seen *as* a performance, or what he called 'Being-as-event'. The entire aesthetic world as a whole, he says, is 'but a moment of Being-as-event', brought about 'through an answerable consciousness – through an answerable deed by a participant (1993: 18). Thus 'Aesthetic reason', Bakhtin proposes, is similarly a moment in '*practical* reason'.

In a seemingly contradictory sense then, the temporality of the artist's practice can be seen to represent the space of creativeness. The unfolding of art practice can be seen as a zone where 'aesthetic reason' is *applied* in some practical way.

This suggests that the (practical) enactment of creative activity is a potentially rich field for investigating the revealing of aesthetic reason at work. Of course, part of the force of the practical application of aesthetic reason, as we have known since Aristotle, is that art throws up, so to speak, *illusions* 'that represent the "absent" as being "totally present"' (Broadhurst 1999: 2). The very concept of creativity, Boden asserts, is intrinsically evaluative. 'In general, randomness (and serendipity) can contribute to creativity, but only if it can be intelligibly related to the relevant cognitive background' (1997: 2).

A consideration of the unique circumstances under which 'the revealing' of art takes place, then, may be tackled through the investigation of the 'act of discovery' of creative practice. A *practice-based approach* to arts research, the attempt to represent something of the creative method involved in creating or developing a specific piece or body of creative work offers a research method for investigating the specific creative method at work. That is, it employs, as Macleod terms it, 'practice as a research tool'(2001: 9), to reveal something of the 'sytematised thinking' or logic of art practice to bear upon researching art practice itself. This involves a kind of conceptual doubling, or reflexivity, where one kind of research activity examines what is involved in another kind of research (creative) act. As Spinoza proposed 'method is nothing but reflexive knowledge, or an idea of an idea' (1992: 241-2). The 'subjectively objective' act of discovery, as Slavoj Zizek terms it, in practice-based arts research attempts to represent the act of discovery in creative arts practice.

So, practice oriented approaches to research in/to the creative arts, especially where they might be applied in a problem setting or problem solving context (professional practice), are potentially well suited to the investigation of creativeness because they examine how the aesthetic knowledge behind practical knowledge is deployed in arts practice. Practical knowledge, in turn, like most cultural knowledge, as Hodder (2002: 272) asserts, 'is nonlinear and purpose dedicated, formed through the practice of closely related activities'. By considering the activity of creative practice from the 'inside', as an arts practitioner-researcher, it is possible to gain insight into how broader cultural systems and precedents are evoked or invoked *through* practice. [Some of the research issues and problematics raised by this 'subjectively objective' way of operating are set out in Dallow 2003.]

Research (discovery) is about learning something we did not know. But art also is about learning something we did not know, or at least did not *know* we *knew*. It causes us to be shocked by the familiar. In this way, the everyday can become uncanny (*unheimlich*, to use Freud's term), and hence monstrous. As Hegel asserted: 'What is "familiarly known" is not properly known, just for the reason that it is "familiar" '(1967: 92). Art practice frequently uncovers and confronts us with the known that was *not* really and truly known. Art works can offer us a liminal space in which we confront our 'selves', and where we might gain a glimpse of

the 'return' of those aspects of us which have been repressed.

Jean-Luc Nancy describes art as being a 'double topology of presence coming into sense and sense coming into presence' (1997: 134). In this view, through the arts an attempt is made to represent *existence* to the *senses*, and thoughts mirrored in their sensory framing. The artist plays with the possibility of making sense of, and to, the senses. Creative practice then offers a vantage point below the usual horizon line of the 'already known' of established critical, theoretical and historically based arts research, for investigating first hand the possibility and impossibility of doing something new, and of moving in and out of established practices.

Creative work is not merely based in skills, and their application, but requires the ability to experiment and play, however conventionalised the idioms, genres or forms employed. All new works and forms are monstrous in that they in some way deform, or attempt to destroy established practices (that make sense to our senses). That is, they attempt to break with constituted normality, 'bearing a monster in a monstrous age', as Poster termed it (1990: 105). New work though demands judgement of the creative practitioner, however radical, based upon a developed sense of discrimination. The investigation of that 'sense' of discrimination, of the 'grammars of practice', as Bourdieu termed them, that inform the choices made, or that set up the 'leaping off' points and directions followed, provides an opportunity for *sense to sense itself*. This is potentially one of the richest veins for practice-based research to pursue.

Sense and Sensibility

A difficulty with participant observation in research in general, according to Berger (2000: 166), is in discerning or identifying unrecognised aspects of the research. This can impair the quality of the kinds of observations reported. Hegel put it that the sensible is 'synonymous with what is self-external' (cited Nancy 1997: 129). With practice-based research, that is, research by the practitioners themselves, this difficulty is doubled, with the potential for not discerning or identifying certain aspects of, and in, the creative work, as well as in the reporting of it. But, equally, it can be said that approaching practice as an external observer does not provide access to the kinds of thinking invested in certain ways of doing, of *acting*, or in assessing the roles performed and the kinds of tactical judgements made in 'the doing'. How can creative subjectivity be objectively accounted for from the outside?

Arguably, an external observer could gauge little of the kinds of internal reflection and logical complexities which the artist confronts at almost every turn, even if sophisticated extended interview techniques were employed. Baxandall (1998) argues that the participant understands and knows 'with an immediacy and spontaneity' what the external observer, who 'lacks the participant's pure tact and fluid sense of the complexities', does not share (p.342). And Nettl (1998) suggests that: 'If you are musical, you have the capacity of musical thinking; to think *about*

music does not necessarily require musicality' (p.345).

All research positions, then, have limitations of viewpoint and method. What validates the research 'viewpoint' is its contextualisation, not its elimination. It is very useful for the creative subjectivity of the participant-observer, on reflection, to be contextualised relative to the internal and external position/perspective. This does not, it has to be said, require the assertion of a generalised theory. This approach of course does not nullify the more comparative view of the (seeming) detached observer, who strives for an analytical, critical and/or theoretical account. However what is sensible, what makes *sense* in art practice, can best be assessed, initially at least, from the inside.

We should not fear abandoning the passive, authoritative position of the scientific observer either. If research is traditionally about generating a 'discourse oriented toward facts', as Luhman asserts (2000: 3), and there is little opportunity for temporal or spatial distance in generating this discourse, then the 'facts' to be reported upon are entirely provisional and subjective, in their original arising. Reflexivity, self-conscious judgement, and systematising its representation are important to/in this method, bearing out Spinoza's proposition that reflexivity *is* method. Any research practice which is divided from itself, removed from its own conditions, as well as those it intends to account for, as Bourdieu has observed, is reduced to seeing practice as mere spectacle (1977: 1). The issue then is not objectivity *per se*.

Researching Contemporaneity

Practice oriented research attempts to map something of the chaotic patterns of the conceptual and sensory space of contemporary practice by following specific journeys across the topography of that space. As Niklas Luhman observed, there is no theory independent of the continual reactualisation of that theory (2000: p.4). So too there is no practice independent of its own continual reactualisation.

Whilst it appears there may be some loss in critical distance in this practice-based method, there is equally the potential for it to generate new perspectives, to participate in the development of new discursive forms, to help open the field to new modes of symbolisation and performativity. Indeed, it could be argued that the timeliness of practice oriented research approaches are indicative of a more general shift towards what Mattelart terms a 'search for contemporariness' (2000: 107). That is, to look along the edges of what is exposed of the contemporary cultural landscape, and to open to view something of the conceptual and sensual contours of the contemporary world. What I might term the 'already unknown'. Interestingly, such movements within 'the contemporary' already imply some small conceptual distance, as Nancy suggests, in that to try to make sense of the world requires that one must 'sense oneself making sense' (1997: 162).

Studies of the modes of evaluation at work in creative arts practice, both from the

inside *and* the outside, can yield valuable insights into the kinds of distinctions informing the cognition and recognition involved in creativity, as well as conveying something of the contemporary nature of the conceptual space of creative arts practice. The existing (stable) conditions of the chaotic space of a specific branch of the creative arts can be seen in terms of both *unpredictability* on the one hand, and social, cultural (including technological) and historical *determinism* on the other. So, the complexity of contemporary creative practice is continuously determined and altered through processes of recursion and iteration. That is, through repetition and difference, seen variously as *stability* and *chaos*. Slethaug (2000: x) puts it: 'Despite their tension, randomness, and pattern, chaos and order exist in co-dependency, and the artistic imagination activates, engages, and enhances them'.

The very subjectivity of the art practitioner-researcher position allows for patterns to be delineated which may be disallowed as random, inconsistent and/or indeterminate through other research methodologies, and by other disciplines. In doing so it provides a glimpse of not only the imaginative transformation of the psychic and physical, social and cultural raw materials into (potentially) monstrous works, but conveys some sense of the ways the various fields of practice in the creative arts are themselves exceeded, changed and/or re-energised in response to the new conditions produced, or reflected upon.

The Modality of Newness or Art as Mutation

Finally, it is worth briefly reflecting here upon the notion of art which sees art as representing a fragmenting of life, in the way that a particular work is generated within, then detaches itself from the everyday world, to become 'art'. In that sense, art can be seen as being (re)produced through mutation. As art splinters some aspect *from* life, it also, simultaneously, offers an opening onto (the consciousness *of*) life. It represents a fragmentation of sense, a separation by sensory means of some cultural aspect from the everyday. It can thus, Nancy (1997) says, be seen as 'the sensuous presentation of truth' (p.134). These kinds of sensory distinctions and cultural presumptions of course became a key aspect of the content as well as methodology of many art forms in the Twentieth Century, particularly through approaches to 'the popular'. Similarly, as has already been alluded to, a practice-based approach to research in the arts can take the investigation of the contemporary work of creativeness as an opportunity to plumb the exposed edges of the splintering of the sensorium of the world. In this way, it is possible to gain insight into the illusion of the exteriorisation of consciousness. As Francis Bacon put it: 'the nature of things betrays itself more readily under the vexations of art than in its natural form' (cited Weinberg 2002: 3).

Baudelaire, as early as 1863, said of 'the modern' in art, that it is manifest in the 'ephemeral, fugitive, the contingent' (cited Smith 1996: 251). This gave rise to the heroic Modernist figure of 'the new', where novelty and innovation are set against the (back)ground of established (Romantic) traditions. This reflected upon

the agency of change in industrialised culture, which in turn shifted to a culture of constant change, a postindustrial 'economy of endlessly variable presentations, a culture of incessant transformation', according to Smith (1996: 251). Thus, in the postmodern era, it is/was 'the old', the recycling of sights and sounds of the past, which came to stand out, giving rise to an ecology of culture – a (relatively) closed economy of cultural signification.

In this kind of view, and embedded in these postmodern kinds of practices, art ceases to be a modality for perfecting the human condition (Enlightenment), and of liberating itself. Art comes to be seen not as something *perfectible*, but as an outcome of a limited range of practice/s, which are invariably and differentially constructed and interpreted (and preyed upon) in a given cultural 'moment'. Creativity is not seen so much as producing some*thing* new, but as a *modality*, of and for 'newness'.

Novelty, then, itself operates as not a method of social and cultural advancement, as such, but as a contemporary *metaphor* for the dynamic aspect of what we experience as living. As with all metaphors, this paradigmatic displacement/comparison carries with it both the similarities *to* that which it represents, and the differences *from* it. And whereas consciousness arises most acutely in the face of the threat of oblivion, so creativity stands also in relation to its own extinction. In the moments when innovation seems least probable, the generation of a new vantage point stands all the more in relief to all around it.

Tracing something of the seemingly informal intelligibility at play in creative work, offers a valuable research window onto the formal space of the creative arts, where form stands in relation to formlessness, and matter to anti-matter. Notwithstanding the institutional formations for producing and distributing new work in the arts, what we now call the 'creative industries', the creative *arts* also remain inextricably bound up with unpredictable, unstable, and, in the contemporary terminology, 'chaotic' activities. The creative *arts* still manage to generate work from outside of the strategic parameters of the industrial model on the one hand, and from that of the academically authorised sets of protocols for initiating (teaching), or reporting upon (researching) creative work in the arts on the other.

Conclusion

The aim here is not to devise a stable or even coherent set of methodological rules for investigating creative practice, any more than it is to diminish the chaotic and monstrous qualities of what may present, or come into presence, as 'new'. The aim is to develop a relatively logical method of considering the task of investigating creative practice. This requires that one remain open to the playful aspects of practice, adopting an operational, or what Hodder (2002) terms a 'connectionist' approach to investigating the 'networking, interconnection, and mutual implication of material and nonmaterial' qualities to be found in cultural practices (p.272), rather than developing a 'rule-based' system for theorising what is done. Practice-based research aims to trace some of the departure points of creative

practice, and to map, in a subjective way, something of the trajectories taken across the material and nonmaterial aspects of contemporary arts practice. Michel Foucault (1976: 224) asserted that perhaps there are no errors in the strict sense once one moves outside the conventional disciplinary and methodological territories – 'outside the true' – when evaluating whether findings are true or false. To that extent, practice-based research in the creative arts remains a risky and radically innovative mode of research activity. As such, it may help guard against some of the risks in the (over) institutionalisation of training programs in creative arts practice, especially those operating within the large, increasingly corporatised universities and other 'education as commodity' higher education sites. But, on the contrary, might studying the results of these emergent (per)mutations of arts practice merely contribute to producing professional arts monsters?

Note

This paper is a slightly expanded version of a paper given at the ELIA *Cómhar* Conference in Dublin, October 2002. It was presented with the assistance of a research/travel grant from the Research Committee of the College of Arts, Education and Social Sciences, University of Western Sydney, and with conference support from ELIA, both of which are gratefully acknowledged by the author.

References

Bakhtin, Mikhail M. (1993) *Towards a Philosophy of the Act*. Trans. Vadim Liapunov. Austin: University of Texas Press.

Baxandall, M. (1998) 'Truth and Other Cultures', pp.242-3 in Korsmeyer 1998.

Berger, Arthur A. (2000) *Media and Communication Research Methods: An Introduction to Qualitative and Quantitative Approaches*. Thousand Oaks: Sage.

Boden, Margaret A. (1997) 'The Constraints of Knowledge', pp.1-4 in Andersson,

Ake E. & Nils-Eric Sahlin, (Eds) (1997) *The Complexity of Creativity*. Dordrecht: Kluwer.

Bourdieu, Pierre (1977) *Outline of a Theory of Practice*. Cambridge: Cambridge UP.

Broadhurst, Susan (1999) *Liminal Acts: A Critical Overview of Contemporary Performance and Theory*. London & New York: Cassell.

Dallow, Peter (2003) 'Representing Creativeness: Practice-based Approaches to Research in Creative Arts', forthcoming article in the UK *Journal of Art, Design and Communication in Higher Education*, Vol. 2 Issue 1.

Foucault, Michel (1976) *The Archaeology of Knowledge*. New York: Colophon.

Hausman, Carl R. (1984) A *Discourse on Novelty and Creation*. Albany: State Uni. New York Press.

Hegel, Georg W.F. (1967) *The Phenomenology of the Mind*. Trans. J.B. Baillie. New York: Harper Torchbooks.

Hodder, Ian (2002) *The Interpretation of Documents and Material Culture*. pp. 266-280 in Weinberg 2002.

Korsmeyer, C. (ed.) (1998) *Aesthetics: The Big Questions*. Malden, MA/Oxford: Blackwell.

Lefebvre, Henri (1991) *The Production of Space.* Trans. Donald Nicholson-Smith. Oxford: Blackwell.

Luhman, Niklas (2000) *Art as a Social System.* Trans. Eva Knodt. Stanford: Stanford UP.

Macleod, Katy (2001) 'What would falsify an art practice?: Research Degrees in Fine Art', Broadside 5, Birmingham: UCE/ARTicle Press.

Mattelart, Armand (2000) *Networking the World: 1794-2000.* Trans. Liz Carey-Libbrecht & James Cohen. Minneapolis: Uni. Minnesota Press.

Nancy, Jean-Luc (1997) *The Senses of the World.* Trans. Jeffrey S. Librett. Minneapolis: Uni. Minnesota Press.

Nettl, B. (1998) ' "Musical Thinking" and "Thinking About Music" in Ethnomusicology', pp.344-53, in Korsmeyer.

Poster, Mark (1990) *The Mode of Information: Poststructuralism and Social Context.* Cambridge: Polity Press.

Slethaug, Gordon E. (2000) *Beautiful Chaos: Chaos Theory and Metachaotics in Recent American Fiction.* Albany: State Uni. New York Press.

Smith, Terry (1996) 'Modes of Production', pp.237-256, in Nelson, R. & R. Shiff (eds.) *Critical Terms for Art History.* Chicago/London: Uni. Chicago Press.

Solomon-Godeau, Abigail (1991) *Photography at the Dock: Essays on Photographic History, Institutions, and Practices.* Minneapolis: Uni. Minnesota Press.

Spinoza, Baruch (1992) *Ethics; Treatise on The Emendation of the Intellect; and Selected Letters.* Trans. Samuel Shirley. Indianapolis: Hackett.

Weinberg, Darin (Ed.) (2002) *Qualitative Research Methods.* Oxford, Blackwell.

12 Related Objects of Thought: art *and* thought, theory *and* practice

Katy MacLeod and Lin Holdridge

Introduction

That small conjunction *and* could so easily signal a nice interrelationship between art and thought, theory and practice. However, many years of empirical research into student experience of doctoral study and sustained investigation into Art and Design research, have led to an understanding of just how easy it is for both the broader inter-institutional research cultures and the social cultures which frame them to produce binary distinctions: art is conceived as practical rather than as theoretical or intellectual and the practices of art are thus confirmed as occupying an academic terrain which is separate from that of theory. In this paper we will demonstrate with reference to exemplars of doctoral submissions how art is thought and practice is theory. We will also indicate what might be at stake in cultures which encourage and refuse relatedness[1] those *related objects of thinking* which characterise doctoral submissions in the Arts.[2]

The relatedness of the manifestations of thought in the cultures of Art and Design research has not yet been fully examined: the form of doctoral study, the relationship of its parts needs to be scrutinised.[3] Instead, a literature has been developed which is inscribed by a drive to provide proof of the validity of doctoral work in the Arts and to elucidate the protocols, procedures and more broadly acceptable methodologies for research at higher degree level (Gray, 1995; Painter, 1991; 1991 & 1996; Seago, 1994/5; Newbury, 1996). The literature has also revealed how difficult students find any negotiation of this accredited research terrain (Hockey, 1999, Hockey and Collinson, 2000 and Macleod, 2000) and how ill prepared they feel to tackle the stipulated dual submission of written and *practical* study. Indeed, the most potent incipient issue within the developing cultures has arisen from a defensiveness about the status of the Arts within the broader traditional academic framework.

The dominant mode of the PhD is sometimes acknowledged to be the 'scientific' model, the model which delivers objective knowledge or truth. The tacit assump-

tion is that the term *research* resonates with the terms *scientific truth* and *knowledge*. This is further compounded by the academic assumption that art is a subjective and anti-intellectual activity. The central question then becomes, how could it be made to fit with the academic regulations required for the higher degree. The symbolic playing out of such distinctions has been the tussle both within and between institutions about the written text: what is the status of the written text in a culture which determines that writing is instrumental to practice, (ie to the process of realising work) rather than its determination? In the face of an inter-university culture where writing *is* the doctoral thesis, it has been inevitable that the tussle is intense. It has been left to the UK Council for Graduate Education to take on a central role in this context. Its published findings in 1977 made the recommendation to reduce the length of the written thesis. However, the precise nature of the thesis was not investigated and writing was privileged over visual research.

Thus, the playing out of binary oppositions between writing and art and theory as against practice remains in place in the UK. While this may seem like a closed debate, it is very far from that because in the institutional refusal to accept writing and artworks as *related objects of thinking*, lies a cruel, social resistance. Artist scholars have produced complex, exacting and related research submissions, which demand engagement with *the sum of the parts*. Doctoral submissions in Fine Art predict a suspension of critical reading until the visual artworks have been encountered.[4] In fact, the independent criticality of these submissions is dependant upon such a suspension of easy or predictive readings. The doctoral thesis, ie the objects of sustained thought, does not reside in the written text on its own; it is part of the exposition of the thesis. It is this *relation of parts* which determines that the doctoral submissions we will outline demonstrate far more than a linear addition to available knowledge. What the multi-parts reflect and critically encounter is experience itself, how consciousness becomes articulated; drawings; diaries; travelogues; academic written texts; interviews; poetic texts, all these are part of a panoply of possible modes of delivering thought. This then, is thought that is hybrid and much closer to how we think our lives and shape their meanings. Of course, this may dictate that there is an ambiguity inherent in this research work. We will maintain that this is the vital stuff of art thought. In its ambiguity lies its poesis or imaginative shape and in this poesis lies its power. The rational world has much to be taught, as so many brilliant minds have so clearly demonstrated, from Joyce to Proust, to Picasso or Leonardo da Vinci. Ontological and unresolved speculation about our worlds is what art is about and it is this which at their best, doctoral studies reveal. While we might lament the extreme nature of the challenge posed to artists who engage with doctoral research cultures and the institutional demands of doctoral study, it is these which have provoked the unanticipated inventiveness of artists' submissions, which have the capacity to take us back to a condition of art as *content*, that is, art as about being in the world and being actively engaged in subjecthood. Our intention is to articulate how this thought manifests itself.

This paper draws heavily on an Arts and Humanities Research Board funded study of doctoral submissions, 2002-2003 (MacLeod and Holdridge, 2003). Originally the study was conceived as a 'pilot study guide'. However, the exemplars proved so rich and complex that we felt we must devise an appropriate method for revealing these studies rather than producing a guide to academic study in the discipline. We decided to concentrate on a demonstration of the thinking processes rather than further categorise the exemplars or reduce them to a set of shared principles. Whilst this might have served to accommodate them more fully to the broader research university cultures, it could well have reduced the sense of their originality. To this end we adopted analytical models. This involved presenting each study through its methodological framing: its structure; its use of theory, which is both extant (Marxism, for instance), and renewed and re-formulated through practice to become the findings of the research, which is theorised practice. Hence each research study's visual constructs are a vital part of the analytical model.

Doctoral exemplars

One of the doctoral studies which perhaps best exemplifies a complex intermeshing of parts is a study entitled *Spatial Determinism in the Canadian North. A Theoretical Overview and Practice Based Response* by Gavin Renwick (Renwick, 2003). This is a provocative study which takes the reader/viewer beyond what might have been anticipated. Anthropological methods of research are dominant and a range of different strategies are employed to present findings which are difficult to articulate because they incorporate different world views. The structure of the submission is complex: it has sixteen parts, each of which could almost be read as free-standing.

The first two sections set out the methodology: the first presents a critical examination of available research methodologies and against these, poses one based on generalist principles according to the tradition of Scottish democratic intellectualism and visual thinking identified with Patrick Geddes. The second section is a review of a contextualising research project undertaken by the researcher and his colleague, Wendy Gunn in seven countries in Europe, including Eastern Europe. The project demanded the invention of a physical space for participants to get together and debate current issues of social and political determinism. The crucial method of employing ideas for the construction of the *debating chambers* was drawing, based on architectural knowledge and technical expertise, imaginatively employed to provide an appropriate space which was fluid, relaxed and transportable. The origins of a method are mapped out not simply through an identification of anthropological methods of research based in historical, pedagogic and academic models, but also through an articulation of the primacy of collaborative drawing as a means of securing and reflecting the myriad dialogues and conversations which were to take place in the *debating chambers*. Underpinning the methodology is a profound understanding of the strengths and limitations of nationality and the importance of open discussion to facilitate mutual understanding. Equally, it is a recognition of the importance of an appropriate and

sensitive research methodology to provide for this.

The subsequent two sections are designed to illuminate the far reaching insidiousness of spatial determinism within nation states, particularly regarding its operations on minorities. The study symbolically enacts the journey each of us must undertake to genuinely understand differing claims to spatial determinism through its travelogue, a visual and textual reconstruction of the researcher's long and arduous journey to get the Canadian North. Historical geography is then employed to reveal the full and alarming workings of spatial determinism in the imposed development of one town, Yellowknife. This central exemplar is used to demonstrate the systematic imposition of Canadian governmental designs, both political and architectural, on one settlement of indigenous peoples. Again this is largely presented through drawing; the research evidence could be characterised as scripto-visual, a mode which has become unfashionable, but which served exceptionally well in the 1970s and early 1980s to illuminate complex political issues. Renwick describes his research thus:

> Each section is self-explanatory and to a degree autonomous. This is as much a visual document as a verbal one, and this should be recognised by the reader/viewer from the outset. Part of this research is undertaken for a culture where knowledge has been transmitted orally. A parity between legitimate, but alternative forms of knowledge is created here as an alternative to the dominant worldview, that of the absolutism of scientific rationalism. In many ways this thesis follows the premise of Dogrib Dene elders in the western Subarctic, that 'those who learn both ways [Dene and Western] will...be strong. ... [the elders] want their knowledge written down so it will be believed, and the differences and similarities between types of knowledge will be understood' (1).

As the Dogrib Traditional Knowledge Project director Allice Legat states:

> The oldest of Gameti elders consistently explained that a person should only talk about what they know. You can only 'know' information because someone who has experienced it knows it and explains it to you ... This is the only way I can put information together given my experiences, assumptions, and knowledge at this time. (2)

In the spirit of both visual communication and oral tradition, this thesis is not presented in linear fashion. Each section has autonomy, being self-contained, while being very much part of the whole. It strives to facilitate a set of parallel readings of the one issue, from either the general to the particular or from the micro to the macro.

1 Legat, Allice, et al. (2000) 'Tlicho Traditional Governance'. Dogrib Treaty 11 Traditional Knowledge Project, Rae-Edzo. p.2.
2 Legat, Allice, et al. (2000) 'ibid' p3

As the research study is read and viewed, different sets of knowledge and modes of understanding are increasingly required. There is an acute change of intellectual pitch in some of these sections. For instance, *The Myth of Primitivism, One to Eleven* contains a biographical account of one man's awkward cultural positioning as author/documenter of his environment and yet subject to the interpretative documentation of a European photographer. The visual and textual documentation produced by him is as moving as individual life stories can be. However, the purposes of the study avoid sentimentality or nostalgia in pursuit of a broader truth concerning spatial determinism, its operations and implications. The last two major sections present research findings which are provocative in their placing together: the first, *Spatial Configurations for Living 'North of Normal'*, ie in North West Canada, comprises eighty three drawings which give a clear indication of how an essentially nomadic peoples use and experience space.

Alongside this, Renwick's research study of the Ethnographic collection at the Royal Albert Memorial Museum (Exeter), resulted in a careful choice of artefacts taken from the reserve collection, which would literally or metaphorically represent indigenous northern Canadian ideas of 'home'. The author then placed these in specific locations throughout the museum. In addition to provoking comparisons of underlying assumptions about the concept of home, the juxtapositions destabilised normative curatorial methods and opened out fissures in our perception of current museological practice. Two examples demonstrate how concealed issues can be exposed, despite the careful and exhaustive cultural and historical research which underpins curatorial categorisation and display. An Inuit doll, placed within an Edwardian dolls' house, provoked a raft of post colonialist concerns. Problems of spatial determinism were raised by the display of a small piece of bone, carved by the Inuit to represent the Canadian coastline. There was no indication of the fact that this was a sophisticated demonstration of how space is perceived, nor that it was a navigational tool for specifically working in and with a land, conceived as space *and* time. Out of context and placed within a collection of disparate objects, the meaning of this tool could only be read in terms of western values. The researcher redressed the balance by indicating the function of individual tools with overlays of documentation, which is essentially scripto-visual.

This study of spatial determinism in North West Canada provides a methodology for cross cultural thinking. As we have sought to demonstrate, the study comprises many related parts which together present a profound set of questions fundamental to the ways in which we lead our lives. Perhaps of central importance is an understanding of how space might be encountered and employed in a more deeply intelligent relationship with our lands. Such a relationship would need to avoid fixity and possession, a research finding most vividly revealed through research drawings, which are conceptual, anthropological documentation and poesis. They demonstrate the evolutionary, democratic, analytic and non-linear nature of indigenous planning and habitation as well as the capacity for doctoral study to combine a range of different disciplines in pursuit of an appropriate ethical positioning as well as racial and cultural responsibility. They also constitute

theorised practice; the sustained conceptual schemata involved in the research documentation cannot be differently characterised. Nor can they be refused as thought.[5]

Art that brings the viewer closer to the conception of thought seems also to distance her/him from discipline boundaries and predictive understandings. This is elegantly demonstrated by a second doctoral study which provokes the viewer/reader to grapple with what might be the sum of its related parts. Entitled *sidekick* by Elizabeth Price (Price, 2000) the contents page is as follows:

> *sidekick* (version as of June 1999); *sidekick* (version as of May, 1999); *sidekick* (version as of February 1999); *sidekick* (version as of January 1999); *sidekick* (version as of October 1998); *sidekick* (version as of august 1998).

The written text is arbitrarily repeated six times in different computational configurations. This precipitates in the reader a sense of the work still being in-progress; it also engenders an understanding of what might be the implications of *how* the work is in-progress and the nature of that progress. The work is being produced by the artist winding shiny sticky tape off the manufactured role onto itself to form an off-spherical piece, at some point entitled *Boulder*. The central theoretical premise is the validity and provenance of this act of making:

> The solidity and weight of the boulder are important because they testify to the production of the thing. And this, the question of how the boulder was made is the prevailing ambiguity which ultimately necessitates these kinds of physical verifications. If the boulder is too light, then it was not produced entirely by winding tape. It might therefore be hollow, or include some other material. Weight is a means to gainsay, or corroborate the apparent visual evidence of the sphere. The testing and corroboration of evidence is time consuming and unending; here it is unpicked and pitched into a philosophical/theoretical arena by the conjunction, in an endlessly repeated ploy, of: So is the boulder a compact mass of wound tape? Did I make it in the way that I claim? Was it made in the way it appears to have been made? Certainly only one material and method is disclosed, but this does not preclude the possibility of others. And clearly the tape lends itself generously to these doubts in as much as it functions as a kind of skin which conceals and encapsulates other materials. There is certainly nothing evident that would disprove the possibility of deception. Even if the weight were consistent with a solid mass of tape, it would not prove that this was the nature of the mass; it might simply suggest a more sophisticated hoax. In such a light the seemingly matter of fact descriptive qualities of the boulder, and the seemingly ingenuous descriptions of this text maybe begin to appear tactical rather than candid (Price, 2000: 80).

Boulder is thus both a *demonstration* and a questioning of this demonstration of the

artist's research labour, a labour which *pitches Boulder* into a *philosophical/theoretical arena* by hinting that this labour might, in fact, be bogus: *is the boulder a compact mass of wound tape? Did I make it the way I claim? Was it made in the way it appears to have been made?* This questioning reflects sustained misgivings about the research requirement of the demonstration of the proof of research, a proof dependant on a methodology which is here described as tactical rather than candid. However, it is precisely through this questioning of methodology that the formulation of the theoretical premise of the submission becomes possible: the validity and provenance of *Boulder* as research.

Boulder can be identified as art because *Boulder* is form. *Boulder* is also misshapen form and represents a philosophical speculation on the provenance of form. It is made from a manufactured object; it is hand made but it is not fashioned; it is conceived but it is not shaped through that conception; it is the result of the *logic* of thinking about what the making of form represents and what the making of form precisely represents in a culture where representation is lexical. This sustained and intense level of scrutiny inevitably predicts an exacting re-visioning of the provenance of the artwork. It also therefore calls into question its relationship to the viewer, who is, of course, both the other within the artist and the other, who is not the artist, (the viewer). The relationship between these is not only very particular, but awkward and challenging; the question of the lapsing of time and the revisiting of encounters is central to any speculation around them. These encounters were characterised by Marcel Duchamp as *rendezvous*. This doctorate implicitly grounds its central theoretical premise in the Duchampian *rendezvous* of artist and object and the shadow *rendezvous* of viewer and object subject to the inevitable delay involved between presentation and reception.

Price's writing encapsulates a variety of different theoretical constructions and outsteps a number of discipline boundaries. The thought is also duchampian in character: *Boulder* represents an equivalent modus operandi to the plastic punning (Duchamp's *Ready-mades*), which is dependant upon a physical manipulation of the objects of thought.

Duchampian thought is not interested in visual results, it is far more interested in the operations of an independent mind exercised upon objects in the world: Nietzschian questions like the following, do designations and objects correspond? Is language the adequate expression for all that is real?

In a third doctoral submission, *Representing Illusions space, narrative and the spectator in fine art practice* by Tim O'Riley (O'Riley, 1998) the central premise of the research is the artist's (and viewer's) sense of being *caught between reality and its representation*. O'Riley introduces the study with the story of Nabakov's *The man who flew into his picture*, 1981-88:

> ...the story of a man who has drawn a small picture of himself on a large, white board which is crammed into his tiny room.....as the man stares at the small grey figure he has drawn, the board appears to change at first into a white fog and then into a "bright expanse pierced by an even, sparkling light". The man feels drawn into this expanse and feels himself merge with the little figure which then appears "entirely alive and real (though small, many times smaller than he...)" Gradually, the depicted figure appears to move away from the surface into the depths of the light eventually becoming indiscernible from the white expanse. Yet while the artist feels himself drawn into the picture, part of him realises he is "sitting completely immobile in his lonely room" staring at a large, badly painted board with a small drawing on it. He is caught between reality and its representation and loses track of where he actually is...(O'Riley, 1998: 1)

Losing track, taking objects as volatile signifiers of a world which we inhabit but do not understand but must engage with to survive is a central, social concern. The teasing out of meaning between the artist's intentions and the viewer's perception of whatever is produced is fundamental to establishing the groundwork of understanding cultural difference. The space between specific and identified intentions and how these are received becomes the powerful space for those intentions to be re-thought.

This study, like the other three, offers thought which is in-progress, potentially in a state of flux: the re-thinking is as much the responsibility of the reader/viewer as it is the artist/scholar's. After the careful tracing of perspectival systems and technologies, of viewpoint and narrative space through art and film, it is that which is unknowable which characterises the study. It is Duchamp's *art-co-efficient*, the interaction between art and viewer which provides its conceptual core. O'Riley cites Paz in this context:

> The work makes the eye that sees it – or at least, it is a point of departure: out of it and by means of it, the spectator invents another work. (O'Riley, 1998: 56)

Thus the use value of art objects is always in play. The event of viewing raises issues about the condition of viewing, of viewing systems and ideological assumptions. Artistic and linguistic meanings are not ascribed to works which constitute an event: whether it be *As far as the eye can see (#1 and #2)*, *Before, during or after*, *From where you are standing*, or, *4 intervals*, each of the digital, sequenced research artworks presents a visual/intellectual conundrum:

4 intervals
...I wanted to pan around a virtual space and create or record a series of discrete pictures which represented the space in a coherent sense but which allowed for a degree of slippage in terms of temporal coherence...this piece acknowledges the viewer's space and scale and

consists of four parts which surround the viewer like a panorama…I wanted to introduce a degree of narrative uncertainty about the apparent order and sequence in the series. Rather than create what would be a continuous pan I decided to create gaps in the sequence…Each image in the series represents a quarter of a complete revolution around the virtual camera's axis. The field of view is wide enough to allow for the repetition of parts of the space and the various objects it contains between the four views. Although the space and most of the objects remain consistent throughout, there are intentional discrepancies in the image's continuity. The gaps between the images are therefore as important as the images themselves with the relationship between them being elliptical in that each image points to either of its neighbours in order to enable us to identify differences as well as repetitions. (O'Riley, 1998: 146)

Like Duchamp's *Ready-mades* or Price's *Boulder* the works are gestures of thought rather than objects of contemplation. They are critical and philosophic rather than artistic. Their logic involves the gesture of thinking within the domain of the visual. If we return to the provenance of the *Ready-mades*, we can identify these objects as 'made' by the gesture of the artist. Octavio Paz describes the *Ready-mades* as contradictory and in this sense as *the plastic equivalent of the pun* (Cabanne, 1971: 42), a pun on value and meaning. The *Ready-mades* are also plastic manifestations of the intellectuality of an artist's (Duchamp's) oeuvre, singular in its precise articulation of the dangers of artistic gesture in terms of the artist's style. They are thus decisively subversive of the traditions and determining conventions of art and it is precisely this subversiveness which must be at the heart of all deeply intellectual art practice.

This subversiveness is nothing more than critically independent thought determined by art practice which is not about making in the conventional sense; it is about conceiving. It is the theorisation of ideas through sustained practice. The intellectual terrain of the artist scholar is the reconception of foundational principles of thought as it is *not* articulated in language. It involves a drawing together or enmeshing of different disciplines and strands of thought, some of which are borrowed, some of which are produced in the processes of realising artworks. It is always accountable to subjecthood and the interrelatedness of what has been conceived, made and received. It is *in progress*; subject to deception, as either the artist or the viewer's experience dictates. But it is not bound by binary thinking which seeks to make neat that which must explode anticipation. This is thinking that is philosophical in nature, but philosophical according to the logics of a practice which founds itself in invention and intuition, in ambiguity and the subjective drives of the artist, whose intellectuality is employed to remove the certainties of the visual to conceive of what might lie behind what is apprehended in order to make sense of his or her material world. Related objects of thought, in this context, are both propositional and provisional. Whether we accept the validity of this thinking will be determined by whether we accept that judgement may be provisional rather than conclusive. In the same way that the distinguished

curators of the Ethnographic collections at the Royal Albert Memorial Museum and Art Gallery were happy to accept the displacement of their curatorial judgements by Gavin Renwick's interventions, we would hope that the conjoining of different disciplines and different modes of enquiry within each study might herald renewed interest in the social and cultural implications of relatedness within academic research. Advancement of knowledge in this sense is not subject to objective measurement, it is subject to understanding. If we care to understand the complex thought being played out in these studies, we gain knowledge. The small conjunction *and* is ever present like a rhizome, encouraging lateral intellectual growth not just of given disciplines but of life itself and an appropriate inhabiting of our worlds.

Notes

1 The concept of relatedness owes much to phenomenology, in particular the work of Maurice Merleau-Ponty and his insistence on the 'fact' of consciousness and The world not being what is conceived but what is 'lived through' and thus, also the 'fact' of existence. However, in this paper and the doctoral studies referred to, it is also a post-post-modern understanding of a global context which predicts a curious cultural fracturing which requires a re-centering of individual consciousness.

2 Description given by an artist scholar of his doctoral work (Macleod, 2000)

3 The form of doctoral study in the Arts has been called for by Chris Rust (2003) amongst others.

4 This is a crucial issue within the research arenas in the Arts where a written text sent to External Examiners well in advance of the doctoral Viva cannot be the basis of a final judgement on the doctoral study because the visual or performative work has yet to be encountered.

5 We have consciously employed a descriptive rather than analytical approach to this doctoral study because it elicits the viewer/reader's perception of how adverse spatial determinism functions.

References

Cabanne, P. (1971) *Dialogues with Marcel Duchamp*, Thames & Hudson, London

Gray, C. (1995) *Developing a Research Procedures Programme for Artists and Designers* Aberdeen: Robert Gordon University

Hockey, J. (1999) Writing and Making: problems encountered by practice based research degree students, *POINT 7*, Spring/Summer, pps 38-43

Hockey, J. & Allen Collinson, J. (2000) The Supervision of Practice-based Research Degrees in Art and Design, *The International Journal of Art and Design Education*, Vol 19 No 3, pps 345-355

Macleod, K. (2000) What would falsify an art practice? Research degrees in Fine Art, *BROADSIDES 5*, Swift, J. (Ed), University of Central England,

Macleod, K & Holdridge, L. (2002-2003) AHRB funded study, *Methodological Models of Good Practice in Doctorates in Creative Art Practice*, University of Plymouth

Merleau-Ponty, M. (1962) *The Phenomenology of Perception*, translation Colin Smith, Routledge, London

Newbury, D. (1996) *The Research Training Initiative: Six Research Guides*, Birmingham Institute of Art and Design

O'Riley, T. (1998) *Representing Illusions space, narrative and the spectator in fine art practice*, Chelsea College of Art and Design, The London Institute

Painter, C. (1991) Fine Art Practice, Research and Doctoral Awards, Research Conference Paper, National Society of Education in Art and Design, Brighton

Painter, C. (1996) Research Degree Regulations and the Recognition of Art and Design Practice: A Survey Report, *POINT 3*, pps 2-6

Price, E. (2000) *sidekick*, University of Leeds

Rust, C. (2002) Context – Many flowers, small leaps forward: debating doctoral Education in design, *Art, Design and Communication in Higher Education*, Vol 1 No 3, pps 141-148

Seago, A. (1994/5) Research Methods for MPhil and PhD students in Art and Design, Royal College of Art Papers, No 2, *Royal College of Art*

13 You are Always Someone Else's Monster

Lucien Massaert

Paraphrasing Goya's oft-quoted title "the sleep of reason engenders monsters", Derrida puts forward a variant, "reason watches over a deep sleep, in which it has a stake". Reason itself seeks a certain blindness, a certain forgetfulness. An appeal to reason will therefore not in itself prevent you from sleeping. Indeed, that sleep might well be the sleep of a monster always about to be reborn, as shown by numerous recent world events. I hope to appeal here to a wakeful reason. I shall only be aiming to effect a minute displacement in the terms of the statement which has brought us together, underlining for instance the polysemy of the concept of monster.

The argument, as presented here, enunciates an epistemological slant on research, theory and thought. Such an epistemological slant presupposes that those who wrote or thought out the argument have some knowledge in the area of (let us say) scientific research, or theory. Based on this knowledge in scientific theory they conclude that the research or theory brought into play or produced in the arts is of a 'monstrous' nature.

This view of things at once made me think of the argument of the "methodology of artistic research" working group led by Carole Gray at the Berlin ELIA conference in 1994. This argument put forward by Carole Gray already suggested that work should focus on theories such as chaos theory, nonlinearity, the uncertainty principle, hybrid methods. All of these can only function as metaphors for the artists involved, as they are unlikely to place them within their original scientific context with anything approaching rigour. Would anyone even think of sticking such terms to the writings of established artists from the past? Would the thinking, the reasoning, the investigations of such artists as Klee, Kandinsky, Malevich, Matisse, or closer to us, Robert Morris, Mel Bochner or Gerhard Richter, would all this research in any way profit from being dubbed chaotic, uncertain, hybrid or monstrous? Or are we to believe that a recent epistemological break separates the writings of those artists from all the interesting thinking of today?

Isn't this tantamount to a return to age-old clichés according to which art is something quirky? Might not ill-understood, but widely vulgarised and broadcast scientific theories such as chaos theory, with its graphic suggestions, allow a confusion with the old saw of artists' spontaneity?

The question also arises of knowing to what extent an experimental research procedure is defined *a priori*. Let us envision various possible instances. Either it is a question of developing a creative process, and describing its experimental operation in the aftermath. In this case the artist would behave in chaotic, nonlinear, uncertain, hybrid fashion in his/her very creating. Or else there is a pre-existing theory, let us call it 'fuzzy' for the sake of brevity. This 'fuzzy' theory is then involved in the actual creative process. That creative process itself can be either systematic or 'fuzzy'. We notice that neither of the two hypotheses, of systematicity grafted on to fuzziness and of fuzziness grafted on to fuzziness, can lead to any formalisable conclusion. This leads us to favour a fourth hypothesis, that of an initial, constructed and rigorous experimental procedure, which will then be displaced in the course of the artistic work. 'Displaced' should here be understood in its strongest sense: displacement is the paradigmatic figure of the 'artistic function', of the operation of art. The theory defined initially will therefore undergo operations of displacement in the course of the experimentation. It will then be possible to describe these operations of displacement and to present them as a breakthrough in art. Art can then be thought of as research in the fullest sense of that word.

It should be noted that what is suggested each time in the arguments of working groups at ELIA conferences is an odd, simplistic partition between so-called 'hard' sciences (including the humanities) and the type of thinking brought into play by artists. Of course it is never contended that artists are incapable of constructing a proper argument. Chaotic, nonlinear, uncertain, hybrid – monstrous – thinking is always advocated.

Either this dichotomy is the work of theorists who investigate the status of our research on our behalf, taking our place, or else we as artists find it very convenient not to have to answer for the rigorous scientific status of our research. We are then falling into line with common sense: all we do is research, art is by definition research, and we need not bother about epistemology or methodology.

As I have tried to show in a few words, from the vantage point of the philosophy of science this binary opposition probably lacks the requisite preciseness. Torn from their scientific context those qualifiers clearly fail to contribute anything specific to artists' own research. The moot point is probably that of knowing who takes it upon himself to define a theory as 'monstrous', or what 'nonmonstrous' theories serve as a foil to the ones dubbed 'monstrous'.

I cannot avoid the suspicion that the parameter being used here is actually common sense, rather than any scientific reference. Now, I would not venture to

come here and allude to some issues I broach in my teaching (both undergraduate and postgraduate) at the Brussels Académie des Beaux-Arts if these issues were not precisely opposed to common sense.

One paradigmatic example, indeed even cliché, of the interrelationship between science and art is the perfecting by artists of the Renaissance of the perspective process of representation. Only in the 17th century, with Descartes and the Port Royal logic, would there be a philosophical construction able to parallel this discovery made by artists. However, it is during the same 17th century that the earliest traces of a topological thinking appeared in Leibniz. This topological thinking will be destined to break open irretrievably the line of classical thinking which the 17th century had just perfected. This heralded unheard-of representations of space, or to put it more radically, unheard-of spaces, spaces which probably still seem monstrous to current common sense. This common sense, which is still with us, constructed itself, somewhat unwittingly, on the basis of classical 17th century thinking. The opposition common sense/topological thinking will be our focus here.

I should like to demonstrate that monsters are not necessarily as you expect them, or that there are gentle monsters and other less kindly ones, to borrow the currently prevalent manicheistic phraseology found in "U.S. made" entertainment. Mr Bush and his spotless good conscience seems a prime example of that 'common' sense with regard to which what I will try to argue is bound to appear 'monstrous'.

I think we see today effects that are monstrous in a literal sense, not in the metaphorical sense I have used so far. Such literally monstrous effects are also part of what artists have to take on. There are monstrous effects today which are the children of common sense. There are effects of 'senseless' killing[1], Le Pen, Berlusconi, Haider or Fortuin effects which need some explaining. And nothing prevents art from also conveying the ideology produced by this common sense, often unwittingly, or thinking that they are being ironical, when such irony merely confirms what it purports to deride. Chakè Matossian, a colleague and (yet) friend of mine often maintains, as did Deleuze, that common sense has tyrannical effects. "Common sense is tyranny". The reason why I introduced a topological type of thinking into my teaching is that I wished to exert a philosophical rigour – a rigour which is no less strict than the scientific variety. There is a question which has always worried me since my teens: what if the works we produce turned out in the long term to convey values which are diametrically opposed to the ones we thought we were purveying?

The question at the centre of all this is that of representation, but I do not have space to do it justice here. Perspective representation, alluded to above, albeit a major achievement by artists, may well turn out to be today the main dead-end of thinking, the main dead end of common sense and of art. Most of the images

produced by so-called 'new technologies', such as computers, digital pho-
tographs, videos, follow the old perspectivistic scheme, namely the scheme of
identification. This occurs within a context in which our societies have witnessed
a hijacking of the pinpointing of the subjective in favour of a 'hypertrophy' of the
ego. We all think in terms of images, of projective images, of identification[2]. I will
use Lacan's terms and say that we think according to the Imaginary. It is on the
basis of this register of identification, of projective, hence perspectivistic images,
that we relate to ourselves, to others and to the world, and also to artistic cre-
ation. Nothing abnormal so far, except that this imaginary register, by becoming
hegemonic, crushes all other registers, and engenders assorted pathologies.
Indeed, it is also on the basis of this overblown imaginary, register that Mr. Bush
designs his self-centred strategy of fighting the 'monstrous', flushing out 'terror-
ists' from the depths of their dark caves. There are bound to be mirror effects
lurking under this. Isn't it Mr. Bush who should be flushed out of his Platonic
cave, out of his planet-wide video game, out of his shadow puppet play?

I will go so far as to advance that the crux of the so-called 'visual' arts is to
escape from a fascination with the image. Maybe plastic arts should not be
dubbed 'visual'. This appellation indubitably reduces their scope, playing a dirty
trick on them. If we described music as 'sound' or 'auditory' art, this would
sound ridiculous. The plastic arts should, according to the hypothesis I am going
to advance, articulate a discourse in which the Symbolic is not entirely over-
whelmed by the Imaginary. I will have to specify what I mean by the Symbolic. In
representational painting, at least since the middle ages, the role of the Symbolic
has been taken on by the various articulations of the historia. As this narrative
dimension now no longer has the same symbolic weight, it is the entire Symbolic
– symbolic in that it has to shoulder the instance of the law – which is under-
mined in favour of a hypertrophied register of the image, or else of a hypertro-
phied register of the object (but I will not be able to go into this here). It is
imperative to emerge out of the device of the Platonic cave, out of the perspective
device, out of the Cartesian set-up. We should develop a strategy able as much as
possible to thwart imaginary alienation, to thwart the omnipotence of the ego, of
narcissism.

I must say that the latest developments in art seem to go in the opposite direc-
tion. Artists seem unaware that they should ask a few questions about this socially
promoted highlighting of the ego, of narcissism. It is odd to say the least that in
the art of the last few decennia everything new is considered worthy of interest.
But then the medium term shows us that those new things which initially evinced
so much enthusiasm are soon forgotten. A modicum of critical acumen, the
development of a few ethical and political, *then* æsthetic criteria would allow us to
avoid many a pointless drifting about. We should for instance ponder the compla-
cency with which artists today tirelessly mine the autobiographical seam. The val-
ue of the undertaking usually seeks its chief justification in a narcissistic refer-
ence: "this is interesting, since I am talking about my precious little individual

history, about my family album, about my family bric-à-brac, and I am, why conceal it, ever so interesting". But then there is no reason why art should avoid the errancies prevalent in our society, and chief among them, the inflation of his majesty, the subject. Nor is there any reason, conversely, why we shouldn't challenge ourselves to exert the greatest vigilance. Why should we today escape *pompier* style, when the 19th century mostly got stuck in it? "Because *we* are not dummies, we are brilliant, obviously!" Our little self-centredness makes us confident that our course of action cannot possibly come a cropper: indeed we can now boast an unprecedented lucidity – a self-delusion which provides additional evidence of that very omnipotence about which we are so boastful.

Working according to topological procedures has had the considerable advantage that it has allowed us to leave the realm of traditional representation. Michel Serres has provided a particularly clear definition of these procedures, by way of a metaphor: "like the weaver or the knitter who move their fingers without seeing them, in them and through them, and not in the Euclidean cube"[3]. Working without seeing: this reminds me of Robert Morris sumptuous "blind drawings". Likewise some of the work developed at times in our studio in Brussels consists in a manipulation of topological surfaces[4]. Or rather, instead of the voluntarism implied by the action of 'manipulating', we might say that it is a matter of slipping into (yielding to) the logic of topological surfaces to explore their possibilities. The world of images presupposes a subject of mastery such as Louis XIV contemplating his gardens at Versailles, to use another *topos*. The topological universe on the other hand forces on us an alienated subjective position, subjected to symbolic laws which are inherent in the logic of this or that specific topological surface. The subject is reduced to the status of an ant walking the topological surface in a loop, without any possible grasp of a totality, without any possible grasp of its path, in the form of a view or of an image. Could we then say that the creative subject has turned away from his narcissism and that this creative subject is subjected to the operation of the surface? There meaning ends: in this subject reduced to the experience of the surface. Very different is our relationship to the image. Isn't this relationship to the image ever and again a specular one? Isn't this relationship to the image ever and again the relentless repetition of the experience of the initial assumption of the *infans* in the face of the specular surface, of the mirror?[5] From a meeting with the topological surface derive entirely different subjective consequences. Identifying with the image in the mirror is clearly not the same as identifying with the possibilities of folds and furrows, of twists and turns of the surface.

Michel Serres stated that an entire world view became null and void with the appearance of topological thinking. In the eyes of science, the metrics of Euclidean space, on which our whole way of thinking depends, has since the 17th century slowly become a mere local peculiarity linked to the sole question of the measurable[6]. This metrics has never been able to account for the qualitative. It is worrying to witness such a gap in today's *episteme* (in the sphere of thinking)

between scientific views and artistic modes of presentation. Science thinks in terms of topology where artists go on living in the age-old universe of representation. What meaning can be given to such a crude anachronism? This break between art and science should make us ponder. Art has thus moved away from science and thinking, to come closer to the utilitarianism at work on technology. Art like technology is at the beck and call of the reigning hypercapitalism.

Jean-François Lyotard in his work *Économie libidinale* advanced the daring idea, an idea derived from a topological conception, that there is no thickness, no libidinal theatre, no stage, no depth. There is nothing to be seen behind, no meaning, no world concealed behind appearances, the appearances of the work of art for instance. There are therefore only surface effects, effects of intensity on the surface. There are energies, intensities linked in a continuity. Theatricality is thus nothing more than the effect of a folding of the surface[7]. In the plastic work produced, there is therefore no longer any subjective will to construct a form or to refer to a theme. Indeed, thematics is the new dominant regression of these last few years. Hence, away with thematics[8].

Those who have heard about it know that no reference is made in topology to dimensions, to size, to proportion: a surface is only defined by a counting of holes and by its orientability, by its one-faced or two-faced character. No longer linked to size, to *Gestalt*, form is now the result of operations on the topological surface, as this surface allows: slippages, displacements, the play of over-under and back-front. The under and the back slip and appear over and in front, while the over and the front disappear under and in the back. There are various modes in which the strip can be pierced, or crossed, various cases of cutting and sticking back together, etc.

This is the monstrosity I'm asking you to envisage here: a qualitative world unrelated to the identity of a measurement, but also the bringing into play of an uncompromising scientific rigour. The appearance of the monster here isn't therefore a consequence of the artist's off-hand ways, but of an attempt to obtain more rigour.

The entire coherence of a system has collapsed over this impossibility of referring any longer to the identity of a transcendent measurement. We have thus gone over to another mode of thinking. If there was one and only one eye at the centre of the perspective device, there was more crucially the possibility of reducing everything, by way of measuring, to one sole reference. Hence the possibility of decomposing and recomposing the world in an ideal fashion starting from one unit, one measurement, one reference. This metaphysics of reference has gradually disappeared, until it has ceased to exist for us today.

I for one tend to think that structuralism represented a radical move forward in the 70's and that a failure to pursue this movement amounts to a regression in thinking, a regression such as all epochs must have known them. Of course,

sometimes you step back the better to jump forward. However I believe that the current return to themes, to biographism is merely a reactionary turning away, and that we need the courage to continue the movement forward involved in the questioning of narcissism by the avant-garde since Constructivism. This seems all the more urgent to me as the prevailing belief in a kingly subject[9] embroiled in the satisfaction of his every whim is the driving force behind the hypercapitalism under which we live. This new tyranny of capital and of the kingly subject is faithfully conveyed by the old conception of representation and of narcissistic images. This is the reason why the deconstruction of that system of representation and the search for different modes of plasticity is essential. Conceptual art had found as its only solution a move away from, out of plasticity towards an appropriation of the conceptual mode. Topological modes offer us a possibility of exploring other modes of plasticity. These topological modes may not be the only ones, but I haven't encountered any other ones. They seem to us today to meet important stakes in the political responsibility of art and of its teaching.

Translation: Philippe Hunt

Notes

1 See Pierre Legendre. *Leçons VIII, Le crime du Caporal Lortie. Traité sur le père* (Paris, Éd. Fayard, 1989).

2 See Pierre Legendre. *Leçons III, Dieu au miroir. Etude sur l'institution des images* (Paris, Éd. Fayard, 1994).

3 See Michel Serres. *Hermès V, Le passage du Nord-Ouest* (Paris, Éd. de Minuit, 1980), p. 69.

4 For further details concerning our teaching see Lucien Massaert. "Art and Theory. An Unorthodox Approach to Teaching," in *European Journal of Arts Education*, volume III, issue 2-3, pp. 25-33.

5 See Jacques Lacan. "Le stade du miroir comme formateur de la fonction du Je," in *Ecrits* (Paris, Éd. du Seuil, 1966), pp. 93-100.

6 Michel Serres. *Op. cit.*, pp. 67-75.

7 Jean François Lyotard. *Economie libidinale* (Paris, Éd. de Minuit, 1974), pp. 9-47.

8 See Pierre Legendre. *Leçons I, La 901e conclusion. Etude sur le théâtre de la Raison* (Paris, Éd. Fayard, 1998).

9 For a critique of the thematic approach see among others Jacques Derrida. "La double séance," in *La dissémination* (Éd. du Seuil, 1972), pp. 276 sq.

14 The Responsibility and Freedom of Interpretation

Mika Hannula

In this essay, I shall try to outline certain premise-related and methodological similarities and opportunities found between the hermeneutic perspective and artistic research. I shall begin by examining hermeneutics, which stresses the temporal and spatial rootedness of the interpreter and the interpretation alike. I shall try to explicate in an applied manner the key points of the hermeneutic approach. I shall then present a version of the methodology of artistic research, one which can be crystallised in the questions: Who am I? Where am I? How and with whom would I want to be? The result will – hopefully – be a preliminary, and, by necessity, a merely tentative notion, of the distinctive character and minimum requirements of artistic research.

The Hermeneutic Approach

I discuss hermeneutics in this essay on a general level on purpose. It is clear that the topic is one with a vigorous and long tradition that is far from homogeneous. (For a good general presentation of hermeneutics, see Bleicher 1980.) I want to see hermeneutics in relation to artistic research, not as philosophy, but as an approach and an attitude. Rather than being restrictive, it aims at opening. It cannot provide answers, merely examine the sensibility of questions, integrate research with tradition, and produce new paths. This being so, an inherent aspect of hermeneutics is awareness of interpretation, where and how it takes place.

The important thing is to realise and accept the historicity of interpretation, and to place approaches within the context of the past. This is a past that is ever present in the present. A past – that is, the tradition and development of forms of thinking and ideas – that we must not denounce, but seek a constructive and critical relationship and attitude towards. (For a general exposition on coping with the past, see Hannula 1997, Chapters 7 and 8.) Similarly, hermeneutics stresses the commitment and contextuality of interpretation. From a slightly different angle, we might say that the content of interpretation is very much dependent on the identity and the situation as well as wishes and needs of the interpreter. What is important is to bring out, publicly and with as much openness as possible, the

conditions and requirements established by the interpreter and the situation.

Temporal and spatial contextuality underlines the reciprocal pendulum move-ment of the interpreter and the interpretation between freedom and responsibili-ty, in which both are present only if the other one is also in the picture. There is no such thing as a perspective or knowledge independent of the object of inter-pretation. The interpreter and the object of interpretation are inevitably forced into interaction. The crucial thing here is how the sides of this interaction affect one another. We are always simultaneously inside the world, a part of it, yet seek-ing for a distance from and a perspective to it. A situation that merits the term double-awareness. Juha Varto has succinctly described the nature of such aware-ness: "Things happen to me and I myself am happening, but there is no way to step outside, to place oneself further off, to see more clearly, to be wiser. I can only exist, in the way typical of human beings: in the middle, putting things in place, foundering." (Varto 2000: 38)

And it is precisely these things – historicity and locality – which practically remove the danger of relativity hermeneutics is all too hastily branded with. An interpretation conscious of its own premises and direction is the very opposite of the idea of a situation in which anything goes and nothing matters. It is quite true that the hermeneutic approach requires a multiplicity of narratives and versions of reality. This, however, does not mean, and must not mean, that all versions would be equally important; instead, it leads to a comparison and also competi-tion between the versions. In the last analysis, the issue is, which versions are sup-ported, and why.

The Italian philosopher, Gianni Vattimo, leaning on the cornerstone of modern hermeneutics, Hans-Georg Gadamer, observes how the point of departure always returns to the historicity and essentiality of content. "An interpretation is not a description by an 'impartial' observer, but a dialogic event, which the talkers par-ticipate in equally and which they leave changed; they understand each other to the extent they are both included in the third horizon, which belongs to neither, but where they have been placed and which puts them in their place."
(Vattimo 1999: 20)

The hermeneutic approach emphasises the being in the world of us all. The fol-low-up question inevitably wrenches the issue back to the ground: where, how and with whom are you in the world? The question refers to a continuous process. To our relationship with ourselves and our environment, a relationship in which the other, strange and unknown, is always both within and without. This shifts the focus onto the attitudes and preconditions as well as restrictions of being together, being in the world. The relationship may, for example, be within the person him or herself, between two people, between a spectator and an art-work, or between the artist and his or her work. But what basic principles does the hermeneutic approach offer and postulate for this relationship?
Even at the risk of oversimplification, the principles can be compacted into two

sequential sub-areas, which in turn subdivide into two. The attitude stems from strategies on how to be together in the world and how to relate to the other, the outsider, after which the attitude must be anchored even deeper in certain restrictive and contextualising basic values, in perspectives on being-in-the-world.

Our relationship to ourselves and to the external world can be crystallised into two strategic elements: 1) to listen, and 2) to criticise. The unavoidable premise is that that relationship must be based on mutual interaction, which in itself renders the situation a highly charged one. The point is, above all, to attempt to establish a relationship at first, which is done by exposing oneself, by listening to what the other wants and is trying to say. In other words, the responsibility rests initially with the recipient, even though it is preceded by, and is impossible without, the will of the person or work to communicate and to seek an interactive relationship. The way in which the relationship is established, as well as its characterisation, are both eminently detailed, contextual and personal. On the general level, encounter and interaction can be described as, for example, lingering by and being astonished in front of the works, together with the works. (Gadamer 2000: 43)

Already at this point it cannot have escaped us how difficult a task we are facing. It is obvious that there is no end to talk or to the need to present one's point, no end to different versions of reality, but who has the stamina, time and ability to listen? This does not mean that we should listen to everything or accept everything with equal seriousness; it means that at first we must, within the limits of our resources, dedicate time and effort to establishing the relationship. After that, the attempt either succeeds or not. Not everything is receivable, or translatable from one language or world-view to another. We must simply accept a certain gulf and incompatibility.

But if and when the attempt is successful and the connection is established, it signals the beginning of a journey, which we may well call a dialogue. A process within which both sides can move and distance themselves from their own premises and points of departure. A process in which the above-mentioned idea of a third horizon gives rise to a third space, which belongs to neither party, but is instead shared by both for that fleeting moment, the duration of their mutual interaction, their shared experience. It is a process of becoming, which, in Gadamer's words, "forces us to linger and offers an opportunity for participation." It is a continuous process, in which "distancing and emerging, lingering and progress, but also movement side by side, alternate." (Gadamer 2000: 54)

First, one must listen and try to establish a relationship. The second, subsequent attitude enters the picture here immediately. It is about taking a constructively critical attitude towards the message received, about placing the message in relation to its origin, the recipient's own background, the chosen tradition and context. The overwhelming questions relate to the identity of the sender of the message, the motive for sending it, the location from whence it was sent, and its

content. The point here is that criticism comes in second place, entering the fray only after the relationship has had a chance to form. If one does not offer a chance for the sender of the message, if his or her message is not placed in the context of the past, if no attempt is made to listen to it, there is no space for, or point to, interpretation.

Of course, listening and criticism always take place in a specific time and place, which means that the event can always be traced back to values and choices. That is, to the fundamental values of the hermeneutic stance, which can be crystallised in two principles: 1) non-violence, and 2) the message of love.

Non-violence is connected with an epistemological situation wherein there is no neutral and objective science or way to distinguish a correct and a wrong inter-pretation from one another in a universal sense. Because there is no single, gener-ally accepted way, something else is needed, and that something else is – in the position adopted here – that things must be discussed and argued without resort-ing to violence. In other words, the only arguments allowed are verbal ones.

This principle can be justified in a number of ways. The background can be found from religious tradition, as Vattimo from a secularised version of Catholi-cism, or it can be found from the perception of the incompatibility of competing scientific theories. Thomas Kuhn has shown how every scientist is a prisoner of his or her premises, for both good and bad. Terms and concepts are always understood with different shades of meaning, depending on the point of depar-ture. The outcome is that dialogue is always incomplete. The point is that, even though Kuhn claims that "the superiority of one theory over another is a thing which cannot be proved by argument", nevertheless "each party must try to per-suade the others to come round to their view". (Kuhn 1994: 208)

Opinions about how the parties are expected to proceed from here differ quite radically within the hermeneutic tradition. Well-known solutions include that of Habermas, who searched for a universal theory of communicative activity, as well as Gadamer's utopistic idea of the unity of perspectives, or horizons, on a tran-scendental level. My point of departure distances itself from these, however, and tries to find an alternative that accepts continuous uncertainty, the lack of certain premises and answers. It also dissociates us from strict, introverted and fixating philosophical disputes.

The attitude may be called the message of love, which, once again, can be found from several sources. Its basis is the Golden Rule, which in the New Testament is expressed as "Do unto others as you would have them do unto you" (Luke 6:31). The command can be seen in the context of a certain religious persuasion, but its content is readily understandable even without it, in which case it conveys a seri-ous and indeed solemn aspiration to treat others the same way as one would wish others to treat oneself, which in turn calls for further clarification: like a fellow human being. (And this opens up one of the many important skeins that reveal

how this beautiful principle only acquires its exacting, even cruel content in particularity. For we must perforce ask, what, in each particular context, do the phrases 'fellow human being', 'fellow citizen', mean, who has the rights of citizenship, and how are those rights interpreted.)

After these principles, we arrive at a famous point in the hermeneutic approach, a point that for some is the very foundation of the devil, for others a necessary precondition of freedom and responsibility. We find ourselves at the hermeneutic circle, where, following the perspective defended here and paraphrasing Heidegger (1986, 152-153), the problem is not the circular movement itself, the endless emergence and exit of perspectives and changing contents, but how to get inside the circle, how to act within it and how to maintain it. In other words, the hermeneutic approach requires active participation in the endless mutual tug of war in which the contents of words and concepts are changed and modified.

This calls not only for a capacity to listen and to criticise, but also for participation, even immersion, but with the courage to call one's accustomed perspectives and values into question and distance oneself from them. This must not, however, mean that we abandon those perspectives and values, but that we adopt a critical and constructive attitude towards them. The key is how the hermeneutic circle, the multiplicity of different versions of reality, is maintained, how the interrelations between those realities are construed and effected. It is obvious that this is a very difficult and cumbersome process. The greatest mistake would be to abandon diversity and try to arrest the, at times, unbearably quickly revolving circle, which is like a carousel.

A carousel in which the individual has no other option but to struggle for and seize the responsibility and freedom of interpretation. This is not naive glorification of diversity, nor blind and escapist denial of diversity, but coping with diversity. One thing is certain. If the carousel is stopped, the reality of each and every one of us is remarkably quickly transformed into a stark cell.

The Methodological Minimum Criteria of Artistic Research

The purpose is not to create an exhaustive methodological set of rules for what artistic research is and how it should be practised. Artistic research, in Finland as well as elsewhere, is an emerging, developing process that is still searching and delimiting its own particular field and methods, and we must accept its process-like nature, including its failures, mistakes and erroneous assessments.

Instead of a finished package, I shall try to bring out, on the basis of the arguments and fundamental values discussed above, the necessary preconditions of the activity called research – whether it be social, political or artistic. We must note that the observations are fairly general, and always insufficient. Only detailed knowledge of and familiarity with the practice and subject matter of one's own research offers an opportunity for the clarification of a local and detailed methodology.

The fundamental impetus of all research must perforce be communication. The desire and the need to say, to communicate something about something – to someone. The next step is not quite as obvious, but unfortunately I must cover it hastily. Communication in research is mostly attempted in a written, analytical form. While this does not rule out other modes of communication, I will concentrate here on the preconditions of written research. Those preconditions always arise from the fact that the researcher and the text he or she produces are part of their environment, part of the world, on which they have an impact and which influences them in turn. Marja Keränen, who has studied the rhetoric of science, has observed that "knowledge cannot be independent of the knower". The conclusion leads to modes of writing "where the writer presents himself as part of the field." (Keränen 1996: 114)

The important thing is to bring out, with maximum openness and clarity, who does the research, why, and on what subject. This makes the method something other than merely a list of distinct rules following which the desired end result can be attained – and then pick up your papers and get out, thank you very much. The method itself remains flexible and evolving over the course of the entire investigation. One fitting umbrella concept for artistic research would be to regard thinking as a methodological map telling both the author of the research as well as its reader how, why and where the research progressed as it did. It is a map that seeks to bring out the premises, progress and end result of the research. And the end result cannot consist of a straightforward answer, or even success, but of the presentation of fruitful new questions and a tentative yet courageous unravelling of the failures.

If the point of departure is a certain version of the hermeneutic attitude, and if the method is seen, not so much an intensely limiting as a directing and contextualising instrument, the fundamentals of artistic research must include at least the following things, which, even at the risk of being boring, I shall enumerate, one by one.

1) As thorough as possible an exposition of the subject matter and underlying premises and motives of the research.
The researcher must explain what he or she is researching, why he or she is doing the research, why it is of interest, and what is the aim. The success or distortion of artistic research is largely dependent on how carefully and meticulously this first step is planned and then, of course, implemented. At this stage, the researcher should explain why the research is undertaken in the sphere of art and within the purview of contemporary art, and not in art history, for example, or sociology. In other words, the first step already sets off the rules of conduct for the chosen mode of research, with far-reaching repercussions. That is, it seeks to discover what autonomous and meaningful artistic research is like. This cannot be done without fearlessly distancing oneself from earlier viewpoints and daring to create a new mode and field of research. We must remember that this does not

take place in isolation. Fruitful and close interaction with the research community is of the utmost importance.

It is obvious that trudging in untrodden snow is difficult and seldom elegant. On the other hand, there is no other alternative. Artistic research should be seen, at one and the same time, as both a risk and an opportunity. The risk has to do with failure. With the fact that the field has no clear tradition or codes of its own. This being the case, the rules of research applied in the neighbouring field seem enviable and indisputable, which, of course, they are not. We ought to remember that only 30 years ago researchers were quite earnestly arguing about whether sociology is a science or not.

Or, going even further back in time, it was not until the early 20th century that the distinction was made between the natural sciences and the so-called humanities and social sciences. All that remains of the larger-than-life mess is a bone, on whose rough surface the debate still goes on about the difference between "explanation" and "understanding". Wilhelm Dilthey, who sought to justify a method not based on the schema of the natural sciences, thus, taking the first steps in outlining the shape of qualitative research, crystallised his idea in these words: "We explain nature; man we must understand." (Gronow & Töttö 1996: 272). Over the decades we have enlivened the maxim and also put a distance between it and ourselves. Even the present article emphasises, not understanding, but the fact of already being in the world and the explication of the relationship to the world. Be that as it may, the question of the scientific validity of any discipline at all is, on the average, accepted as a given. The question is only ever posed if the status of the discipline is uncertain – in practice, this means when it is still developing. And this uncertainty in artistic research is something that must be endured and accepted. An uncertainty that will not be resolved within the next five or even ten years. The discipline's own profile and tradition will take form – if they ever do – only after the work of a few generations.

2) Exposition of the inherent premises in the subject and approach of the
 research.
In practice this requirement, of a historical thrust and further explicating point number 1) above, means that the research is contextualised and linked with earlier writings and research on the subject. This means the determination of whom the research is in dialogue with, which traditions it can be seen as being linked with, and what kind of a stance it adopts in relation to these traditions. As noted above, the tradition of artistic research itself is not very long, but we must not let this fact confuse us or obscure the significance of the theme. It is obvious that very many artists of all kinds have, in particular during the 20th century, produced reams of text as well as statements and diverse views.

The background of research can be, what and how artists have investigated in their own works in the past – and, at the same time, to further develop such

investigations. It can also be some specific area or topic of research to which we want to introduce a distinctive artistic research perspective. The topic can be – quite deliberately drawn out of a hat found in a bar – the relationship of the researcher's own desires to Joseph Kosuth's installations of the late '60s, for instance, or the artist's relationship to Bill Viola's video installations of the early '90s. The point in both cases is that the research is placed within a certain critical continuum, and that it seeks to find its place in relation to earlier research and, thereby, also to attain that which is necessary: possession of the place and locality of interpretation.

3) Appropriation of the chosen research tools and subject.
First of all, we must make clear how and why we have selected the tools in question. This must be demonstrated with adequate knowledge on how the subject has been addressed previously. Moreover, we must try to show adequate grounds for how the research differs from, say, philosophy, gardening or art education. This should not be done by rejecting and shutting out some other viewpoint. Appropriation is possible only if we find our own centre of gravity and perspective and are capable of justifying them in relation to earlier propositions and claims.

4) Artistic research must follow the classical modes of presentation for valid written research.
These exceedingly traditional modes can be listed as follows. We must try to present the research with as much consistency, honesty, economy and precision as possible. That is, elegantly, carefully, sparingly and systematically. Its thrust must be extroverted, opening up to those who are interested, not introverted.

Herein lies a very important distinction between how research, which is unavoidably subjective, can either at worst turn into narcissism and end up in an uninteresting cul-de-sac. Or at best starts from an emphatically individualistic experience and foundation, but seeks to bring out the experience and opinions in such a way that anyone who takes the trouble and is interested can communicate and establish an interactive rapport with the research. If and when these different areas – subjective experience and a relatively general way of using language (yet one which never strays from its proper field and context) – fall in place at the same time, the result is something special, something innovative and something that in good conscience can be called an independent viewpoint. A process that can without tears even be described as artistic research.

5) Assessment of the end result.
Towards the end of the map it is necessary to bring together those experiences that have emerged during the research. It is clear that artistic research cannot and must not provide absolute answers. Instead it can, in a fresh and significant way, search for new perspectives and connections to all kinds of themes. The final report must also present those further questions and problems that emerged dur-

ing the investigation. This secures the possible continuity of the research. At the very least it makes possible a new investigation arising from its basis.

The important thing is that the researcher has the capacity and the courage to assume the responsibility and freedom of interpretation throughout the entire investigation and especially in the final report. He or she must be able to say something, to present an opinion on the research topic as based on certain premises. In other words, he or she must take a stance, present an opinion and support it with arguments. This is part and parcel of the researcher's being in the world, of the fact that the researcher is part of the research subject. If we accept this, we cannot proceed from a need for total understanding of the subject, or from the idea that the research investigates a subject that is on the outside, distinct and separate from the research itself. In other words, the research must be carried out as an instance of being in the world. As a process and a strategy that investigates the subject together with the various parties and aspects associated with it. Research is not of something, but with something. We do not talk, read or look at something and from somewhere, but instead, always, together with something – in a poignant and passionate, yet also beautiful, ever continuing push and pull.

6) Adaptive re-formulation of research practices required by artistic research and autonomous appraisal of the criteria of adequacy.
If and when the field of artistic research is relatively new to its practitioners, it is also quite as demanding and unfamiliar to its readers and critics. Therefore, the demands and conditions presented above apply with equal force to everyone operating in the field of artistic research. This being the case, they all must perforce return to point one, go back to square one, reappraise the rules of the game. This calls for flexibility from all concerned, and for a willingness to discover and examine new modes of operation and new criteria through the preconditions, requirements and opportunities of their own field.

Conclusion
And so. One, two, three and four, together like in a restless dream, on our way from a devilish, insidious nightmare towards the swishing wings of soft-cheeked angels. And back. We shall end with these pictures and these feelings. We end up on a partial, part-time, moving terminal stop, where we find the responsibility and freedom of interpretation, which sounds nice and grand , but which is a dangerously empty space, if we are not in each particular case capable of taking and using enough time and effort to give these demanding terms and conditions a detailed, precise and localised content. Hermeneutic research is and must be about this. About being in the world, about searching for the relationship with the world, and then modifying that deliciously muddled and crazy relationship.

Mika Hannula

References

Bleicher J. (1980) *Contemporary Hermeneutics. Hermeneutics as Method, Philosophy and Critique.* Routledge, London

Gadamer H-G. (2000) *Kuvataide ja sanataide. In Elämys, taide, totuus – Kirjoituksia fenomenologisesta estetiikasta.* Edited by Arto Haapala and Markku Lehtinen. Yliopistopaino

Gronow J. & Töttö P. (1996) Max Weber - *kapitalismi, byrokratia ja länsimainen rationaalisuus.* In Sosiologian klassikot. Edited by Gronow J., Noro A. & Töttö P. Gaudeamus

Hannula M. (1997) *Self-Understanding as a Process - Understood through the Concepts of Self-Understanding as a Narrative Form, the Third Dimension of Power, Coming to Terms with the Past,* Conceptual Change and Case Studies of Finnishness, University of Turku

Heidegger M. (1986) *Sein und Zeit.* 16. Auflage. Max Niemeyer Verlag

Keränen M. (1996) *Tieteet retoriikkana.* In *Pelkkää retoriikkaa.* Edited by Kari Palonen & Hilkka Summa. Vastapaino

Kuhn T. S. (1994) *Tieteellisten vallankumousten rakenne.* Helsinki, Art House

Varto J (2000) *Uutta tietoa. Värityskirja tieteen filosofiaan.* Tampere, Tampere University Press

Vattimo G. (1999) *Tulkinnan etiikka.* Tutkijaliitto, *Uskon että uskon.* Nemo

15 Self-awareness and Empowerment in Architectural Education: a case study

Tony Aldrich

Introduction

This paper reports on a module entitled 'Architecture and Self-Awareness' within a course on *Humane Architecture* at the University of Plymouth, UK. A key premise is that the ability of an architect, artist, or designer to engage with the qualitative dimension of their work relies upon their capacity to empathise, care, and be self-aware. This conviction, that the 'attitudes of the designer' condition outcomes derives essentially from the Romantic tradition in philosophy – from Goethe, and from Ruskin. The paper describes learning activities, asks how skills might be developed which address these qualitative capacities, and cites examples of work produced. It emphasises a strategy to use students' reflections on their own life-experiences and knowledge gained from formal as well as informal means. One tool in this is the 'Rep Grid' derived from the psychology of George Kelly, a way to state implicit beliefs and assumptions which inevitably affect practice and are best seen openly at the outset.

Humane Architecture

The following case study describes a module within the Post-graduate diploma programme, delivered by the author, within the department of architecture and design. The programme, which is entitled *Humane Architecture*, openly calls for an architecture that displays more reverence for life and the environment - one that challenges the desensitising effect of modern cities, celebrates the ordinary, and opens up the extraordinary. The programme promotes an understanding of the determinants of such an architecture and aims to allow students to develop the 'skills' necessary for its realisation.

With an agenda that values holism and inclusivity it is challenging to describe in academic parlance the theoretical context of such a programme. It might variously be construed as originating from a 'critical' position, or feminist ideology, from educational theory regarding student centred learning, or even from the field of ethics. Connections with all of these are acknowledged, as well as with Romanticism, and Humanism. However, perhaps the best way to make things clear is to

remind the reader that, whichever of the above appears to be the case, it is you for whom this 'appearing' is taking place. From the point of view of the programme it is not actually that important to produce an abstract articulation of its position – it is much more interested in direct, participatory transformations of our lived reality. (reader: "Oh, so it's Tibetan then?!"; author: "Did I say that it is?").

Designing the module
Conceiving pedagogy in terms of Self Awareness and Empowerment
The module considered here is entitled *Humane Architecture and Self-awareness* In relation to the above programme the module serves as a vehicle for enabling students to identify and develop skills and operations that might characterise an humane design process. In doing so the module presents the attributes of self-awareness and empowerment as essential factors in the development of such an approach. Pedagogically, these qualities have already been argued as being significant in education (Feigenberg, 1991; Willenbrock, 1991; Dutton, 1991; Sara, 2001). However, the module described here aims to extend the degree to which students are able to engage with these qualities. In particular, it capitalises on the programmatic opportunity for allowing the module's subject matter to be concerned with the self same qualities of self-awareness and empowerment. As a result, this account considers both programmatic and pedagogic information.

In alignment with current practice (Moon, 2002) teaching modes and activities in the module are derived through a consideration of the subject matter and the desired learning outcomes. However, in order to fully accommodate the notions of self awareness and empowerment the pedagogy of the programme itself needed to be recast. In particular, the personal involvement of students in the learning activities was clearly required and, in relation to this, their personal experiences and opinions would have to be admitted as legitimate academic material. What was required therefore was a 'participatory' pedagogy - one that would allow a subject to be held close, understood from within, and nurtured into development and transformation. This alternative approach shares many characteristics with the Romantic and phenomenological philosophies as developed by Goethe, Husserl, and, in a contemporary setting, Henryk Skolimowski (1994). It is distinct therefore from those academic pedagogies which prioritise 'objective appraisal', reduction and detachment. Instead, the students are asked to personally 'engage' with the subject, not just 'learn' about it. As a whole, the programme refuses to reduce education to the process of knowledge transfer and instead, in agreement with Dutton (1991), it regards it as a critical/ political practice.[1]

These reflections on how the programme philosophy might influence its pedagogy also had a reflexive consequence regarding how the module's subject matter was considered. Essentially, when considered from a participatory perspective, the typical conception of the creative design process also had to be transformed and expanded.

Conceiving the design process from a 'participatory' perspective - the 'Attitude of the Designer' and 'Cognitive Process Skills'.

Within Architecture, a typical conception of the design process is of its being an iterative, analytical, exploratory cycle which is impinged upon by numerous internal and external factors. Moreover, in a post-modern context these factors are seen to be in an interactive, multi-directional relationship where causes can equally operate as effects and visa versa.

A diagram of the process might look something like this:

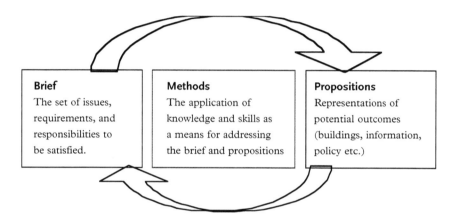

Brief	Methods	Propositions
The set of issues, requirements, and responsibilities to be satisfied.	The application of knowledge and skills as a means for addressing the brief and propositions	Representations of potential outcomes (buildings, information, policy etc.)

In itself, this description is not necessarily problematic. However, the consequences of its dynamic nature do not yet seem to be fully acknowledged. This is especially apparent in those approaches towards teaching design that offer students isolated techniques and strategies for operating within it.

If the design process is genuinely 'chaotic', in the sense of a higher order of complexity rather than just a random disorder (Lovelock, 1979), then trying to engage with it by first breaking it down into stages, quantifying and considered these stages in isolation, and then recombining them is unlikely to be successful. One of the agendas within the *Humane Architecture* programme is to find ways to engage with this difficulty. A particular route that offers potential has emerged through acknowledging the growing discourses within popular and architectural theory that are predicated upon a Phenomenological rather than Cartesian epistemology[2]. Through these discourses, and by reflecting upon the presentations from the numerous visiting experts who have contributed to the programme, a way to relate this area of concern to the design process has developed.

In essence, all of these phenomenological accounts appear to implicitly value a particular type of quality within the design process and call for its wider adoption. Characteristics such as empathy, authenticity, sensitivity, contemplation,

and serenity, are mentioned again and again. These are seen as central characteristics that shape the design process, but which we tend not to give overt consideration to. They are like invisible hands on the tiller, steering the quality of design outcomes in a distinct direction. Acknowledging the significance of these characteristics has required the traditional conception of the design process illustrated above to be expanded. The initial diagram has to make space for a new influence – namely, the role of ones 'state of mind' or the 'attitude of the designer'. A revised diagram might therefore look like this:

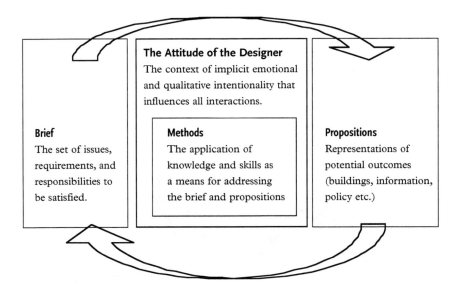

The Attitude of the Designer
The context of implicit emotional and qualitative intentionality that influences all interactions.

Brief
The set of issues, requirements, and responsibilities to be satisfied.

Methods
The application of knowledge and skills as a means for addressing the brief and propositions

Propositions
Representations of potential outcomes (buildings, information, policy etc.)

The module aims to address this region of the design process by considering how the 'attitude of the designer' is characterised in accounts of design activity and in descriptions of completed works. It then asks students to identify attributes that an individual might need to develop in order to re-create these characteristics. Because these attributes are i) concerned with the designer's 'mental/conscious' capacities ii) embedded within the operation of the design process, and iii) dependent upon a level of mastery or ability, they have been given the name 'Cognitive Process Skills' (CPS).

The concept of CPS provides the essential vehicle for the way in which the module pedagogy seeks to engage with the design process. For example, students are not directly asked to articulate ethical / humane strategies for how they might address the various requirements which impinge upon a design process. Neither are they asked to forecast the potential outcomes of such an approach. The choice of principles that one gives priority to, and the procedures that one might adopt, are all acknowledged as varying with the individual. Whilst they do become articulated during the course of the module, individual positions are not overtly judged or assessed. Instead, the module proposes that it is more important to be

'Mindful' of ones aspirations for the production of an *Humane Architecture*. The concept of CPS therefore allows a consideration of the area within the design process where this sort of attention is most present. It allows a focus upon the 'attitudes of the designer' and, as Goethe and Ruskin continually advocated, it acknowledges that honest, empathetic engagement, is a pre-requisite for authentic outcome. As the saying goes – 'it's not what you do it's the way that you do it!'

At the point in the module where students are asked to make connections between their aspirations for architecture and their design processes, the concept of CPS affords them a pathway to bridge between the two realms. (See appendix 1 for a list of the CPS for a humane designer identified to date).

Again, as with the reflections on pedagogy that the subject matter prompted, a participatory approach is central and the attributes of self awareness and empowerment are significant. The following section describes how the outcomes from these two areas of reflection are further built into the module.

Delivering the module
The module overall
Because of the potential mismatch between students' typical / conditioned expectations of pedagogy and the personal participation that is called for in this module, a detailed briefing and an open discussion of its aims and processes takes place at the outset. These highlight the key roles of introspection, reflection and engagement within the module as the means for developing a culture of self awareness, self reliance, and thus empowerment.

In order for students to engage with a subject matter that is often unfamiliar to them (at least within an academic context) it is necessary for the module to prescribe a certain degree of procedural framework. To this end there is a 'set' of given ideas that students are asked to engage with and these are described in detail in the following section. Essentially, these pertain to the methods that need to be utilised for allowing the students to come to grips with the module subject area. For example, techniques for investigation are given, students are required to utilise them, and also to follow the various stages and tasks within the module. At this organisational level therefore, the module is not 'student led' or 'democratic' and this will appear to run counter to the agenda of empowerment. However, it is an intentional strategy, and is seen as supporting the underpinning agenda of self awareness. It is based upon the view that, as long as ideas are openly presented and can be critically responded to, specificity of request is perhaps more beneficial than the apparently more democratic approach of asking students to set their own agendas and find their own ways. It is argued here that having clear, tangible 'objects and arguments' to respond to provide a context that allows clearer and more focussed insights to be gained. Students are asked to critically comment upon the module's methodologies (pedagogic and programmatic) as part of the coursework submission.

The module itself is divided into five stages, each providing a key step towards meeting the overall aim of enabling each student to operate in a more self-aware and empowered manner. One of the difficulties facing the students along this developmental journey is that, in order to maintain a suitable depth and quality of engagement, students are required to negotiate numerous tasks with potentially complex interrelations. A key component in ensuring that these are successfully achieved has been the development of a 'module guide' or workbook which, to a degree, also allows each student to engage with the module tasks at their own pace.

The module stages ask the student to:
1 articulate their current personal relationship with architecture and their agendas and aspirations for architecture;
2 represent their findings in a form that allows them to be addressed and developed (using the concept of CPS);
3 identify and undertake activities that support this development;
4 reflect on the outcomes of the various module activities;
5 produce a reflective written and graphic record of the entire process.

The module stages in detail
Stages 1 and 2
In order to address these stages an interpretative tool imported from psychology is utilised – namely the 'Repertory Grid'. Rep grids originate from Personal Construct Theory, an approach developed by George Kelly in the 1950's (Fransella. 1977). They are based upon the assumption that all of our judgements in everyday life are based upon implicit personal theories that we hold about ourselves and the world. Rep-grid technique is a way of exploring the structure and content of these theories (and which it calls constructs).

Originally, Rep-grids were utilised by Kelly in the context of therapy. By identifying implicit themes and patterns in one's behaviour one was placed in a position to be able to transform them beneficially. The Rep-grid is therefore a tool that affords self awareness and empowerment – you interpret your responses to its questions in your own terms.

The first stage in Rep-grid technique is for the individual to answer a set of given questions. In the context of the module the original Rep-grid questions were recast from Kelly's (which sought to articulate inter-personal relationship constructs) to a set that focussed upon one's personal / architectural relationship. For instance, being asked to cite 'the person whom you regard as your best friend' becomes transformed into being asked to cite 'Your ideal home place'. All of the original questions were transposed in a similar manner resulting in new questions relating to architecture. For example 'The place that is most like you', 'A place that you secretly admire but can't tell anyone about', 'A place that you disagree with', and 'A place that you feel sorry for and would like to help'. (For a full list of the questions utilised see appendix 2)

Following this the students are asked to compare, cross reference and interpret their answers to the above questions. The comparisons are made in sets of three (*triads*), in a predetermined order. (For an example of a completed Rep grid see appendix 3). In essence, its format ensures that responses to negative or positive questions are compared equitably across the set. For every triad of answers, each student is asked to identify a personal theme (*construct*) which they consider to be common to two of the answers but which the third does not fit with or is in opposition to (*contrast*). In this way, each student builds a set of 22 constructs and 22 contrasts – all of which have arisen through a consideration of their own relationship with architecture.

Following this task, the students are introduced to three potential techniques for interpreting the 'qualitative data' that they have compiled so far. Through these techniques they identify significant personal themes and agendas. Originally, in Kelly's usage of the grid, interpretation was undertaken using statistical analysis. In this module however, all of the techniques are located in what the behavioural sciences would term a 'discursive', 'qualitative', or even 'post-modern' investigative paradigm. In part, this is because students of architecture are not typically skilled in undertaking statistical analysis. More significantly however, it reflects the intention to use the rep-grid as a tool to be possessed and integrated by its users. It was felt that statistical analysis would stand as an additional and unwanted 'filter' between the student and the material being considered, and would therefore reduce the degree to which they felt 'ownership' of their findings.

At this point in the module the students have highlighted a number of personal, qualitative themes (both positive and negative) that are central to their relationship with architecture, and their aspirations for it.

Stage 3
In this stage of the module students are asked to identify exercises that will develop their capacity to engage with their themes positively within the context of the design process. This is achieved by asking them to identify the skills that they consider to be pre-requisites for realising their aims.

This request is also seen as a valuable pedagogic strategy for fostering self-awareness and empowerment. Through it, students move towards new understandings and acquire new skills through using tools and concepts that they have come to posses through everyday experiences outside of the academic context. It is a direct recognition of the value of the 'whole' person, and admits their personal 'life' knowledge and experiences as legitimate within an academic context. As a result, students' engagement with new concepts is rendered more tangible, more relaxed, and ultimately more successful.

Not surprisingly the students tend to feel a great deal of ownership and commitment to their themes. However, due to their personal/private character, there are

occasions when students do not wish to discuss them openly. This is not a problem within the pedagogy of the module as it attends to 'engagement with process' and to 'reflection upon personal development' rather than 'product' or 'justifications of attainment'. In reality, the great majority of students can't wait to talk about them and hear from other peers!

A further interesting observation in relation to this enthusiasm is that students seem to own or 'connect with' their 'themes as self knowledge' much more strongly than when they are asked to consider similar themes as presented within existing theoretical or philosophical precedents.

As mentioned above, the concept of CPS is offered here as a tool for enabling students to make connections between their aspirations for architecture and their design process. Once students have identified the CPS that are of value they are asked to prioritise them. Following this they are asked to identify a set of creative exercises that allow these skills to be developed. Ironically, but not surprisingly, this tends to be a step in the dark for many students. The way in which the module supports this step is currently to provide a number of potential 'ready-made' exercises which the students can choose to undertake if they wish.

These model examples consist in part of exercises generated in past student work. Largely however, they comprise a selection from other creative design based programmes. In particular the 'Basic' Foundation course in 'Design and form' at the Bauhaus, created by Johannes Itten (1975), provides many useful exercises, albeit graphic and 2-dimensional ones. For a list of the potential 'ready-made' exercises see appendix 4.

Itten also intended these exercises to cultivate the thinking and practical skills that he saw as being essential in design. Whilst he did not identify the skills specifically, or acknowledge their 'type', they are clearly very similar to the conception of CPS identified above. Parallels also exist with the 'early years' educational theory within the Montessori system and in Friedrich Fröbel's approach.

The latter stages of the module then give the students time to undertake these personalised exercises, either from the given models or of their own creation. For each exercise undertaken students are asked to repeat it at least three times and to keep a reflective and critical log of its outcomes (for some examples of completed exercises see appendix 5)

Stages 4 and 5 Reflection and writing-up
Throughout the module students are asked to keep a reflective log, which, once edited and collated with a record of all of the module activities, comprises the assessed coursework for the module. Within their log students are also asked to respond to the following questions:
• How your understanding of what you value in architecture has changed / developed as a result of the module?

- Your experience of completing the Rep-Grid?
- Your experience of interpreting the Rep-Grid?
- Your experience of undertaking the exercises?
- How your own design process, agenda and techniques will change in the future as a result of the insights gained during the module?
- How do your comments relate to the philosophical / theoretical context of *Humane Architecture*?

Pedagogically, this form of submission aims to avoid the predominantly 'product centred' outcomes that still characterise much of architectural education. In this module, the only judgements about the validity of personal themes and insights are made by the individual student themselves. The module pedagogy, and thus its assessment format, does not need to, it is only concerned with considering the extent and depth to which students have engaged with the various stages of the module. By assessing students engagement and understanding of process instead of 'product', and by assessing their capacity to self learn, self direct and develop, instead of their current level of performance, students have the opportunity to openly and genuinely pursue personal goals for growth and development.

The decision to adopt this submission format reflects the aim of the programme to create a pedagogy that promotes self awareness and empowerment. For example, often in higher education, in order to get students to articulate and develop their agendas or 'position' they are asked to construct arguments that support their beliefs. Whilst in principle this aim is laudable, it often appears not to succeed because it does not fully acknowledge the academic context within which the request is made. Factors such as the 'public' context of the classroom, the power differential between student and tutor, and the system of awarding marks for quality of academic argument (rather than the degree to which it is meaningful for the student), can all hinder the freedom of students to develop and express their agendas and position. Instead, by asking students to articulate their aims in terms of insights that they have gained, rather than asking them to adopt existing external justifications, the module aims to allow them to focus upon improving their personal performance rather than defending an adopted position.

The approach also aims to give students the time to become clear about their position and for it to mature at its own pace. Nearly all students already posses agendas, but they often appear to experience difficulty in making connections between them and academic requests. Whilst student's notes often contained many clues about underlying themes and preconceptions, they often find it hard to spot them. At a pragmatic level, this difficulty was addressed in the module through the use of tutorial support and through peer group discussions. However, it is clearly also further evidence of the need to acknowledge the relevance of students' own personal knowledge earlier in the educational process. This view is also supported by the related experience that many students often initially had little insight into their own design process or agenda. Their heads were full of potentially useful knowledge, but they had yet to synthesise and apply it.

The submission format is also considered relevant as a means to counteract the 'premature closure' of thinking that some academic requests can cause. Students' agendas, like everyone else's, are always evolving. Asking for them to be submitted to external scrutiny (assessment) rather than internal scrutiny (personal reflection) is likely to result in their being either withheld, presented defensively, or even presented falsely (for example, an agenda may be presented because in the student's eyes it is more likely to succeed academically than their own).

The sort of reflective comments that students felt able to include at the end of their reports suggest that these aims were being met. For example:

- "Insights have been gained that surprised me".
- "It is now clear that the processes I currently use as a designer are not the most useful for producing an humane architecture".
- "Having now seen what kind of spaces I wish to create I am amazed that I had not clarified them earlier".
- "I had never consciously realised the connection between my 'self' and my 'design values' before. I feel quite silly stating this as it seems so obvious".
- "If I hold these themes in such high regard why are they so absent in my work? - has architectural education done this?"

Reflections and critique

In conclusion, the module sets out to address the issues of self-awareness and empowerment though three main strategies, all of which are related to pedagogic aspirations and to agendas within the *Humane Architecture* programme.

1. Admitting the student's personal knowledge and opinions as legitimate, necessary, and central academic material. The programme is a vehicle for allowing students to make sense of, and contemplate what they consider to be important – namely, their own experiences, preconceptions and agendas. As Feigenberg (1991:276) argues "students are most likely to become interested in, and knowledgeable about, their subject matter if they are actively involved in their own learning from their own perspectives."[3]

2. Being sensitive to the problems of prescribed learning and instead, creating a participatory pedagogy. As Willenbrock (1991:117) proposes, "words bouncing back and forth are meaningless until they originate from a mind that perceives itself as a partner to an exchange of equality".

3. Acknowledging the influence of pedagogy beyond the arena of educational theory - by treating the qualities of self-awareness and empowerment as both academic, and personal, value-laden, subject matter in their own right. From the humane designer's perspective, as Powers (1999:41) argues, it is "hard to imagine a restoration of beauty and truth without an accompanying understanding of people's material and spiritual needs and a desire for greater social justice than the world has ever seen. This inevitably places politics at the centre of design".

A number of positive outcomes appear to have arisen from adopting these strategies.

- Students reported that self directed learning clearly increased their sense of empowerment.
- Using student's own knowledge does improve the perceived relevance of subject material and therefore also improves their motivation.
- Allowing students to gain insight into their own value systems improves their confidence, clarity of mind, and their ability to give hierarchy to their understanding.
- Exercising reflexivity and contemplation improves their level of 'self-awareness' skills generally.
- Applying these insights through practical exercises reinforced their significance.

Aspects that require further attention also became apparent in relation to the module and in relation to wider pedagogic practice. For example:

- Within the module, the potential for student autonomy and collective decision making can be exploited further in relation to the identification of programme tasks, the timescales during which they are to be addressed, and the methods for engaging with them.
- Similarly, the potential of CPS can be further exploited. Future workshop exercises will aim to allow CPS to be developed in relation to wider contexts – such as interpersonal communications, team working, communication and working with non-architecture professionals or lay persons (Sara 2001).
- Generally, pedagogies which adopt the strategies described above need to be utilised more widely, and much earlier, in student's educational experience.
- At present there is still a gap in educational practice. There is a need for both the architectural syllabus and for pedagogic practice to be recast/expanded to account for the significance of the individual and of qualitative agendas in general. As Dutton (1991:xvi) argues, "to comprehend educational practice in cultural political terms, enables teachers to investigate pedagogy in relation to the larger society, and to ... work toward alternative visions about how life might be organised".
- Similarly, there is a need to move away from solely product orientated study towards student centred and process centred study.
- There is a need to progress pedagogy by reflecting upon the epistemologies and value systems through which subject areas are conceived as much as upon potential teaching practices. Subject and method are more deeply intertwined than much educational theory proposes.

Finally, in its current form, it is clearly difficult, and even inappropriate, to try and obtain a direct 'measure' of the success of the module. The *Humane Architecture* programme critically distances itself from the narrow confines of discourses that only deal with quantification. The module's effects are qualitative in nature, and are individually characterised. Moreover, their context of operation is also

'beneath the surface' of everyday awareness. Any benefits are likely to be realised in the future and in subtle, but hopefully significant, changes within the subsequent work that students undertake. Perhaps what is required are further Cognitive Process Skills that are concerned with our capacity for having 'faith in our own judgement'?

Notes

1 Of course, such a strategy is not wholly new within education. For example, the pedagogical principles embodied within existing approaches such as the Montessori and Steiner systems are related to this position. Similarly, pedagogic accounts from within other disciplines (Sara, 2001: 120 -133) also seek to legitimise and champion self awareness, empowerment, and participation. This is taken to be further evidence of the relevance of these concepts to contemporary teaching and professional practice. What is surprising is that, despite the existence of these systems, and despite the apparent aspirations of higher education to engage with student centred/empowering approaches, current practice still has a long way to go in order to really engage with their ideals. By addressing this issue from a pedagogic perspective the Humane Architecture programme aims to better address this challenge.

2. See, for example, Abram, 1996; Franck, 2001; Day, 1995; Casey, 1993; Skolimowski, 1994.

3 Similarly, Sara (2001) argues that there is a need to "allow for self responsibility in learning", "value students' prior experience", and that "learning is most likely to take place when it builds upon previous knowledge and understanding".

4 A similar concern seems to have been active in project work undertaken at Copenhagen school of Architecture. See Hermann. E, Richter Lassen. J, & Palsbøl. S. (2001) 'Maximum Minimisation' in Harder E. (ed) EAAE. Transactions on architectural education. No 15.

References

Abram, D. (1996) *The Spell of the Sensuous.* New York, Pantheon.

Billington, R. (1990) *East of Existentialism.* The Tao of the West. London, Unwin-Hyman.

Casey, E. (1993) *Getting Back into Place.* Indianapolis, Indiana University Press.

Day. C. (1995) *Places of the Soul.* London, Thorsons.

Dutton. T. (ed.) (1991) *Voices in Architectural Education. Cultural politics and pedagogy.* New York, Bergin & Garvey.

Feigenberg. A. (1991) in *Voices in Architectural Education. Cultural politics and pedagogy.* New York, Bergin & Garvey.

Franck. K, & Lepori B. (2001) *Architecture, Inside Out.* London, Academy Editions.

Fransella. F. & Banister. D. (1977) *A Manual for Repertory grid technique.* London, Academic Press.

Hermann. E. Richter Lassen. J. & Palsbøl. S. (2001) *Maximum Minimisation* in Harder E. (ed.) (2001) EAAE. Transactions on architectural education. No 15.

Itten. J. (1963, 1975 reprint) *Design & Form. The Basic Course at the Bauhaus.* London, Thames & Hudson.

Johnson, M. (1987) *The body in the mind.* Chicago, Chicago University Press.

Lovelock. J. (1979) *Gaia. A new look at life on Earth*. Oxford, Oxford University Press.

Moon. J. (2002) *The module and programme development handbook*. London, Kogan Page.

Pallasmaa, J. (1994) *Six Themes for the Next Millennium. Architectural Review*. July.

Powers. A. (1999) *Nature in Design*. London, Conran Octopus.

Ruskin. J. (Links. J. G. ed.) (1960, reprint 1988 ed.) The Stones of Venice. New York, De Capo.

Tarnas, R. (1991) *The Passion of the Western Mind*. London, Pimlico.

Sara. R. *The Pink Book*. in Harder E. (ed) (2001) in Harder E. (ed.) 'Writings in Architectural Education. EAAE Transactions on Architectural Education No 15. From & Co, Denmark.

Schön. D. (1985) *The design studio*. London, RIBA Publications Ltd.

Schön. D. (1990) *Educating the reflective practitioner*. Chichester, John Wiley & Sons Ltd.

Schneider. R. (2002) *Montessori. Teaching Materials 1913 – 1935. Furniture and Architecture*. Berlin, Prestel, Verlag.

Skolimowski. H. (1992) *Living Philosophy*. Arkana, Harmondsworth Penguin.

Skolimowski. H. (1994) *The Participatory Mind*. Arkana, Harmondsworth Penguin.

Swenarton. M. (1989) *Artisans and Architects*. Basingstoke, Macmillan

Willenbrock.H. (1991) in *Voices in Architectural Education. Cultural politics and pedagogy*. New York, Bergin & Garvey.

Appendix 1

To date the following have been identified by the author and the students as cognitive process skills for a humane designer

1. Capacity for contemplation (Goethe's valuing of 'deep engagement')
2. Capacity for patience / slowness
3. Capacity for concentration / focus
4. Capacity for care and empathy (both towards others, objects and situations)
5. Capacity for heightened awareness of detail, form, situations, and ideas.
6. Capacity for a heightened awareness of ones own emotional response
7. Capacity for depth of insight
8. Capacity for clarity of observation and intention
9. Capacity for holistic thinking (and the poetics of the interrelatedness of things)
10. Capacity for attention to detail
11. Tenacity
12. Strength of conviction
13. Dedication – the capacity to sustain, regular, repeated practice and application
14. Self confidence
15. Capacity to remain open to change
16. Capacity for playfulness
17. Capacity for visualisation
18. Capacity for synthesising solutions from multiple criteria
19. Ability to prioritise
20. Increased sensitivity - physically, and emotionally.
21. Increased sensitivity - towards form, context, materials, and compositional dynamics.
22. Capacity for generating dynamic balance.
23. Capacity for making multiple interpretations
24. Ability to summarise and see essentials / perceive hierarchy / recognise pattern – order
25. Capacity to value the everyday and the ordinar

Appendix 2

Rep Grid questions as utilised in the module.

1. Your ideal home *place*
2. The place that you feel most sheltered by
3. The place that you would most like to work in
4. The place that you would sleep best in
5. The place that you would most like to cook and eat a meal in
6. The place that you feel is most sensual
7. A building that you secretly admire but can't tell anyone about
8. The place that is most like you
9. A place that you used to like but don't any longer
10. The place that you feel you can relate to spiritually
11. The place that allows you to have a good relationship with technology
12. The place in which you feel most 'connected' to your surroundings
13. A place that you feel denies your potential
14. The place that you feel sorry for and would like to help
15. The place that is the most unfriendly
16. A place that you are interested in but want to know more about
17. The place that taught you most
18. A place that you disagree with
19. The worst workplace you have experienced
20. The place that you could not do without
21. The best place you have ever had a celebration in
22. The most ethical place you know

Appendix 3

Two examples of a completed Rep-grid.

Appendix 4

A list of the potential 'ready-made' exercises that students could select from, ranked in relation to the priority given to CPS by the individual concerned.

Pro-Forma **Map of how 'Cognitive Process' Skills are addressed in Activities**

Ranked list of 'Process' skills to be addressed

Key:
✓ = Skill addressed by activity

⊘ = Skill addressed very directly by activity.

Column headings (1–17):
1. IDENTIFICATION/EMPATHY/CARE
2. DEEP INTUITIVE CONTEMPLATION
3. HEIGHTENED SENSITIVITY
4. 3-D. VISUALISATION
5. CREATIVE/METAPHORIC ASSOCIATION
6. HOLISTIC AWARENESS
7. AWARENESS OF IMPLICIT ORDER
8. " OF ORGANIC PATTERN
9. " OF HIERARCHY
10. RICHNESS/TACTILE READING
11. RELATIONAL AWARENESS (BODY)
12. " (FORMAL)
13. DISTILLATION TO ESSENTIALS
14. SYNTHESISING ABILITY
15. CAPACITY FOR ABSTRACTION
16. CONCENTRATION SPAN
17.

No. Description of activity	1	2	3	4	5	6	7	8	9	10	11	12	13	14	15	16	17
(BAUHAUS SERIES)																	
1. EYEBORD TONE SCALE	✓	⊘			✓		✓				⊘	✓			⊘		
2. TONE RELATIONS (3 N°)	✓	⊘			✓	✓		✓			✓	⊘	✓		✓		
3. TONE RELATIONS (MULTI GRID)	✓	✓	⊘		✓	⊘	✓	✓	✓	✓	✓	✓	✓	✓	✓	⊘	
4. HARMONISED TONE SEQUENCE	✓				⊘	✓					⊘		✓		✓		
5. BALANCED TONE COMPOSITION	✓	✓			⊘	✓					⊘			✓			
6. BALANCED FORM COMPOSITION	✓	✓			⊘	✓					⊘		✓		✓		
7. EXPRESSIVE POTENTIAL – LINE	⊘	✓	✓	⊘		✓					✓					✓	
8. " FORM	⊘	✓	✓	⊘		✓					✓	✓				✓	
9. " TEXTURE	⊘	✓	✓	⊘			✓	✓			✓					✓	
10. " COLOUR	⊘	✓	✓	⊘							✓					✓	
11. EXTENDED TEXTURE SCALE	✓	⊘			✓		✓				⊘	✓			✓		
12. BALANCED TEXTURE COMPOSITION	✓	✓			⊘	✓					⊘		✓		✓		
13. EXTENDED COLOUR SCALE	✓	⊘			✓		✓				⊘	✓			✓		
14. BALANCED COLOUR COMPOSITION	✓	✓			⊘	✓					⊘		✓		✓		
15. DIVISION OF FORM WITH LINE	✓	✓	✓		⊘	✓	✓				⊘				✓		
16. " TONE	✓	✓	✓		⊘	✓	✓				✓				✓		
17. EMPATHETIC RESPONSES	⊘	✓		⊘		✓	✓	✓		✓	✓		✓		✓		
18. PHYSICAL EXERCISES		⊘									⊘						

Appendix 5

Some examples of completed exercises, and of reflective commentary upon the results.

Ready-made exercise No3. Tone relations (multiple)
As with exercise 2, obtain a good colour A4 size copy of an original masterwork. Divide up the painting into a grid of squares (at least 12 squares wide by 12 squares high). Make a pencil copy of the painting made up of the same arrangement of squares, which just uses tonal values. Again, do not draw any lines around the squares, just use tonal difference to describe them. You can use an unlimited number of tones but you must try to preserve the relative tonal values of the original painting. Repeat the exercise with progressively more squares.

Original chosen. *John Constable*.
Detail from : 'Boat building by Flatford Mill'. (1815

Attempt 1 Attempt 2 Attempt 3

16 Outside the Frame: teaching a socially engaged art practice

Beverly Naidus

This is a story of not being satisfied with what was expected. It is a story about filling in the blanks that were left by a public education system eviscerated by the McCarthy Era in the U.S. It is a story about a painstaking search for role models in histories that weren't taught. It is a story about discovering how art can get under the skin more deeply than any political speech. It is a story of stepping away from what one thinks one knows, and opening the door for students to teach.

This story starts with a confluence of events, but I can't say which one was the most significant. Was it the twinkle in my father's eye when he spoke about standing on soapboxes in Union Square in New York City in the 1930's – a place where he found his voice, when the scheduled speaker did not show up, to speak about the injustices of fascism? Was the passion born in summer camp, where so many of us, children of immigrants' children, belted out socially conscious folksongs while sitting around campfires? Or perhaps it all started when I was seven as I sat in what became a favorite room in the **old** *version of the Museum of Modern Art, before it became an art department store. In that favorite room were paintings that offered spaces of truth I hadn't seen before. Among them were David Alfaro Siquieros's* **Echo of a Scream** *and Pavel Tchelitchew's* **Hide and Seek.** *I was transported into complex worlds filled with something quite unlike the picket-fenced facades found in suburban U.S.A.*

But perhaps more importantly than my assorted individual experiences, this story has to do with being born into a time where so many of us were asking questions and confronting the status quo. I was eagerly caught up in that generational whirlwind, yet another cycle in the movement for social change. Somehow it seemed like the mass of us taking part in anti-war protests, feminist support groups, and civil rights actions, were part of a huge force, a tidal wave that would change society for the better. In the midst of this, I chose art, or perhaps it chose me, as a way to process my confusion and make sense of my fears about the world. In the terrain granted by the Muse, I found the freedom to vent, challenge, and call forth uncensored a range of thoughts and feelings disallowed in my neatly mowed, hemmed and tucked New Jersey town. Early on I saw art

making as a path to power and knowledge, and as a juicy, uninhibited way to find community and create dialog. This path was not encouraged in my upwardly mobile family who wanted me to do something "serious" with my life. But my ambition was not frivolous; I did not want to become a wall decorator for the rich, but rather I saw the potential for an awesome cultural revolution.

Breaking the Trance: Deconstructing an Art Education

Scene 1: A New Jersey suburb of New York City in the late Sixties. The art room in our high school was a safe space. The teacher promoted free expression while giving us the standard, but mostly unconscious dose of Late Modernist doctrine: "universal" aesthetic values and a belief in the idea of genius. I was not his genius, but the approval I received for my paintings, images that vented my teenage angst, helped reinforce my very tentative path towards a life in the arts.

Scene 2: The Art Students League, New York City. My Saturday morning ritual of taking the bus into the city aroused worried looks from my high school peers who were taking the same bus to the local malls. This was not the first suggestion I had received that studying art, especially in an urban setting where you might get dangerous ideas, could be seen as threatening to suburban U.S. values. When I first sat down to draw, heard the buzz of students around me and inhaled the pungent smell of oil paint and turpentine, I was sure that I had come home. The sensuality of that moment resonated for years to come, each time signifying a deep desire for risk-taking, expression, communion, and recognition.

Scene 3: Summer of 1974 in Provincetown, Massachusetts. There were at least 30 of us, young and ambitious painting students, squeezed into a steamy, fume-filled studio listening to our teachers drone on and on about the merits of one painting over another. Both trained by the Abstract Expressionist, Hans Hoffman, these teachers placed the highest value on images that had no representational residue and no clear meaning. Allowing my stream of consciousness to flow was liberating, but the personal iconography that emerged from our work spoke to a very small audience and ultimately did not speak to me. Every day I was having a raw confrontation with class issues as I cleaned the beach houses of the rich. I swam both figuratively, and literally, in the sea of Provincetown's blossoming gay culture. And the art I made had no clear connection with my life.

Scene 4: Fall of1974 at a small liberal arts college in Minnesota. Some of the male art teachers were attempting to groom me as their "queen bee," setting me apart from the other female art students as the one who might actually become a producing artist, rather than a consumer of culture: "most of these girls will marry well and, if we do our job well, they will decorate their homes with our work." Perhaps it was the time, or the fact that we had no female teachers and few female role models in the art history lectures. We decided that we had had enough of this patronizing arrogance, and put our collective feet down. We talked late into the night, revolted en masse and asked for our own budget. Then we

brought in feminist visiting artists, hung our own exhibits, worked collaboratively and began to question everything we had learned. Maybe painting our own stories was not a bad thing to be doing. The status quo art world said that what we had in mind was "therapy," but we didn't care what they thought. We would not be satisfied with anything less than a cultural revolution.

Scene 5: Fall of 1976 at graduate school in Halifax, Nova Scotia. I was a teaching assistant in a beginning painting class. Over twenty students, mostly young, were spread out at easels and walls, each working quietly and intensely on paintings of all different sizes, shapes and materials. I watched the instructor slowly move around the room, engaging in private conversations with each student. When I listened in, I heard her ask them questions about their art practices; what were they struggling with in this painting, who were the artists that inspired them, when did they know when a painting was finished, and so on. In a few cases the questions became quite personal. There was a strange intimacy about the dialog, as if the instructor was facilitating a therapy session.

Much more intensely personal than my experience in Provincetown, I wondered if this was the new way to teach a studio art class. Whether in private conversation or in group critiques, the discussions revolved around each individual, his or her search for meaning in form, and the odd obsessions that defined their vision. Art seemed to be made by these students without any social context other than the art world. It was assumed that all the students felt alienated from society; after all, wasn't that why they were in an art school in the first place? But with that fate, came no social responsibility.

Although I was only beginning my research on this topic, I saw this attitude as the legacy of McCarthyism and the "art for art's sake" ideology of Late Modernism. I had grown up in a family where doing work of social value was both implicit and explicit. Despite suffering economically during the Black lists of the Fifties, my parents raised me to be a socially concerned person and to contribute my skills to make a difference in the world. This upbringing made me quite uncomfortable with an art practice that seemed to manifest totally as an upwardly mobile lifestyle or as a black clad, bohemian pose.

The Reconstruction Begins

The questions that went unasked by that graduate school instructor became a wellspring for me: *why* were the students making art, who did they feel was their *audience*, what were their *intentions*? Did they aspire to have their names in the trendy art magazines or in art history books, or did they want to speak their truth with no goal of fortune or fame. During that first year in graduate school I was blessed with an insightful studio mate and fellow graduate student, Bruce Barber (a conceptual artist from New Zealand), with whom I could have long conversations about these questions and the purpose of art. Soon I was reading John Berger, Walter Benjamin, Ernest Fischer, Arnold Hauser, Paul Von Blum, Lucy Lippard and many of the early feminist art writers who could be found in the

inspiring, but now defunct, *Heresies Magazine*. I discovered that political art had a long history, beginning with the broad sheets produced by peasant revolutionaries during the Middle Ages, and that the tradition of using art to tell stories of injustice was well rooted, if submerged, in Western Culture.

As a result of living in Canada and having the world news filtered in a profoundly different way, I began to question more and more of my assumptions. I developed a fresh socio-political perspective that I had not been privy to in the U.S. At the same time, I was asking myself why I was making art and for whom, and so, without much hesitation, my process of art making began to shift. The cryptic symbols that had emerged as abstract marks from my brushes were replaced by lines of text, typewritten on translucent paper. Each scrap of paper dangled like a price tag from bare hangers, exclaiming "Buy One Now!" and "You Need This!" My angst-ridden search for a private iconography was being transformed into a quirky sense of humor about the contradictions in everyday life. A pair of white pants was lightly cartooned on paper; a small red dot of paint placed politely on the crotch. Scrawled across the top was "the wrong day to wear white pants."

Slowly I found images and words that could *communicate* my increasing sense of urgency about the state of the world and my place within it. I learned how to use art as a tool for consciousness raising and as a way to invite others to share their stories. I began to make site-specific, audio installations about my nightmares about nuclear war, my frustration with consumerism, and my questions about standard notions of success and middle class propriety. When my pieces were effective they provoked an unexpected response and reward: audience members would offer me stories about their own lives, including their nightmares and dreams for the future.

Visitors to my audio installation, *This is not a Test*, that depicted the dwelling and inner voices of the last survivor of a nuclear war, were provoked to tell me stories about their terror during the Cuban Missile Crisis and their cynical responses to the official phrase "duck and cover." They talked about being numb and wondered how many missiles were targeted in our direction at that moment. I was amazed that my art had triggered such a generous outpouring of stories and began to see how art had the potential to turn what I thought were my personal anxieties into collective concerns. I was developing my artistic voice at the same time that feminist art was becoming visible as a movement. Within the context of that movement, personal story was profoundly important, especially as it referred to the politics of oppression. Along with the experience of gender politics, I began to see how economic class, cultural identity, geography, sexual orientation, and age could influence or frame an artist's point of view. As a teacher, I wanted to share these discoveries with others.

I assumed that there might be a few other students who had been affected deeply by the liberation movements of the sixties and seventies (civil rights, anti-war, feminism, gay rights, self-realization, etc.) and who might be searching for a

different path as an artist and looking for support.

My last semester in graduate school (1978) I had the opportunity to create my own course and to find some of those students who wanted to explore different approaches to art making. The course focused on the assumptions we have about the world, by looking at the meanings and connotations of "loaded" words. I had just finished reading *Teaching as a Subversive Activity* by Neil Postman and Charles Weingartner (1969). These two educators questioned an outmoded educational system that was not keeping up with the rate of change in our world. They offered new strategies for critical thinking that might give our society tools for confronting the problems that were and are threatening its survival. Their approach to making the classroom relevant by addressing political and social issues included a discussion of the shifting meanings of language. By focusing on the connotations and denotations of words, they exposed a method for examining the underlying values and assumptions of a culture. I wanted to expand their approach to critical thinking and relevance by adding images into the equation.

We started with the word "exotic." A loaded word to be sure. It was a particular favorite of mine because I had often been given that label (because of my dark skin, eyes, and hair) by well-meaning acquaintances. The students jumped into interpreting this word visually, producing a wide variety of artistic forms—from photocollage to painting to found object sculptures—to illustrate their meanings. We had a wonderful debate about which meaning was the "right" or "correct" meaning of the word, what it means to be considered an outsider or an "other," and what it means to make art to communicate meaning. As the course progressed, students chose their own provocative words and we brainstormed ways to share what we had learned with a larger audience. During the final week of the course, we had a public exhibition and dialog about what it means to make art with a particular intention: in this case, to communicate meanings and look at the implications of those meanings in the broader society.

Whose Culture has Value?

After leaving graduate school I returned to New York City and found work, teaching art in several museums. Every three months we would focus on one section of the museum, for example: The American Wing, the African Collection, or the Twentieth Century painting galleries. I knew from the moment I was hired that I was not going to follow the party line, offering the "disadvantaged" and "culturally deprived" an experience of "high" culture. I was looking for a new strategy to make art in the museum relevant to my students, a strategy that would help the students develop critical thinking about the world, and give the students more awareness of their values. My supervisor gave me a great opportunity: I could address the content of the collections in any way I saw fit and I could develop whatever kinds of art projects that I felt were relevant to my focus.

The students came from public high schools all over the five boroughs and were mostly the children of the working poor and the lower middleclass. I worked with

the students at their schools for several sessions and at the museum twice. During one of my school visits we looked at advertising as a visual and social message and discussed the values that ads promote. We wrote lists of what we were being sold, aside from the product. From that list we were able to explore how the students' values contrasted with what Madison Avenue was promoting. In all cases, the contrast between the slick and manicured glossy magazine ads and the student's personal lives and communities was extreme. They could see quite clearly how the ads made them feel badly about their lives, and how ads intended to make them buy products in order to feel *better*. Developing this kind of critical thinking was key to my process with them.

We also had long discussions about what they valued in their communities and cultures and whether they saw those values displayed on the walls of museums or in advertising. Our talks generated images and ideas about genuine needs and concerns, rather than ones the students felt they were supposed to have – based on what they saw in popular or "high" culture. We also looked at slides of art that raised questions about the world, which spoke to the truth of what it means to suffer and struggle, and that provided visions of better life.

The student art that emerged from all of this talk was multifaceted. They created papier maché masks that expressed the individual student's power. The masks were used to make plays about the community's stories and local hidden history. They designed ads to promote each individual student's strengths and talents. They made paintings of their dreams and nightmares. Some looked at the ways the crises in the economy and the environment were affecting their local communities. At the end of each semester, the schools were invited to display the student work at the museum for one evening and were given a special reception for this event.

While this series of workshops did little to subvert the museum environment, it certainly raised many questions for the students about how culture is transmitted and whose culture is given more visibility and why. During the five years I taught in NYC museums, I not only asked students to notice how little of the work on the walls was made by women and artists of color, but I encouraged them to find new venues for their self and community expressions.

At that time, NYC was filled with all kinds of alternative art spaces and collectives of artists doing socially engaged art. I participated in several activist artist groups whose collaborative projects on gentrification, reproductive rights for women, and nuclear issues entered the public realm in new ways – as site-specific installations, performance art, interactive carnivals, billboard correction, "subvertizing" and other forms of street art. This was an exciting time and a desperate time. There was no shortage of subject matter for an activist artist. Reagan was the president; the Cold War appeared to be on the verge of HOT. The economy had shifted dramatically, with housing costs becoming exorbitant. The ecosystem was rapidly falling apart.

Still the huge shadow cast by the New York art market and the financial stresses most of us were encountering forced many of us to make choices. Some chose to promote their ideas through the mainstream gallery context, some found grants to work with communities as cultural animators, and others found educational contexts in which to promote their vision for social change.

Shifting the Discourse within the Ivory Tower

I was among the latter group and left NYC in the mid-Eighties to teach art at a small liberal arts college in the Midwest. It was a time of ivory tower insulation with little visible student activism. Many students were focused on securing glamorous and lucrative careers and didn't want to be bothered with uncomfortable social issues. I remember being asked by a sarcastic student, "what are you gonna paint out here in the middle of the cornfields?" So I went back to the studio and painted the cornfields down the road, with nuclear missiles sleeping in underground bunkers ready and waiting for red alert phone calls. I painted the empty farms with "for sale" signs hanging on the barns, decorated with symbols of mourning for the farmers committing suicide left and right. There was no shortage of subject matter for anyone paying attention.

Despite the dominant feelings of apathy on campus, there were many young students who had a strong social conscience, and some of them found their way into my classes. Some were working to end apartheid in South Africa, some were trying to heal from dysfunctional family life, and some were looking to understand the epidemic of eating disorders among their peers. While it was important to share with these strongly motivated students how art could be part of their vision for social change, I also felt a sense of mission to awaken other students who seemed asleep at the wheel. Most of my assignments offered opportunities for students to find their personal voice, a voice that was informed by the place where they grew up, the economic class of their family, their cultural heritage, their age, and many other factors. While strengthening their sense of artistic voice, the students could also broaden their understanding of their place in the world.

Using a social frame, the simple choice of placing objects in a "still life" had larger implications. Where did the objects come from? What natural resources were used to make them? Who labored to fabricate them and how much were they paid? Who purchased these objects and how were they used in their new home? What meaning did the student derive from each object in their new context and how did this social lens expand the meaning? And how could we reveal these meanings in the actual art piece and communicate them to a less aware audience?

When painting a landscape, could we observe the effects of development, farming practices, and ecological stresses on that landscape? How could we find an appropriate art form to share those revelations or concerns with an uninformed public?

And so on. Every formal tradition of teaching art could be analyzed and reconstructed using this lens, from assumptions made about the study of the figure and its objectification of the body to the cultural imperialism often implicit in art history classes.

Engaging students in this kind of question asking was the only way I found it comfortable to sit in academia. During my two-year appointment at this college and my subsequent nine years teaching "New Genres and Intermedia" at a state university in southern California, I kept challenging the standard curriculum, trying to find ways to make my art classes reveal more about the world. Not surprisingly, this questioning made some of my colleagues quite uncomfortable. I saw this discomfort as healthy, giving us all the opportunity to grow. It was heartening to see some of my more adventurous colleagues shift their practice and research to include a more socially conscious perspective.

Action/Research as a Strategy for Social Change

As time passed, I felt I needed more tools and role models to offer my students. After attending several national meetings of the Alliance for Cultural Democracy, an organization of artists who made their socially engaged art specifically within community rather than in the studio, I was inspired to offer my students new strategies for making art. Many ACD members saw themselves as cultural or community animators, artists who facilitate a creative process *within* the community rather than as artists making pieces *for* communities or directing the communities to make work based on the artist's vision. With this new insight, I encouraged my students to work collaboratively and to find new public contexts for their art.

When my students were designing a public art project, we would discuss the various strategies available to us. Would we create "plop art" that had no relationship to the community, but had everything to do with our individual vision? Would we attend public meetings that gave us some notion of community concerns and then shape those ideas into an art piece of our own design? Would we invite specific communities to paint or perform in pieces of our design? Or would we bring our skills into the community and offer them up, encouraging the community members to collaborate with us and make the art about their lives?

In the summer of 1993 I had the opportunity to study cultural animation with founding members of the exciting and well-established community arts organization, Jubilee Arts that has been based in West Bromwich, England since 1974. Jubilee, now known as "The Public,"[1] is one of several groups that have given definition through their work to a kind of socially engaged art practice known as cultural/ community animation. As the brilliant cultural activist and poet, Charles Frederick, theorizes:

> "cultural/community animation means to revitalize the soul, the subjective
> and objective, collective and personally experienced identity of a community

in historical or immediate crisis. Using a plethora of art and performance forms, the community gathers in all of its internal diversity with autonomous democratic authority to explore critically its social and historical existence. The product of this cultural work is for the community to create new consciousness of itself and a renovated narrative of its imagination of itself in history expressed in a multitude of forms. This new narrative is created beyond the boundaries (while in dialectical recognition) of the previous, external and internalized narrative of oppression. Identifying itself within this new narrative of subjective and objective history, the community is empowered, while publicly expressing its presence in history, to make new history and a new destiny for itself, in an organized program of social and political action, thus adding new chapters to its historical narrative. While in the aesthetic project of composing its narrative and while at the same time in the political project of acting from its new story, the community is re-composing itself, both symbolically and actually in freedom and with justice."

Jubilee had been invited to northern California to do art projects in the very polarized community of Mendocino County. The major tensions in the community existed between the people who relied on the logging industry for their daily bread and the environmentalists who were putting their bodies on the line to save the remaining old growth forests.

Into this fray came a group of thirty or so activist artists and cultural workers from all over the U.S. and the Jubilee team. Our goal was to learn how to use art to create dialog between communities in conflict and to make the narrative of invisible groups visible. We had a laboratory to learn about the process. Every day we participated in a series of exercises that are standard fare for Jubilee cultural workers. *Action / Research*, a term to describe a way of gathering information and making art from it, was the most important lesson we gained from our time together.

We broke into small groups and were asked to share a social issue that concerned each of us at that moment. We each discussed our individual issue for several minutes, and shared a story with the group that illustrated our concern. We created a list of issues and discussed how our issues were interrelated.

After that we were invited to make a skill inventory. The skills that we listed were very broad from: "writes poetry" to "makes good soup" to "talks well on the phone." With this list and the list of social concerns, we began to brainstorm a form, an intention, and a context. In other words, we developed an art piece that connected many of the our social concerns and that could be made in the space of 24 hours using the skills that we have brought to the table. We thought carefully about who our audience was, what the limitations of our skills, materials, and

exhibiting space were, and what we hoped to accomplish.

While the product of our efforts was not memorable, the process was. Within two days we had developed new ways to communicate and create consensus with a group of strangers. We were ready to go out into the world and practice with these new skills.

Our group was assigned to the local Senior Center where our intention was to collect stories about the elders' perceptions of both the tensions and the benefits of living in the area. We found different ways to start conversations and once a little trust was established we asked people if they wanted to photograph each other. The portraits and the stories became the substance of an exhibit at the local mall. Since the stories were gathered in the cafeteria we decided to exhibit the portraits and the stories as place settings.

This taste of *Action / Research* was a beginning. To be effective cultural animators requires all participants to make a commitment of time and resources. Trust must be built slowly. When one is not a member of the group, a bridge person must be found. An artist/facilitator who dips into a group for a short stay and exploits the group's talents for the artist's own benefit can create bad feelings all around.

The inspiration I brought home from my work with Jubilee was obvious. I was asked by my department chair to renovate and re-energize a course on "Artist Survival Skills" that had previously focused on resume and portfolio development, and networking skills. My new course looked at social concerns that affected artists' lives and was a required course for all art majors. Students looked at how artists are educated, how the mainstream art world functions, how artists who work in community facilitate their work, how sexism, censorship, homophobia and racism affect artists, and how to survive in a society that is trained to be art-unfriendly. We had guest artists and art professionals come and give relevant lectures every other week. I put together a collection of readings to supplement the issues raised by the speakers and my lectures. Aside from an open book essay exam at the end of the course, the only other assignment was for students to work collaboratively on a community art project of their own design.

This course became controversial for quite an interesting reason. One colleague despaired that I was not preparing students properly for the outside world. He said, "These are working class students who need to find jobs in the art world and in the Industry (Hollywood). Your questions will make it difficult for them to fit in and accept the positions that are available."

Perhaps this colleague did not understand the goal of social change. Realizing that most art students stop making art and looking for work in art related fields after receiving endless rejections from employers, galleries and granting agencies, my greatest desire was that these students would develop the confidence, resources, and smarts to create new opportunities, paths, and alternative institu-

tions. Or, if they chose to work within the mainstream, that they could offer up their critical thinking skills to subvert the discourse and open up the minds of their colleagues.

Art for Imagining the Future and Envisioning Utopias

In 1991 I was invited to lecture on my work and activist art at the Institute for Social Ecology (ISE)[2]. At the time ISE was located on the Goddard College campus, in the lush, green mountains of central Vermont (ISE has since bought its own property in the same town and is now accredited through Burlington College). During the month long residency I facilitated several art projects with the students, including a collaborative bookwork filled with photo collages, drawings, and text of visions for the future. I call that first summer at ISE my "introduction to utopian thinking. "There I met some of the most idealistic and visionary community activists that I had ever met. The students came from all over the world, some working in communities where their work in literacy campaigns or planning housing projects was life threatening (because of the inhumane governments in power). Many of these students had never thought of themselves as artists, but they had the imaginations to fuel movements and to create bridges into all kinds of communities.

From that first summer and through eleven more, my husband Bob Spivey (who had received his Master's in Social Ecology with a focus on activist art) and I co-facilitated a course called "Activist Art in Community." The course changed shape, size and facilitators but it remained an essential part of the ISE summer diet and was offered at other colleges as a weeklong workshop.

We started the ISE course with an introduction to various strategies for making activist art and community cultural work. I shared a slide show about activist art that had many threads: pre-McCarthy era socially engaged art from the early part of the 20th century, the first stirrings of protest art during the Vietnam War era, early feminist art and contemporary work that embraces women's issues, ecological art that ranges from projects that "reclaim" damaged pieces of the environment to work that addresses the infiltration of genetically modified foods in our diet, art about racism and cultural identity, art created as part of the anti-nuclear movement, art about the AIDS crisis, homelessness, poverty, unemployment and gentrification, community-based art projects, and anti-globalization art.

After viewing the slides we began a discussion that continued in different forms throughout our time together. We looked at satire as it manifests in the form of "culture jamming," also known as "subvertizing," and debated the effects that it has on viewers. We looked at the advantages of showing work in all kinds of public spaces: college galleries, museums, shopping malls, city walls, subway cars, billboards, magazine racks, storefronts, the Internet, beauty salons, laundromats – basically anywhere that people gather.

We talked about the many purposes of socially engaged art; including: to provoke thought, to wake up those who are in denial, to create dialog between groups in conflict, to make invisible groups more visible, to empower, to heal, to educate, to reveal hidden histories, to celebrate a community's strengths, to document, to speak when everyone is scared, to enlighten, to transform, and to speak to truth. We debated the necessity for strong aesthetics; in other words, does it need to be beautiful or visually seductive in order to attract the viewer?

Next the students were introduced to a version of an *Action / Research* process that we learned from members of the Jubilee Arts group. I suggested that the students work with gut issues, things that they had directly experienced. During the brainstorming process we encouraged students to focus on how their issues were interconnected (using some of the theories of social ecology), what their goals were for their piece, who they were trying to reach and in what context they wished to reach this particular audience.

We also encouraged students to continue a version of *Action / Research* in their home communities with a team of collaborators. Every community can benefit from this process – whether it is celebrating the creativity of invisible residents, working with the alienation between teens and adults, healing splits between new-comers, transplants, and old-timers, or sharing antidotes to consumer culture.

After the students shared their *Action / Research* work and gave each other helpful feedback, they spent the rest of their time at ISE developing new projects (both individual and collaborative ones). In our many conversations, we tried to distinguish the difference between many forms of activist art and made no judgments about which form is more important or valuable. Socially engaged art that is produced by individuals working alone may have a powerful impact on audiences. Cultural work that is a byproduct of a movement can make a significant impression, especially when the media lens is focused on it. Projects that emerge out of a community/cultural animation process may also have an enormous effect on the public, but perhaps the most crucial aspect of this particular work is what it does for the community itself. The key point here is that one form might be more appropriate for a particular intention and context, and each artist needs to evaluate those choices based on her or his abilities.

The two-week schedule of our last version of Art, Media, Activism and Social Change included many different components: social ecology theory, media theory, hands on technical workshops, a practicum on media literacy, performative exercises that were influenced by Playback Theater techniques[3] and Augusto Boal's Theater of the Oppressed[4], and lecture/demonstrations by visiting artists like the Beehive Collective (whose anti-globalization projects take many forms)[5]. Graciela Monteagudo (member of Bread and Puppet Theater and creator of her own street theater projects concerning the Mothers of the Disappeared from Argentina)[6] and Seth Tobocman (founder of World War III comics – a publication

whose artists have focused on many social issues including homelessness and the squatter movement of the Lower East Side).

Unfortunately the failing economy during the Bush-Cheney era has had a deep effect on the future of ISE. With many fewer students and the loss of faculty who had to find a more generous source of income (including myself), our program has come to a temporary halt. Still it is important to mention a few success stories. One student, who was part of our weeklong course at Hampshire College, co-founded the Cycle Circus, also known as Puppets on Bikes. This diverse group of cyclist performers and cultural activists based in Austin, Texas focuses on border issues and looks at how the Free Trade Agreement affects the people who live there. Using puppet shows, comic books, and "cantahistorias" (they sing or chant a story with pictorial banners), their collaborative work looks at the life of sweatshop workers along the Texas-Mexican border[7]. Another recent ISE student was inspired by our workshop to continue a series of video and audio projects that look at how patriotism is manifesting in the public sphere in Urbana-Champaign, Illinois. Still others have gone on to host independent radio programs, run cultural programs at bookstores, and do all manner of street art in collaboration with grass roots movements.

Widening Circles

After twenty plus years of lecturing on activist art I am sometimes discouraged when audience members come up to me and say, "I had no idea that there was art like this. It is so inspiring." This feedback suggests to me that what little art education most people receive is not giving them a broad range of models. At a time when the most innovative frontiers of education are exploring the interdisciplinary, it would make sense that more art educators would be attracted to socially engaged art. Of course, as I mentioned previously, there are many institutions that are quite frightened by the idea of critical thinking. These art departments will continue to happily graduate students who stop making art within a few years of graduation because they can't find a way to survive in the art world as it is currently constructed. Sadly many of these graduates think that it is their fault. What a benefit it would be to society as a whole to have more artists who feel a sense of social responsibility and who have the passion to continue making their work despite the obstacles.

In 1998 I was invited to join the faculty of the new and innovative program, the MFA in Interdisciplinary Arts at Goddard College[8]. This program manifests a part of my dream for a socially engaged art education. Students in this low residency, long distance program are asked to develop or strengthen their artistic voice and to look at their work in terms of personal story, social engagement, healing and spiritual growth. Like other Goddard programs that are based on John Dewey's philosophy of learner-based education, students must develop their own study plan with an advisor each semester. Critical thinking is an explicit part of the program goals. As part of the five semesters, students must spend at least

one semester working on a community-based art practicum.

This program has attracted some of the most remarkable students and faculty I have ever encountered. One graduate is doing audience participatory installations and workshops in the local high schools about body image and eating disorders. Another former student is doing performance art and videos about newly revealed stories about the U.S. involvement in Korea. The graduates from this program are teaching, exhibiting, organizing conferences, raising money and facilitating projects all over the world.

While my work at Goddard was rewarding in many ways, my work as an advisor did not pay the bills. I spent years applying for other jobs, becoming known as a professional finalist among my peers. The academic job market (not to mention the life of an artist) is a perilous one, and it has required a combination of dogged perseverance and the support of a meditation practice to maneuver the roller coaster. The latter, what is often referred to as mindfulness practice, has served me well as a teacher as well as an artist.

In 1989 I had my first opportunity to study with Thich Nhat Hanh[9], the Vietnamese Zen teacher, poet, and peace activist. After participating in a retreat that he led for activist artists, I began a slow process of integrating this socially engaged spiritual practice and different traditions of yoga, into my work and everyday life. Two subsequent health crises, both of which I have recovered from completely, reinforced the need for these spiritual disciplines to guide my activist art making. The breathing in and breathing out of despair, art as the embodiment and connection with a vision, and the communion offered by meditating with others, are now essential pieces of my path.

As a teacher I discuss mindful breathing and deep listening as an important part of the creative process. When we engage in exercises that allow the students to be grounded in their bodies, I know that the work that emerges will be stronger. Art that creates dialog and reconciliation between polarized groups, develops awareness and compassion about the suffering of others, explores a positive identity in relation to a society that diminishes and oppresses "the other," and celebrates aspects of life that are not promoted by consumer culture, can be deeply refreshed by a socially engaged spiritual practice of any kind.

Perhaps more than anything else, mindfulness has allowed me to embrace the idea that a cultural revolution needs many kinds of practitioners: those who are solitary, who use art to heal and process that angst of living in the world today; those who work collaboratively, facilitating an emancipatory community-based art; those whose culture jamming, street art, and performances critique the current hegemony and galvanize grass roots movements; and finally those whose work creates a utopic and celebratory vision of what we are working towards.

In the fall of 2003 I joined the faculty of the Interdisciplinary Arts and Sciences Program at the University of Washington, Tacoma.[10] For this program I have been developing new studio arts curriculum to be part of an Arts, Media, and Culture concentration. With the enthusiastic support of several progressive educators who are my new colleagues I am creating courses that will hopefully be a model of how to teach the arts for personal and social transformation. So far my new courses include: "Eco-Art – Making Art in Response to the Environmental Crisis," "Body Image and Art," and "Cultural Identity, Fear of Difference, and Art." Syllabi are being developed for "Media Literacy and Culture Jamming," "Sense of Place and Community-Based Art" "Art that Responds to War," "Labor, Globalization and Art." [11] In an environment that has encouraged me to teach whatever I want, more ideas for courses keep emerging everyday.

My students are non-traditional and range in age from 20 to 65. Many have or have had families and jobs, and are retraining after being laid off. Most are working class, and some are the first in their families to attend college. Tacoma is a small city surrounded by military bases, and many of the students are veterans or connected with the military in some way. I am definitely not preaching to the choir.

Right now most of our students have little or no background in art (even though they are all in their last two years of college) and are taking art classes as an elective. My tasks with each new group of students are multi-faceted. The work is similar to facilitating two community-based art projects every 10 weeks. I help the students develop critical thinking skills about the social issue being addressed and offer them the opportunity to tell their stories, both individually and collaboratively, with a wide variety of art strategies. I introduce them to the visual grammar I learned as a student of Western aesthetics while pushing them to think conceptually and contextually. We list stereotypes that they have about artists and art making, explore the various roles that art can play in society, and look at examples of contemporary art that speak to the social issue we are examining. I watch as their minds stretch and bend to take it all in, and hope that, above all, taking my courses will help these students become more imaginative, open-minded, critically-thinking and responsible citizens. One student at a time, one story at a time, it might be possible to spark a progressive shift in the culture.

Seeing Beyond This Moment

Doing the "slow" work of teaching when looking at the scale of problems our world is currently facing can be overwhelming, but I feel grateful for the privilege to do this work and it helps if I stay focused on a vision. I imagine a world where daily problems are explored and collective consciousness raising is shared through art making. Where people don't look to one spiritual or political leader to make things right, but seek solutions creatively, using their intellects, hearts and spirits, examining how their efforts and decisions can affect the 7th generation.[12]

At this particularly challenging moment in our nation's history, when civil rights are being curtailed and public dissent regarding the dominant political will is either being ignored or suppressed, the arts can play a key role in generating more democratic discussion of social policy. The arts can also give us a sense of hope and possibility in an era when many are losing their will to believe in a just and thriving future for the people of the world. I try to remain optimistic that more of us will use the arts to provoke dialog, empower the invisible and alienated, raise questions about things we take for granted, educate the uninformed, to heal rifts in polarized communities and within individuals who have been wounded by society's ills, and provide a vision for a future where people can live in greater harmony with each other and the natural world. Perhaps the work I have been doing will inspire others and keep the passion for social change burning.

Notes

1 www.thepublic.com
2 www.social-ecology.org
3 www.playbacknet.org/iptn/index.htm
4 www.unomaha.edu/~pto/
5 www.beehivecollective.org,
6 http://members.aol.com/autonomista1/about.htm
7 www.cyclecircus.org
8 www.goddard.edu
9 www.parallax.org/
10 www.tacoma.washington.edu/ias/
11 www.artsforchange.org
12 The *seventh generation standard* is a concept that originates from indigenous North Americans who believed that the decisions of today should take into account the well being of the next seven generations.

17 The Body Politic: reflections on a pilot course exploring new pedagogical and interdisciplinary approaches between art and social and ecological justice

Jane Trowell

"It's serious – it's art, it's politics, it's economics, it's everything, and art in that instance becomes so meaningful."
(Ken Saro-Wiwa)[1]

Since 1983, artist-led London-based group PLATFORM has been working through interdisciplinary collaborations to address and advance social and ecological justice[2]. Education in formal and informal contexts is a key part of our work. Currently, we are involved with our long-term production *90% Crude*, exploring the ethics of transnational business in relation to environmental and human rights abuses, with particular focuses on the oil industry and corporate psychology. PLATFORM's practice involves long-term collaborations between people from different areas of knowledge: at present, for example, a sculptor is working with a corporate analyst and a campaigner on the sub-project Unravelling the Carbon Web, an ongoing public investigation into the oil industry, specifically Shell and BP. The methods include performance, publishing, consultancy and strategic networking, all underpinned by rigorous primary research.

Up until 1999, the educational work we undertook was mostly reactive in origin – merely responding to invitations and requests for workshops, seminars, lectures, keynote presentations etc. However, November 1999 marked a watershed in PLATFORM's conceptualisation of the role of education in our work: we began to feel complicated about the passivity of this approach, and wanted to devise a more active, long-term strategy for pedagogy within PLATFORM. It is fitting that this change was catalysed by the needs of an art student.

In 1999, we spoke at a conference held at Teesside University, UK, entitled "Seen & Unseen" organised by Artists Agency (now Helix Arts), which brought together a range of individuals and organisations from the fields of social practice arts, environmentalism, science, and community activism to address collaborative solutions to water pollution[3]. One comment in the plenary session, from a student in his final year at Glasgow School of Art, lodged itself as of immense importance for us and for the field we are working in:

> "We've heard some inspiring examples about work in this emerging area over the last two days, but is there any place I can go to learn more about how I might work collaboratively on such (social/ environmental arts) issues? You see most of what we get taught at art college is about how to be an individual artist, not how to work together, and certainly not interdisciplinarity beyond the arts." [4]

This question echoed various other conversations we had been having over the years, especially at the two international Littoral conferences on social practice arts (1994 in Salford, and 1998 in Dublin)[5]. As a result, in the years subsequent to 1999, we started actively monitoring the growing number of people, ranging from artists to community activists to doctoral students, who expressed a similar desire to study this area in a truly interdisciplinary context. We felt troubled that, apart from giving people time, further contacts and suggested publications, there was no obvious course, context, or institution to refer them to, within the UK.

Reflecting on this, we conceived a long-term plan to create an educational experiment, exploring radical approaches to fusing art and activism in Britain and around the world.

This article undertakes some initial explorations of the origin and process of this experiment, the first manifestation of which – a 36-hour course run over twelve weeks, January to March 2004, with 17 interdisciplinary students – has only just finished at the time of writing. There is much more to be digested and much to be reconceptualised before the second year of the course commences in January 2005 (with the course to be extended to 24 weeks), so this article acts as a provisional reflection of a work-in-progress. You can read and see students' work in the education section of the PLATFORM website: www.platformlondon.org. Finally, it should be noted that this piece is written by only one of the Body Politic's co-initiators – Jane Trowell – but after considerable discussion with the other – Dan Gretton.

Our original concept in 1999/2000 was to run a type of 'summer school' as a pilot project, a hothouse for artists, activists and other interested people. At the same time, we researched examples of courses with related interdisciplinary and social change agendas, such as Judith Baca, Amalia Mesa-Bains and Suzanne Lacy's BA in Visual and Public Art at California State University at Monterey Bay, which was at that time approaching its launch[6]. Within the UK, there were

examples of courses run within art departments and colleges, or theatre/performance courses that addressed 'art/performance and community', or 'art/performance as contextual practice', but there didn't seem to be a course or context that was interdisciplinary between arts, environmental, social justice and activism. It seemed that what we were considering was possibly unique, at least in the UK.

We contributed a workshop to the Conference "Out of the Bubble , Approaches to Contextual Practices within Fine Art Education" 1999, hosted by Central St Martin's College of Art and the Contextual Practice Network, on what an art education for social and ecological justice might look like, later written up and published[7]. We made initial approaches to the Arts Council of England (ACE), who are very familiar with PLATFORM's work, to gauge their interest in supporting such a pilot scheme. While there was interest from the then Combined Arts Unit, there was also uncertainty as to the "fit" with their remit.

Essentially, we ran up against two particular difficulties – of constituency and logistics. While we had well-developed networks in certain zones (the more progressive courses and modules in art colleges and theatre/performance education, environmental organisations, and certain activist and campaigning groupings), we were also aware of the need to reach out beyond our known constituency and attract individuals from more diverse backgrounds in terms of life experience, race, class, political-cultural perspective. As a small charity, we would need to fundraise to do this networking. Secondly, we would also require financial support for the conceptualisation of the course, the time for planning and organisation (involving resolving questions of student accommodation, fees, hardship funds etc). We began to think about the benefits of seeking a partnership with an educational institution to help support this project's development.

Beginning a dialogue: PLATFORM & Birkbeck, University of London

In Spring 2002, theatre specialist, policy consultant and educationalist Dr Godfrey Brandt, Course Director in Arts Policy and Management in the Faculty of Continuing Education (FCE) at Birkbeck[8] approached Jane Trowell of PLATFORM. Jane had been teaching Arts Policy on the MA course in an individual capacity, and Godfrey wished to discuss whether PLATFORM was interested in developing formal links with Birkbeck? Could there be scope for collaborating on new courses?

With a growing sense of potential, PLATFORM discussed some initial ideas, and then on 24th July 2002 we held a planning meeting with Godfrey Brandt and his colleague Peter Burtt-Jones at PLATFORM. We discussed our individual artistic and political journeys, learnt more about each other's work and talked about what kind of collaboration might emerge. We were surprised, but delighted, at Godfrey and Peter's openness as to the form of the course that might develop - it could be a term or a year, it could be a summer school or a weekend, it could be accredited or unaccredited. They absolutely appreciated that such a project had

been gestating for several years and it was more important to find the right form than to rush it. They emphasised that they were interested in working with us over the long-term. This was very exciting: we had found a partner we could really imagine working with, whose values we could strongly share, who was giving us considerable creative freedom, and who would take on much of the administration of the course. Additionally, this was an institution that had an inspiring history of radical pedagogy embodied in its founding principles, of opening up opportunities to people previously disenfranchised from education.

At the same time, we were aware that forging this link could also have several disadvantages: whatever Birkbeck's roots, it is now an established part of the University of London, and despite its principle of running courses all over London in partnership with different institutions, including the Workers Educational Association, it is, some would say, remote from the immediate urgent social change radicalism of its early days; the relationship we had forged was within Arts Policy and Management, not a context immediately related to our intent, and perhaps a heading that would give the wrong impression (in terms of prospectus entry and course categorisation); it is also part of a huge bureaucracy with its own conventions and constraints, some of which would of course impact on our course. It could very well be argued that this was not the most innovative context for an experimental course on social and ecological justice, and that certain kinds of "activists" for example, would not associate Birkbeck in the first instance with radical possibility.

However, we resolved that this was part of the experiment, and that if Birkbeck could help us get the conceptualisation and realisation of the course off the ground, then it could only be a fruitful relationship at this stage. Anomalies could be learnt from. Furthermore, the impetus had come from individuals within Birkbeck who wished to extend opportunities for students, inject more of the social justice agenda into the overall programme. These were important factors to respect, representing a very unusual opportunity.

Developing the first course: The Body Politic
Practicalities
In Autumn 2002, the three core directors of PLATFORM (Dan Gretton, James Marriott and Jane Trowell) began to conceptualise the shape and feel of the collaboration. We decided on certain practical parameters, the first of which was to get away from the summer school model. This felt too intense and intensive at this stage: we wished to work on developing a long-term relationship with participants over time. We wished to build in reflection, so that together with the participants, we could evolve the course as necessary, learn to understand collectively what we were doing.

The other key parameters were to start in the academic year 2003/4, to run from January-March, to comprise twelve weekly 3-hour classes, to have a maximum of

20 in the group, to be an unaccredited course – formal assessment requirements seemed restrictive at this early stage, to be organised on an interdisciplinary basis, with the possibility of developing collaborations across several departments at Birkbeck, ranging from art to economics, psychology to history, to be based at Birkbeck's main Malet Street or Russell Square sites (central London), to be team-taught by two PLATFORM co-directors, with the third co-director available on occasion.

Most importantly, we were determined that the course should be aimed equally at people from arts and activist backgrounds.

Not all of these desires could be fulfilled. It was explained to us that as an unaccredited course, we would have to charge fees at direct cost, that there would be no subsidy. To cover the two tutors, the cost per student would be at least £120. It would be increased for full-price students if we wished to create a reduced rate by subsidising from the full-price rate. If it were an accredited course, ie. that students could use it as a module towards a certificate or diploma – the fees would be subsidised – £90 full price, £45 reduced rate. This would mean that money would not be a huge bar to participation. The challenge would be to come up with a creative approach to assessment that fitted the values of the course and institutional requirements. This latter is proving tricky at the time of writing. Ironically, it is so unusual for Birkbeck to run team-taught courses of this length, that it was not possible for them to pay us for two tutors for twelve weeks each. This is a big issue for interdisciplinary and collaborative practitioners in formal education in most contexts. We eventually compromised at a fee for 1.5 tutors, and successfully applied for a development grant from the socialist education foundation, the Lipman-Miliband Trust, but this is not a sustainable solution.

Cross-departmental collaboration was something that we were advised would take time, and we decided, perhaps wrongly, that it shouldn't be a priority for the first year of the course. Given that the FCE does not pay visiting lecturers developmental monies, we felt already pushed for time and decided to prioritise conceptualising the content and delivery methods of the course over the bigger question of strategic links. This is unusual for PLATFORM, as we like to think and act systemically as the core activity of the work, but on reflection, the pressure to write the course, and the potential drain on time of locating the right Birkbeck links persuaded us of this course of action. The institution does of course work inter-departmentally, but this is usually between permanent staff and no communications mechanisms or fora existed that our course could fit into. It was resolved that we would flag up our course in relevant departments' prospectus sections, and use the website to stress interdisciplinarity. We would hope to begin to work on forging formal links in year two of the course.

In terms of location, we were initially convinced that there were some benefits to being located in central London, within Birkbeck's central campus. This was not

only because of good transport links, but also because of the density of the group of educational institutions immediate to Birkbeck: the School of Oriental and African Studies (SOAS), and the Institute of Education (both part of University of London). SOAS in particular is known for its radical student base, and we felt to hold the course in these environs would be useful. However, the course was unable to be accommodated in this location, and we started in a very box-like room in University College London on Gower Street. This seemed, at first, equally useful in that the neo-classical imposing temple that dominates the courtyard could only speak volumes about the nature of British imperialist confidence in the late 19th century, one of the many subjects for our course. Halfway through the course schedule, we had allocated a session to take place at PLATFORM's premises on the south side of Tower Bridge. At the end of this session, we asked students whether they wished to return to the UCL venue and were greeted with a resounding NO. The second half of the course took place at PLATFORM, and the resultant change in atmosphere – from institution to more domestic artist-activist space – was palpable. People were more relaxed and took more control of their learning. There is more thinking to be done on the impact of that change of space on the teaching and learning.

The artist/activist balance was not as we would have wished: marketing the course through ordinary Birkbeck channels and our own mailing list and networks (which include many environmental and human rights activists and campaigners), we enrolled eleven people who described themselves as coming from the arts (artists, actors, performance, poets musicians, curating, clowning), and ten people from other backgrounds and disciplines (law, health, education, campaigning, business, retail, psychology). But, of all the students, there were only two who were to describe themselves first and foremost as "activists".

What is noteworthy about this is that upon investigation, it transpired that most people in the group had at various times participated in campaigns and demonstrations, protests and other vigorous social activist initiatives, from Pride festivals to environmental campaigning, from squatters' rights issues to Palestine. One woman who did not describe herself as primarily an activist was a student who had been very involved in non-violent direct action on peace issues. So on the one hand we felt disappointed with the number of self-named activists in the room, in the sense that we wished for more full-time activists/campaigners to contribute to and learn from the debate, but on the other, the very act of asking students for self-definition and naming was obscuring some more complicated, and – in terms of social justice and democracy – perhaps more useful subtleties on how people like to describe their political engagement. This issue relates to a key question for PLATFORM: we know that many people involved with the arts wish to learn more about how to work interdisciplinarily on these issues, to better express their political and ethical selves in the world, but we are not aware of a similar need among activists and campaigners, except the ones we have collaborated with in PLATFORM. We would argue that activists and campaigners in general

don't (yet) sense that working with artists can be a crucial element in the effectiveness of the work. This situation is related to the urgent speed which can characterise environmental and social justice activism, pushed by the need for a "critical path", an achievable set of goals and outcomes that the "campaign" or actions can be measured against. This culture can militate against values that are common in others fields, processes that Wallace Heim has called "slow activism"[9]. Furthermore, we are still a long way from the public at large readily associating the word "artist" with a person who is concerned with ethics and who might contribute to social and environmental change, a perception that can act as a deterrent. A new provocation for the second year of the course is to create a context where artists wake up and activists slow down, together.

As mentioned above, the group had a degree of interdisciplinary spread, but, while we had some international students – from Australia, Brazil, Italy, and Chile – all the students were white and most were women. This situation is perhaps not surprising: people who publicly demonstrate concern over environmentalism in the UK, for example, are mostly white and middle class. Research has shown that this is related to notions of cultural exclusivity around access to nature in the UK, and also to the fact that most people of colour who are politically active are working on issues of direct racism and representation.[10] Also it is a commonplace that more women than men undertake adult education – a fact that would bear more discussion than is appropriate here. Regarding race, PLATFORM needs to question the cultural message of the context (Birkbeck), the message of PLATFORM itself (white, largely middle-class small organisation), the methods of and language used for advertising the course (in year 1, through Birkbeck and PLATFORM mailing list), and restrategise for year two.

Conceptualisation & Content
In December 2002 Dan Gretton and Jane Trowell, both of whom are experienced educationalists in the field of language, literature and art & design as well as through PLATFORM's considerable work in education, met to focus on the specific form the twelve sessions of the course could take. At this stage we identified the biggest questions we wanted the course to raise, which were as follows:

- What are the aims of such a course? For the students, for PLATFORM, for ourselves as individual educationalists?
- What does it mean to be politically or artistically "effective"?
- What is the relationship between an artist's or activist's public life and their private life? Is any kind of holism either necessary or desirable?
- Is there an issue of creative 'burnout' which affects individuals in both fields? Is it possible, or even desirable, to aim for a 'sustainable' life as an artist or activist?
- What are the archetypes in our culture? Why are activists expected to either 'give up' or 'grow up' at a certain stage of life? Is there a relationship here to art?

- What does it mean to look back on past work? Is there a tension here between the tangibility of art and the intangibility of activism?
- What is the relationship between individual creativity and collective organisation?
- When have we, as artists or activists, felt moments of 'epiphany'? What is the relationship between such moments of intense politicisation or creative revelation and the cycles of our lives? When are the greatest risks taken?
- What is the role of listening in creativity and activism? What impact does our personal history of being listened to or not, have on our ability to really open ourselves to others?

Out of the above discussion we resolved that the first two sessions of the course would focus explicitly on foregrounding the political and artistic journeys and experiences of the students and ourselves. We saw this as a vital way of building the trust necessary for such an innovative course to work. After much discussion, we decided that the remaining ten sessions would use the framing metaphor of 'The Body Politic'– which would serve a double function: confronting a danger for discussion to become 'academic' in a negative sense (in the sense of a drying out, an over-rationalisation and an over-theorisation that divorces the mind from the body); also providing an effective and poetic frame, a creative way to examine work we wished to discuss, whether PLATFORM's own projects, or the work of other practitioners, writers, critics and filmmakers. The following course outline was developed and subsequently agreed with our colleagues at Birkbeck, but note the flexibility clause in the preamble – we were determined that students (and we) should have the right and opportunity to comment on and change the direction of the course, should it feel necessary:

The Body Politic
Social and Ecological Justice, Art, Education
PLATFORM & Birkbeck, University of London

Commencing Wednesday 14th January 2004, 6 - 9pm
Tutors: PLATFORM – Jane Trowell, Dan Gretton
Location: University College London, Gower Street, Rm G23, Pearson Building
The Body Politic website: www.bbk.ac.uk/fce/artsmanage/bodypolitic/index.shtml
Birkbeck Course Code: FFAP002NACA

Course Outline
Please note that this outline highlights the key subjects and practitioners that will be discussed – there are more that we haven't mentioned here. The outline may change according to how the course develops, which is why we have kept it in outline form only. We have devised the programme according to our particular experience and knowledge over 20 years' work, but we are not attempting to be comprehensive, covering all practices and methods. Of course there are absences and holes: we can try to address these, according to students' needs and desires, and expertise within the group.

"Art lets us think in uncommon ways."*

1. 14th Jan Introductions and political "epiphanies" (JT/DG)

2. 21st Jan Inner Ear: listening as a prerequisite for any act of creation; learning to listen to ourselves, trust ourselves; under what circumstances do we stop listening? (DG/JT)

3. 28th Jan Outer Ear: listening to places and communities, and what happens next?; "others", "othering" and ourselves - through writings of bell hooks, Audre Lorde, Paulo Freire; the Forum Theatre practice of Augusto Boal (JT)

4. 4th Feb Tongue: the use of silence and the use of speech; articulation of language as political danger – including the films of Claude Lanzmann and Patricio Guzman; writings of Osip and Natasha Mandelstam, and Susan Griffin (DG)

5. 11th Feb Frontal Cortex and Solar Plexus: the limitations of using facts alone to effect change; connecting information to experience, and going beyond the rational – through PLATFORM projects Carbon Generations, Some Common Concerns, and killing us softly. (JT/DG)

6. 18th Feb Lungs: endurance and stamina; how can you keep focused, evolving and working over time without burning out/becoming cynical; reflective practice; networks – through the writings of Suzi Gablik, Malcolm Miles, John Berger; the Littoral social practice arts conference 2005 (JT/DG)

7. 25th Feb Benevolent Viruses: NB to be held at PLATFORM' s space; An exploration of other contemporary collective/collaborative practitioners, including the work of Ala Plastica, Apsolutno, Ground Zero, Helix Arts, Littoral, Social Sculpture Research Unit (Oxford Brookes Univ), Wochenklausur... Plus mid-course review (DG/JT)

8. 3rd Mar Legs: experiencing breakthrough through walking/exploring real space; land/cityscape and dialogue – through PLATFORM projects, and writings of Rebecca Solnit (JT/DG)

9. 10th Mar FREE SPACE – for development of new subjects or deepening of ones covered already – content to be decided in weeks 7/8.
 OR Feet: "The path is made by walking", a critical walk through the City.

10. 17th Mar Knee and Heel: Facing the other direction, the path less travelled, courage in difference; invisible histories and untold stories; the acupuncturist's needle and the rhinoceros's hoof – through the work of artist

Joseph Beuys and writer WG Sebald (James Marriott, PLATFORM/DG)

11. 24th Mar Hand and Fingertips: co-operation and solidarity; how do we find each other – seeking collaborators; the huge challenges of working collectively and/or through consensus; overcoming conflicts/acknowledging differences; when to stop and when to push through (DG/JT)

12. 31st Mar Review: summing up and feeding back; what have we learnt ?

* quote from artist Wolfgang Zinggl of Austrian group Wochenklausur

What happened?
NB. In this section, I use "tutor" as short-hand. This is not the right word, just as "student" and "participant" also are inaccurate, but we have yet to resolve what roles were being played. All students' comments are from their written feedback.

The single most important task we set ourselves in beginning the course was to establish a "community of learning" [11]. In our experience across all areas of work in PLATFORM, to achieve a cohesive, productive and active ongoing group process, where everyone feels able to contribute and everyone feels they have a stake in the outcome, one must begin with developing individual and collective listening skills. This is always important, but particularly so where people are coming together from different backgrounds, cultural expectations and disciplines, and particularly when entering territory which can be controversial. On the back of this process, trust is developed and almost anything can happen.

To develop this we used from the very beginning of the course a range of methods that build listening skills and trust. These methods also forge alliances and establish useful critical differences.

"I learnt how to hush, and I listened. I had practical evidence that being open to the outside (outsiders?) is a stepping stone to awareness, which is an 'intelligent' place to be."

Pairwork, small group work and whole class discussion was combined carefully with formal presentations of ideas by the tutors and students, drawing exercises, silent and group brainstorming, and audio-visual stimuli such as video, slides etc. We were also very careful to problematise any tendencies to easy categorisations among the group in terms of politics or background. This was in order to allow for multiple identifications, change and fluidity of people's thinking during the course, for the content of the exchanges to be able to work on all of us.

We also gave a lot of status and time to personal experience as it connects to art, politics and ethics, with the tutors revealing their own anomalies and revelations, as much as the students. This strategy, closely allied to the feminist principle "the

personal is political", is another core tenet of PLATFORM's method, and one we wanted to share and debate with the group.

As one student put it:
"The course was very inspiring for me in the honest practical way the tutors brought their own experiences of collaborations to be available for dissection, so to speak. These discussions along with the tutors' and group's individual experiences of other collaborations helped me build my confidence in going forward to work in a collaborative methodology..."

Or another:
"We were asked to experience new, often shocking and challenging stimuli together. It is that togetherness that interests me – in terms of group solidarity and in terms of who these individuals are. You were aware of making sure we worked with those we had not spoken to, and you are to be congratulated on encouraging us to bring in photographs, newspaper articles, songs. This shift from the conventional shook the room..."

And a third:
"I was happily surprised by the "talking" element of the course. The starting-off point was always our personal views on things. Then putting together everyone else's perception of the same subject we came to unravel issues that beforehand scared me because of their complexity, the peeling off, the trying new uncomfortable routes, the questioning, re-questioning and counter-questioning... and the almost scary sensation that there is no final answer because it would always be the basis for a new question"

We spent time at the beginning on what students wanted or hoped for from the course, a task which was fascinating as it was daunting. Why had people signed up? What did they think was going to happen? Each student wrote fully about and discussed their anticipations of the course (see summary on website). This summary was returned to at the end of the course – we read through the hopes and asked "is this what happened? Do you/we recognise this?" Testing against students' and tutors' original hopes and expectations is a humbling and honest part of this kind of education – an education where tutors are seen to learn as much as anyone. We were relieved to find that all agreed that the hopes had been largely born out, and that the main frustration was time: 12 weeks was far too short.

"The course should be extended to 24 or 36 weeks. This would allow things to deepen. I would suggest more input by the students. Maybe leading to a collaborative action of some sort."

"I would have liked more of everything and less of nothing on this course"
In terms of content, we structured a sequence of issue-driven elements, tackling subjects such as listening to a community, personal responsibility, violence and

bureaucracies, silence and protest, and interwove them with more practical discussions on collaborative working such as stamina and longevity, conflict resolution, finding collaborators, building networks etc. We were continually concerned about the balance of formal input from tutors to students' formal input, an issue which came up for some students more strongly than for others. Some students very much liked formal tutor presentations, but it is the explanation in the extract below that is most revealing in terms of how different people process change:

"I did enjoy the course as a concept and I must say that the best that I had of it was the formal lectures (I am more the sort of person who absorbs information to transform and put into practice later rather than immediately)"

We made extensive use of the bibliography, of pre-sessional reading in preparation for discussion, as well as inviting students to respond to or develop ideas in writing, drawing, sound, performance, or speech. However, the performance and formal students' presentations only began to be volunteered towards the end of the course, a fact we feel is at the centre of redesigning the course. Our conclusion is that we achieved an imbalance between, on the one hand, group work/community building and tutors' formal input, and on the other, providing a structure for individual students' contributions. We had dedicated a session to the tensions between individual and collective, yet we did not manage to resolve them in the pilot course itself! One student came up with a very interesting solution to this:

"Each area could have been extended into two sessions [24-week model] - maybe the first one as it was, and the second looking at work produced and discussing ideas that came up as a result of the previous session and homework. Maybe looking at planning actual projects, or ideas for projects, that could be picked up by whoever wanted to continue them after the course?"

Because of other factors such as trust and honesty about time constraints, this tantalising situation happily seemed to lead to greater and greater desire for students to know each other more intimately, such that four weeks before the end, one student took the initiative and proposed that the course should continue, that it was too soon to stop and that she felt they had only just begun. This was greeted with universal agreement, and immediately she volunteered to compile a list of wants and needs of the group. Subsequent discussion resulted in PLATFORM offering the group our premises to meet in, for sessions that would take place every other week after the end of the course. The tutors would not attend, but would come to sessions where invited. The first meeting in this format took place on 12th May 2004. Of course, it is uncertain how long or how committed the continuing group of about ten people will be, but it is a good sign and a measure of the course's success nonetheless.

One issue that we did not feel was resolved was how to share students' writing. Students did a great deal of writing, but this was mainly read and discussed by

the tutors (each tutor giving individual feedback) to the student alone. This was patently not at all satisfactory for anyone, a fact we discussed as a group, but time felt so short and no-one could come up with a solution without chopping half the course off (see above). The use of the website as a place to share writing was promising, but this is not the same as time allocated in the sessions themselves. Partly this dissatisfaction was born of the fact that we (the tutors) were in no way anticipating such fulsome and powerful written responses: students were invited to write as much as they wished, with few formal constraints.

It remained unresolved, and people perhaps remained more abstract to each other for longer than perhaps they might have done had we addressed it differently. As one student said "I would have liked more opportunity to look at the work of other participants immediately (on the day of submission) as I think it would have made for lively discussion and also brought new elements into the work we were doing together and alone."

There is much more that could be said about the process and outcomes of this course, and indeed in structuring the course for the year 2005/6 we will be intrinsically addressing them.

Some provisional comments on the pilot of The Body Politic are that:
i) there is a demand for this kind of course – definitely among people in the arts, and increasingly from other sectors, although this needs work;
ii) with good facilitation, a common language and agreed working process can be arrived at consensually;
iii) interdisciplinary education requires depth of process over breadth of subject content;
iv) reflective time is everything;
v) the more students are involved with designing the process, the more they commit;
vi) the key to trust is when tutors/facilitators share as much as they expect their students/participants to;
vii) the context is the message - the course will attract different people according to its location (physical and linguistic);
viii) it works – we retained 17 of the original 21 students who enrolled. Of the four who left, two were offered jobs abroad, one returned to Chile and one had personal reasons.

One thing we have not mentioned is the emotion behind the course. Talking about and witnessing environmental and social justices and injustices, the role of art, the uses of education; looking at the practices of artists and others in relation to this; revealing your own personal political journey; all of this involves inhabiting and embodying the material. It is a big commitment for all concerned - tutors and students. A big expense of the self, but an expense which is mutually transformative. Finally, three students' conclusions, and an extract from an e-mail sent by Yin Shao Loong, a social justice campaigner based in Malaysia who we

have worked with:

"This has been one of the most pivotal things I have ever done. It has reached far wider and far deeper than I could have imagined. I am not quite the same person I was when I started. My confidence as an artist is growing and my keenness to use that artistic urge is sharper."

"I needed stamina – sometimes the sessions would leave me reeling. I had to quieten my mind enough to sleep, yet awoke refreshed every time. Sometimes I would feel almost in some kind of pain at the enormity of it all, of the impossibility, of the range of paths open… It is almost impossible for me to express how I feel about it, particularly in words on paper. It would be like pulling up a seedling before it took proper root, but I will try to give a picture of how it is today. I say today because it is growing all the time. When I think about what to write it's like trying to write an enormous smile on paper. It is like trying to find adjectives to describe all the best things in life – conversation, movement, description, inspiration and sustainability. Like commitment and perseverance."

"Looking back on what I expected from the course, I can full-heartedly say it has been what I was looking for. I was after…a place to think and explore and get lost, but not least, an experience that would help me 'leave a mark on this tormented little planet'."

"I've just had a look over the results of your Birkbeck course [on the website]… I only wish I could have attended. The themes selected are ones I have struggled with intensely the last few years, and quite honestly, it has been art or an artistic approach which has really "saved" me from being a complete beast. (The "cause" can really do that to you)."

As Paulo Freire said "Educating involves ethics and aesthetics hand in hand; it is beautiful because it is ethical"[12]. We believe "The Body Politic" pilot has been a very useful experiment in this direction, and one upon which we can now build.

Notes

1. From interview with Nigerian writer and environmental campaigner Ken Saro Wiwa in the Channel 4 documentary The Drilling Fields, Catma Films, 1996
2. www.platformlondon.org
3. www.seen-unseen.com; www.helixarts.com
4. Student's comments taken down from notes.
5. www.littoral.org.uk
6. www.csumb.edu/academic/descriptions/vpa.html
7. 'Words which can hear': Educating for Social and Ecological Art Practice in Out of the Bubble, Approaches to Contextual Practice within Fine Art Education, Eds John Carson and Susannah Silver, London Institute/Central St Martins College of Arts and London Arts
8. www.birkbeck.ac.uk
9. Slow Activism. Homelands, love and the lightbulb, Wallace Heim in Nature Performed: Environment, Culture and Performance, eds. B Szerszynski, W Heim and C Waterton, Sociological Review/Blackwell, 2004
10. See Black Environment Network's studies of this: www.ben-network.org.uk
11. hooks, bell (1995) Teaching to Transgress, Education as the Practice of Freedom, Routledge, 1995
12. Freire, Paulo, in Figueiredo-Cowan, M and Gastaldo, D (1995) Paulo Freire at the Institute, Institute of Education, University of London, p 20.

18 Green Visions/Grey Infrastructure: interventions in post-industrial society

Noel Hefele

Introduction

Green Visions/Grey Infrastructure (GVGI) is an intensive two-part reading and project course with an environmental focus. The objective of the course is to have students explore their potential as agents of change while learning about emergent ideas and philosophies in the radical and restorative ecologies. GVGI integrates students from the colleges across the university. They apply the knowledge of their specific discipline through collaborative projects in an attempt to analyze and resolve real world interdisciplinary problems.

This paper begins with a brief description of the context in which Green Visions/ Grey Infrastructure emerges. The problem is stated as the legacy of ideology, infrastructure, and pollution that have defined the dominant nature-culture relationships of the past 150 years. GVGI views nature as a social construct and is interested in the public space opportunities and potential reclamations that have emerged in the wake of the industrial down-turn. It teaches students, through research and experience, how to have a voice in those opportunities. The paper outlines the module by first defining the prevailing questions behind the course, and then breaking it into four approximate sections. The first section is about the discursive and spatial forms of the post-industrial public realm—the context of the problem and, therefore, the project work. The second section is about systems theory and how to intervene in a system. This provides a perspective that helps students understand and conceptualize ways to act upon the complexities of public realm issues. The third section focuses on environmental history and land ethics in order to provide background and a philosophical foundation, also highlighting the many different ways nature can be conceptualized. The fourth section is on planning and collaborative projects, prepping the students with discussions on planning approaches, methods, and group dynamics as they move into the project half of the semester. The paper also details the course development over three years and its innovative, trans-disciplinary pedagogy, as well as possible directions it could take in the future. It then examines the implications of such a

development for interdisciplinary teaching and practice.

Context

This is a course on creative change and nature-culture relationships; it hopes to promote individual clarity and responsibility for forming those relationships. At best, it can be said that culture has a schizophrenic relationship with nature. Society can claim to value nature, and in many cases, does. Yet, historically, expanding human infrastructure has been the comforting indicator of progress while nature was a place to be feared and ultimately conquered in a flurry of resource extraction. Nature was also a force to be controlled and managed; the rivers of Pittsburgh were dammed by the turn of the last century and transformed into infrastructure for industrial transportation. In the subsequent years, vast tracts of homes and businesses that once faced the rivers were removed, land was consolidated, and a public/private investment created the largest steel industry the world has ever known. Homes that once faced the river turned away from it. Even Three Rivers Stadium, on the banks of the Allegheny at the confluence with the Monongahela and Ohio Rivers, was a closed stadium with views only into itself. The rivers were abandoned to industry, to act only as transportation infrastructure and sinks for industrial and human waste.

(All management of nature was not done for the sole benefit of industry – there was a sincere attempt to "technologically fix" pressures and calamities from the natural world. Perhaps it could be said that these fixes were as mechanistic as the industrial revolution and therefore more tied to industrial thought than it might seem.)

In Pittsburgh today, we struggle to understand the value of the rivers. Are they still infrastructure with value that only accrues through their utility to private industry? Or are they public amenities, sources of drinking water and recreation, with view corridors and public access that add value to the homes, communities, and individual lives in this region? We can't seem to make up our minds. In the next ten years, we will see a $107 million dam[1] rise on the Monongahela River to increase barge traffic. But that same project will create a 30 mile stretch of unimpeded river.[2] In the face of a decision based on market reasons, can we find value and opportunity for recreational boaters We may also see a highway along that same river that cleaves the main streets of economically devastated steel towns, separating the communities yet again from the very rivers that gave rise to them in the years before steel. As change occurs, who speaks for public space and culture?

We have seen what happens when private interests define our dominant concepts of nature. The global climate is on the verge of a crisis due to those relationships and it is painfully clear that new epistemological approaches to describe the dichotomy are essential. If we poison the environment and then later find that same poison in our bodies, what does that mean? Quite literally, when we consume nature, we ultimately end up consuming ourselves.

It may be a mistake to continue thinking of nature and culture as two separate and distinct entities. Perhaps the phrases themselves are relics of the Industrial age. What is nature? Falcons nesting in downtown Pittsburgh skyscrapers – in what realm do they participate? And how about the empty urban brown-fields that, upon careful inspection, reveal themselves to be more bio-diverse than the Allegheny National Forest? Nature is finding ways to interface with culture; are we doing the same? New relationships are being bridged across the nature-culture divide with new physical and mental landscapes opening up as industrial imperialism rescinds its iron grip on our land With that retreat, extraordinary opportunity arises; the forms that nature-culture relationships take in the coming century are being shaped right now and all citizens have a chance to take part – but how? GVGI believes that Restoration Ecology can provide us with tools to understand and participate in a responsible way. It values ecological integrity and historical fidelity, working in accordance with economic progress and other intangibles, such as individual well being and expanded ideas of human-nature communities.

Restoration Ecology is a community of disciplines that examines the form and function of land and ecosystems disturbed by industrial culture for the potential of recovery, reclamation, rehabilitation, and healing. Of the three applied ecologies (preservation, conservation, and restoration), it is the only one that is equipped to address all three political programs of humanity in nature, post-dominion humanity, and the intrinsic rights of nature. It acknowledges human impact on the environment and raises significant questions about nature in the urban environment, calling for new methods of planning that consider these questions. Current pedagogical and public values are based upon the ideals and scientific pursuit of pristine nature. These ideals are uniquely American and based on the "taming of the wilderness" idea that ignores the history of human occupation of this continent. We must develop new ways of teaching that will cultivate a desire for healing the nature-culture relationship and promote long term sustainable planning. The planet's collective future depends on it.

A desire for healing or nurturing relationships does not arise without due cause. GVGI seeks to engage nature as a primary value that we feel responsibility for. Responsibility flows from intimacy. Intimacy comes from proximity, be it physical or otherwise. In many ways, society maintains a cultural distance from nature; it is quite hard to understand our daily actions in terms of their environmental consequences and nature remains a place where we go on weekends, outside of city life. GVGI believes in attempting to infuse meaning and create value to work to close this distance. Nature is also working to close this distance. Whether we like it or not, it seems as if we have entered an era of participatory ecology. We have fallen into ownership of natural systems through use and abuse, and are now faced with significant and troubling responsibilities. New models of perception, understanding, and interaction are needed to acknowledge and act upon those responsibilities. Intimate knowledge is a good place to start. GVGI encourages this through reading as well as experiential project learning.

Green Visions/Grey Infrastructure overview

The primary focus of the first half of Green Vision/Grey Infrastructure is investigating nature-culture relationships, both personal and societal. Students are asked to consistently frame, reframe, and reference their individual understanding of nature-culture relationships, developing a reflective stance on their relationship to nature, public space, and the democratic decision making process. For the first seven weeks, they read and think about systems-intervention, planning, landscape preservation and conservation, restoration ecology, and various radical environmental philosophies. The class examines some of the challenging ideas about nature and society and considers the role of people, disciplines, and institutions in creating the various meanings of nature. Classroom discussions also cover ideas of public space and the larger ideas of the commons, acknowledging the history of these realms, while envisioning the potential shapes they could hold in the future (and what role concerned citizens can play in realizing that form). The class also explores the differences between creative transformation, radical planning, and activism.

For the second eight weeks, students work within teams to apply the learned knowledge. The focus of this half is to empower the students as potential agents of change. The instructors and teaching assistant work closely with the teams to develop projects that result in a social dialogue with aesthetic and scientific components that are open to supplementary response and potentially action. The projects should engage and expand upon common public issues. Students experiment with the creation and application of tools for change. The project teams plan and conduct interdisciplinary field research and analysis. They also develop a formal report and decide upon a creative transfer of the knowledge learned, either in direct discussion with specific communities or through a range of public art, design, or other creative interfaces. The boundaries of the projects are regional and limited to Allegheny County. The project themes are environmental (land, water, and related organisms and infrastructures). The social aspects of the projects include: experience, knowledge, aesthetics, policy, and the semiotic components of public value.

The foundations of the work stem from the histories and philosophies of nature; deep-ecology, eco-feminism, social-ecology, and planning. The concepts and practices of visionaries from a range of disciplines are presented and considered; local practitioners give classroom lectures throughout the first eight weeks. The course teaches by example, experience, reflection, and reading. We encourage creativity at every step, regardless of particular discipline. The process of the course is inherently systems based, following Donella Meadows. GVGI is an intervention itself that attempts to teach ways of changing nature-culture relationships. The students create new knowledge strategically applied to shift values and discourse through a mix of creative envisioning, discussion, and action. The course prerequisite is a desire to contribute to positive change.

Green Visions/Grey Infrastructure considers these questions:
- What does nature mean in a post-industrial society?
- How does post-industrial nature relate to the public and private realms of our capitalist society?
- Who speaks for public culture in a market-based democracy?
- Is there a role for students and academics in shaping the form and function of the post-industrial public realm?

and requires the following texts: (See Appendix)

Content

Green Visions/Grey Infrastructure is grouped into four major sections in the following sequence:
- 4.1. Discursive and spatial forms of the public realm
- 4.2. Systems Theory and Intervention
- 4.3. Environmental History and Land Ethics: Preservation, Conservation, Restoration, and Radical Ecologies.
- 4.4. Planning and Collaborative Projects.

Discursive and spatial forms of the public realm

GVGI is concerned with the systems and ecologies that create experiences understood as the post-industrial public realm. Post-industrial refers to the shift in the dominant economy from carbon based industrial power and production towards a computer based economy of information, goods, and services. Public realm can be defined at two scales –in relationships between individuals (as public space) and as the more encompassing social-political concept of a shared commons.

The post-industrial era provides significant biological and ecological challenges located in the public realm. Nature-culture relationships are compromised when vested interests capture both the spatial and discursive forms of public space for private interests. Spaces can be fenced, land can be purchased, and access can be controlled. Civic discussions can be captured and redefined to reflect powerful interests and minimize the voices of less powerful interests. GVGI holds the position that students and citizens alike can define the discussion and open up spaces for public dialogue if only given the knowledge of how to participate.

GVGI views the public realm as the context in which social change takes place. It is also where ideas and concepts of nature are formed and transmitted. We feel it is valuable to spend time defining and expanding concepts of the forms the public realm can take, so to begin GVGI, students read a threshold text. Thresholds alter our perceived reality and move us into a new space, a confluence of concept and experience. We ask that they read *Ishmael* or *Story of B*, both by Daniel Quinn, during the summer recess. The books function as a radical dismantling of the capitalist influenced concepts of shared history, space, and nature. They expand the conceptual map of the integrated history and collective

future of the planet, giving equal regard to all life upon it. The books are enjoyable, as well as informative, and place nature at the forefront of the intra-species public realm, the ultimate shared commons. There are discussions on the readings in the first week of class.

The Quinn books feed and nurture the imagination, daring the students to question some of their fundamental beliefs of the distinct realities that they all wander through. The books also feed the desire for creative change by illustrating very clearly how dire the current prevailing nature-culture relationships are. However, they do not provide any clear cut answers to taking on the task of social change with a positive environmental impact. The readings that follow are structured with the intent to empower the student to attempt to answer these questions themselves.

In the first week, students read *The Theory and Politics of the Public/Private Distinction*, by Jeff Weintraub. This selection provides four main distinctions helpful in understanding discussions about the public and private realms. They are:

• Liberalism: The Market and The State – distinction primarily between state and market.
• Citizenship: From the Polis to the "Public Sphere" – public as collective decision making, separate from both market and state.
• "Public" Life as Sociability – public as dynamic social fabric
• Feminism: Private/Public as Family/Civil Society – public as life outside of family

This reading is followed by a class discussion where students discuss collective and individual perceptions of the public/private distinction as it relates to their own experience and where it would fit in the Weintraub matrix. The instructors facilitate the discussions as to highlight the inevitable contradictions and paradoxes that will emerge, illustrating that the meaning, form, and functions of the public realm are constantly shifting. Example: A century ago, rivers were considered unalterable natural commons. In the last century, industrial tools allowed us to re-define their function and manage them as resources for industrial production, minimizing their ecological values. But as industry recedes, will the rivers be reclaimed as commons?

These discussions encourage students to highlight the various opportunities and constraints of public realm issues. This also serves as a "pre-brainstorming" on ideas and issues that could lead to potential projects in the second half of the semester.

After provoking the students to think about public realm issues outside of themselves, the scope turns inward as they read the introduction to Carolyn Merchant's Radical Ecologies. This short selection provides a conceptual guideline for

students as they begin to define and clarify their own personal relationship to nature and culture. It is essential for them to understand their own position in the public realm and how that affects their ideals and goals before they can become an effective agent of change. Merchant claims that this confidence will "replace feelings of individual helplessness with feelings of power to make changes."[3] The three points of reflection that she uses are Self in Society (values of land use shaped by family history), Society in Self (how the individual may have been socialized), and Self vs. Society (contradictions between individual values and goals and the institutions and environment.)

With these readings as a starting point, students are then asked to complete the first assignment, which is a three to five page paper answering the following questions:

> Think about your understanding of nature. Is nature an intimate, proximate or external reality for you? What are the values that inform this understanding? What are the experiences that formed your nature values? When were these perceptions integrated into your world view? What effect has your education had on your understanding of nature? Are your values static or dynamic? What is nature? What is the public realm? How do the two relate in your life? Are these definitions fixed or dynamic? What social conditions influence these definitions? What values are reflected in these definitions?

Students are asked to revise and reflect on these aspects through the rest of their deliberations in the course.

Systems Theory and Intervention
At this point, a framework for achieving change is needed to continue the discussion. Systems Theory is used because it focuses on the arrangement of and relations between the parts of a system rather than reducing them to a simple summation. Students read Kaufman's *Systems 1: An Intro to Systems Theory* as a primer on how to identify and understand systems. Class discussions range from the systemic elements of perceptions and institutions that define and inform nature and the public realm, to detailed descriptions of natural systems, such as watersheds.

Green Visions/Grey Infrastructure is interested in having students open up a dialogue of social and environmental change. That can be done through two primary approaches: from the bottom up through individuals and communities, or from the top down through policies and decision-making. Each requires resources and power to engage with in any significant way. The course asks the question, how does the average citizen, student, or faculty achieve a voice? One can assume that most are without political or economic power. Power can be borrowed through strategic alliances with organizations to begin this work, but once that occurs, we

need to be equipped to act strategically if we are to achieve an effective transformative discourse. Donella Meadows, a nationally known author and systems analyst, provides a wonderful concept tool to help address this question and its relationship to the top-down/bottom-up framework in Places to Intervene in a System. Meadows outlines leverage points that can bring about significant change. The following illustrates those points, from the least effective to the most.[4]

9. **Numbers** – quantitative knowledge of what does what, how fast or how slow.
8. **Material stocks and flows** – materials and their paths through the system.
7. **Regulating negative feedback loops** – information switches regulating the system.
6. **Driving positive feedback loops** – driving growth, explosion, erosion and collapse.
5. **Information flows** – the knowledge which informs the systems management.
4. **The rules of the system** – incentives, punishment, constraints, degrees of freedom.
3. **The power of self-organization** – adapting to change by reorganizing/changing.
2. **The goals of the system** – what the system is designed to accomplish.
1. **The mindset or paradigm out of which the goals, rules, feedback structure arise.**
0. **The power to transcend paradigms.**

Meadow's leverage points provide guidelines for action. It is important to remember that while the paradigm may be the highest form of intervention, it is also the point at which power is most invested. Individuals must find the point of intervention which is most likely to produce a realistic and satisfying product. Creating change is challenging and prone to failure.

> "Change means movement. Movement means friction. Only in the frictionless vacuum of a nonexistent abstract world can movement or change occur without that abrasive friction of conflict."[5]

Students are to spend some time discussing in groups on the systemic elements of public realm issues that they have been considering.

Environmental History and Land Ethics : Preservation, Conservation, Restoration, and Radical Ecologies.
GVGI looks at the history of environmentalism and land ethics with a focus on preservation, conservation, restoration, and the New Ecologies to establish the genealogy and historical philosophies of this type of work, as well as what current efforts are concerned with.

Students read selected chapters from Samuel P. Hays, *Conservation and the Gospel of Efficiency: The Progressive Conservation Movement*. It traces the origins of the

BRAINSTORMING SESSION

SATURDAY, JANUARY 18TH 9:30-5:30

Join your neighbors, designers, developers and policy makers for a daylong
community design session to explore ways to restore Homewood to a sustainable
and thriving community

The Homewood Project started a dialogue and created awareness about the impending
destruction of several homes as well as the related issue of vacant property in Homewood.
The project attempted to get the community to understand the values of neighborhood fab-
ric and existing history and promoted ideas of ecology and preservation as economic gener-
ators instead of drain.

preservationist and conservationist movements and offers valuable reinterpreta-
tions of the movement's ideals. Hays challenges the common belief that these
movements were based on a public-private dichotomy where the cooperation was
the private interest concerned with only resource extraction and the public was
the champion of wise land use. The early 20th century political climate was
deeply entrenched in the Industrial mentality; everything was viewed as a
machine. Conservation arose out of a desire for efficiency. If there is waste, that
means that the engines of progress are not running optimally, and, during the
peak of the industrialized years, progress was the necessary king. Implicit in con-
servation is a management of nature, specifically for the benefit of humans. On
the other hand, preservation implies complete protection of ecosystems, with little
human disturbance. Preservation and conservation are necessary tools of restora-
tion in some instances.

The purpose of the Hays readings are to illustrate the land ethic history in the United States and how policy, markets, government, and environmental aspects all inform the development of particular land ethics. Historical conditions are important for understanding the needs and conditions of the present day, a point we also stress during the project work as we encourage students to research the history of their collectively defined issues

The second assignment is given at this time. We ask the students to familiarize themselves with a historic environmental figure. They are to lead a class discussion on Henry Thoreau, John Muir, Aldo Leopold, or Rachel Carson, detailing the ways they contributed to the evolution of land ethics in the United States. Students research and develop a short overview of who these figures were, what they did, and why this work continues to hold (or not hold) import for the contemporary citizen. A typed paper of this research is submitted.

At this point we have framed previous environmental land ethics as either in the interest of nature's intrinsic rights, or humanitarian causes. Class discussions touch upon the benefits and perils of each. GVGI now introduces Restoration Ecology as a potential way of dealing with both nature's intrinsic rights and humanitarian causes. This claim is contested and investigated by having the students read five chapters from *Environmental Restoration: Ethics, Theory, and Practice*, edited by William Throop. Elliot, Katz, Light, Turner, and Jordan each write a chapter that fleshes out the restoration debate quite provocatively. Students are asked to map out the concepts on a large sheet of paper and debate the implications in groups during a class session. They are also encouraged to talk about which position resonates with them.

Nature by Design, by Eric Higgs, is suggested to the class as a text that further explores the issues surrounding Ecological Restoration, but is not required. At the present time, we are hesitant to add more reading to the class syllabus because students have already expressed a feeling of being overwhelmed. However, we find that the Higgs text is informative and clearly written, and the teaching team feels that it is an ideal text to consider if we were to extend this class to another semester.

The New Ecologies

Students read selections from Carolyn Merchant's book *Radical Ecologies* that examine the principles of Deep Ecology, Spiritual Ecology, Social Ecology, and various manifestations of these thoughts in Green Politics, Eco-feminism, and Sustainable Development. The class discusses the radical ecologies brought up in Merchants book and how we situate ourselves in relation to them, with emphasis on the following:

Social ecology - an ecology that calls for a grand decentralization scheme with a move to smaller cities and appropriate technologies. It seeks a balance with nature

and an equitable "human footprint" on the planet. This is the broadest of the three eco-philosophies, firmly rooted in the garden but respectful of wilderness. Social ecology claims a spatial allegiance to city, town, and country. It believes that nature is a fundamentally human concept, and it must be resolved in a social setting. Industrial economies, political and urban forms all must change if we are to achieve an ethical and sustainable relationship to nature and our remaining wilderness lands. The approach is built upon a powerful critique of the oppressive nature of industrial-capitalist society. Murray Bookchin is the primary thinker in this area.

Eco-feminism – an ecology that examines the historical relationship between women and nature. Eco-feminism claims no spatial allegiance. The focus is upon the biological relationship between humanity and nature. The eco-feminist reveres wilderness, but the eco-feminist project is still the garden. It is focused upon resolving humanity's inequitable relationship to nature. The argument is that dominant (male) culture in its role of master with dominion over all is unable to acknowledge the dependency upon nature, which has culminated in a threat to survival. "We must find a form which encourages sensitivity to the conditions under which we exist on the earth, and which recognizes and accommodates the denied relationship of dependency and enables us to acknowledge our debt to sustaining others of the earth."[6] The eco-feminist approach is built upon a critique of the oppressive nature of an inherently masculine society.

Deep ecology – an ecology that recognizes the intrinsic value of non-human nature. In terms of our garden-wilderness metaphor, it is explicitly wilderness. It declares a lack of critical knowledge in the context of increasingly complex worldwide ecological catastrophes. In this vacuum of rational eco-knowledge it demands an advocacy and activism based on philosophical principles. Deep ecology is bio-centric; it recognizes the value of all living things and emphasizes non-interference in natural processes. "The flourishing of human and non-human life on Earth has intrinsic value. The value of non-human life forms is independent of the usefulness these may have for narrow human purposes."[7] The deep ecology approach privileges nature and places humanity on a co-dependent footing. It declares the human interference in nature excessive and calls for a substantial decrease in human population. The deep ecology approach is the most radical of the three ecologies; it is built upon a critique of materialism and technological progress. It obligates action through a dynamic platform first developed by Arne Naess[8] and George Sessions.[9]

The purpose of these readings is to provide philosophical grounding for the students as they move into project work. At this time they are asked to complete the third paper, where they are to align themselves with one of Merchant's "isms." We ask them to ponder if their position is unique, and if they can add anything to what was already laid out. Finally, they are to write about a transformative action taken from their ideal position. The paper should be three to five typed pages.

Planning and Collaborative Projects

The practice of planning, in the modern sense, began in the early decades of the past century when people began to think about the rational application of knowledge and technology to issues that were emerging in relationship to the material scope and scale of the industrial economy.

John Friedmann, author of *Planning in the Public Domain*, provides a detailed overview of planning in terms of its traditional relationships to state, capital, and the civic or public realm. Planners can work to retain order in the social-political system; they can provide the means for incremental or measured change, or focus upon radical system transformation. Planners have also been known to revolutionize society, particularly when they step beyond their normal relationship in service to either state or capital. Radical planners serve the public good through distribution of knowledge and advocacy for issues that are not represented by the dominant interests of government or capital.

The students read selections from Thomas Finkelpearl's *Dialogues in Public Art*. The author speaks with Rick Lowe, the artist behind *Project Row Houses*, and Mel Chin, the artist behind *Revival Fields*. Both are collaborative projects that involve positive change as a theme. *Project Row Houses* is from the social perspective, where it revitalizes several blocks of row houses in Houston, Texas with care and meaning, turning something that the community had abandoned into something the community could cherish. *Revival Fields* is a process that uses plants to remove toxins from the soil of a poisoned industrial site, using nature itself to reclaim abandoned earth. The reading details various aspects of the planning and collaborative processes of both. The projects could not have been realized without collaboration because of the extensive set of skills required. Coordinating those skills to keep in vision with the projects takes a certain type of informal planning, key to keeping the project together at the seams. Social change in many cases requires 90% planning and 10% action.

In all cases, planning is about knowledge that informs decisions and enables action. We all want to make the best decisions in life; planners help us see the total picture, understand our options then proceed in a rational manner to achieve stated goals. We have the students read these texts to give them a sense of formality and precedence as they begin the project work.

Beyond the reading, time is spent combating the modernist hegemony of authorship by discussing the important issue of developing a collective practice. Egos have a different place in a group. The group only functions as well as in interacts internally. Respect is essential. We ask the groups to consider these questions. Does everyone do everything or do you break down into two sub-working groups? Who organizes? Who manages production? And so on. These issues are important to discuss. A successful group becomes a single organism and communication is vital in making that happen. We provide a useful excerpt from *Truth*

or Dare: Encounters with Power, Authority and Mystery, by M. Simos. This is a lyrical text that breaks up group dynamics into separate entities, namely the crow, spider, snake, dragon, and grace. It speaks in loose metaphors, but is useful in understanding the prevalent roles in group work. The text also asks individuals to ponder where they lie in respect to the rest of the group.

Seven weeks is a short amount of time to accomplish change. It is in the student's best interests to be efficient. We advise them to increase efficacy by understanding the means and limits of production. We tell them to act with conviction and kindness, plan with available knowledge, and understand their collective strengths and weaknesses. Most importantly, we stress that they communicate with each other, enjoy the process, and to not fear conflict but act to resolve it. Valuable life lessons can be learned from intensive interdisciplinary work. We try to minimize the potential for painful experiences, but also challenge the students to push themselves.

The project assignment is as follows. Students are to identify a system that they have access to. They are asked to organize a team and create change. They identify the issue, work through likely points of intervention, and develop an advisory committee of stakeholders or experts to inform the process. They plan the program and execute it. There are seven weeks to run this experiment in instrumental creative change. The final product will include a written report and a public presentation. A small project budget is provided.

Previous Student Projects

In the first year, a group of students decided to investigate the issue of the Mon-Fayette Expressway, a highway development planned to follow the Monongahela River all the way into Pittsburgh. The students were mostly against the project and united on a vague sense that the highway was "wrong." They were the first group that decided upon an information session in which to hold a debate upon the prevalent issues behind the highway dilemma. The panel was slightly unbalanced; most thought there were other solutions to the proposed highway. The discussion was held in a university room, with mostly university and university affiliated audience members. The panel did most of the talking and unfortunately the project seemed to be over after the event. Several students tried to continue the project work past the panel discussion, but soon became overwhelmed and/or disinterested. Although the audience might not have been ideal, it was a successful and informative event; very well organized and perhaps the first such thing that any of the students worked on. There was a sense of pride and accomplishment immediately afterwards, followed by a productive critical assessment. But it may be the highway issue was simply too large an issue to achieve satisfactory change. The group did not have a clear sense of the public opportunities available and strategies to heal the nature-culture relationships; spreading knowledge was one, but perhaps not the most effective, given the audience.

In the second year, two students broke off from a larger group early on in the project work to create what became known as *The Urban Stream Impact Protocol*. A biology student and an architecture student collaborated in developing a method of low cost watershed testing that would allow average citizens to investigate stream conditions in their environment. It would give an informative portrait of the watershed on the stream segment level, where trouble spots and clean areas could be identified. The group identified the issue; local water quality problems. They identified the constraint as a lack of knowledge or means of sufficient testing in acquiring that knowledge. They saw an opportunity in using a low cost citizen based testing program that would both fill that void and reform the relationship between citizens and local waterways. While claiming that these methods would empower citizens, they did not seem to consider how they would actually make citizens interested in participating. They did partner with 3 Rivers 2nd Nature in the following semester and had completed field tests of the protocol by the summer, some of which were done with community groups from a particular watershed. The students are not working with the issue directly any more but their work continues to hold interest. Several groups have expressed interest in adopting the protocol in their own programs in the future.

In the third year, one group took on the issue of a proposed woodland development in a project called *Public Voices/Private Development*. The issue was the concern about a plan to mine coal and eventually build a racetrack and casino on a 600+ acre undeveloped hilltop within the city limits of Pittsburgh. The group recognized that the timing was right to further add fuel to the burgeoning public controversy. They were concerned that one of the largest green spaces within Pittsburgh was going to be permanently altered with little room for public opinion at all. The method was to create a forum for public opinion that was guided by expertise. The group partnered with local non-profits already working on the issue and created a day long event with experts presenting on the issue in the morning. In the afternoon, citizens and experts alike collaborated on alternative design proposals for the site. These documents were then presented to the local communities and government as alternatives and tools for discourse. The project received extensive media coverage but perhaps was a bit lacking on local community involvement. The students were overwhelmingly positive about the work and several of them continue to work with the non-profit organizations on the issue of the hilltop mining.

History of Green Visions/Grey Infrastructure
As with any project that gets revisited over time, Green Visions/ Grey Infrastructure has been modified and tuned over its three iterations since it was introduced in 2001. While the fundamental goals of the course have remained the same, there have been changes in three significant ways.

The amount of reading has been an issue in the past. Even though the class is 12 units as opposed to the university average of 9 units, students have brought up

Public Voices/Private Development partnered with local non-profits in a public planning and information initiative to create a dialogue about the proposed mining and subsequent development on Hays Hillside in Pittsburgh. The hillside is a 635-acre forest that was mined by LTV Steel over 50 years ago and been recovering since.

the fact that they feel overwhelmed by the reading, and occasionally do not get to it in time for class discussions. Since the course depends heavily on class discussions, this is a problem. The instructors feel that this could be an indication that the actual amount of reading may be too much, or the content itself may be the cause. As a result, each semester, the reading list is edited with two things in mind: to trim off any excess texts, superfluous to the goals of the course, and to constantly be looking for texts that express a wide variety of ideas in an easier to digest format. Another complication is the fact that new books are released each year.

Texts added on since GVGI began include: *The Sunflower Forest: Ecological Restoration and the New Communion with Nature*, by William Jordan, *Nature By Design: People, Natural Process, and Ecological Restoration*, by Eric Higgs, and *Radical Ecology: The Search for a Livable World*, by Carolyn Merchant.

Texts dropped since GVGI's inception include: *Discordant Harmonies: a New Ecology for the Twenty First Century*, by Daniel B. Botkin, *The Sunflower Forest: Ecological Restoration and the New Communion with Nature*, by William Jordan, *Wilderness and the American Mind*, by Roderick Nash, *Art as Experience*, by John Dewey, *Energy Plan for the Western Man, Joseph Beuys in America*, compiled by Carin Kuoni, *Where Bigfoot Walks*, by R.M. Pyle, *Explorations in Environmental History*, by Sam Hays, *Humans as Components of Ecosystems*, edited McDonnell and Pickett, and *The Careless Society*, by John McKnight.

The second significant change is in how project groups are constructed. One of the biggest surprises from the first semester was how important group dynamics became during the project work. Initially, we allowed the groups to organize and form themselves. Successful groups are ones that act as a single organism and are efficient at dealing out tasks that need to be completed in order for the group to function. We learned that students are more apt to fulfill self-defined roles regardless of the needs of the group. The group cannot be successful if it is composed entirely of leaders or followers. Understanding the range of roles and strengths within a group is essential to success.

The third significant change is the quality of the work. Both the students and the instructors benefit from the history that accumulates with each successive semester. The instructors benefit from experience in being able to respond more effectively to the students. Students may find it easier to conceptualize potential projects if they understand the scope and scale of projects before them. In the first semester, the projects seemed to lose steam and draw to a close at the end of the course. We believe it is important to think about how to give the projects "legs" of their own, so that the momentum and energy can continue on. This did not happen the first semester and the projects were rather insular to the university community, with no clear direction to go after the course work was done. In the second year, one project stepped clearly outside of the university into Pittsburgh communities, and another found a way to give the project work legs, passing off a protocol that was then implemented by the STUDIO for Creative Inquiry that following summer. In the third year, two projects took great steps outside the university, forming partnerships with local organizations and interacting with community members. Both projects continued their work well after the course ended.

As for potential areas for change in the future, one of the primary constraints of the class has been time. It would be interesting to see how the course would change if it were extended to encompass two semesters, with the first semester devoted solely to the readings and the second semester focused on project work. More time could be spent digesting the various concepts and ideas, and the project period would allow for a greater scope of issues. In a single semester, it would be possible to experiment with allotting several more weeks for project work, the readings could continue into that period instead of being cut off exactly at week seven. Another idea would be to begin the project work almost immediately and have it continue amorphously on the back burner during the reading

period. We could work to define the groups and the issues within the first month, allowing students to switch groups, up until week seven perhaps. That approach might join the theory and the practice a bit better and create a sense of momentum so that when week seven arrives, the groups can hit the ground full stride. There is slight concern that by the time the groups get their bearings straight, the semester is nearly over.

A possible constraint might be the age of the participants. GVGI currently allows juniors, seniors, and graduate students to enroll. However, the class demographics have primarily been undergraduates. We would be curious to see how the class would change if only graduate students enrolled.

Conduct and Evaluation

Many of the Green Visions/Grey Infrastructure class sessions are discussions on the readings of the day. The readings for the course are chosen as a broad overview of some of the different modes of thinking within Restoration Ecology and its related fields. Students are expected to have the time to read all of them, allowing for wide-ranging and engaged discussions. Discussions also break off into smaller groups, allowing for more space for students to speak. Class participation is extremely important. If students are expected to engage in a social dialogue with creative change as its intent, practice among peers is essential. We encourage them to take notes and draw out concept maps of the wide range of topics and ideas covered.

Learning about the diverse concepts that define nature and culture relationships is only one part of this course. More importantly, students should be listening to themselves and their peers, reflecting on their values and interests in these areas. In eight short weeks, GVGI touches on systems, preservation, conservation, ecology, planning, and transformative cultural models. The course aims at empowering students to think critically in these issues and asks them to continually consider their personal, biological, and technological relationships to nature.

Students are encouraged to do the reading slowly and deliberately. We ask them to work at understanding the literal meaning of each author and consider how it fits with their particular world view on the topic. Each class member will be reading outside their disciplines in this course and will need to work to understand the meaning of the words as well as their context.

The instructors put as much effort into teaching the course as they hope the students will put into participating. They frequently meet with individuals and project groups outside of class time, sometimes even on weekends. Implicit in their style of teaching is a compassion for the integrity of the individual, recognizing that life can be quite complex for students. They work in accordance with that, but also challenge the students quite extensively, truly believing in the capabilities of each one.

The class also employs a custom evaluation form that the students are required to fill out at the end of the semester. It is intended to be a thoughtful and productive critique that the students can use to reflect upon and the instructors can learn from. In it, we ask them to write a page answering the question, "have your ideas about nature changed?" We also ask them to review themselves and their group members, in areas such as, generating ideas, working effectively in a group setting, ownership of tasks, and so forth. Each question is answered with a numerical value. Averaging all the responses from the last semester, the highest score was 4.6 out of 5, and was in response to the question, "would you work on an interdisciplinary project again?" The lowest was in response to a personal assessment of leadership skills. That score was 3.3 out of 5.

We ask the students what text was most important, which was most provocative, what was the hardest, and which reading they would delete. The texts that some students would delete are Radical Ecologies and to shorten *Conservation and the Gospel of Efficiency*. The first of which seems to be rather dense and wide ranging. We chose it for exactly those reasons. But it is heavily entrenched in references to other thinkers and philosophies, from Taoism to Darwinism, and from Paganism to Marxism. If a student is unfamiliar with even just occasional referenced ideas, it would be easy to feel like one is consistently missing something. And that makes for a frustratingly difficult read. Most acknowledged the value of Radical Ecologies but also commented that it was quite difficult. Spending more time with the text would alleviate these frustrations and would happen if the course extended over two semesters.

The final evaluation assesses the course and the instructors themselves. We ask the students:
- Did you learn to frame and reference your understanding of culture and nature relationships?
- Do you have a better understanding of the application of knowledge within domains of power and interest?
- Do you understand how to conduct strategic research with social intent?
- Do you have a better understanding of the transformative potential of new ideas and concepts?
- Do you have a sense of your own personal inquiry and its relationship to society?
- Did you learn how context and strategy can affect the presentation of ideas?
- Do you feel that you have become more skilled at change?

The highest average score was 4.2 out of 5 in response to the "sense of your own personal inquiry and its relationship to society?" The rest of the questions were in close contention. It is our hope that students come away from the class with an interest and confidence in their own questions about their world around them as well as viable methods for acting on those questions.

Implications of the Course

There are several avenues into thinking about the implications of a course like Green Visions/ Grey Infrastructure. The first of which is to gauge the university response, in terms of administration as well as student enrollment. The course, even after its 3rd semester, still exists outside of any set program within the university, and is taught on a year by year basis. We hope that the success of GVGI could act as a catalyst in defining a "Green Knowledge" program at university level. And on some level, the fact that a 4th year is in the works speaks to a moderate degree of institutional success. Student enrollment can also be an indicator. In 2001 nine students completed the course, in 2002, thirteen, and in 2003, twenty-one.

If one views GVGI as a systems intervention in its own right, with the goal of empowering the students as agents of social change within the field of Restoration Ecology, perhaps the students themselves are a place to turn to understand the implications of the course.

Some quotes from the evaluation forms from 2003:
"I never thought of myself as someone particularly passionate about nature - I thought I wasn't extreme enough and my ideas weren't extreme enough to warrant such a passion. Now I realize that any personal connection on has with nature is significant, and furthermore, making personal connections to nature is how we derive the motivation to implement change."

"Its not so much that my ideas about nature have changed, but more the position and responsibility within nature that I hold as a human being...I don't think I have ever been exposed to a teaching perspective that views human existence and society within the framework structure of Nature."

"The question of restoration and how social and ecological communities fit together – even in the context of development – these are exciting and new ideas to me."

"Radical Ecology was the best, I think, because it exposed us to a wide spectrum of developed ecological and social theories and practices – it challenged me to question my own beliefs and where I fit (or didn't) with the given spectrum. Hard but in a great way!"

"This is the best class I have ever taken. I like the different formats of the class – the beginning critical thinking and theoretical approach, and the final direct action, exciting, invigorating, challenging – really hard, but great project at the end. This is what I want to do with my life, and it's great to get a chance to take a class with social change as its goal. I am also very happy to have such an emphasis on group dynamics – this is such an important skill we often ignore – it's especially important when trying to join together with a community (large or small) and trying to make positive social change."

"The history of conservation and preservation was an interesting subject, but it was very dense and dry. It would be more effective to find a more readable alternative."

"I admit I didn't care much for Merchant's Radical Ecology, though I recognize its value to create definition in what could be a very muddled arena of Ecological activism."

"I feel like perhaps we should have started working on defining projects and groups earlier on in the class. It would have allowed us more leeway in planning schedules for public functions, deadlines, and other matters."

"It frustrated me that other people slacked on the reading because rather than getting to expand my ideas further with the readings as a jumping point, we ended up just outlining what we had read."

"I would've liked to see more readings on sustainable development associated with cities, not mainly ecology."

Green Visions/Grey infrastructure is what could be called instrumental interdisciplinary practice. It begins to define a way to actively pursue social change without succumbing to the outdated model of myopic expertise. It empowers and activates the students from the individual outward, denying the sort of institutional paradigms that govern activist platforms and define their constituency. In a sense, it teaches the true democratic platform, where all citizens are invited to envision and define the future. It is experiential learning, where students are removed from the sanctity of their respective disciplines into the wild unknown of collaborative work, much like the "real" world. It is a path out of post-modernism, a pragmatic attempt at restructuring ways of relating to the world. If a skill is learned, we like to think of it as learning how to cross the disciplines and create new ways of dialoging with the ever changing world around us.

Notes

1 USAC – Pittsburgh District Internet Site www.lrp.usace.army.mil/pm/lowermon.htm
2 Mon Valley/Fayette Expressway – www.monvalleyprogress.org
3 Merchant C. (1992: 1) *Radical Ecologies*
4 Meadows (1997: 78, *Places to Intervene in a System*
5 Alinsky S. (1971) *Rules For Radicals*, The Purpose
6 Plumwood (1993: 198, *Feminism and the Mastery of Nature*
7 Naess (1989: 29) *Ecology, Community, and Lifestyle*
8 Naess (1989) *Ecology, Community, and Lifestyle*
9 Sessions, 1995

Conclusions

Malcolm Miles

The evidence of the new courses described in some of the preceding chapters (by Beverly Naidus, Tony Aldrich, Jane Trowell, and Noel Hefele - Chapters 15 to 18), is that within institutions of higher arts education in the UK and USA initiatives are taking place which respond to, rather than merely reflect, the issues and agendas of an emerging post-industrial society, and reassert a value of human well-being within it. Of course, the cases profiled in this book are only a few of those which exist, included here because those involved in them contribute to some of the same networks as myself. No doubt there are many more, and their responses will be diverse. But it is interesting that, while the commodification of mainstream art is almost total now, as every departure from it (from the Secessions of the 1890s to 1960s conceptualism) is colonised by the market, the University and the Fine Arts Academy offer spaces outside the promotional loops of art fairs and glossy magazines, in which other attitudes can be developed. The growth of research degrees in art practice, discussed by Iain Biggs and Amanda Wood, Katy MacLeod and Lin Holdridge, Peter Dallow, Lucien Massaert, and Mika Hannula in Chapters 10 to 14) is one of several niches for this development. I see it fed, too, by interactions of writing and art-making - I do not say between theory and practice because theory *is* a practice. This remains a personal view, but if accurate then academic niches which go against an increasingly market-led grain in education are paralleled by the new opportunities seen by Saskia Sassen (Chapter 1) in the interstices in which cultural producers and intermediaries insert themselves in a world of globalised communications. And, as Clementine Deliss indicates (Chapter 2), the most engaging (and engaged) initiatives may be found outside the affluent world, in sites of former colonial cultural as well as political regimes. New technologies enable trans-global networking (in art as well as anti-capitalism protest). Geoff Cox and Joasia Krysa argue (Chapter 3) that these technologies are more than technical in their import, and suggest new possibilities for criticism and curating as well as a need to intervene in their production.

Interventions in how meanings are constructed, as discussed by Judith Rugg (Chapter 6), amount, together with a realisation of their immanent plurality, to interventions in the structures of perception and categories of thought. This is one kind of cultural upheaval alongside another represented by artists' material and tactical involvement in environmental issues and sites of environmental degradation, addressed by Tim Collins and Reiko Goto (Chapters 4 and 8). Ann Rosenthal introduces cases of practices between what I would see as environmental and social agendas in Chapter 7, and for many students it is this complex terrain of being alive and conscious in a world which they can both critically observe and imagine as transformed which fires their imagination. Matthew Cornford and David Cross show (Chapter 5) that art can be disruptive and at the same time

eloquent in its wit and irony. There is much to play for, and playing – implying a ludic future in place of service to the performance principle – may be a more appropriate activity for arts education than subscription to the audit-based culture of large areas of higher education today. As Peter Renshaw argues persuasively, we need conversations, and we need these to take place disregarding conventional divisions of discipline or institutional organisation.

Now I have mentioned all the contributors and emphasised a few issues I regard as constituting parts of a new agenda for higher arts education, I want to add a few thoughts of my own. There are two in particular: firstly, that the possibility for a renewal of critical practice seems more alive now than through the period of retrenchment – and a market-totalitarianism from the Thatcher-Reagan years – after the disappointments of 1968; and secondly, that an underpinning aspect of the emerging scenario is a replacement of the Kantian idea of 'free art' (or Modernist autonomy) by a post-Kantian aesthetic. These ideas overlap, and I will try now briefly to explain what I mean by both of them.

Looking at the strand of contemporary art known as Brit-Art, which has its allure for many in arts education as well as the media industry to which it is aligned, it might seem foolish to write of criticality. Yet the work of artists such as Jochen Gerz, Krzysztov Wodiczko, and Mierle Ukeles, among others, demonstrates a refusal of – respectively – fascism, militarism, and alienation. These and many other artists, and artists' groups such as PLATFORM in the UK and Critical Art Ensemble in the USA, work in the cracks of the dominant society, not so much de-centering its power (because power has already de-centred itself by out-sourcing key functions) as re-defining the understanding of power. I call such work critical because it constructs or gives visual form to a critique of the social and production relations in which it is situated. This differs from the mimetic tradition in Western art, and from documentary work which records, even exposes, but does not engage in the conditions of its production. It differs equally from the Modernist claim for autonomy in the artwork, the so-called value-free art of the white cube.

To give an example: in her residency at the Wadworth Athenaeum in Hartford, Connecticut, Ukeles re-classified a glass case containing an archaic Egyptian mummy as an art-work. At first reading this may appear a gesture. But it is an intervention in the hierarchic structure of the museum, in which only curators, not cleaners, can touch exhibits. The cleaning of the mummy case thus became the responsibility of curators. In a final fling, Ukeles took charge of all the museum keys, moving from room to room locking and unlocking them whether they were occupied or not. This provocation, which might be compared to the provocations of Cornford and Cross (Chapter 5), was too much for the curators who brought matters to a head when they declined to be locked in their room – even as art. As keepers of knowledge, the curators held power in a stratified micro-society reflecting the wider society in which such relations of power and privilege

are (re)produced. The role of the artist is to draw out the situation into a visible form at which point it produces its own commentary.

This links to a key difficulty in modern thought: that the alignment of knowledge with power produces a sense of power as *power-over*. This differs from the sense of power implied in the term empowerment. The latter is over-used, often to mask a situation in which power-over is retained through technological or other dependence while – as in third-world development – a claim is made to hand over its baubles. Probably power is never given, only rarely successfully taken, but can be realised in another sense from within. The difference is like that between authority as authority-over (authoritarianism) and the authority of a person who is expert in a particular kind of knowledge. That, too, can be degraded when the claim to knowledge is restricted to professional elites, but what I mean here is the tacit knowledge of, say, dwellers on dwelling. Michel Foucault's contribution to a discourse of power was an optimistic proposal that, despite the pervasiveness of a coercion in which the subject-citizen is complicit, power is never fully efficient in delivering its ends: it leaks, frays, trips over its own feet. This de-mystifies the structures of power-over. But complementing this, though not normally put beside it, is Paolo Freire's idea that a subject can be self-empowered.

Freire's experience was initially in adult literacy programmes in Brazil before the military coup of 1964, and in *Pedagogy of the Oppressed* (1972) he cites Fanon on the tendency for the colonially oppressed to seek to mimic or acquire part of the culture of the oppressor – as an unauthentic consciousness which first has to be seen as it is. He writes:

> The oppressed, who have been shaped by the death-affirming climate of oppression, must find through their struggle the way to life-affirming humanization, and this does not lie simply in having more to eat (though it does involve and cannot fail to include having more to eat). The oppressed have been destroyed precisely because their situation has reduced them to things (Freire, 1972: 44).

He adds that to regain their humanity the oppressed must cease to be things and fight as people. They can do this only for themselves. In as much as propagandists or avant-gardes interpret the world for the oppressed, the power relation is unchanged.

What does this have to do with higher arts education? For Freire, whose literacy classes took the student's life experience (not a set text) as point of departure, an obvious implication is that the students should write the curriculum – *if there is one*. In a symposium on higher education at the National University of Mexico, Freire argued that both the rigidity of scientific methods and the (seemingly liberal but manipulative) work of those who seek to stimulate creative work in specific ways are instrumentalist; to these positions he contrasts the concept of

radical, or direct, democracy (to which Joseph Beuys also subscribed). He writes: "the curriculum is represented as a type of unintentional perversity"; and "the curriculum will appear as a mercenary, hired to save those who will remain under domestication" (Escobar et al, 1994: 75). He continues:

> I do not want to reduce all this to mere intellectual comprehension, but it is absolutely indispensable that there exist certain critical reflection and theory on the practice of creating curriculum where obstacles are found in relation to the determined limits of authoritarian power. It is absolutely fundamental to understand the nature of the limits of creative praxis for this. (I would like to stop here and offer the floor to other colleagues who would like to delve deeper ...) (ibid).

This corresponds with one of the findings of an ELIA working group which met in Barcelona in 1996 to reconsider the concept of an arts academy (and first proposed the idea of a Teachers' Academy, though not in the form adopted in 2003): that the structure and internal methods of an institution committed to an ethical society should themselves be ethical.

At this point I have probably stepped over the line which many of those who manage higher arts education regard as the limit of a viability which, among other requirements, links education to employability, research to enterprise. Well - not my problem. As it happens, the cases of new practices and pedagogic models described in the preceding chapters make clear that the market does not rule quite everywhere. Neither does the art market, with its relentless drive to turn art into mass entertainment of the kind Adorno sees as mass deception (1991), obliterate the possibility for an art which is critical without being instrumental, and which affirms agency while illuminating the structures in which agency operates (and is produced even when it seeks to change them). What this is not, however, is free art.

The term free art – nothing to do with helping yourself to the goods in the gallery or art museum – derives from a Kantian aesthetic of the disinterested judgement of taste. In the Anglophone world, it is more often put as art's autonomy. My use of the term free art is borrowed from discussions in which I have participated in continental Europe (usually through ELIA), in most of which it has been defended passionately. I do not know whether some scientists would defend the notion of objective truth in a similar way; to me both notions are undone by realisation of the contingency of their historically-specific production. Leaving that aside, the idea of a critical distance was defended by the critical theorists of the Frankfurt School, notably by Herbert Marcuse in his delineation of an aesthetic dimension (1978). But for Marcuse, and Adorno, there is a creative tension between critical distance and being embedded within that which is viewed at this distance. From the paradox, which for Adorno must not be resolved even if it appears a mutual disablement of the polarities, comes the possibility to interrupt.

In dire times, that might be as much as can be attempted. But what I think it indicates is an aesthetic, not of disinterested judgements, but of interested though non-judgemental insights.

Where now? I would say it is not a question of producing new theories to rationalise new practices. We have plenty and much work to understand them. For me the work of the Frankfurt School remains central though I accept it is an acquired taste, a bit like burnt toast. But it is a question, in institutions of learning, of creating environments in which freedom thrives. The beginning of this is in recognising and investigating unfreedoms, including those of institutional structure and power (and the limits of agency which is never fully autonomous, always produced and hence contingent). This is a research agenda, but I would like to end by quoting Miguel Escobar, from the Freire symposium. After arguing that professors tend to rely on the interpretations of others so that "in a struggle for power [they] simply turn it into a struggle over the representations that we have of reality", he says:

> It is very easy to tell the students to organise themselves, but we as professors are more and more outside the political struggle and not even part of the academic struggle. I feel that the best weapon to fight technocracy is to commit ourselves to an academic project. It is logical for the central power not to be interested in discussing academic projects since authoritarian decisions are very easily made.

> Thus, this discussion about the curriculum deeply affects our lives. We must reconsider our dialectical selves, the way in which we are reading our reality, transforming it, and attempting to wade through it (Escobar et al, 1994: 123).

Coda

The beginning of one century seems much like the end of the previous: after the fireworks and the parties, the clearing up and the carrying on; or perhaps a realisation that the calender which marks a millennium is only one of several available globally. There is no reason to expect a sudden shift, either apocalypse or epiphany, which ends the old regime and announces a new dawn, just now.

The difficulty is that while we need divisions of time to arrange our days just as we need divisions of knowledge to do our work, and chapters to organise a book, categories which begin as being simply convenient soon become institutionalised. As Lewis Mumford wrote in *The Human Prospect*: "The clock, not the steam engine, is the key machine of the modern industrial age" (Mumford, 1956: 5), but evolved from the marking of times of religious observance (hours) in the monastery. It was no accident that in Paris in 1871 the Communards shot at public clocks which inscribed the alienating time of wage labour on the city. Today, as a post-industrial society moves to a 24-hour city which despite its

fluidity is no less alienating or divisive than the industrial city, the action of the Communards seems a fanciful intrusion of imagination into ordinary life. Or perhaps it was a reassertion of ordinary life in face of an ordering which from another point of view would seem extraordinary.

References

Adorno T W. (1991) *The Culture Industry: Selected Essays on Mass Culture*, ed. Bernstein J M, London, Routledge

Escobar M., Fernandez A L., Guevara-Niebla G., with Freire P., (1994) *Paolo Freire on Higher Education*, Albany, State University of New York Press

Freire P. (1972) *Pedagogy of the Oppressed*, Harmondsworth, Penguin

Marcuse H. (1978) *The Aesthetic Dimension*, Boston, Beacon Press

Mumford L. (1956) *The Human Prospect*, London, Secker & Warburg